A New World

England's first view of America

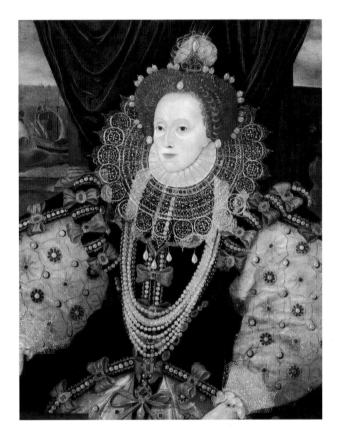

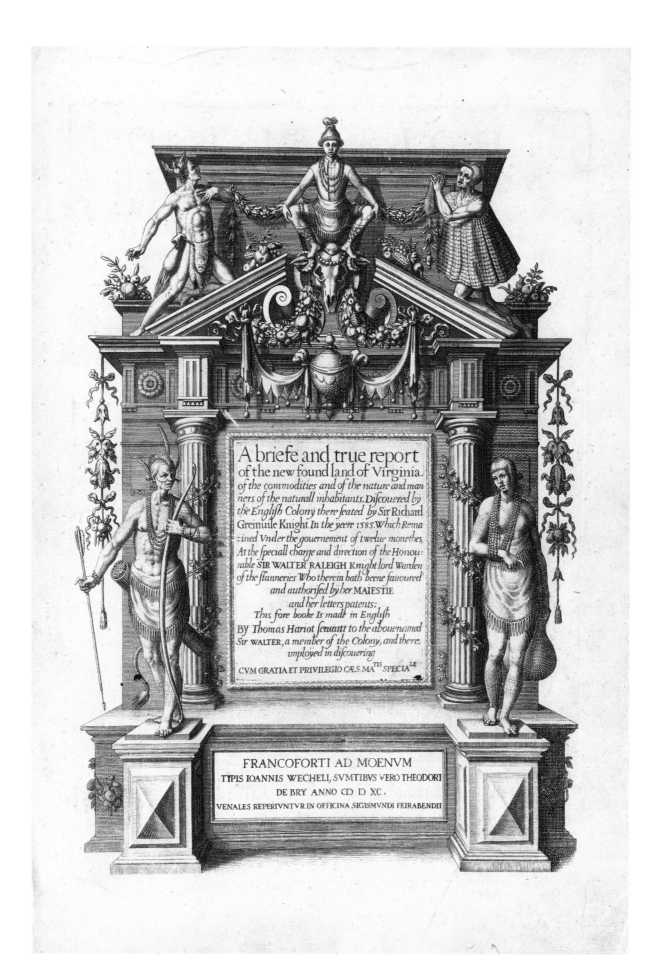

A briefe and true report
of the new found land of Virginia.
of the commodities and of the nature and man
ners of the naturall inhabitants. Discouered by
the English Colony there seated by Sir Richard
Greinuile Knight In the yeere 1585. Which Rema
ined Vnder the gouernement of twelue monethes,
At the speciall charge and direction of the Honou-
rable SIR WALTER RALEIGH Knight lord Warden
of the stanneries Who therein hath beene fauoured
and authorised by her MAIESTIE
and her letters patents:
This fore booke Is made in English
By Thomas Hariot seruant to the abouenamed
Sir WALTER, a member of the Colony, and there
imployed in discouering

CVM GRATIA ET PRIVILEGIO CÆS. MA.^TIS SPECIA.^LE

FRANCOFORTI AD MOENVM
TYPIS IOANNIS WECHELI, SVMTIBVS VERO THEODORI
DE BRY ANNO CꝹ Iꝺ XC.
VENALES REPERIVNTVR IN OFFICINA SIGISMVNDI FEIRABENDII

A New World

England's first view of America

Kim Sloan

with contributions by Joyce E. Chaplin,
Christian F. Feest and Ute Kuhlemann

The University of North Carolina Press
Chapel Hill

For my daughter, Morwenna Chaffe

© 2007 The Trustees of the British Museum

Kim Sloan has asserted the right to be identified as the author of this work

Published in the United Kingdom in 2007 by The British Museum Press
A division of The British Museum Company Ltd

Photography by the British Museum Department of Photography and Imaging
Designed and typeset in Bembo by John Hawkins and Harry Green
Printed in Spain by Grafos SA, Barcelona

Publication of this book was made possible in part by a generous grant from the North Carolina Museum of History Foundation.

A catalog record for this book is available from the Library of Congress.
ISBN 978-0-8078-3125-0 (cloth)
ISBN 978-0-8078-5825-7 (paper)

cloth 11 10 09 08 07 5 4 3 2 1
paper 11 10 09 08 07 5 4 3 2 1

CONTENTS

DIRECTOR'S FOREWORD

Among the many stories the British Museum tells is how people, at different times and places, have tried to imagine the world beyond their immediate horizons. And among the most remarkable imaginings in our collections are the works of John White, who sailed to North America in the 1580s and became the first Englishman to record the inhabitants, animals and flora of the New World. As his watercolours are fragile and may safely be exhibited only once every thirty or forty years, this exhibition is our generation's chance to think again about these astonishing documents of an encounter filled with curiosity and wonder.

For the next two years John White's watercolours will be on display in the exhibition that this book celebrates. With generous support from the Annenberg Foundation, it will run here from 15 March to 17 June 2007. It will then open in the autumn at the North Carolina Museum of History in Raleigh, the start of a tour of four venues in North America. People from around the world will be given the opportunity to share England's first view of America through the eyes of a man who made five voyages to 'Virginia' in the New World. They will also be able to think about the man himself, and why he saw and drew as he did.

Although his images of the North Carolina Algonquians are instantly recognizable and familiar, the name of the man who painted them is less well-known. He was a gentleman who lived in London and circulated amongst courtiers and privateers such as Sir Walter Raleigh and Sir Richard Grenville. Like other gentlemen-adventurers, John White invested his own money and was willing to plant his own family in these New World ventures. All this situates him perfectly as our Elizabethan interpreter of the New World. But he had further qualities: in London he knew the artist Jacques Le Moyne who had himself met and drawn the Indians of Florida; he worked with scholars such as Thomas Harriot and Richard Hakluyt; he drew maps inspired by the work of Ortelius and Mercator and he may have surveyed estates in Ireland for the land commissioners. Above all these, however, John White was what his contemporaries would have called a gifted limner – a man who could paint in watercolours.

When John White painted his portraits of the Indians he met and recorded the flora and fauna he saw on his travels, it was not just an artist's eye that guided his hand – it was the mind of a man shaped by his time, his education, his country, his religion and his associates. Only by examining and understanding them can we begin to look at the New World through sixteenth-century European eyes, without the preconceived notions of our own time, and begin to understand what happened when these two worlds met.

For the members of Raleigh's circle and the English court who saw White's watercolours, they brought to life the complex and sophisticated culture of the people of America, specifically the coastal Carolina Algonquians, as no other drawings, watercolours, paintings or prints had done before or were to do for another two or even

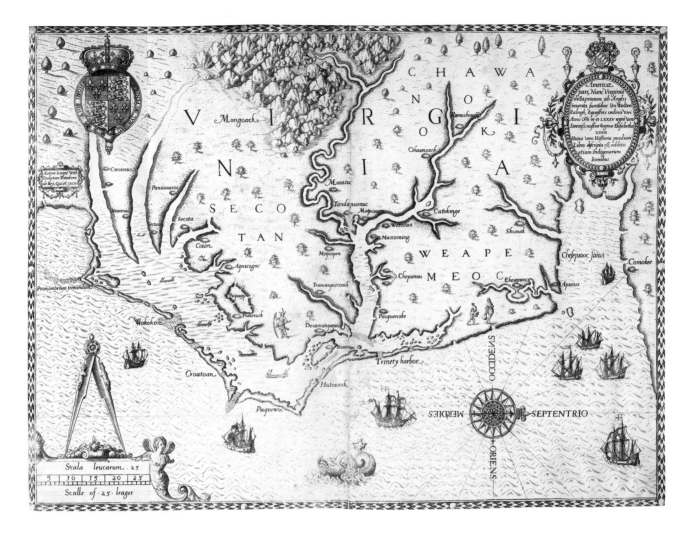

3. *A Map of that part of America, now called 'Virginia'*, 1590. Engraving by Theodor de Bry for Thomas Harriot, *A briefe and true report*, Frankfurt. Based on John White's maps (nos 2 and 6). By permission of The British Library, London (c.38.i.18)

three hundred years. Theodor de Bry's engravings introduced that vision, filtered through his own artistic manner and religious agenda, to all of Europe.

The watercolours from White's American voyages account for just over half his drawings in the British Museum. The others are what appear at first to be unrelated costume studies of Florida Indians, Inuit, Turks, Greeks, Picts and Ancient Britons. In fact, these provide yet another context for White's visual record of the 'Virginia' Indians – a *theatrum mundi* that they were all perceived to inhabit, just as his maps provided a visual encyclopaedia of the voyage and the particular part of the world the maps recorded. In the early humanist tradition of Mandeville, White humanizes the American cultures he describes. He sees them as far more civilized than the fantastically tattooed, head-hunting Picts and Britons of our own past.

The profound significance of Raleigh's Virginia voyages to the history and culture of the modern world is often forgotten or undervalued. But they laid the ground for the later English settlement of America – at Jamestown and then at Plymouth – and all the wonders and horrors which that was to entail, with all the resonances for America and the rest of the world today. In unlocking John White's drawings, these 'secret treasures' from the repository of world cultures that is the British Museum, we are providing an opportunity to reassess England's first view of America.

Neil MacGregor
Director of the British Museum

7

NOTE TO THE READER

John White, the man and his work, must be examined in the context of the variety of intellectual, cultural and commercial ventures taking place in his time. In the following book I have attempted to explore some of these at length and to touch on others and have invited contributions from scholars whose approaches would reflect this variety. Their various ways of seeing have resulted in differences, even tensions in interpretation which have not been edited out; they are important signifiers not only of the complex and multi-layered attitude that must be taken in such studies but also of the simple fact that there is no right or wrong way of knowing history, only different ways of exploring it. An interdisciplinary academic conference is planned for June 2007, the proceedings of which will be published on the British Museum website, and this will hopefully provide an even wider basis for further enlightening tensions, research and discovery. Because this book is necessarily based on White's drawings which provide first of all an English way of viewing America, I hope that the participants will be able to utilize White's drawings and our new knowledge of their context and of White himself to tease out a new understanding of the culture of the American Indians he depicted and their own ways of seeing.

The nature of this book demands a few explanatory notes. As it is based on the British Museum's collection of drawings by John White and acts in part as a catalogue of them, its focus necessarily has been on White and his drawings; although they were produced on one of Raleigh's voyages to Virginia, this book is not intended to be a full account of the voyages, the Roanoke settlements, the Lost Colony, the North Carolina Algonquians or the beginnings of the English colonization of America. There are many excellent books already in print on these, most of which are listed in the Select bibliography, and this book is intended to complement them and earlier publications on the drawings themselves.

A note is necessary concerning the spellings and quotations used in this book. For consistency, Raleigh and Harriot have been used throughout rather than the equally acceptable Ralegh and Hariot. Theodor de Bry, whose own name is spelt in various ways, used a variety of translators and German typesetters and the resulting English in his book is interesting in itself and mostly recognizable and therefore has been retained on the whole, except for the titles of his plates in the captions here – the original is always clearly legible in the reproductions. I have tried to replicate the original spelling of more lengthy quotations, either from the original text or as transcribed by Quinn. Finally, Harriot devised a remarkable phonetic script to record the pronunciation of Indian words and place names, but this did not result in consistent spelling in his account, White's or de Bry's. I have selected one variation for each and have tried to be consistent in their use. Secotan and Pomeiooc are referred to variously as towns and as villages in the accounts.

ACKNOWLEDGEMENTS

This book stands on the scholarship of two people in particular – the remarkable historian David Beers Quinn and Paul Hulton, former curator of British and French drawings in the British Museum. William Sturtevant of the Smithsonian worked with them and provided invaluable advice. In the British Museum, over the past two years, I have leant constantly on the deep knowledge, kind patience and guidance of my colleague Jonathan King. I am also indebted to Antony Griffiths for suggesting the exhibition in the first instance. Although I cannot name them all here, other colleagues in the Museum have assisted with the exhibition and, as always, made it a much easier and more enjoyable experience.

The contributions of Joyce Chaplin, Christian Feest and Ute Kuhlemann make this book more wide-ranging and challenging of received perceptions than I could possibly have hoped. They were a pleasure to know and to work with; Ute in particular deserves my warmest appreciation, as she also served as exhibition assistant, helping in every possible way, intellectually and organizationally, her commitment remaining constant in spite of more personal interventions. Karen Ordhal Kupperman very kindly read a first draft and improved it immeasurably. Nina Shandloff has again been an incredibly supportive editor who chose the best designer, John Hawkins, and copy-editor, John Banks, I could wish for. I am also extremely grateful to the following colleagues on whom I have relied for advice about their collections: Sian Flynn, Susan Doran, Brian Thynne, Jon Astbury and Lisa Patterson at the National Maritime Museum, Judith McGee and Rob Huxley at the Natural History Museum, Karen Watts of the Royal Armoury, Bróna Olwill, Stephen Ball and Elizabeth Kirwan of the National Library of Ireland, Tarnya Cooper of the National Portrait Gallery, Barbara O'Connor and Peter Barber of the British Library, Dana Josephson of the Bodleian, Kathryn Whistler and Arthur MacGregor of the Ashmolean, Stephen Johnston of the History of Science Museum in Oxford, Amanda Saville of Queen's College Oxford and particularly Vanessa Hayward and Lesley Whitelaw of Middle Temple, Diane Le Brun and Lise Légaré of Parcs Canada and Elisabeth Fairman at Yale. Mor Thunder, Julius Bryant and Mark Evans of the Victoria and Albert Museum provided useful advice, but I would particularly like to thank Katie Coombs and Alan Derbyshire whose expertise and careful reading of chapter 2 made it infinitely better and correct. Karen Hearn at Tate Britain has been a fountain of information on Elizabethan artists.

On a research trip to North Carolina I received generous assistance, advice and hospitality from lebame houston, Tom Shields, Bob Anthony, William Powell, H. G. Jones, Rob Bolling, Steve Harrison, Phil Evans, Betsy Buford and more recently Larry Tise. I look forward to thanking them properly when the exhibition travels to the North Carolina Museum of History in Raleigh in 2007. As usual, though, it is those at home to whom I owe the most for their inspiration and support: my parents for childhood memories of the excavations at Ste Marie among the Hurons, my husband, Paul Chaffe, for his constant support in every way, and our daughter, Morwenna, to whom I dedicate this book as she begins her own voyage of discovery about North America and its people, past and present.

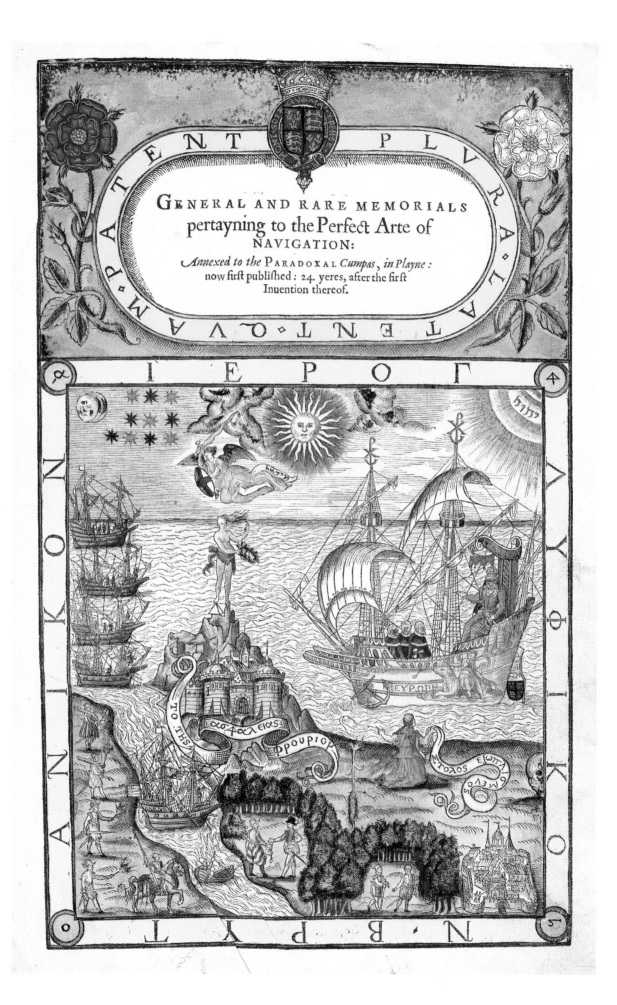

CHAPTER 1

SETTING THE STAGE FOR JOHN WHITE, A GENTLEMAN IN VIRGINIA

KIM SLOAN

4. Title page to John Dee, *General and Rare Memorials pertayning to the Perfect Arte of Navigation*, 1577, published by John Daye, London. Hand-coloured woodcut with gold and silver. Queen Elizabeth steers the Christian ship of Europe, forecasting England's position as mistress of the seas. The Bodleian Library, University of Oxford (Douce, D. subt.30, title page)

'*The fift voyage of* Master *Iohn White into the West Indies and parts of America called Virginia, in the yeere 1590*'

… Captaine Spicer came to the entrance of the breach with his mast standing vp, and was halfe passed ouer, but by the rash and vndiscreet styrage of Ralph Skinner his Masters mate, a very dangerous Sea brake into their boate and ouerset them quite, the men kept the boat some in it and some hanging on it, but the next sea set the boat on ground, where it beat so, that some of them were forced to let goe their hold, hoping to wade ashore, but the sea still beat them downe, so that they could neither stand or swimme, and the boat twise or thrise was turned the keele vpward; whereon Captaine Spicer and Skinner hung vntill they sunke, & seene nor more … They were a 11 in all, & 7 of the chiefest were drowned …

Richard Hakluyt, *The Principal Navigations, Voyages, Traffiques and Discoveries of the English Nation* (1598–1600)

The drowning of men with whom he had shared several voyages is only one dramatic incident in six drama-filled years of the life of John White. He was born some time in the 1540s and last heard of in Ireland in 1593, but we know almost nothing of his life apart from this period of six years, from 1584 until 1590, when he accompanied five voyages to the New World. Most of them were under the patronage of Sir Walter Raleigh to the land he christened 'Virginia' after his Queen – now the Outer Banks, islands and mainland of North Carolina.

The only other clues to John White's life and to his role on these voyages are his brief accounts of two of them, one letter and 75 astonishing watercolours. Some if not all of the watercolours were probably made for Raleigh, Queen Elizabeth or another patron after White's return from his second voyage in 1585. They record the fleets of ships in which up to six hundred men sailed, the forts they built, the flora and fauna they encountered, the land they surveyed and, most wonderfully of all, the Algonquian Indians who lived in various villages in the land the English believed they called *Assamacomuck*.[1]

The watercolours survived in an album which was sold to the Earl of Charlemont in the late eighteenth century and was sent to Sotheby's in London for sale in the mid nineteenth. There was a fire in the warehouse in which it was stored; its spine was burnt and it lay soaking under pressure for three weeks afterwards.[2] Much of

the pigment was blotted on to the blank sheets interleaving the drawings, and what remain of the watercolours today are in many cases what might justifiably be described as shadows of the deep and brightly coloured originals. Other watercolours from the album depict the costumes of other nations, including two Inuit captured and brought back to England by Martin Frobisher in 1577, two Florida Indians and a series of magnificent watercolours of ancient Picts and other early inhabitants of Britain.

A second volume of drawings relating to John White was purchased around 1715 from White's descendants by Sir Hans Sloane, the founder of the British Museum; unfortunately he did not record who or where White's descendants were.[3] Sloane believed that some of the drawings were White's originals for the engravings that illustrated Thomas Harriot's account of their voyage, *A briefe and true report of the new found land of Virginia*, renowned throughout Europe from the time of its publication in Latin, English, French and German by the engraver Theodor de Bry in Frankfurt in 1590. The watercolours in the Sloane volume have been dismissed as copies ever since the discovery and purchase by the British Museum in the mid nineteenth century of the 'originals', but their status is re-assessed in the present book (see pp. 224–33). Before he purchased this volume, Sloane had all of the drawings in it copied for his own collection of drawings of natural history and these in turn were used for reference by Mark Catesby for his publication on the flora and fauna of Carolina. For some of White's images, therefore, there are as many as three or four versions.

The British Museum is fortunate indeed to be the custodian of this uniquely important series of watercolours which are the main focus of this book. They provide a window on the New World through which we look with the eyes of the artist, John White. We know very little of the man but a great deal about the five Virginia voyages and the Elizabethan world that sent them. By attempting to learn more about John White, a 'gentleman' first and 'artist' second, and what these social and professional labels, his drawings and his accounts of the voyages tell us about him and his Elizabethan contemporaries, we will be better placed to understand England's first view of America.

There were three main voyages to Virginia in the 1580s. John White made five: in 1584 on a small reconnaissance expedition under Philip Amadas and Arthur Barlowe; in 1585 with a military colony under the Governorship of Ralph Lane; in 1587 as Governor himself of the 'Cittie of Raleigh', the settlement attempt now known as the 'Lost Colony'; in 1588 on an aborted rescue attempt; and in 1590 on a final search. They were funded not only by Raleigh, to whom the patent for the discovery of Virginia had been given by the Queen with the support of her chief ministers, Francis Walsingham and Lord Burghley (fig. 5), but also by individual supporters such as William Camden, John Dee and Philip Sidney and by wealthy merchant investors.

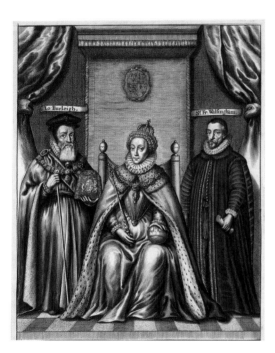

5. *Lord Burghley, Queen Elizabeth I and Sir Francis Walsingham*, 1655. Engraving by William Faithorne, published as title page to Sir Dudley Digges, *The Compleat Ambassador*. British Museum (P&D 1868,0822.2340)

The Virginia colonies were the direct outcome of earlier voyages made to Newfoundland, Labrador and lands further north by Martin Frobisher and by Raleigh's half-brother, Humphry Gilbert. A variety of reasons drove the voyages: a search for personal wealth, in the form of gold, silver, copper or merchantable commodities that might be acquired or grown there, or by privateering from the laden Spanish and occasionally French ships that might be encountered *en route*; the establishment of a military and naval base in North America from which to launch attacks on, or protect the English from attacks by, the French and Spanish already established to the north and south; a place to export criminals and the starving poor of London; a search for knowledge, of the sea, lands, animals and people, by natural philosophers, cosmographers and courtiers who wished to 'know the world'; and to establish a Protestant base from where the 'true religion' could be spread throughout the New World.

These voyages to a continent whose extent was not yet known on the far side of the Atlantic were not undertaken lightly: they were enormously expensive and fraught with more perils than high seas and hurricanes through which countless men lost their lives or their fortunes. John White was witness to and suffered from the dangers himself: many of the ships on the Virginia voyages lost valuable time or were subject to deadly attack or capture while privateering off the Azores or the West Indies *en route*, they were in danger while re-stocking there with salt and provisions, the Englishmen's laziness, greed and violent retributive treatment of the Indians would make the latter extremely reluctant to assist the colonists with food in the winter and inclined to retaliatory violent attacks, and political and financial incidents at home could rob the colonists and their investors of vital support. A drought in this part of America at the time and the high mortality rate of the Indians from the diseases the English trailed in their wake were also contributing factors to unstable relations. All of these very real risks experienced by John White force the reader to wonder what drove this man even to begin, never mind persist in, an enterprise that lost him his family, his wealth and very nearly his life.

Many authors have attempted to answer these questions through a variety of approaches and this book cannot attempt to summarize them all. Instead it will focus on rediscovering the man John White and re-examining his work and the way it was viewed in his own time and now.

John White's drawings are now iconic and appear in nearly every book that discusses early America and its inhabitants. They have been catalogued in full twice before by David Beers Quinn and Paul Hulton, but both publications are now out of print. It is hoped that the present book will provide a supplement that builds on their scholarship through new research and approaches to the subject. Thomas Harriot's *A briefe and true report of the new found land of Virginia*, published first as a small pamphlet in 1588 and then in 1590 by Theodor de Bry with thirty engraved illustrations, is available in a modern facsimile with an introduction by Paul Hulton. Modern accounts of the Virginia voyages, however, are legion. The most essential are Quinn, *The Roanoke Voyages 1584–1590*, 1955, in a two-volume modern reprint, *Set Fair for Roanoke* by the same author, one of the excellent series published in 1985 by

the Four Hundredth Anniversary Committee of the 1584 voyage in Chapel Hill and Raleigh, North Carolina, and Karen Ordahl Kupperman, *Roanoke: The Abandoned Colony*, 1984 (for details of these main publications see the Select Bibliography).

Studies of John White have always attracted an interdisciplinary approach. The first illustrated complete catalogue of his work was written by a team consisting of an art historian, historian, cartographer, ethnographer and natural historian. Edited by Paul Hulton and David Beers Quinn, the publication of *The American Drawings of John White* in 1964 was a landmark of such co-operation and it still stands today as the basic reference for his work and for the study of the North Carolina Algonquians and Inuit.[4] Since that time, however, although the interdisciplinary approach is still the most valid, those various disciplines have changed almost unrecognizably. Scholars in American studies, Indian studies, Atlantic studies, the history of science, ethno-history, archaeology, living or recreation history, literary criticism, cartography and the history of the print have all contributed to and changed our understanding in a fundamental way.

This book hopes to summarize and build on these new ways of seeing and understanding John White's world. In Chapters 2 and 3 I will re-examine the known and surmised events of John White's life as an Elizabethan gentleman, his activities as an artist and finally his part in the Virginia voyages and colonies. Joyce Chaplin's chapter will help us to understand how he played to his audience and what they expected to learn from his images, how they read them as well as what they did not want to see or know. Christian Feest places and judges White's drawings within the context of European visual recording of the people of the New World and assesses their accuracy. Finally Ute Kuhlemann re-examines the role of the engraver and publisher of his images, Theodor de Bry, his alterations in them and how he and his descendants circulated them in print and through their engravings helped to frame a way of seeing the New World for generations of Europeans, English and even Americans. But first, we must list the players and set the scene: the Old World's understanding of the New World as it was before John White first set sail for the 'new found land' of 'Virginia'.

ATLANTIS, UTOPIA, ARCADIA, EL DORADO

In sixteenth-century Europe all these terms were used to describe the New World: it was potentially all things to all people, the source of unknown wealth and power for monarchs, merchants and missionaries. Its original inhabitants were regarded, like its flora and fauna, as exotic curiosities and potential sources of revenue, assistants or impediments to their progress. First mistaken for Cathay in the Far East, after its 'discovery', the New World was described in a multitude of different ways by possessive Europeans. Dubbed 'Antillia' by the Portuguese and 'the Indies' by the Spanish, it became 'America' to both from 1507.[5]

Through the ninth and tenth centuries, the Norse had been sailing past Iceland and Greenland via favourable winds and currents to the land to the south west they called 'Vinland'. Much later English, Portuguese and French fishermen rediscovered

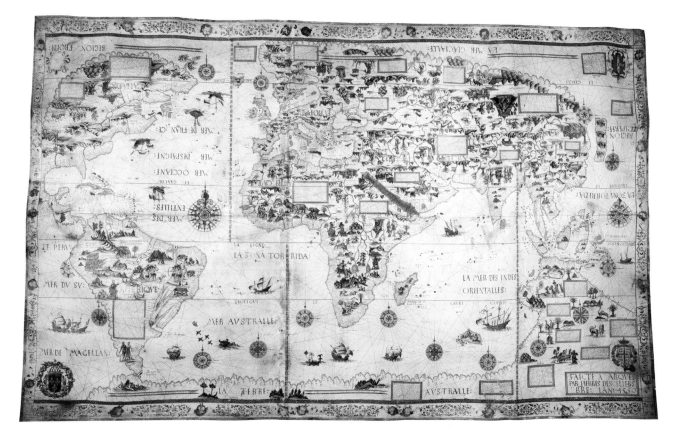

6. *Map of the World*, 1550, by Pierre Desceliers. Vellum with illuminated borders, fantastic figures of people, flora and fauna, and the arms of France, Montmorency and Annebaud. This large map, c. 1375 × 2100 mm, served as an encyclopaedia of information about the world and can be viewed from the north or south. By permission of The British Library (MS Add. 24065)

their routes and came sometimes twice in a summer to load their boats with cod off what John Cabot had named 'Terra Nova' and claimed for the English. Occasionally *en route* the fishermen landed at 'Laboratum' – described by Cabot as 'the Land God Gave to Cain' – inhospitable Labrador. In the 1530s Jacques Cartier explored 'New France' via the St Lawrence, travelling past the St. Lawrence Iroquois town of *Hochelaga* (now Montreal), which he hoped would provide the route into *Saguenay* and *Canada* to the west and to *Norumbega* to the south – the first use of Indian rather than European place names.[6]

While the English and other northern Europeans were fishing off the Grand Banks in the colder climes of North America and slowly pulling away from the Catholic Church at home, the more powerful and wealthy Spanish and Portuguese were wrangling over the clearly richer areas they laid claim to further south. In 1494, only two years after Columbus's first voyage, the Spanish-born Pope Alexander VI's Treaty of Tordesillas had effectively drawn a vertical line through the wealthy islands of the Indies and the southern continent. This settled all non-Christian lands to the west of longitude 46° 37′ west on the Spanish, leaving most of Brazil and parts of Newfoundland and Labrador to the Portuguese.[7]

This was England's view of America in 1558 when John White was probably in his teens and Elizabeth came to the throne. The lands across the Atlantic were handy for stockfish but otherwise were something to be circumnavigated in England's trade routes to Cathay in the Far East and a wealthy resource in the possession of Phillip II of Spain (fig. 7), the husband of Elizabeth's late half-sister Queen Mary. Soon

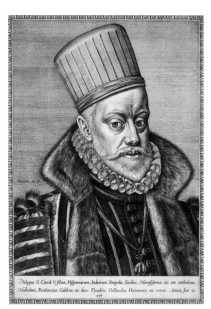

7. *Philip II of Spain*, 1586. Engraving by Hieronymus Wierix. He also ruled over the Low Countries, Naples, Sicily, the Spanish colonies and, from 1580, the Portuguese empire. British Museum (P&D O,9.199)

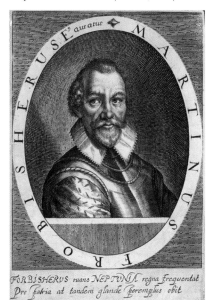

8. *Sir Martin Frobisher*, 1620. Engraving and etching by Willem or Magdalena van de Passe for *Heroologia Anglia*, a book of the lives of famous Englishmen. Frobisher (1535?–94) also sailed with Drake to the West Indies and against the Armada. British Museum (P&D O.8-97)

Philip was to accede to the Portuguese throne as well, so, as far as Spain was concerned, the Americas and all their wealth-giving assets were theirs. However, in spite of Spain's extensive forts and fleets, the widely distributed source of their wealth and its transport to and from the New World across the Atlantic were too much for even their great resources to defend. The French, Dutch and English were studying the charts, building their own fleets and looking at Catholic laws again in order to mount a Protestant challenge and stake their own claims in the New World. Elizabeth's was to be the first and the most successful and her new world was to be named after her – 'Virginia'.

MARTIN FROBISHER AND META INCOGNITA

The earth was made for the children of men, and neither the Spaniard, nor the Frenche, hath a prerogative too dwell alone as though God appointed them a greater portion then other nations.

Thomas Churchyard, *A prayse, and reporte of Maister Martyne Forboisher's Voyage* (London, 1578)[8]

In his poem celebrating Martin Frobisher's 1570s voyages to 'Meta Incognita', Churchyard was referring not only to Spain's and France's control of the continent and the southern routes to the Far East but also to Spain's ownership of the New World through the Treaty of Tordesillas and to the French in Canada and Florida. He was repeating the arguments of all Elizabeth's advisers of that decade and the following, that she should place the might and financial support of the state behind her countrymen's efforts to plant colonies in the New World. The arguments were many and various and came from fervent Protestants, politicians and privateers, from merchants and men on the make, from empire builders, but also from empiricists who wished to study, understand and know the New World.

It was believed that the northerly route to Cathay, whether it was the Northeast Passage over Russia or the Northwest Passage through North America, would prove to be faster than the southerly Spanish route. The search for it been exercising Englishmen for decades – it had been one of the main purposes of Cabot's voyages. John Dee (1527–1608/9) (fig. 9) and Richard Hakluyt the elder were helping the Muscovy Company search for their north-east route in the 1550s. Dee was a polymath – a mathematician, astronomer and astrologer, amongst his many activities – and in the 1540s he worked on the continent with great navigators and cosmographers, including Ortelius and Mercator, and brought back with him to England the newly invented cross-staff to assist navigation.[9]

After Elizabeth came to the throne, Dee advised her on maritime matters and was a constant advocate for the 'Brytish Empire', particularly in his *General and rare memorials pertaining to the Perfect Arte of navigation* (fig. 4). Published in 1577, it

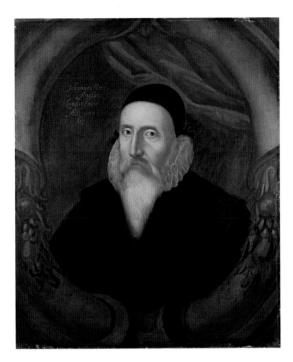

9. *John Dee*, c.1594, British School. Oil on canvas, 740 × 620 mm. Queen Elizabeth referred to Dee as 'my philosopher' although his later reputation suffered because of some of the methods he used in his pursuit of knowledge. Bequeathed by Elias Ashmole to the Ashmolean Museum, Oxford (WA 1692.0; F746).

justified the rise of the empire and predicted its achievement through maritime supremacy. Dee argued for the maintenance of a royal navy 'for manifold great Commodities procuring to this British Monarchie' - a natural development from the earlier commercial efforts to find a passage to Cathay and to assert England's early claims, through Cabot and others, to North America. The main purpose behind Richard Hakluyt's publications of the various voyages to America, Cabot's and other early voyages as well as more recent ones, was to consolidate these claims by encouraging the colonization of America and the re-orientation of British trade along more long-distance routes.[10]

The idea of the Northwest Passage had been revived by Raleigh's elder half-brother Humphry Gilbert (1537–83) in 1565 when he petitioned the Queen to allow him 'to make a tryall thereof' at his 'owne costes & charges', in return for a monopoly of trade through the Passage and 25 per cent of the customs duties on goods brought through it.[11] The following year he wrote his *Discourse of a Discoverie for a New Passage to Cataia*, dedicated to the Queen, which circulated in manuscript and was strongly influential. However, Gilbert was currently employed crushing rebellions in Ulster and Munster, with terrible savagery, for which he was knighted, and then had gone to Flanders: this venture had ended in disaster, and he was unable to pursue his money-making scheme. His manuscript (see Chronology) was published without his permission in 1576 just in time to encourage investment in the Company of Cathay formed to fund Martin Frobisher's attempts.[12]

It is with Martin Frobisher (fig. 8) that the question of John White's involvement with these earlier voyages is raised. Two watercolours of Inuit are with the group of original drawings in the British Museum collection, and four more were in the Sloane volume (see pp. 164–9). Those depicting the man, Kalicho, and woman and child, Arnaq and Nutaaq, might have been drawn on board ship or in England, as they were captives carried in October 1577 to Bristol where they died shortly afterwards. But the view of the skirmish with the Inuit at Bloody Point (see p. 164) has been taken to be proof that John White accompanied Frobisher on this, his second voyage, of 1577. Morison states that White sailed on Frobisher's own ship, the *Aid*, and that the sketch was 'drawn on the spot', but he gives no proof apart from its accuracy.[13] A wages list was kept of all the men who sailed on the voyage and White's name does not appear; Frobisher did carry with him a number of 'gentlemen-companions', so, if White was on the voyage, he was an unpaid volunteer.[14]

Further details of Frobisher's voyages, the change in aims from trade passages to mining for gold, their consequent expense and ultimate failure, will be found in Chapter 4 (pp. 52–3 and also on pp. 164–9); but some of the most important outcomes were the experiences gained for future ventures and the advances made as

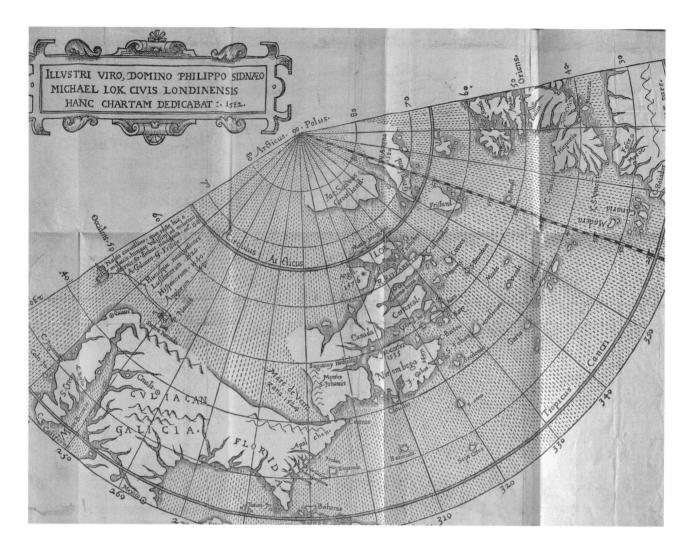

10. *A Map of North America*, 1582. Woodcut by Michael Lok, from Richard Hakluyt, *Divers voyages touching the discouerie of America*, published by Thomas Woodcocke. Dedicated to Philip Sidney, the map show parts of North America already named and claimed by the English. By permission of The British Library (c.21.b.35)

a result in navigation and surveying. Much of the money invested in the initial voyage was put up by the London merchant Michael Lok (see fig. 10), who was advised by John Dee and had a substantial knowledge of cosmography himself. He ensured that the enterprise was provided with the latest in surveying and charts (including a ruled blank map for Frobisher to 'fill in'),[15] and navigational and astronomical instruments made specifically for the voyage by Humphrey Cole, who repaired them on their return and, as an officer of the Royal Mint, invested in the second voyage himself.[16] Cole was the first of the great English instrument makers, and his instruments developed alongside the burgeoning production of English books on navigation so essential for building English confidence and experience at sea in the 1570s; when Raleigh's voyages set out in the following decade, the list of instruments the surveyor was expected to take reflected these advances. 'Gentlemen-companions' on these voyages owned some of the most intricate and elaborate; but these were not just expensive playthings, they made it their business to be familiar with their use and with the latest methods of land surveying and determining longitude and latitude while at sea (figs 13, 14) (see pp. 41–2).

HUMPHRY GILBERT: PREPARING TO PASS ON THE 'PATENT OF DISCOVERY'

He suffered so much by shipwrecks and want of necessary provision, that he was constrained to give over his enterprise, learning too late himself, and teaching others, that it is a difficulter thing to carry over Colonies into remote countries upon private men's purses, than he and others in an erroneous credulity had persuaded themselves, to their own cost and detriment.

William Camden on Humphry Gilbert in *Annals of Queen Elizabeth*[17]

In their preparations for the voyages to the New World, Gilbert (fig. 11) and his half-brother Walter Raleigh read widely: classical and contemporary accounts of voyages, recent cosmographies of the world by Italian, French and Flemish authors and the latest books on navigation and the flora and fauna of the New World. In his *Briefe Lives*, Aubrey stated that Raleigh 'studied most in his Sea Voyages, where he carried always a Trunke of Bookes along with him, and had nothing to divert him'.[18] A catalogue of Raleigh's library survives and, not surprisingly for someone who was later to write *A History of the World*, its depth was astonishing.[19] They also sought maps and personal advice from John Dee and both Richard Hakluyts, and from other learned men Raleigh knew from his time at Oxford. The men they took with them needed to have a variety of mathematical, navigational and military skills and engineering and surveying experience. Certainly other specialist skills and crafts were required (see below) and they needed merchants, some of whom might have invested in the voyage, for conducting trade *en route* and when they arrived; but they also needed gentlemen with the skills of courtiers, like themselves.

11. *Sir Humphry Gilbert*, 1620. Engraving and etching by Willem or Magdalena van de Passe, from *Heroologia Anglica*, published in Arnhem. Gilbert (1537–83) was included in this book of English heroes, but his half-brother Walter Raleigh was not. By the time it was published, Raleigh had fallen out of favour and had been executed. British Museum (P&D L,78.1-67)

In many ways the gentlemen-companions they took on these voyages, especially those without any particular skill, proved to be the most useless of passengers, unwilling or unable to attempt to feed themselves by planting or fishing, expecting their work to be done by servants and their life to be as comfortable as it was at home. Why then was their presence requisite?

Both Raleigh and Gilbert were courtiers, and in Elizabethan England the court was the seat of power; life there was led according to the humanist code that dictated courtly life throughout Europe. Baldassar Castiglione's book on conduct and education *Il Cortegiano* (Venice, 1528) had been reinterpreted for an English audience by Sir Thomas Elyot in his *Boke Named The Governour* in 1531, the change from 'Courtier' to 'Governor' in the title reflecting the shift in emphasis in Protestant England to the ideal of public service – the gentleman as 'governor', of use to society. At the Elizabethan court, the two traditions had become fused, encouraging the accomplishments of the courtier alongside the 'governor's' pursuit of useful knowledge.[20]

By the 1570s a growing number of landowning gentry, including Raleigh and Gilbert themselves and just possibly John White (see Chapter 2), had become an accepted part of a court society no longer restricted to the nobility. Educated in the humanist tradition, these courtiers were gentlemen scholars – students of diplomacy, cosmography, history, natural philosophy and often also the more gentle arts of

poetry and, occasionally, drawing and painting.[21] Raleigh was a product of the existing educational system, the universities and the Inns of Court, but by the 1570s Gilbert at least felt there was a need for a third option for producing men useful to the court and proposed to the Queen 'An Achademy in London for education of her Maiesties Wardes, and others the youth of nobility and gentlemen'.[22]

As well as a traditional curriculum with the study of ancient texts and languages, rhetoric and logic, and discourses on peace, war and reason, in his plans for an academy Gilbert placed an emphasis on the practical application of knowledge and included a reader in natural philosophy and two mathematicians. One of two mathematicians was to give detailed instructions and practice in military matters such as fortification, artillery and mining as well as drafting such works on paper and in models. The other mathematician would teach astronomy, cosmography, navigation, the use of instruments and the 'Arte of a Shipwright' through the use of a ship's model, fully rigged and furnished (see fig. 12). 'Also there shall be one who shall teache to draw Mappes, Sea Chartes, &c., and to take by view of the eye the platte of any thinge, and shall reade the growndes & rules of proportion and necessarie perspectiue and mensuration belonging to the same.'[23] Riding, tilting and tourneys, music, languages, dancing and the art of defence and the law were all included, and a physician and surgeon would give practical lessons.[24] Finally, a herald would teach them to 'blaze armes, and also the arte of Harrowldrie, togeather with the keeping of a Register in the said Academy of their Discentes & Pedigrues'.[25]

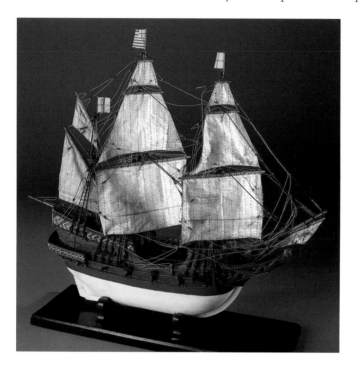

12. *Model of an English merchantman of c.1580*, 1950, made by F. C. P. Naish, to scale of 1:60, based on a shipwright's manuscript of c.1586. The ship is the type that was taken on the 'Virginia' voyages and would have been about 68 feet long by 19 feet in the beam and a weight of 100 tons. National Maritime Museum, Greenwich (SLR0326)

A gentleman proficient in all these arts and sciences would be the perfect 'governour' to take on voyages to the New World – but Gilbert's academy never went any further than its proposal on paper and such paragons as would result from such an education were few and far between, even in Elizabeth's court. But one could take men who were proficient in several of these areas, and find others who were experts in just one or two.

Humphry Gilbert finally secured the Queen's patent on 11 June 1578, 'to discover, searche, find out and viewe such remote heathe and barbarous landes countries and territories not actually possessed of any Christian prince or people … for the inhabiting and planting of our people in America', anywhere between Labrador and Florida. He also had the right to dispose of land.[26] His expedition of that year included 365 gentlemen, soldiers and mariners, including a band of musicians,[27] and one ship captained by his half-brother Raleigh with the Portuguese-born Simon Fernandez as pilot. Gilbert did not get any further than Ireland and the rest of his fleet engaged in acts of piracy off Spain.

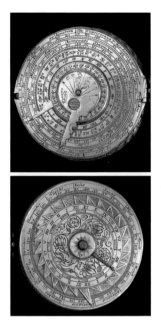

13. *Astronomical compendium*, 1593. Gilt brass, hinged (showing top and bottom), made by James Kynvyn in London. It belonged to Robert Devereux and included a nocturnal, latitude list, compass, sun dial, perpetual calendar and lunar indicator. British Museum (P&E 1866,0221.1)

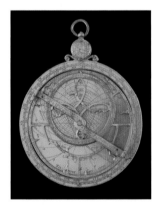

14. *Astrolabe*, 1594. Gilded brass, made by Humphrey Cole in London. This example may have later belonged to Henry, Prince of Wales (1594–1612) and was the type a gentleman would take with him for timekeeping, surveying and determining latitude. British Museum (P&E 1855,1201.223)

In 1580 Fernandez sailed Gilbert's ship the *Squirrel* to New England and back,[28] and presumably as a result Gilbert began preparations for his second voyage in 1583 to found a colony in Norumbega. He raised funds from personal investors, including Walsingham, Raleigh and various merchants, and by making amazing promises of land – everything north of 50° latitude (nearly all of Canada) to John Dee in return for cash and expert advice,[29] and three million acres to Philip Sidney, who knew Dee and was 'haulf perswaded … very eagerlie' to join the expedition, having heard much of it from the younger Hakluyt, then in Paris.[30] Gilbert's 260 complement were all men, including masons, carpenters, mineral men and refiners, 'Besides, for solace of our people, and allurement of the Savages, we were provided of Musike in good variety not omitting the least toyes, as Morris dancers, Hobby horse, and Many like conceits to delight the Savage people, whom we intended to win by all faire meanes possible. And, to that end, we were … furnished of all petty haberdasherie wares to barter with these simple people.'[31]

Unfortunately, he did not set out until June, too late in the season for the longer southern crossing which no doubt Fernandez had taken earlier, and landed first at St John's, where there were thirty-six Spanish, Portuguese, English and French fishing ships already in the harbour. Raising a pillar with England's arms, on 5 August 1583 Gilbert took formal possession of Newfoundland for England (as Cabot had already done in 1497). Battered by storms off the coast of Newfoundland on their route south to found their colony, they abandoned the attempt and Gilbert's pinnace was lost in heavy seas north of the Azores; the legendary reported last view of him from the other ship was waving them off with a copy of Thomas More's *Utopia* in his hand and crying 'We are as neere to heaven by sea as by land'.[32]

In some ways Raleigh's voyages to Virginia were to benefit from the earlier experiences of Frobisher and Gilbert, but in others they were hindered: the Queen's support and private and merchant backers were harder to find after the enormous financial losses suffered from Frobisher's cargoes of fools' gold. But Gilbert and Francis Drake, who had returned from his circumnavigation of the globe in 1580, had shown there were potentially new markets and commodities to encourage merchant adventurers and another type of 'gold' to be gathered by taking the southerly route to North America and harrying Spanish ships and capturing them as prizes on the way there and back.

Immediately after his brother's death in 1583, Walter Raleigh, by then a favourite at court, petitioned Queen Elizabeth for Gilbert's patent. On 25 March 1584, he was granted a new 'letters patent' for six years:

> *to discover search fynde out and viewe such remote heathen and barbarous landes Contires and territories not actually possessed of any Chirstian Prynce and inhabited by Christian people … and so many of our sujiectes as shall willingly accompany him and them … shall haue holde occupy and enioye to him his heyres and assignes and every of them for ever all the soyle of all such landes aforesaid and of all Cittyes Castles townes villages and places in the same …*[33]

By the time the patent was signed, preparations were well under way and the Elizabethan stage was set for Raleigh's voyages to Virginia and John White's role in them.

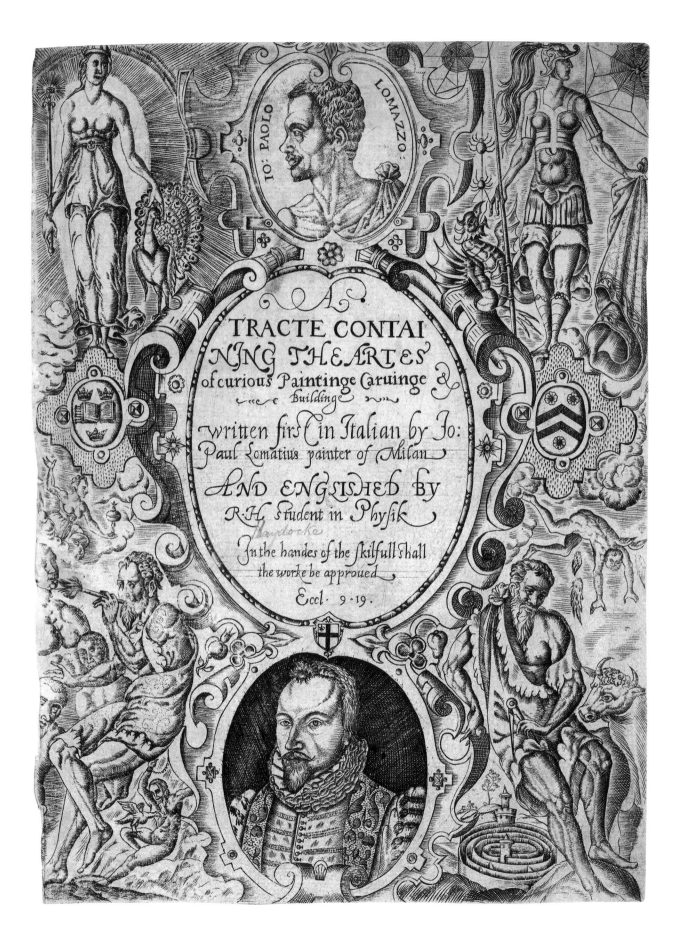

IO: PAOLO LOMAZZO:

A
TRACTE CONTAI
NING THEARTES
of curious Paintinge Caruinge &
Building

written firſt in Italian by Io:
Paul Lomatius painter of Milan

AND ENGLISHED BY
R.H. Student in Physik
Haydock
In the handes of the ſkilfull ſhall
the worke be approued
Eccl. 9·19.

CHAPTER 2

KNOWING JOHN WHITE: THE COURTIER'S 'CURIOUS AND GENTLE ART OF LIMNING'

KIM SLOAN

Our English view of the New World in this book will not be that of Queen Elizabeth, nor of one of the leaders of her various voyages of discovery and colonization. Instead, our view will be through the eyes and watercolours of a relatively obscure Englishman with a very common name – John White. In spite of his making five voyages to Virginia, no cities, towns or rivers were named after him and none bears his coat of arms. We do not even know when or where he was born or died. Nevertheless, uniquely amongst all the other hundreds of men from all those European countries who journeyed to the New World, he has left a substantial pictorial legacy far more enduring and valuable than any – a first-hand original record of the people who lived in America long before the Europeans arrived, 'discovered' and claimed it for themselves and changed their lives and continent for ever.

JOHN WHITE: A HOSTAGE TO HISTORY

Records of the lives of individuals in Elizabethan England are hostages to the accidental gaps of history. Many parish records are partial or illegible and even where they do survive, without any clues where to search and with a common name such as John White, most researchers have despaired of finding any incontrovertible evidence. Yet each generation has added a piece to the puzzle; in the eighteenth century, Sir William Musgrave recorded John White's date of death as 27 March 1598. This is in fact the date of the death of the engraver Theodor de Bry and, unless by an amazing coincidence they did both indeed die on the same day, then we must assume that Musgrave confused two of the innumerable slips on which he made his records.[1] David Beers Quinn combed the records of the five Virginia voyages White had made in the 1580s for details, traced Sir Hans Sloane's acquisition of White's album of drawings from his descendants and also had White's coat of arms and its quarterings examined for clues to his family, but all without any concrete results.[2] William Powell discovered that White's son-in-law, Ananias Dare, had a son John living in St Bride's parish who inherited Dare's estate after he was declared legally dead in London in 1597.[3]

This in turn recently led lebame houston to comb the London parish records more carefully. Here she found a wealth of vital facts not known to Hulton and Quinn. She has discovered that John White married Thomasine Cooper in St Martin Ludgate in 1566 and their son Thomas was born 27 April 1567 and buried there 26 December 1568. Proof that this is our John White was provided by the record of their daughter Elinor's christening in the same church on 9 May 1568. If he was between eighteen and twenty-three when he married, this would put John White's date of birth from around 1545 (or earlier) to 1550. Elinor White married Ananias Dare in St Clement Danes on 24 June 1583. They moved in 1585 to St Bride's parish, which is where Ananias's son John, probably from an earlier marriage, was living when he first petitioned the courts for his father's estate.[4]

These bare statistics and John White's drawings, along with Richard Hakluyt's published accounts of White's voyage to Virginia to found a colony in 1587 and his attempts to rescue the colonists in 1588 and 1590, as well as his final 1593 letter to Hakluyt from Ireland with its statement that he made five voyages to the New World in total, are now the concrete skeletal facts upon which we must build an account of John White's life in Elizabethan England and Virginia.

ARMS MAKE THE GENTLEMAN

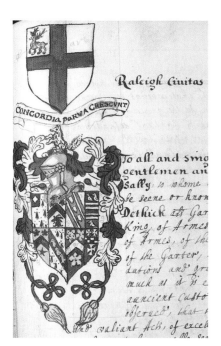

16. *The grant of arms to the Cittie of Raleigh* [Raleigh civitas in Virginea], 1587, showing the arms of the city above those of John White. Copy made after 1660 by John Vincent from Sir William Dethick's 'Great Register', no longer extant. The Provost, Fellows and Scholars of The Queen's College, Oxford (MS 137, no. 120, p. 1)

All previous attempts to identify White have looked at all the likely recorded John Whites of the period and at his coat of arms, granted in January 1587 when he was made Governor of the colony known as 'the Cittie of Ralegh in Virginea' (fig. 16).[5] The coat of arms was examined again in 1984[6] but this as before led only to guesses of possible family connections with Cornwall, since his family arms were used in a Visitation for White of Truro in 1620. However, Clive Cheesman, Rouge Dragon Pursuivant, has carefully re-examined the 1573-5 Heralds' Visitation of Cornwall and has discovered that the quarterings of White's arms indicate a solid claim of descent through a sequence of heiress-marriages (referred to in his quarterings) as far as Robert White (probably of Truro) who married Alice Wymark. They had a son John but our John White was probably descended from another of their sons, who are not included in the pedigree recorded.[7] The 1620 Visitation of Cornwall, as has been noted before, included the descendants of a White family of Truro who used the same quartering for White as our John White. Their family included a John White who was a member of the Haberdashers Company of London who died in 1584 and had two nephews, John and Robert.[8] Unfortunately, their pedigree did not go back far enough to indicate their relationship to Robert White and Alice Wymark. Sadly this does not enable us to link them to our John White who married Thomasine Cooper in 1566 in St Martin Ludgate. It does mean, however, that his ancestry when his coat of arms was granted in 1587 was clear and confirmed from an ancient pedigree with Cornish connections.

Instead of taking the usual route of guessing which of the hundreds of John Whites mentioned in archives ours might be, we might look instead at other signifiers of identity and status in Elizabethan England and, as the most recognized proof of identity and status was a coat of arms, it will be worth considering White's again. From 1587, when his arms were granted by William Dethick, Garter principal King of Arms, John White was officially an *armiger*, a man of gentle birth proven through

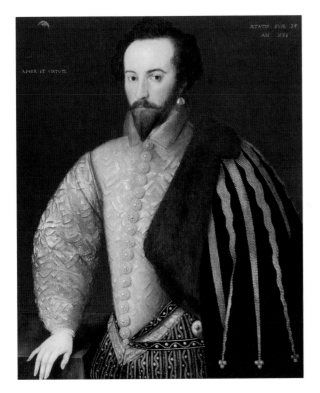

his pedigree, entitled to bear heraldic arms. The initial of the eight quarterings on White's arms was a reward, which took the form of a field of ermine with a *fuzell argent*, a silver diamond, found on Raleigh's coat of arms (see the map, no. 2). The second quarter was his 'own ancient coat' of the White family (a chevron between three goats' heads *razed sables*) and the other six quarterings were various family associations, four of them the heiress-marriages mentioned above.[9]

White's crest, surmounting his arms, was a helmet with an *argent and gule*s (silver and red) wreath surmounted by an ermine *Seant proper*. The ermine was a symbol of purity and chastity and was probably a reference to 'Virginia'; Sir Philip Sidney's *New Arcadia* alluded to the portrait of Queen Elizabeth with an ermine as her *impresse* painted in 1585 for Lord Burghley.[10] Raleigh's *fuzell* on an ermine ground, and the ermine crowning all, were a clear allusion in this, the personal 'reward' on John White's arms, to his 1585 voyage and his position as Governor of the new colony. It also seems to indicate that he was indeed, as de Bry stated, 'sent into the contrye by the queenes Maiestye'.[11]

17. *Sir Walter Raleigh*, c.1588, attributed to the monogrammist 'H'. Oil on panel, 914 × 746 mm. Raleigh (1554–1618) wears the Queen's symbols, a large pearl and a cloak with the moon or sun's rays embroidered in pearls. The crescent moon upper left makes reference to her as Cynthia, the goddess of the moon who controlled the tides or 'water', her pet name for him. National Portrait Gallery, London (NPG 7)

Many wealthy 'new men' produced pedigrees and were granted arms at this time and heralds were often criticized for making grants to 'base-born' individuals.[12] The assistants to the colony of 'the Cittie of Raleigh' were also granted arms on this occasion and each of theirs also bore Raleigh's *fuzell argent*. Sir Walter Raleigh

*elected, Chosen, Constituted made & appoynted, Iohn White of London Gentle*man, *to be the chief Gouernor theare, And Roger Baylye: Ananyas Darr: Christopher Cooper … and Symon Fardinando of London Gentle*men *to be the Twelue Assistants theare, And them the said Gouernor & Twelue Assistants, & their Successors, hath for euer Confirmed made encorporated, & accepted one Bodye pollitique & Corporate, by the name Tytle and Aucthoritye of THE GOUERNOUR AND ASSISTANTS OF THE CITTIE OF RALEGH IN VIRGINEA …*[13]

The grant was also in part a reward for 'sondry vertuous & renowned Acts, & enterprizes of the wurshipfull, the said Gouernour & Assistants'. No doubt Raleigh had the power for arms to be granted to all the gentlemen assistants, whether their pedigrees entitled them or not, but this was a corporate body and certainly each of the assistants would have invested heavily in it. There is no reason to suspect that any of them, particularly John White, was 'base-born'.

There are other indications of White's wealth and status. He was certainly not in the class of Sir Walter Raleigh, then a favourite at court, who demonstrated his considerable wealth and status through his dress (fig. 17), but we know that on his voyage in 1587 White took armour, books, framed pictures and maps with him to Virginia and was used to travelling with servants.[14] He wrote with a fine Italic hand, produced well-written emotive accounts of his voyages that demonstrated navigational understanding; his drawings of fortifications and his maps indicate a knowledge of military and land surveying. He travelled out on the 1585 voyage with the high treasurer, Francis Brooke,[15] worked closely with Thomas Harriot and afterwards petitioned and reported to Sir Walter Raleigh in person, and corresponded with Richard Hakluyt and met with him several times.[16] There can be no doubt that John White was a 'Gentleman', well-born and educated to a standard well above that of an artisan, craftsman or small merchant.

Yet in 1587, given a watercolour of a butterfly by him (no. 63), Thomas Penny described him as 'Candidus' [White] 'Pictor' [painter]. In his address 'To the gentle Reader', introducing the engravings accompanying Harriot's *Briefe and true report of the new found land of Virginia* which he published in 1590, the engraver Theodore de Bry wrote that, in order to

> offer unto you the true pictures of those people wich … I creaued [acquired] out of the verye original of Maister Ihon White an Englisch paynter who was sent into the contrye by the queenes Maiestye, onlye to draw the description of the place, lynelye [lively] to describe the shapes of the Inhabitants their apparell, manners of Liuinge, and fashions, att the speciall Charges of the worthy knighte, Sir Walter Ralegh, who bestowed noe Small Sume of monnye in the serche and Discouerye of that countrye, From te yeers, 1584. to the ende of The years 1588.[17]

PAINTERS AND STAINERS

We are accustomed to associating English 'painters' of Elizabethan England with professional craftsmen and guilds but seldom at the same time with someone who might also be described as a 'gentleman' – so much so that until the middle of the twentieth century it was assumed that the Governor John White and the painter could not be the same man.[18] But this was a period of great social mobility, when one's status and its outward symbols were paramount, and one served the Queen and her court in whatever capacity they dictated. We know a great deal about the foreign professional painters such as Hans Holbein, who were brought to England because of their skills, particularly in portraiture, which could not be matched by English painters. Others with similar skills, such as Lucas de Heere and Cornelis Ketel (p. 165), were Protestants and came to England in the 1560s and 1570s with the hope, usually successful, of finding work.[19] They painted portraits, allegories, and sets and designs for masques and tournaments for the Office of the Revels and worked in all materials and all scales from cloth to wooden panel, full-length portraits to small illuminated emblems on vellum. But we know comparatively little of the native English painters, who could also turn their hands to anything the

court, church or individual patrons required, but generally without the skill and training, in portraiture at least, of their continental counterparts.

The English painters did, however, have a guild, the Painter Stainers Company, whose Master supervised the Queen's Revels and its Freemen usually provided the Queen's Serjeant Painter. On the whole, particularly because of their close relations with the Office of the Revels, they tended to work on more decorative than fine art; but, as the court employed the foreign artists for the Revels as well, they worked side by side with them and the quality of their work rose proportionately.[20]

Recently much more evidence of the work and influence of the Painter Stainers, their concern for the native school of painting and for their status, in the city, in society and at court, has come to light.[21] They did not by any means hold a monopoly on painting, even by native artists, as a painter needed only to live outside the walls of the City of London to avoid their control, and members of the Goldsmiths, Plasterers and Heralds all claimed their own rights to painting in various forms. Plasterers painted their own work; limners, who had evolved from illuminators of manuscripts, were frequently Goldsmiths; and Heralds were particularly worried that Painters were taking money 'for serching for Armes, do forge and devise both cotes, creasts and make pedigrees.'[22]

The records of members of the Painter Stainers Company before 1623 are generally limited to conveyance documents for their large Hall. The name John White appears on the list for 1580 but not on a list two years earlier, which, given his age, one might expect.[23] There is now a large corpus of paintings which has been identified as English, but to which no definite name can be attached. English painters did not generally sign their work and much of it, for the Office of Revels, was ephemeral. It is impossible to state whether our John White, Gentleman, was the member of the Painter Stainers listed in 1580; being an *armiger* may not have precluded him being a Painter Stainer, but it would have been unusual, and the type of work by him that survives is in watercolour on paper, not the sort generally known to have been carried out by members of this guild.

18. *George Gower, Self-portrait,* c.1880. Engraving by James Basire after original oil self-portrait of 1579, recording the inscription on the painting above the scales. British Museum (P&D 1865,0114.355)

LIMNING: 'A THING APART'

In fact two artists who were not Painter Stainers enjoyed the most patronage at court and were official painters to the Queen. In a court and society so actively in flux, they were both actively concerned with their status as 'gentlemen' and painters.

George Gower (d. 1596) was the grandson of Sir John Gower of Stettenham, Yorkshire, and was entitled to bear his family arms. In 1579, he painted his self-portrait, in plain black garb rather than the more elaborate dress he was entitled to wear, with his palette and brush in hand; to his side, a balance with a drawing instrument outweighs his coat of arms (see fig. 18). A verse inscribed above records

that youthful ways enticed him from arms and virtue until his skill as a painter ('God's good gift') led him to lead his life by his 'pensils'' (brushes') trade. His claim that his status as an artist was greater than his status as a gentleman by birth is 'a startling claim in England where a painter was still viewed as little more than an artisan'.[24] He was skilled as a portrait painter in oils and many works have been attributed to him, including one of the 'Armada portraits' of Elizabeth (see fig. 1). Two years after this self-portrait he was appointed Serjeant Painter to the Queen.[25]

At the same time, 1584, Nicholas Hilliard (c.1547–1618) was given the monopoly by the Queen 'to make portraits … of our body and person in small compass in limning only'.[26] This was a significant monopoly, as it separated the two media, painting in oil and painting in watercolours – called limning. Earlier, continentally trained artists such as Holbein made a portrait drawing first, in chalks, and painted from it large paintings in oil as well as small portraits in watercolours; they did not specialize and were at home in either medium. Holbein was probably taught to paint these small watercolour portraits by Lucas Horenbout, who was the son of a Ghent manuscript illuminator and came from that tradition of limning. 'Illumination' and 'limning' derive from *luminare* (to give light) and originally referred to the decoration of manuscripts. 'Limning' was used for all painting in watercolours, not only for portraits but for all subjects. The medium included lead pigments which provided deeper colours and also the use of gold and silver (see pp. 234–5).

19. *Portrait of Elizabeth I*, 1586–7, by Nicholas Hilliard. Watercolour on vellum, in vellum seventeenth-century mount (86 × 66 mm, portrait only). The jewelled crescent in her hair refers to Cynthia, goddess of the moon; Raleigh's poem 'The Ocean's Love to Cynthia' was written in the late 1580s. V&A Museum, London; Bequeathed by Mrs Doris Hershorn (P.23-1975)

Hilliard noted that limning 'excelleth all other painting whatsoever in sundry points … being fittest for the decking of princes' bookes … for the imitation of the purest flowers and most beautiful creatures in the finest and purest colours … and is for the service of noble persons very meet, in small volumes, in private manner, for them to have the portraits and pictures of themselves, their peers, or any other foreign person which are of interest to them'.[27]

The English artist Nicholas Hilliard was a son of an Exeter goldsmith who was a reformist, and Nicholas spent some of his youth in exile in Geneva with Thomas Bodley who was later to found Oxford's great library. On his return he was apprenticed to the Queen's Goldsmith, becoming a freeman of the Goldsmiths Company in 1569, producing jewels and miniatures for Elizabeth and her favourites at court.[28] He drew a portrait lightly in watercolours on a card prepared with vellum surface covered with a carnation ground, and then built up the image from life with tiny hatched strokes of colour (fig. 19). From 1577 to 1578/9 he was in France in the train of Elizabeth's ambassador.[29]

Hilliard would never have described himself as a 'painter', which he felt was a mechanical art 'for furnishing of houses … for tapestries, or building, or any other work'.[30] Limning on the other hand, according to his 1598 manuscript treatise on

the subject, was 'a thing apart … which excelleth all other painting whatsoever' and 'tendeth not to common men's use…none should meddle with limning but gentlemen alone'.[31] His treatise was never finished, but it borrowed much from the physician Richard Haydocke's 1598 translation of Lomazzo's *Tratto* (see p. 34) (which was dedicated to Thomas Bodley) and Hilliard recorded conversations on the subject with Sir Philip Sidney, who was knowledgeable about Italian illumination, and Sir Christopher Hatton.

Hilliard described limning as 'a kind of gentle painting, of less subjection than any other … it is secret', and he was reluctant to impart its secrets in case it made him appear to be a mere mechanic.[32] The use of gold and silver, the availability of pigments from apothecaries, the simplicity of the tools (see fig. 20) and its neatness and cleanliness made limning or painting in watercolours the perfect activity for the English 'gentleman' courtier. Originally limners worked mainly on vellum, but the term limning may have continued to be used for a time for painting in watercolour on paper, as White did. Thus, although he employed a different painting technique and ground (see pp. 234–5), John White's watercolours fall more easily into this type of 'gentlemanly pursuit' than the products of a more traditional Painter Stainer.

By the 1620s when Edward Norgate (1581–1650) addressed his manuscript treatise on limning to the physician Sir Thomas Mayerne and 'the Gentry of this Kingdome' it was clear he had an audience of gentlemen amateurs.[33] Norgate was the son of the Master of Corpus Christi who, 'finding him inclined to Limning and Heraldry, permitted him to follow his fancy therein'.[34] He wrote 'Yet never was it my meaning that the time spent in this Art, would become a hindrance to better studies, but rather to a discreete Artist may serve as a witty commendable recreation.'[35] Both Hilliard and Norgate circulated their treatises in manuscript; they did not want their art demeaned by becoming the practice of mere craftsmen or artisans: 'I conceave this our Art of Lymning transcends all other of this kind, as farre as a Curious Watch doth a Towne Clocke.'[36] Norgate never earned his living practising one art and has been described as belonging to 'a cadre of gentlemen jacks-of-all-trades, professional virtuosos who also filled middle-level administrative posts and were enriched by additional royal patents and monopolies'.[37] It is into this category, of a gentleman/courtier/amateur, that our John White probably falls.

We can only guess at John White's education and the nature of his association with Sir Walter Raleigh and the Queen. Apprenticeships or more formal education, such as that provided by the universities or Inns of Court, were normally completed around the age of twenty and before one married; our John White was married in 1566. Any apprenticeship or education would probably have been completed by that date but the records are incomplete for all of these institutions at this time.

20. *Artist's pigments and tools*, modern, but of sixteenth-century type. From top: Indian lake (raw material, prepared, mixed in mussel shell), brushes (here squirrel hair, fixed in quills then attached to handles), and gold (reduced to powder by grinding with honey, in mussel shell). V&A Museum (made by Alan Derbyshire and the late Jim Murrell, Conservators)

21. *Design for armour for Sir Henry Lee*, from the *Almain Armourers Album*, c.1560–80. Watercolour by Jacob Halder, master of the armoury at Greenwich. Lee (1533–1611) was the Queen's Champion; the armour used for tilts is on the right, decorated with his own and the Queen's symbols in parcel-gilding (including a morian helmet, top row, third from right). V&A Museum (D.599-1894 and D.599A-1899)

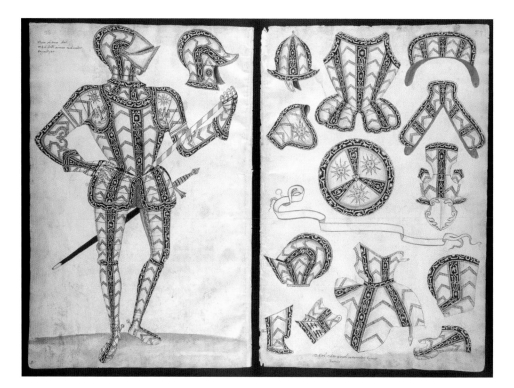

THE OFFICE OF THE REVELS

If White had been apprenticed as a painter and worked professionally as one, one would expect to find his name in the records of the Office of the Revels where painters' employments and fees were recorded, but the only record of a John White found there is one who was paid thirty-two shillings and three pence for 'the parcell gilding of two Armors compleat for Mr Tresham and Mr Knowles being two of the Knightes in the Amasons maske'.[38]

This Twelfth Night Masque of the Amazons was held in January 1579: 'after the Knightes had daunced A while with Ladies before her maiestie did then in her maiesties presence fight at the Barriers'.[39] The Amazons entered first, in elaborate armour and tinsel, and presented a speech to the Queen. They then 'daunced with Lords' in the Queen's presence. The Knights followed, and in the instructions for the Masque, their armour was to be 'compleate parcell guilte also guilte within this office with like counterfeit Murryons upon their heades silvered and parcell guylte with plumes of feathers in the tope of every of them … and guylded shieldes with A posey written on every of them.'[40] The names of John Bettes and Robert Peake (who like Hilliard had trained as a goldsmith and was a member of their company) were included in the list of payments to painters, at tweny pence per day for a total each of fifteen shillings, while the materials and gold for the armour alone cost over 81 shillings.[41]

Certainly parcel-gilding paid better than painting, but is this something that our John White, who later described himself as a 'gentleman', would be pursuing professionally? The actual parcel- (part-) gilding, usually of the raised, decorative,

embossed parts of the armour, involved the use of mercury and poisonous fumes and was left to apprentices and workshop assistants; the John White who was paid was probably the designer or sculptor of the pattern of the embossing and gilding, which could be very elaborate (see figs 21, 22), and the overseer of the work. The records of the Goldsmiths Company, which are also incomplete, have been searched without a John White being found.[42] Although it must remain purely speculation whether this John White is ours, exposure to and knowledge of the work of the Office of the Revels for court masques (which included amongst its list of figures 'Turkish magistrates, Greek worthies and Turkish commoners')[43] would help to explain his interest in costume in his watercolours now in the British Museum (nos 25–34) and the manner in which he depicted the figures of the Inuit and North Carolina Algonquians (nos 7–24, 35, 36).

His presence in the workshops of the Office of the Revels in 1579 would also place our John White in a position where he might come to the attention of Walter Raleigh, who became an Esquire of the Body Extraordinary in 1580, part of a group of personable young men available for any duties, virtually unpaid, at court.[44] Philip Sidney (1554–86) was also at court during this period, helping to devise the entertainments and working on his early version of *Arcadia*. Before the end of the year, however, Raleigh had accepted a position from Walsingham to take a troop to Ireland and he did not return until 1582. It was during these years that Humphry Gilbert was involving both men in his plans for a colony in the New World (see p. 21).

A GENTLEMAN'S EDUCATION

It is worth considering one further alternative form of education which our John White might equally have pursued as preparation for the life of a gentleman: the universities and Inns of Court. In his preface to the engravings after John White that illustrated Theodor de Bry's publication of Thomas Harriot's *Briefe and true report*, de Bry referred to John White, Richard Hakluyt (1552–1616) and Thomas Harriot (c.1560–1621) each as 'Maister'. The term 'Master' was reserved for men of a certain class, predominantly for gentlemen or squires, but more specifically it was also used as a title for men who had received the degree Master of Arts from Oxford or Cambridge; Harriot probably attended Hakluyt's lectures involving the new geography and the two were to remain close friends until Hakluyt's death.[45] Philip Sidney, Walter Raleigh, Thomas Bodley (the founder of the library) and William

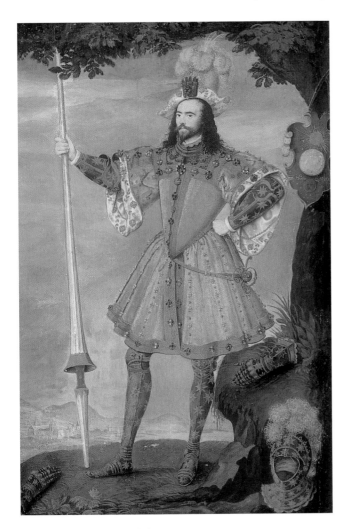

22. *George Clifford, Third Earl of Cumberland*, c.1590, by Nicholas Hilliard. Watercolour, bodycolour and gold on vellum on panel (257 × 178mm). Clifford (1558–1605), who was also a privateer, succeeded Lee as the Queen's Champion and here wears his parcel-gilt tilting armour with a hat and surcoat embroidered with armillary spheres and other symbols. National Maritime Museum, Greenwich, Buccleuch Collection (MNTO 193)

Camden (the antiquary) were all at Oxford at some time in the early 1570s, all knew Hakluyt and probably all knew each other; some stayed only for a year or so and did not formally matriculate, while others obtained their degrees. Only those who matriculated are recorded by Anthony à Wood in his *Athenae Oxonienses*.

The will of one further John White illustrates the other half of this route our 'gentleman'/'painter' may have taken to find himself on Walter Raleigh's expeditions to Virginia – the Inns of Court. Because they are so firmly associated with the legal profession, it is often assumed that the Inns' members had to be intended for the law. In the sixteenth century, however, they also served as preparatory or finishing schools for Oxford and Cambridge, and young gentlemen, usually in their late teens or early twenties, with no intention of becoming barristers, were often admitted for one or two years to become familiar with the law and with London – the city, its Companies, guilds and merchants – as preparation for running their estates or making their financial way in the world. Richard Hakluyt's cousin, also Richard Hakluyt (d. 1591) and a cosmographer associate of John Dee, was a lawyer in Middle Temple, from where he advised the Muscovy Company in their search for the Northeast Passage to Cathay. Walter Raleigh was admitted to the Middle Temple in February 1575, and Philip Amadas was also a member.[46] Non-members of the Middle Temple, such as Francis Drake, who was an Inner Templar, could attend and enjoy the revels performed there or benefit from the intellectual debates and merchant contacts,[47] since they probably also welcomed in their company merchants such as the wealthy William Sanderson (1547/8–1638),[48] married to Raleigh's niece, who often provided the ships and the financial backing. The backing took the form of individual private funding or investment as members of a joint stock company such as the one formed by Raleigh and the Governor and Assistants of 'the Cittie of Raleigh'.[49] The Inns of Court and the City Companies were two of the main sites of social, intellectual, cultural and commercial exchanges that were changing Elizabethan England from a feudal-based economy with clear-cut social divisions to an emergent capitalism that challenged the categories of gentry and merchant.[50]

Sir Christopher Hatton (c.1540–91), courtier and later Lord Chancellor, was at Oxford c.1556–7 and entered the Inner Temple in 1560. He was the dedicatee of John Dee's *Perfecte Arte of Navigation* and was 'an eager investor in overseas enterprises,' including Drake's circumnavigation and Frobisher's voyages, on which he sent his own nominee, George Best, who published an account of the voyage.[51] Sir Richard Grenville (1542–91) (whose father was master of the *Mary Rose* and went down with his ship in 1545), invested in Gilbert's voyages and later commanded Raleigh's Virginia expedition, and had enrolled at the Inner Temple the term before Hatton, in 1559.[52] On 12 November 1580, John White, gentleman, of South Warnborough, Hampshire, resident at Clifford's Inn (an Inn of Chancery), was admitted to the Inner Temple.[53] He was the grandson of Sir Thomas White of Warnborough (1507–66) and son of Thomas White (1532/4–1558), of Downton, Wiltshire, whose wife was the daughter of a wealthy London merchant.[54] There are reasons why this may not be our John White: his family crest does not appear on our John White's coat of arms. Our John White would have been in his early thirties in 1580, which would be a problem if he

were entering the Temple to continue his education. But if he were entering it to join the society of like-minded men, then he only needed their patronage.

The will of this John White, Gentleman of the Inner Temple, is recorded in Probate for 23 October 1597.[55] He was not survived by a wife or children and left money to the poor of South Warnborough and of his parish in London, St Andrew Undershaft. He left specified amounts to the children of his half-brother, William Dutton, Esquire, a wealthy gentleman of Gloucestershire who was also his executor, and to Thomas Dutton, who was his servant.[56] The only possible connection with our John White is that the name of William Dutton is included in the names of the colonists who travelled with John White to Virginia in 1587.[57]

From our consideration of John White's possible identity as a painter but above all as a gentleman, it is clear that he was well-educated, well-connected and an accomplished artist. Before entering on the lists of preparations that explain his duties and responsibilities on the Virginia voyages, it is important to review the status of the art of limning by gentlemen, its practice and purposes, at the Elizabethan court and in Europe in general. This will help us to understand the place of White's watercolours within this tradition, and explain why his presence was felt to be important amongst the gentlemen-courtiers on Raleigh's voyages. It will also help to locate the status of his drawings in the second half of this book as documents of the voyages, of the flora and fauna and of the life of the Indians they depict.

THE COURTIER-GOVERNOR AND THE 'CURIOUS AND GENTLE' ART OF LIMNING

In *Il Cortegiano*, Baldassar Castiglione demanded that his courtier should know the arts of drawing, painting and even sculpture, citing the example of the ancient Greeks and Romans, when the liberal arts were limited to the gentle classes and not taught to servants or bondsmen. These arts all sprang from *disegno*, the ability to abstract beauty from nature through imagination and a trained hand – a combination of mind and body. Drawing in particular not only was useful at court, for portraits and embellishments, but could be put to good use when travelling or for military purposes and mapping. In addition, this virtuous attribute improved the courtier's appreciation of beauty, enabling him to set an example of taste and provide pleasure – all vitally important at a court where surface appearances and outward show regulated all aspects of life. Sir Thomas Elyot's anglicized version *The Boke Named The Governour* (1531) opened up the opportunities for becoming such a courtier to men who were not noble-born: 'excellent virtue and learning do enable a man of the base estate of the commonality to be thought of all men worthy to be so much advanced'.[58] He also leaned away from Castiglione's emphasis on the virtue of the arts being in the appreciation of beauty towards the virtue of its application to the more practical arts of illustration of history, geometry, astronomy and cosmography. Gentlemen should not labour at it or spend so much time on it however that it become their 'business'; it should rather remain a virtuous recreation so that they might concentrate their time on 'business of greater importance'.[59]

Elyot's *Governour* was the guiding text for humanist education in Tudor England and was supplemented by Thomas Hoby's 1561 English translation of *The Courtyer of Count Baldessar Castilio … Very necessary and profitable for yonge Gentilmen and Gentilwomen abiding in Court, Palace or Place …*, which was republished three times before 1603. Hoby reinforced Elyot's strictures that the courtier's path was open to all men but he helped to clarify the difference between the arts practiced by professional artisans, and those finer 'curious' arts appreciated and practised by gentlemen.[60] Hence George Gower's concern (above) that he might appear to have abandoned his entitlement to be considered a gentleman, in which state he had been born, by becoming someone who earned his living by the more laborious practice of painting in oils, while Nicholas Hilliard, born the son of a goldsmith, argued his entitlement to be considered a courtier through his practice not of ordinary painting but of the more 'curious' art of limning.

Finally, as the work and knowledge of so few gentlemen who practised these arts at Elizabeth's court is known, it is worth considering the example of one gentleman-courtier who embraced not only them but also the Protestant humanist concept of the virtuous sharing of his knowledge. The physician Richard Haydocke's *A Tracte containing the Artes of curious Paintinge, Carvinge & Buildinge* (1598) was a translation of Lomazzo's manual *Il Trattato dell'arte* published in Milan fifteen years earlier. He engraved the title page himself (fig. 15) and, in his dedication to Thomas Bodley, stated that 'many my spare howers of recreation, have bin occupied in the sweete contemplation, and delightfull Practise of the more curious kindes of *Painting*, Carving and Building'.[61] After conferring with 'divers men skilful that way', studying fine examples, and '7 years dilligent and painfull practice in the Arte' which he is at pains to assure us was '(though for my meere pleasure and recreation)', he was providing his translation, which was more than a literal one, of this book which had instructed him in the 'mysteries of this Arte of Painting, whereby the unskillful eye is so often cozened and deluded, taking counterfeit creature for true and naturall'.[62]

Haydocke noted that he himself had encouraged Hilliard to write his 'perfection of painting/limning … forthcoming' and he planned a further volume, which did not materialize. He planned a chapter on the practice of the art, including 'drawing counterfeits by the life, drawings counterfeit by arte, the limmes & partes of mans' body, actions, gestures, figures with one another … Colours, and of the customes of the countries and people of the world, Apparel and drapery, The description of living creatures … Diverse instruments, Diverse kindes of Landskips' etc. His treatise and many of those that followed,[63] arose from demand not from artists themselves but from gentlemen who did not want to become professionals, and indeed had a healthy Protestant fear of painting's skills in 'counterfeit and deceit', but who might, with a few lessons, teach themselves as a recreation, in their leisure. John White's watercolours in this book are just such 'counterfeits from the life' and he must now be considered one of the earliest documented of these gentlemen practitioners of the 'curious' arts.

We have already noted how few Elizabethan paintings in oil that survive by English artists are signed: surviving examples of that most 'curious' of all arts, 'limning', in the

form of drawings and watercolours by gentlemen are even harder to trace. The traditional art-historical approach to the art of Elizabethan England, which considered it as backwards and provincial in relation to developments in the arts, chiefly of painting, in Italy and the rest of Europe, has actually been counter-productive to the appreciation and study of works on paper of the sixteenth century.[64] Much has changed in the past two decades in the study of Elizabethan art and patronage, particularly with the new multidisciplinary approach to material culture, but to date only manuscript illumination and miniatures have received the kind of attention given to works in oil, or to architecture, sculpture or garden design.[65] What forms did the work not only of gentlemen-courtiers but even of professional artists who worked on paper take, that it survives so rarely and is of so little concern for scholars of Elizabethan England?

These more 'curious' examples of fine arts were not substantial works that were hung on walls, but were usually created for albums or portfolios. They survive in libraries as anonymous books of drawings, their subject matter natural history, heraldry, costumes, maps and occasionally portraits or landscapes. Their quality, as they are after all the work of what we now term 'amateurs' or the work of anonymous professionals, was often not high, one of the reasons they have been ignored by traditional art historians. Their original maker and purpose is often lost and frequently their only value now truly is as a 'curiosity'. John White's album survived and is now known *only* because of its unique subject matter and because it could be associated with a renowned publication.

It is easy to forget that it was only during the sixteenth century that the illumination of manuscripts began to be replaced by printed books with illustrations, and the nature and character of the illuminations also changed. Some book illustrations took the form of small highly detailed paintings, often but not always on vellum, that, like the small limned portraits, seem to have walked off the pages of illuminated manuscripts and taken on a life of their own, sometimes in albums and sometimes framed. These began as full-page illuminations in Books of Hours or Calendars such as those created by the Fleming Simon Bening (1483/4–c.1558), whose daughter Levina Teerlinc was a portrait limner in England. The remaining leaves of one of Bening's late Calendars (now framed and in the Victoria and Albert Museum and British Library) are landscapes remarkably similar to those created by de Bry in the background of his engravings after John White.[66] Hilliard's larger full-length limned portraits with landscape backgrounds are a development from this (see fig. 22), but the two surviving watercolours on vellum attributed to Le Moyne (figs 77, 94) are in the same technique and style as the Bening landscapes. The Sloane volume watercolour of the 'Skirmish at Bloody Point' associated with John White (fig. 102) is of this scale but is pen and ink and watercolour on paper and records a historical event; as such it is a unique work with no known parallel at this time.

Other surviving examples of watercolour on paper take the form of an *album amicorum*, an autograph album filled with personal tributes and decorated with limned drawings of flowers, coats of arms or costumes of the country. The pages

23. *View of the Palace of Nonsuch with a Royal Progress of Queen Elizabeth*, from *Civitates orbis terrarum*, c.1582. Hand-coloured engraving by Franz Hogenberg after Joris Hoefnagel. The print is decorated below with a series of studies of costumes of English women, the noblewomen in expensive reds and the wives of merchants more soberly dressed. British Museum (P&D Y,5.153)

were inscribed by the friend who then paid for a professional limner to decorate their verse; others were decorated with prints. They were more popular in Protestant German universities than elsewhere but were also kept by some Englishmen who travelled on the continent or knew refugees in London.[67] Copperplate engraving began to replace woodcuts only during the middle of the sixteenth century.[68] These albums seem to have evolved from emblem books which were originally made of drawings but later were also printed. One of the finest was published by Theodor de Bry, *Emblemata nobilitati et vulgo scitu digna* (Frankfurt, 1592), and they could be hand-coloured or cut up for the decoration of albums.[69]

We know very little about who might have done the hand-colouring of prints (see p. 83) but no doubt the practice of colouring them was one of the most useful and pleasurable ways of learning to limn (see fig. 23). Copying was another; treatises on limning and drawing usually contained simple outline examples and recommended copying them and other prints as the first stage in training the hand. An amateur or professional would probably begin by copying them into his own *vade mecum*, which would be filled with drawings of eyes, noses, heads, bodies measured with proportional lines, heraldic and allegorical emblems, birds, beasts and flowers, providing a source book for later use. Although their work is even harder to trace, women too created such sample books, used for patterns for embroidery or other decorative works, and some were professionals.[70] The Almain Armourer's album (fig. 21) was an important record of patterns used so that they would not be repeated, and painters in the employ of the Office of the Revels were required to produce 'Patternes for personages of Men & Women in strange attyer'.[71] Such books were passed on in their workshops, as a record and inspiration.[72] Although they are

later, Inigo Jones's well-known watercolour drawings for court masques fall into this category, and similar works can be found for masques all over Europe, particularly in Italy and Prague.[73]

The numbers of professional limners available to give lessons or to do such 'jobbing' work as colouring prints, providing coats of arms, emblems or other decorations for albums, creating books of patterns or providing copies of other works were probably legion, though now almost no record of them exists. In his will Thomas Harriot left five pounds to one of them, his 'auncient servaunte Christopher Kellett a Lymning paynter dwelling neare Petty frraunce in Westminster'.[74]

JOHN WHITE'S 'WAY HOW TO LIMN'

Portrait limners first drew their subjects lightly with a brush directly on the prepared vellum before building up the image in colour.[75] John White first sketched his subjects in black lead (the Elizabethan term for graphite) in a manner much closer much closer to that employed by natural history artists such as Jacques Le Moyne de Morgues, who worked for the Sidney family (see pp. 170–4) or the costume studies of Lucas de Heere (1534–84), a 'man of considerable learning and refinement, as well as a painter and poet' from Ghent who was in exile in London in the 1560s. While he was in England de Heere also painted emblems in the *album amicorum* of his fellow Flemish exiles, including Ortelius, and a gallery of costumes of different nations for the Earl of Lincoln (see p. 147 and fig. 95).[76]

In addition to albums of natural history and costume watercolours, illustrated travel journals are the other survivors in this medium, although there are very few. The only comparable one of this date is by an anonymous artist on Sir Francis Drake's voyages, which has occasionally been though to be by Drake himself (fig. 41);[77] if so he was a far less accomplished artist than John White.

Travel journals, natural history records, maps, manuscripts and prints were all changing so swiftly at this date that John White's fascinating watercolours are not quite so astonishing when set in the social and artistic contexts discussed above. A gentleman not under the normal constraints of a profession but who had sufficient leisure to practise and derived enough enjoyment from it to improve his 'arte' was in a position to respond to what was required at the time with whatever tools and abilities he had at hand, and improvisations and inventions were a natural outcome. This goes a long way to help us understand why the form his watercolours take is so new and different from any comparable surviving work of the period. His pigments and painting technique are discussed on pp. 234–5. The content and context of John White's different groups of watercolours, the Indians, flora and fauna, Inuit, costume studies and the Sloane volume, are all discussed in detail in the catalogue entries in the second half of this book. In this chapter his identity and status as a gentleman and the unique quality and survival of his work as a practitioner of the more 'fine and curious' art of limning have been set forth. Raleigh has purchased the patent to explore and settle the New World and John White is set to play his role as a gentleman-companion on the first voyage to Virginia.

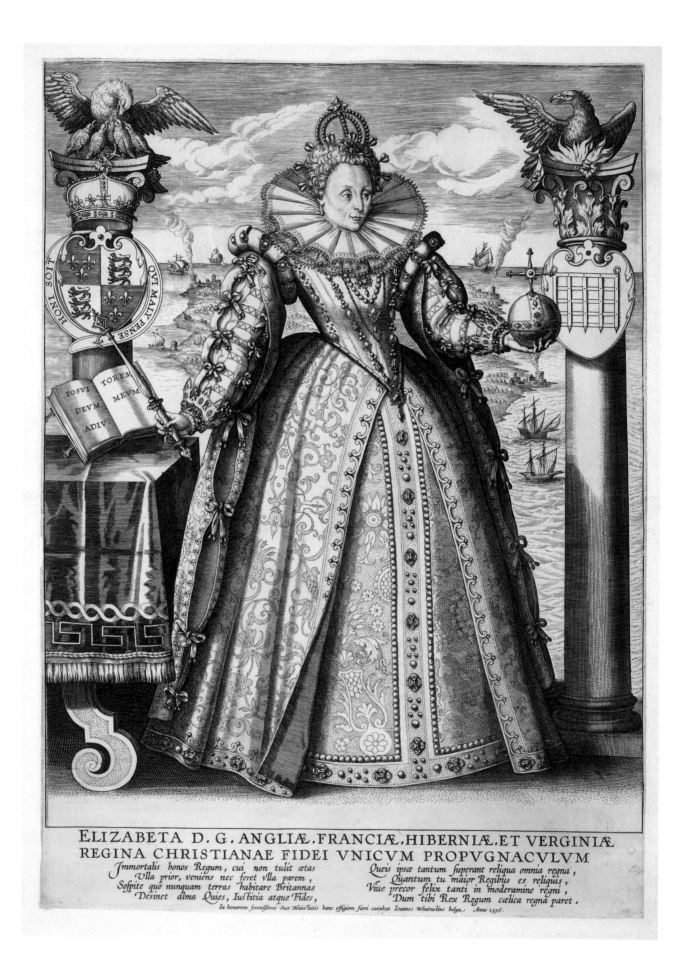

ELIZABETA D. G. ANGLIÆ. FRANCIÆ. HIBERNIÆ. ET VERGINIÆ
REGINA CHRISTIANAE FIDEI VNICVM PROPVGNACVLVM

Immortalis honos Regum, cui non tulit ætas Queis ipsæ tantum superant reliqua omnia regna,
 Vlla prior, veniens nec feret vlla parem, Quantum tu maior Regibus es reliquis,
Sospite quo nunquam terras habitare Britannas Viue precor felix tanti in moderamine regni,
 Desinet alma Quies, Iustitia atque Fides, Dum tibi Rex Regum cælica regna paret.

In honorem serenissimæ Suæ Maiestatis hanc effigiem fieri curabat Ioannes Woutnelius belga. Anno 1596.

CHAPTER 3
AN ELIZABETHAN 'GOVERNOUR' IN VIRGINIA

KIM SLOAN

24. *Elizabeth, Queen of England, France, Ireland and Virginia*, 1596. Engraving by Crispijn de Passe the elder, published by Hans Woutneel. Elizabeth is symbolized here as supreme ruler and protector of all her realms, including Virginia, where the colonists were still believed to survive, and holding her claim. British Museum (P&D 1868,0822.853)

It was not only the view of the world, society and the arts that was changing so swiftly in Elizabethan England. What we today would call the sciences – mathematics, navigation, astronomy, cosmography, the use of instruments and natural philosophy – had all undergone rapid change during the Renaissance. The humanists at Elizabeth's court were instructed in these changing disciplines by John Dee and a series of Flemish Protestant refugees, including the great cosmographers Ortelius and Mercator, who fled to England with the knowledge gained through the courts and their *belles-lettres* network all over Europe. Many of Elizabeth's gentlemen courtiers, including Philip Sidney, Francis Walsingham and Richard Hakluyt, had themselves visited these courts in a diplomatic capacity and returned to London with the latest ideas and publications.

According to Richard Hakluyt in his dedication to Raleigh of his *Decades of Peter Martyr* (1587), some time around Gilbert's death in 1583 Raleigh began to 'maintain in your household Thomas Hariot, a man pre-eminent in those studies [the navigator's art assisted by mathematical sciences], at a most liberal salary in order that by his aid you might acquire those noble sciences in your leisure hours, and that your own sea-captains, of whom there are no a few, might link theory with practice, not without the most incredible results' (fig. 25).[1] In 1583 Raleigh had been granted the use of Durham House, the residence of the Bishop of Durham on the banks of the Thames next to the Strand (near where the Adelphi now is), and he set Harriot up in rooms there to prepare for the voyages.[2]

Raleigh utilized them all in his preparations: Walsingham with his political support at court, John Dee providing him with maps, Harriot instructing his seamen in navigation and shipbuilding, not only collecting everything published but writing his own manual, *Arcticon*, for their use.[3] The Hakluyts prepared the way with reports to persuade the Queen and potential investors and with collections of the accounts of earlier voyages. Richard Hakluyt the elder penned two manuscript 'Inducements to the liking of the voyages' listing ways to exploit the land and the skills needed, while his younger cousin carefully researched and prepared his 'Discourse on Western Planting'. A more full list of Dee's and the Hakluyts' pamphlets and publications with a summary of their contents is included in the Chronology.

PREPARATIONS AND THE PROTESTANT PROPAGANDA FOR PARADISE

It is clear from Harriot's papers that survive that he made navigation his special study, gathering books, maps, charts and information from the men who had sailed with Frobisher, Gilbert and Raleigh. Harriot's biographer felt that the notes indicated that Harriot made some of the early voyages himself, including the initial 'fact-finding' one to the New World by Philip Amadas and Arthur Barlowe in 1584, but his papers from this early period do not survive.[4] It seems, from John White's own statement that he had made five voyages to Virginia, that he too may have gone on this initial voyage. It is impossible to say whether he was part of Raleigh's 'private academy' when Harriot gave lessons to Raleigh's captains at Durham House during these years, but the evidence seems to point to the likelihood that both men may have sailed in April 1584 with Amadas and Barlowe 'with direction to discouer that land which lieth between Norembega and Florida in the West Indies'.[5]

25. *Thomas Harriot*, c.1620. Engraving by Francis Delaram. Although often printed as a portrait of Harriot (c.1560–1621), along with an anonymous oil painting in Oxford to which it bears some resemblance, the identification of the sitter is based solely on the calculating board and vague allusions in the verse below. Harriot was known to dress sombrely in black. British Museum (P&D P,1.216)

By the time Raleigh's patent for the discovery of the New World was granted, he had some experience of Atlantic voyages himself, his seamen were prepared by Harriot, he had purchased two ships – a flagship, of about 60 tons (see fig. 12) and a pinnace of about 30 – and two gentlemen of his household, Philip Amadas and Arthur Barlowe, were to be his expedition captains. Simon Fernandez – a ship's pilot and captain originally from Portugal but married to an Englishwoman, who had turned Protestant, had worked for Walsingham for years, and had identified the best place to head for between Norumbega and Florida – was to be their pilot. Eleven gentlemen and merchants, including Richard Grenville, William Camden and William Sanderson, had invested. The first exploratory expedition Raleigh sent to the New World set out in April 1584.[6]

The only account of this voyage was written for Raleigh by Barlowe on his return and it was published in 1589 by Hakluyt, probably with substantial editing by him or Harriot, so that it reads as a promotional tract for Paradise. After landing on the Outer Banks near Wococon and officially claiming the land for England:

> wee viewed the lande about vs, being whereas we first landed, very sandie and lowe towards the water side, but so full of grapes, as the very beating,and surge of the Sea ouerflowed them, of which we founde such plenty … that I thinke in all the world the like aboundance is not to be founde: and my selfe, hauing seene those partes of Europe that most abound, finde such difference, as were incredible to be written … the vallies replenished with goodly Cedar trees … This Island had many goodly woods, full of Deere, Conies, Hares, and Fowle, even in the middest of Summer, in incredible aboundance … no people in the worlde carry more respect to their King, Nobilitie, and Gouvernours, then these doe … Wee found the people most gentle, louing and faithfull, void of all guile, and treason, and such as lived after the manner of the golden age. The earth bringeth foorth all things in aboundance, as in the first creation, without toile or labour. The people only care to defend themselues from the cold, in their short winter, and to feed themselues with such meate as the soile affoordeth.[7]

No list of the men who travelled on this expedition exists but it is now generally believed that it included Thomas Harriot, who was instructed to learn as much as possible of the Indians' language, and John White, presumably in the capacity of one of the gentlemen-companions so necessary to these voyages, or as an investor, as there is no evidence that anyone was required to draw maps or make any sketches of the people or the land on this first expedition.

They returned in mid-September 1584, with glowing reports of fertile and wooded lands, abundant skins and furs, copper and pearls. The ship also brought two Indians, Manteo from the friendly Croatoans, and Wanchese, a subject of Wingina, the powerful *werowance* ('he who is rich') or King of Roanoke (see no. 21). They were paraded at court as an advertisement for Raleigh's colonial project and worked with Harriot at Durham House learning English and teaching him their language and more about their country, people and culture while Harriot developed a phonetic script with which to make written transcriptions.[8] Raleigh had already begun his preparations for establishing a colony there in earnest by having Hakluyt prepare a manuscript state paper to persuade Walsingham and the Queen of its benefits and another publication to persuade the court in general (see Chronology). Raleigh also brought a bill to Parliament asking for an act to confirm the Queen's letters patent, and, although it was not passed by the Lords, it was scrutinized by a committee of the men he most wanted to influence, including Walsingham, Sidney, Drake, Grenville, Cavendish and others. Along with Hakluyt's *Discourse*, it succeeded in persuading the Queen to knight him on Twelfth Night, in January 1585, and permit him to call the land in her honour. She donated some powder from the Tower and released Ralph Lane from service in Ireland to accompany him. The seal he had made to celebrate described him as Walter Raleigh, Lord and Governor of Virginia.

26. *Seal matrix of Walter Raleigh as Governor of Virginia*, 1584, PRINTED IN REVERSE in order to make the legend legible. Silver, 57 mm. His arms bear the legend 'AMORE.ET.VIRTVTE', which appears also on his portrait (fig. 17). British Museum (P&E 1904,0113.2)

'PICTURES OF SUNDRY THINGS COUNTERFEITED ACCORDING TO THE TRUTH'

John White's precise 'duties' on the second voyage that set out in 1585 to plant a colony in Virginia have been discussed at length in the past by Quinn and others.[9] In his 1584–5 manuscript 'Inducements to the Liking of the Voyage intended towards Virginia in 40. and 42. degrees', the elder Richard Hakluyt proposed what types of tradesmen should be taken, including 'A skilful painter is also to be carried with you, which the Spaniards used commonly in all their discoveries to bring the descriptions of all beasts, birds, fishes, townes, &c.'[10] Thomas Cavendish, who was to sail as one of the captains, consulted with a military expert and compiled notes on the number of men, their arms and the size and type of fortification they were to build. He also

listed the specialists that would be required including engineers, a physician who knew the properties of herbs and minerals, a 'good geographer to make discription of the landes discouerd, and with hym an exilent paynter, potticaris [apothecary] and Surgiantes for low sycniss [fevers] and woundes. An alcamist … to trye the mettaylls that maybe discouerd and an perfect lapidary … Masons, Carpentiers. makers. of mudwals, su[m] of ye myners of Cornwell, Sume excelent husband men, with all thinges appertayninge to husbandry, and all maner of Sead Corne.'[11] The government of the colony also included two justices and a high treasurer.

But in 1582–3 there had been similar instructions for Humphry Gilbert's voyage which are recorded in the commonplace book of Sir Edward Hoby, the son of the translator of *Il Cortegiano*. Gilbert, Frobisher and the Hakluyts may have contributed suggestions to the instructions. These give far more detail concerning the duties of the 'observer' who was to keep a journal recording all of his observations and see they were incorporated in the maps and drawings. The instructions also detail the duties of Thomas Bavin, the intended surveyor and draughtsman on the voyage, including the instruments he was to take and what he was to record.[12]

The first page or two of the instructions are missing and they begin half-way through the instructions for the observers. It consisted of a list of things to be noted in the journal and on the 'drawn plottes' [charts] and 'mappes' including springs, coastlines, the islands and their elevations and commodities, the soils, minerals, trees, herbs, beasts, birds, fish and insects and how they differ in kind or colour from those in Europe and the exact place where they were found. Of the people they should note their manner of taking birds, fowls, fish and beasts, the manner of their planting and manuring of the earth, their stature, apparel and manner of food, what manner they arm and order themselves in war, also 'the greatnes and quantetie of euery distinct Kinges Contryes people and forces', their languages (the same man is to take a dictionary to record their words next to the English equivalent), their defences, boats, landing places and convenient places to make salt. Very detailed instructions about surveying, navigating and map making required someone to attend Bavin with instruments for observing and calculating elevation, latitude and even longitude. Another was to watch and ensure there are no mistakes and that the correct given symbols for hills, rocks, water etc. are employed in the 'plottes'.[13] For this an enormous array of instruments and tools was required including, in addition to navigational ones, a table, royal paper (24 by 19 inches), quills, ink, black powder to make ink, a 'pensill' with black lead, 'all sortes of colours to drawe all things to life', a stone to grind colours, glue, gum, two pairs of compasses and 'other Instruments to drawe cardes and plottes'.[14] Two further instructions emphasized the particular importance of two mentioned earlier and were most relevant to Harriot and White:

Also drawe to life all strange birdes beastes fishes plantes hearbes Trees and fruictes and bring home of eache sorte as nere as you may.

Also drawe the figures and shapes of men and women in their apparell as also of their manner of wepons in every place as you shall finde them differing.[15]

The products of their labours, in the form of Harriot's *Brief and true report* and White's watercolours, certainly fulfilled their brief.

WALTER RALEIGH'S FIRST COLONY IN VIRGINIA

In the end, after all the preparations, Raleigh was forbidden by the Queen to go on the voyage and instead the seven ships sailed from Plymouth on 9 April 1585 under the command of Richard Grenville as the admiral/general of the voyage (fig. 27), with Ralph Lane as the Governor of the colony. Amadas, Barlowe, Fernandez, Cavendish and others sailed as captains. Their route is documented on John White's large map, the title page to his pictorial record of the journey (see no. 2), and, although the ships became separated, most arrived at the Outer Banks in July.

The only record of John White's presence amongst the six hundred men who set sail is in the journal of the *Tyger*, Grenville's ship, as it was published in Hakluyt's *Principal Voyages* in 1589. White's name appears amongst the party of men who set out from Wococon to explore the mainland on 11 July in a tilt boat, pinnace and two ship's boats.[16] The party seems to have consisted of most of the captains and gentlemen who travelled with them, including Harriot in the pinnace, and the treasurer Francis Brooke and John White in one of the ship's boats – small rowing boats kept on the decks of the ships for landing and exploring shallow waters. It was on this expedition, which lasted to 18 July, that they visited Pomeiooc, Aquascogoc and Secotan and that John White made *all* of his drawings of the Algonquian Indians, with the possible exception of drawings of some of the inhabitants of Roanoke (see nos 16, 21). It was also on this expedition that Harriot probably made most of his written records.

The first act of violence by the English against the Indians occurred on this expedition, when on 16 July Amadas put the town of Aquascogoc to the torch, in the belief that one of the people there had stolen a missing silver cup. Fortunately all of the inhabitants had fled before they set fire to the town, but the English also destroyed their crops, which meant a lean winter if not starvation over the coming year, as drought had already reduced the crops of neighbouring tribes.

Grenville's ship the *Tyger* returned to England on 25 August, and the other ships departed at various times over the summer, leaving Ralph Lane as Governor of a colony of 107 men who were to remain over the winter as the first plantation in Virginia. The names of the colonists were published in a list by Hakluyt but John White's is not on it. This has been explained variously by stating that his name was misspelt or accidentally omitted.[17] It has always been assumed that he stayed because his map includes the Chesapeake and other areas that Harriot and some of the colonists were known to have explored over the coming months.[18] However, the majority of the six hundred men who had travelled to Virginia with Grenville went back with him or on other ships. Only those needed to hold the colony or with specific tasks (some of

27. *Sir Richard Grenville*, 1571, anonymous. Oil on canvas, 1060 × 733 mm. Grenville (1542–91) served in Munster and was an investor in Gilbert's voyages; he may not have had a great deal of seafaring experience before leading his cousin Raleigh's 1585 expedition to 'Virginia'. National Portrait Gallery, London (NPG 1612)

the captains, Lane, Harriot, the mineralogist Joachim Ganz, a surgeon, various miners, soldiers and servants) would have remained – certainly the treasurer Brooke did not stay, as he was the bearer of messages written to Walsingham by Lane in September. Lane also sent letters to Philip Sidney and Hakluyt reporting on what they had found and urging their continuing support for the venture back home; something that would also be pursued in person by those such as White who probably returned.

The instructions for Gilbert's voyages indicated that the observer and surveyor would have had assistants and probably servants; John White's skills as a watercolourist would not have been necessary for the basic surveying and map making – his role in the maps was to draw and colour the final versions, working from surveyors' rough sketches, something which could be done back in England from the surveys taken and with personal directions from Harriot (see nos 2, 6). There are no images in his surviving watercolours that could not have been made during the activities of July, August and early September. His inscription on the title page of his watercolours clearly states the voyage was made in the year 1585 and does not mention the colony as Harriot's title page did, nor does the date include the following year (see no. 1).[19] If John White was a gentleman-companion who was also an artist, as we have argued in Chapter 2, it would make sense for him to return swiftly with first-hand reports and images in order to enlist further support for the colony in the form of investors and settlers. With his pictures of a land of plenty inhabited by friendly civilized people, this is precisely what John White set out to do on his return to London.

Thomas Harriot's name, however, is prominent on the list of Lane's colonists with those of the captains and gentlemen who stayed and perhaps played a role in the parties that explored inland and further up the coast, and witnessed the hardships endured by the colony over the winter. We have no clear account of the settlement and its buildings or the activities of its inhabitants from September until March when Lane's account of the remainder of the year begins.[20] But Harriot would have witnessed what White did not: the deterioration of relations with the Indians detailed in Lane's account which ended with the slaughter of Wingina just before the timely arrival of Francis Drake in June 1586. The supply ships that were supposed to be sent out for the colony's early relief were delayed, as was Richard Grenville, who arrived about a month after Drake's rescue.

Drake had been successfully laying siege and laying waste to Spanish ports and towns including Cartagena, San Domenico and San Augustine in Florida where their settlement had been established since they had driven the Spaniards out two decades earlier (see pp. 98, 108). Drake succeeded in making greater enemies of the Spanish but at the same time reducing their threat to the success of the Virginia colony by reducing Spanish opportunities to send ships against the small fort that had been built on Roanoke. Both Grenville and Drake and some of the other ships had also come back laden with Spanish gold from privateering *en route*, one of the most compelling arguments for continuing with the plans for the colony and creating a permanent harbour and settlement in the area from which they could attack Spanish shipping.

White and Raleigh and the merchants, who anticipated good opportunities for trade or the chance of finding copper reported by those who had returned with Grenville in August 1585, were already planning a settlement slightly north in Chesapeake Bay where there was deeper water and relations with the Indians had not yet soured. Fernandez and Amadas and Barlowe (and possibly White) had identified it on their earlier voyages.

However, there were also rumours circulating through unofficial reports, and from others who returned with Drake in 1586, that hinted that Virginia and its inhabitants were not as full of promise as Grenville's and Lane's reports and Raleigh's political manoeuvrings might indicate. The vision of Paradise provided by White's watercolours was available only to a select few, and Harriot's journal and papers had probably been lost – a public account was needed that could stall the rumours and re-encourage investors in the 'Cittie of Raleigh' whose company was already formed by January 1587. Harriot's small unillustrated pamphlet of which only six copies survive, entitled *A briefe and true report of the new found land of Virginia*, was clearly based on a handful of notes and what he could remember. It was intended to be followed later by a fuller 'Chronicle', which never materialized. It may have circulated in manuscript, but it does not appear to have made it into print until February 1588, a year and a half after his return.[21] De Bry's lavishly illustrated edition did not appear until 1590.

THE 'CITTIE OF RALEIGH', THE LOST COLONY

Nevertheless, the promise of the report and the activities of White and Raleigh through 1586 seem to have been sufficient to make possible the creation of the new company of the 'Cittie of Raleigh' and to see off the first of the new Governor John White's ships from London towards Portsmouth in March 1587.[22] Until this time, colonies that the English had attempted to establish in North America had consisted of men whose main business had been to build and man forts and build basic structures, to find minerals, to establish trade in valuable commodities, to map and to find enough food to feed the colony over the winter. For various reasons these had failed and the main aim of the present company was to 'plant' people – not soldiers but farmers, artisans, small merchants, gentlemen and above all families, not just men, but women and children, to settle and hold the land usefully for England.

Although White's ships headed for Portsmouth in March they did not set out across the Atlantic until the beginning of May, later than any of the other expeditions, and, after various delays and problems obtaining supplies in the West Indies, they arrived at the Outer Banks in late July. This was not, however, their intended destination. Amadas and Barlowe and, according to Hakluyt, Peter Martyr and even Cabot much earlier had identified 'the bay of the Chesepians' as the ideal site for their colony.[23] But Fernandez claimed that it was too late in the season to go on to Chesapeake as intended and forced White and his colonists to land at Roanoke where relations with the Indians had deteriorated in the last months of the previous colony under Lane, culminating with the death and beheading of Wingina. Shortly after they landed and began to occupy the buildings left by Lane, one of the

twelve Assistants was killed and a retributive expedition sent by White went badly wrong, wounding friendly Indians. White's daughter Elinor gave birth to his granddaughter, Virginia Dare, and White was persuaded by the colonists to return with Fernandez to obtain assistance for the colony as soon as possible.[24]

The colonists thought to head for safety elsewhere if possible, either to Croatoan with Manteo or to the Chesapeake, and they agreed on a sign if they managed to get away safely. White was delayed by storms on his return and, by the time he arrived back in England, the Spanish Armada was threatening retaliation for the piracy of Raleigh, Drake, Grenville, Fernandez and the others. By the time Harriot's small unillustrated pamphlet was published in February 1588, it was clearly intended to serve the purpose of soliciting further investors, colonists and supplies to supplement those John White had settled there but had been forced to leave behind in August 1587.

But White was due to disappoint the 117 men, women and children, including his own family, Ananias, Elinor and Virginia Dare. He was to append the list of all their names in the account of the voyage he later sent to Hakluyt for publication.[25] Immediately on his return in November 1587 he saw Raleigh, who duly promised to send his pinnace as soon as possible; Grenville was also fitting out a larger expedition with more settlers for the colony, but which would probably also serve as a privateering enterprise as in all his previous sailings. But in October 1587, with the Armada threatening England on its doorstep, there had been a general stay of shipping and Grenville's ships and provisions were re-diverted the following year to the battle with the Armada.

Raleigh and Grenville managed to keep back two very small vessels, on which White eventually set sail in April 1588. But the captain leading the expedition was set on privateering *en route* and, after losing their provisions for the colony in a battle with a French ship off Cape Verdes where White was wounded twice in the head, by a sword and a pike, his ship returned to England.[26]

The following year, 1589, another group of merchants and backers, including William Sanderson, John Gerard and Richard Hakluyt, were found to join the existing Governor and his twelve Assistants to continue the patent of the Cittie of Raleigh 'to carrie with them into the late discouered barbarous lande, and countrie called Assamacomuck, alias Wingandacoia, alias Virginia, there to inhabite with them, such and so many of her Maiesties subiects, as shall willingly accompany them.'[27] It was formed in March but no expedition sailed that year, perhaps because of events in Ireland or Raleigh being in temporary disgrace with the Queen.

ENGLAND'S FIRST PLANTATION: IRELAND

To this point in our account of John White, Ireland has featured only in the background. Gilbert, Raleigh, Grenville and Lane had all, before their voyages to the New World, served there in a violent repressive military capacity, enforcing Elizabeth's confiscation of lands and plantation of her 'colony' in Ireland over which she claimed sovereignty (see fig. 24). For years it had been serving in many ways as a

28. *An estate map of Mogeely, Co. Cork*, 1598. Manuscript with watercolours and bodycolours on vellum (540 × 480 mm), possibly by Harriot and White. Raleigh was given 40,000 acres of attained land in Munster, including this estate of 1135 acres which he leased to Henry Pyne, just to the south of White in Newtown/Ballynoe. National Library of Ireland, Dublin (Lismore Papers, MS 22028)

'rehearsal' for the New World and even 'in a real sense turned English minds towards America'.[28] Her success there was seen to prefigure and predict success in America. Various tracts discussed the inhabitants of Ireland in the same way some referred to the Indians of the New World, as wild men, cannibals, idle and bestial; others compared them, as Harriot and White did, with an ancient stage in the development of the British towards civilization (see pp. 153–63).[29]

Raleigh had taken refuge in the lands he had been given around the town of Youghal, near Cork in Munster, which he had contracted to settle with 320 families. He brought craftsmen and their families from the south-west of England and many people who had sailed on his voyages to Virginia, including Thomas Harriot and John

White. Harriot was established at Molana Abbey on an island with dense woods near Ballinatra north of Youghal, while White's home was at 'Newtowne in Kylmore'. This was not the town currently named Newtown but the place further to the north west of Youghal, now called Ballynoe (Irish for Newtown), which in White's time was called by the English version of its name.[30] Harriot's property around Molana had been transferred to Raleigh in 1586 and presumably to Harriot shortly afterwards; Harriot sold it in 1597, but he resided there only occasionally and undoubtedly spent most of his time in London.[31] White's residence and the length of it are less well documented, and we know only that he was there for certain in February 1593. Harriot's inscription in the phonetic script he had used to record the Algonquian language has been found on a survey map of 22,719 acres around the River Blackwater, including Lismore and the lands near Molana Abbey, in the National Maritime Museum (F2033, P/49(29)), drawn on 28 August 1589 as part of the surveying of the English estates; it has been argued that he and White worked together on this project, producing at least one final joint map of Mogeely, dated 1598 (see fig. 28).[32] If they were working on the mapping and dividing up of confiscated Irish estates, Harriot and White were participating in a new kind of cartography that would have proved useful in America if the colonies had been successful and the parcels of land allocated. But this has taken us ahead of the subject of White's letter written from Newtown in 1593 – the account of his final attempt to find the lost colonists.

Wherever he had been living in 1589, it was not until 20 March 1590 that John White had finally left Plymouth for Virginia again. He had received a bond from Sanderson and others but, when the ships were ready to leave, he was suddenly told that the additional colonists and provisions he had hoped to take with him would not be permitted and he was forced to board alone with one chest and 'no not so much as a boy to attend upon me'.[33]

The distressing tale of further privateering and delay and the one day he was permitted to search on Roanoke for the survivors of the 'Lost Colony' has been told many times. Five men were drowned when their boat overturned coming through the dangerous breach in the Outer Banks (see Chapter 1, p. 11). On Roanoke the colonists had been gone for some time, but an agreed sign carved on a post indicated they had left for Croatoan and not under great duress. The buildings of the 'Cittie of Raleigh' had been pulled down, probably by the colonists themselves to be more easily transported; but White's chests which had been buried for safekeeping had been dug up and their contents destroyed and scattered: 'about the place many of my things spoyled and broken, and my bookes torne from the couers, the frames of some of my pictures and Mappes rotten and spoyled with rayne, and my armour almost eaten through with rust … but although it much grieued me to see such spoyle of my goods, yet on the other side I greatly ioyed that I had safely found a certaine token of their safe being at Croatoan, which is the place where Manteo was borne, and the Sauages of the Iland our friends'.[34] The worst and final blow was that it was late in August and the hurricane season was fast approaching; cables holding the ships off the Banks were breaking and he could not travel to Croatoan to search for his family and the other colonists who he believed still survived.

RESIGNMENT

In Elizabethan England men who chanced their lives on these voyages were viewed in different lights. In Hakluyt's *Principal Voyages*, which printed the accounts of all the Virginia voyages along with hundreds of others, Philip Sidney's father Henry praised the explorer who 'commits his like ... to the raging Sea, and the uncertainties of many dangers'; but he also saw virtue in those who remained behind protecting and promoting the nation at home – 'We shall here live and rest at home quietly with our friends, and acquaintance ... We shall keepe our owne coastes and countrey: He shall seeke strange and unknowen knightdomes.'[35]

Edmund Spenser composed most of *The Fairie Queene* in Ireland and filled it with references to the New World from the Virginia voyages of his friend Walter Raleigh.[36] In Book 2 Phaedria entices the virtuous knight Guyon away from action, describing the dangers of New World travel as 'fruitless toile' and Spencer thus criticizes the idleness of those who were content to remain behind:

Who fares on sea, may not commaund his way,
Ne wind and weather at his pleasure call:
The sea is wide, and easie for to stray;
The wind vnstable, and doth never stay.
But here a while ye may in safety rest,
Till season sure new passage to assay;
Better safe port, then be in seas distrest.[37]

Our last glimpse of John White is in his house on Walter Raleigh's lands in Munster near Cork, having finally decided 'better safe in port' than to make any further forays into the New World. In 1593, he sent Hakluyt the account of his final unsuccessful voyage to find the lost colonists in 1590, enclosing a letter giving his very personal and emotional response to his failure:

Thus may you plainely perceiue the successe of my fift & last voiage to Virginia, which was no lesse vnfortunately ended then frowardly begun, and as lucklesse to many, as sinister to my selfe. But I would to God it had bene as prosperous to all, as noysome to the planters; & as ioyfull to me, as discomfortable to them. Yet seeing it is not my first crossed voyage, I remaine contented. And wanting my wishes, I leaue off from prosecuting that whereunto I would to God my wealth were answerable to my will. Thus committing the reliefe of my discomfortable company the planters in Virginia, to the merciful help of the Almighty, whom I most humbly beseech to helpe & comfort them, according to his most holy will & their good desire, I take my leaue from my house at Newtowne in Kylmore the 4 of February, 1593.[38]

We have seen the New World as it was imagined by the English and as it was actually viewed by John White – a Paradise that was spoilt by temptation to greed and violence fed by a sense of superiority that the English were not able to resist. Just as no record remains of what happened to the Lost Colony, no record remains of the rest of John White's life: only his watercolours are left to record an Englishman's first vision of America.

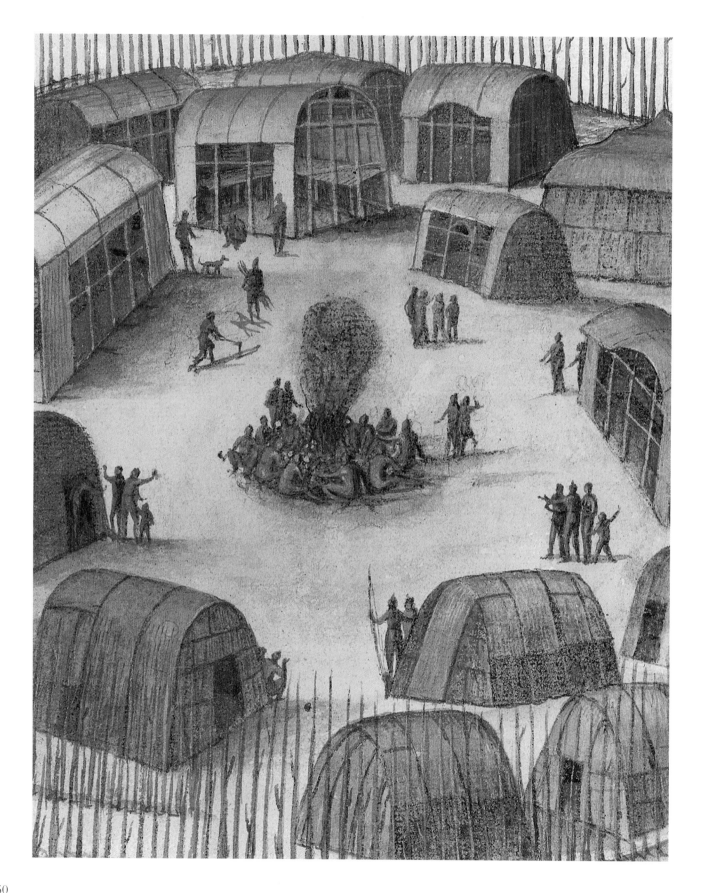

CHAPTER 4

ROANOKE 'COUNTERFEITED ACCORDING TO THE TRUTH'

JOYCE E. CHAPLIN

29. *The town of Pomeiooc*, c.1585. Watercolour with bodycolour and gold, by John White. Detail of no. 9

They dance. They wave to each other. They prepare food. They smile. They keep dogs. John White's watercolours of the Roanoke or Secotan natives of Virginia show them doing these and other things. Why these things? Even more than is usual in a European account of another cultural group, this is a selective portrait. In a very real sense, White introduced Virginia's natives to the English as if he were displaying them in a theatre. The spectators who had the front-row seats, meaning the English who colonized Roanoke, are invisible, even though they were actually interacting with the natives whom White depicted. And White did not see, or did not want his audience at home in England to see, what took place 'backstage' among the Roanoke themselves. Instead, he displayed, in dumbshow, certain Indian people, in certain places, wearing certain clothing and wielding certain objects – all to make points about their usefulness to an English plan of colonization.

White's illustrations, like so many of the narratives of Roanoke, were part of a propaganda campaign intended to promote the tiny English outpost. His fellow colonist Thomas Harriot wrote the best-known published account, *A briefe and true report of the new found land of Virginia* (1588). Even compared to that optimistic narrative, White's friendly, smiling, waving Roanoke are too good to be true – they lack the complexity of real humans. They are, in essence, the eager assistants of the English colonizers: they have ample food, they have free land, they make and use tools, they are cheerful and welcoming. Hardly any of these claims were true.

And even as White tried to make the Indians (and their land) seem welcoming to the English, he gave a few hints that they might not fit easily into England's colonizing plan. They were pagans who needed to be evangelized but whose idolatry was, in the meantime, disturbing to the English. They had a reproducing population, evidence that they needed land and food for their own people. Above all, they were perfectly capable of making war against outsiders. On that final point, White may have meant to indicate the natives' ability to help repel the settlers' competitors, the Spanish. But the armed Indians indicated a possibility that the English could themselves end up as the targets of Indian archers.

In the end, the Roanoke natives did not help the newcomers establish their hoped-for colony. The English settlement vanished, along with its residents and its Indian neighbours. White's watercolours remain. They are a haunting reminder of an

English fantasy about Indian people who would welcome and help establish an English colony on their territory. As White indicated on the title page to his portfolio, the watercolours were 'pictures of sundry things collected and counterfeited according to the truth'.

To counterfeit the truth – White's statement of intent describes only too well the entire Roanoke venture. The word *counterfeit* implied, by his day, a kind of falsehood, including the kind that players did upon a stage. The players were real people, and they may have imitated other real people (as in Shakespeare's history plays), but their art was just that, artifice. Yet the imitation of life mattered because it presented to spectators scenarios that they might not otherwise witness. For that reason, a theatre had become a powerful metaphor for the world itself, the *theatrum mundi*. By the time White unpacked his drawing instruments at Roanoke, the metaphor was a near cliché, recognized as such by Shakespeare and Cervantes (who nevertheless cited it). The concept of *theatrum mundi* was also important for conceptualizations of the natural world; God was the fabricator of the wonders displayed on the world's stage and humanity was the awestruck audience.[1]

In presenting North America's natural world and natural inhabitants to English spectators, White created a distance between colonizers and colonized. That distance was and would remain a characteristically English approach to their growing empire – from Ireland to Virginia, and then eventually beyond. White's illustrations preserved the Roanoke natives, even as the colonizing programme to which he subscribed was designed to displace them entirely in favour of the English.

To America

Before the 1580s, the English had voyaged to and claimed land in North America and had tried to establish a colony there, but had failed badly. The attempts and the failure would influence their plan to establish a beach-head in the Chesapeake, a location meant to challenge Spanish claims to North America but itself north of the Spanish settlement at St Augustine, the first European colony in North America.

Several voyages of exploration, starting with those of the Cabots in the early 1500s, had given the English reason, to their minds, to claim portions of North America for themselves. But these were tentative assertions and, in the wake of the massive Spanish claim to Central and South America, rather puny ones. An Anglo-Spanish competition for North America had begun and would not end until the nineteenth century. The situation was especially dangerous during Elizabeth's reign. With the death of Queen Mary, dynastic links to Spain broke apart; an Anglo-Spanish rapprochement under James VI and I was yet to come. The Elizabethan English realized that they would, in any open military confrontation with Spain, probably lose.[2]

So the English went north, into the Arctic zones that were far from Spain's new world settlements and that no one else wanted, anyway. Between 1576 and 1587, Martin Frobisher and John Davis made a total of six voyages (three each) into Baffin Bay. A primary object was to discover and chart the Northwest Passage, the fabled conduit that would take travellers directly toward Asia without having to

voyage around the South American territories held by the Spanish. The English called the lands they charted Meta Incognita, meaning an unknown goal or boundary. One map that accompanied an account of Frobisher's 1577 voyage nevertheless depicted 'Frobisher's Straightes' as if they offered clear sailing from the Atlantic to Pacific (see fig. 10). To this rather high hope the English added the expectation that they might discover, along the way to the Orient, something of value. The ultimate prize would be the resource that the English enviously associated with Spanish America: precious metals.[3]

At the time, gold and jewels were associated with hot climates – Europeans thought that the earth nourished such treasures only when subjected to the sun's greatest heat. Yet the English hoped that Meta Incognita's unknown qualities might include an unexpected ability to produce precious metals. During an initial English reconnaisance of an island later called Kodlunarn, the explorers determined that the native rock contained gold ore. A party returned in force, in 1577, to dig up more ore. Then a final party of 1578 established a mining camp at the island, a projected 'hundred man colony' that was intended to stay through the winter. During 1577 and 1578, at seven different sites, the miners extracted over 1500 tons of what they thought was gold ore and shipped it back to England. Astonishingly, the 1578 voyage was the largest and most elaborate Arctic expedition that would take place until the twentieth century. It required 397 men on fifteen ships – the single largest fleet in the history of European maritime exploration.[4]

White seemed to have joined the 1577 venture, one of at least five voyages he made to America. In the Arctic he may have executed several watercolours of the Inuit; if so, most of these are now lost. One copy of an Arctic scene survives but only two originals, a pair of portraits, have been preserved (see pp. 164–9). Their subjects were an unrelated man and woman (with her infant) whom Frobisher had kidnapped. He took them back to England, proof of the newfound peoples who lived in Meta Incognita. All three of the Inuit perished before they could be exhibited to Elizabeth, who greatly regretted not seeing them.[5]

White's portraits were exceptional. In their detail and their sympathetic portrayal, they are unlike the generally hostile attitudes toward the native inhabitants of the Arctic that the English had shown in their written accounts of the Frobisher and Davis expeditions. The English generally believed that the Inuit were barely human – they exhibited little of the ability to transform nature through artifice or technology that Europeans thought was characteristic of humankind. Several observers denied that the Inuit could manufacture clothing and shelter against the Arctic winter; they believed, instead, that the natives must migrate south during the winter. Some accounts implied that the local people were barely different from animals; they would 'eate their meate all rawe', would consume grass undressed with the salt or oil with which Europeans seasoned their salads, and would suck ice rather than drink water.[6]

It is possible that the English thought so little of the Inuit because they saw no use for them. The ships that supplied Kodlunarn had brought everything that the mining camp could possibly need: food, tools, clothing, prefabricated houses, alchemical instruments, raw materials, and, above all, skilled personnel. The final

voyage of 1578 brought fishermen, assayers, bakers, cooks, religious ministers, and musicians. To a large extent this cautious preparation again indicated the English conviction that the land they were entering offered nothing but the gold they sought. Even had tiny Kodlunarn swarmed with animals, the English did not know how to track Arctic creatures. Nor could they manipulate the kayaks and darts that the Inuit had mastered for their hunting and fishing. Above all, the far-northern place had no timber, the essential element for much of European material life. It was for that reason, and at great expense, that the English brought all necessary supplies with them, from shoes to assay cupels, from timber to coal.[7]

It was a gamble, and a bad one. Kodlunarn's ore turned out to be quite free of gold. Competing mineralogical experts gave competing opinions about the Arctic rock until the venture's backers could no longer insist that the most hopeful assays were correct. A series of bitter lawsuits attempted to determine culpability. In the end, almost everyone but the Queen (who was carefully shielded from personal loss) had reason to regret his or her investment in the mine. Losses were spectacular. It was a national embarassment. The Spanish knew exactly what was going on – they had even supplied an undercover spy for the third and final English voyage to Kodlunarn, and the man confirmed that the English venture was no threat to Spanish pre-eminence in the New World.[8]

On to Roanoke, where the English would find a better climate, though it came at the price of closer proximity to Spanish settlements. The warmer colony would, however, require closer assessment of the land and natives, and that would allow John White greater scope for observation of North America's native peoples.

Roanoke in Virginia

After the Kodlunarn bubble burst, English colonization would never be the same. Elizabeth was understandably wary about investing in overseas ventures. Her successors were rarely bolder. Ever after, English settlement of the New World would be done on the cheap, meaning it would depend on individual and corporate investment, not that of the monarch. The Crown usually did little more than grant rights to settle and trade in given portions of the Americas, then left things to whoever took the risk of the actual trade and settlement.[9] This new and thrifty manner of colonization made it necessary for the interested parties to sing the praises of their chosen territories and their schemes for developing them – why else would potential settlers and investors take the plunge? The promotional tone was immediately apparent in the plans that would establish Roanoke, and would eventually be present in John White's watercolours.

One result was England's most famous piece of colonizing propaganda, Richard Hakluyt the younger's *Discourse of Western Planting*. Hakluyt wrote his 1584 essay to woo the reluctant Queen. At the start of his plea, he listed twenty-one reasons for Elizabeth to continue her support of ventures into the new lands. Many of these were meant to challenge 'the king of Spayne'. Some were meant to continue what little had been accomplished with the Arctic ventures, as with a renewed search for

'the Northwest passage'. But Hakluyt stressed a new goal, the actual settlement or *planting* of English people in America. Only a permanent English presence in North America would deter Spanish encroachment and would guarantee the flow of American commodities back to England. Settlement would also provide work for various classes of English people and would give vent to English manufactures, which colonists would need to import.[10]

Elizabeth did support the Roanoke venture, but barely. She made no investment herself in the colony. It took a total of seven voyages to Virginia to explore the region, find a site worth colonizing, and then send out sequential groups of colonizers. But the numbers of ships and people sent to Roanoke did not approach the totals sent to Kodlunarn. And it was clear from the outset that the colony would have to support itself – the many ships and hundreds of men that had brought supplies to the Arctic would never service Virginia. The settlers needed to secure food and other materials on the ground, yet were still expected to find some lucrative commodities (preferably gold) to repay the colony's investors.

The result was a view of the land and its peoples far different from the one the English had had of the Arctic. It was vital for Virginia to be highly productive and its native inhabitants welcoming. It had to be – how else would colonists survive? Two men who went to Roanoke, John White and Thomas Harriot, would be instrumental in creating this picture, White with visual images and Harriot with a verbal narrative, *A briefe and true report of the new found land of Virginia.*

White's watercolours of Roanoke, and its people, the Roanoke or Secotan, stress the natural abundance that would let the English survive, even flourish. His illustrations fall into four rough categories: portraits, scenes, creatures and maps.

The portraits were probably just that – images of particular individuals. This was, after all, what White had done in his two images of the kidnapped Inuit, when he had painted actual people. It is also possible that he added details to these portraits in order to represent more broadly the native way of life; the specific tattoos, ornaments, and implements may have given a composite image of the Roanoke. What was that image?

His subjects' clothing emphasized the warmth of the climate at Roanoke. The Indians are stark contrasts to the bundled Inuit, and the contrast is telling. Two men do wear cloaks, including an old man in a long, fringed garment and a priest in a hip-length capelet. But the other men, women and children are much more lightly clothed. The adults wear something that covers them below the waist, but nothing above. The bare legs and chests made them immediately different from Europeans. This was in part a convention about savage people, whom Europeans regarded as *naked*, whether literally unclothed or simply lacking in civilized amenities.[11]

But White's portraits do not imply any patronizing assessment of the Indians. His subjects seem, instead, comfortable in their own skins, and in the few animal skins adequate to protect them in a climate very unlike that around Kodlunarn. However they actually stood while White sketched them, some of their postures were conventions of European portraiture. The men stand with careless elegance, many of them hand on hip, a pose reminiscent of the high-status men in European paintings.

The women have more modest deportment, yet unselfconsciously meet the viewer's gaze. One woman covers her bare breasts with her upraised arms, but another folds her arms in a way that frames and accentuates her breasts.[12] All have clear, direct gazes; many are smiling; some appear to be laughing or talking.

The Indians are likewise equipped with a remarkable range of props. One native woman carries a large gourd and slings her other wrist casually through the multiple strands of beads that hang from her neck. A man leans on his bow, as tall as himself, and has a quiver over one shoulder as well as a brace on his left wrist, which would have helped him grip the bow with greater strength as he drew back its string and would protect his wrist from the impact of the released string. A conjuror has a pouch tucked under his belt. Nearly all the subjects wear ornaments: necklaces, headbands, earrings, ties or feathers in their hair. Ethnohistorians have been grateful to White for depicting so many southern Algonquian ornaments, containers, rattles and tools.[13]

White had his own reasons for painting these objects. The things the Indians carry give a sense of their admirable status as tool makers. They are capable of the kind of artifice that distinguished humans from animals and made them similar to the English. Consider the man who carries a bow (no. 13). His bow and the brace on his wrist were very much like the classic longbow and vambrance or brace an English bowman used. The image would have reminded any English person looking at it of the similarity between English soldiers and Indian warriors, a similarity that survived the gunpowder revolution of the late Middle Ages. The English had of course adopted firearms. But those weapons cost a great deal and were not as accurate as bows and arrows. For those and other reasons, they had yet to replace bows and arrows in English militia units. Likewise, the Roanoke colonizers brought an intriguing mix of weapons with them, four hundred firearms and 150 bows, the latter slightly over a quarter of the total number of portable weapons in the colony.[14]

All those inexpensive bows indicated the new penny-pinching regime for American colonies. Yet they were also reminders of English pride and nostalgia over their national prowess as archers. National memory of how archers had defeated the French at Agincourt was but one example of English nostalgia over their hardy, bow-bearing past. With that in mind, they could hardly scoff at the similarly armed Indians.[15]

White underscored the nostalgia when he included, among his watercolours, three of Picts and two of ancient Britons (nos 30–34). These remote ancestors of the English are all painted blue and all carry weapons, even the women. The Picts are also painted, over their entire bodies, with elaborate designs and are naked but for necklets and girdles about their waists. In contrast, the Roanoke Indians' clothing and only partial tattooing make them seem quite tame. The fact that the ancient British woman carries a pike and sword, while Roanoke women carry domestic implements and children, also showed White's assumption that the Indians were somewhat more civil than his national ancestors. Above all, the fact that none of these blue-painted ancestors carried bows, which the Indians did have, was a subtle compliment, acknowledgement of Indians' clever discovery and exploitation of a weapon the English still admired.

The materials that the Indians used to make their weapons and tools was further evidence, as far as the English observers were concerned, of the resources available in Virginia. Wood is plentiful – the watercolours include images of no fewer than eight wood-burning fires. Fur, leather, shell, clay, horn, stone, vegetable fibres and wood appear in multiple forms. White used his brush to pick out the details of beading on the edges of garments and of the woven texture of mats. And in one portrait, of a 'chiefe', the man wears a large rectangle of copper on a cord around his neck (fig 30; see no. 21). That was an important detail. Copper was not quite the gold that the English still hoped to find in Virginia. But it was intriguing evidence that the Chesapeake had at least one readily available form of metal, and that its people could find, trade, and work in that metal.

Above all these devices is a general statement: these people are handy. Harriot made the same claim in his report on Virginia. 'They seeme very ingenious,' he concluded. Even without European tools and crafts, 'they shewe excellencie of wit'. Harriot also supported White's point that the natives had copper and related that they got it from people 'that dwell farther into the countrey' where the mountains held mineral resources.[16]

Indians' usefulness and industry are also apparent in the scenes White depicted. These were elaborate visions that opened out for English spectators a panorama of native life, as if they watched different scenes upon a stage. The scene with the village of Pomeiooc includes nineteen houses, all covered with mats or bark, the whole enclosed by a circle of upright poles that form a protective wall (fig. 29; see no. 9). Toward the upper left, one man is busy splitting lengths of wood with an axe; another seems to be carrying away the results. A man with a tame dog is just above them; below the central fire, a man stands with a bow. Anyone who is not working is sociable. A group sits around the fire, engaged in conversation. Other Indians who are standing have their hands raised in greeting or exclamatory gesture. The overall impression is of a village one would not mind entering and filled with people one would not mind meeting.

A scene of the village of Secotan is even more elaborate (fig. 31; see no. 8). The houses are arranged along a central lane. On the left side, trees indicate uncleared land; on the right is land cleared for planting. White in fact shows three plantings of corn. At the bottom was 'Corne newly sprong', above that, 'greene corne' and above that 'Their rype corne'. In that final field a child is hidden on a platform, ready to scare birds or other animals that might nibble the grain. Throughout the village,

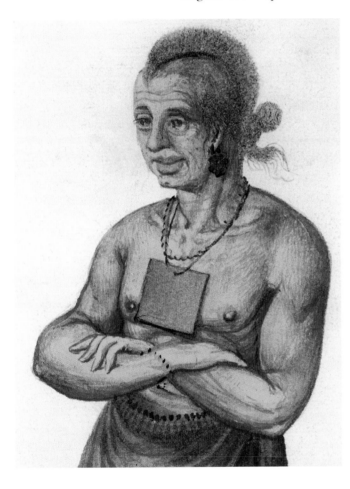

30. *Portrait of a 'werowance' or chief (possibly Wingina), c.1585. Watercolour with bodycolour and gold, by John White. Detail of no. 21*

57

other people are busy in several tasks. Some pray around a fire in the lower left. Opposite them, others dance while observers or resting dancers sit in a line extending outward across the lane. Above the line of sitters, some people gather around a mat that holds platters of food. The clearings and structures are further evidence of Indian ability to transform their environment, turning natural resources into palisades, habitations and productive farm sites.

White also represented the Indians as if they were performing for an audience. One such image is actually a close-up of part of the painting of the village of Secotan (no. 11). It shows Indian men and women who dance around carved posts set into a circle. Three women embrace around the central post while fourteen men and women dance around the outer circle of posts. Most of them shake rattles as they dance. Two men also brandish arrows. Many flourish branches of a plant and the two men at the bottom centre seem to be exchanging one such branch. What is the ceremony they enact? White's watercolour of the village has an inscription which claims that the Indians are offering 'prayers' with 'strange' gestures and songs. This circle is, then, a counterpart to the smaller one across the village lane, which White designates as a 'place of solemne prayer'.

In all this there is a remarkable emphasis on the productivity of the land, and on food, especially food. Those three cornfields in Secotan are the most obvious indication of English fascination with Indian edibles. White also painted a group of men fishing in a helpfully labelled 'Cannow' or canoe; the water beneath them is clear enough to reveal the teeming variety of fish available in the area (no. 7). The

31. *The town of Secotan*, c.1585. Watercolour with bodycolour and gold, by John White. Detail of no. 8

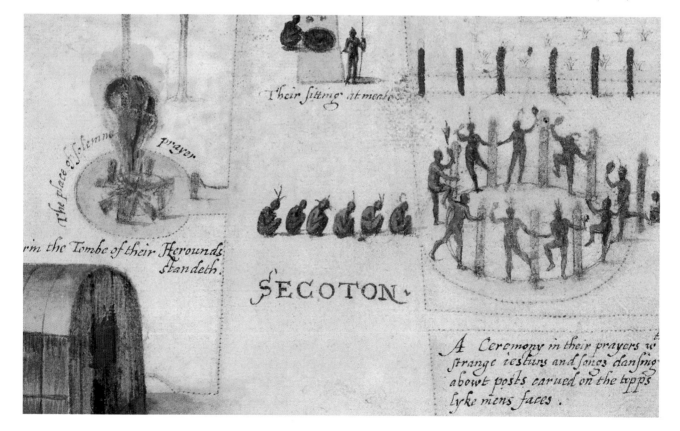

bottom of the canoe is filled with fish and the two men in the centre of the vessel seem already to be cooking or smoking them. Another canoe is plying the waters in the distance. Between the two craft two other men spear fish and, to the left, an elaborate fish trap has caught still more prey. Fish and shellfish swarm up to the very bank, on which White has painted plants. Birds hover in the skies above. Every inch of the scene contains something to indicate the land's plenty.

And then there are the close-ups of food being cooked. In one image stew is boiling in an earthenware pot; a corncob juts above the seething mass, which may have been a south-eastern version of succotash (no. 42). In another watercolor, two fish broil over a grill and two others are smoked alongside (no. 43). Then, the payoff: a man and woman eat, sharing a platter of food between them while seated on a mat (no. 24). It must have been reassuring for the English at Roanoke to think of the locals in this way, as resourceful denizens of a productive landscape. Again, the contrast with the Inuit is striking. If the Inuit ate their meat and fish raw and sucked ice rather than drink water, Virginia's Indians cooked their food and served it up in a manner the English would have regarded as primitive, but civil none the less. The stewpot, grill, platter and clean mat on which eaters can sit were all evidence that Indians could offer a life similar to that which the lower classes had in England.

A more important message is clear. The Indians can easily feed themselves, and perhaps the newcomers as well. Harriot shared White's optimism. He speculated that the Indians could plant and harvest two crops of corn per year. And he thought one Englishman could, in twenty-four hours, clear and plant enough corn to feed himself for a year. (The assumption was that an Englishman could do much more, with metal tools, than an Indian woman could do with her shell hoe and wooden digging stick.) On that basis, Harriot concluded that the land could hold many more people than it currently did – meaning that English people could easily insert themselves into the landscape.[17]

It was wildly optimistic. Virginia's growing season was not long enough for double cropping, let alone the three successive crops White had implied when he painted distinct stages of corn cultivation into the village of Secotan. And the English settlers had managed to arrive in Virginia during one of that region's worst-known droughts. Scholars who have examined the sizes of tree rings around Roanoke have concluded that the average annual rainfall in the late sixteenth and early seventeenth centuries was well below the norm. That meant the Indians had almost no food to spare and were probably frantic to conceal their supplies from the invaders. Harriot even noted at one point that 'their corne began to wither by reason of a drougth which happened extraordinarily'. But his observation did not dampen his and White's enthusiasm for the productive capacity of the land and of the people who worked it.[18]

If anything, White's evidence about the size of the population around Roanoke was contradictory. Was there plenty of room for the English? What if the English settlers were to increase their own numbers? White would have reason to appreciate the question – his granddaughter, Virginia Dare, was the first English child born in North America. Yet she was not the only child in the area. It is striking how many of

White's images include infants and children. The smaller figures in the village of Pomeiooc indicate the presence of youngsters; among the portraits, one woman carries an infant and one is accompanied by her small daughter. Although several of the Roanoke men are described or depicted as old (they have lined foreheads), all of the women are young enough to be of childbearing age (they have firm breasts). The women are as fertile, White implies, as the land on which they live. This imagery would have reassured the English that Virginia was healthy and its people fecund – both promises that the English would likewise thrive and increase there.

White also represented Indian deaths, though not in a way that undercut his prevailing emphasis on fertility. One of his paintings is of an Indian charnel house, where bodies are lined up in a row (no. 10). Because the preserved bodies were only of chiefs, adult male notables, their accumulation gives no evidence of overall death rates among Indians. Instead, the implication is that the children and young adults are thriving, offset only slightly by natural deaths among the elderly. White quite definitely wanted to portray the Indians – walking indicators of Virginia's healthfulness – as sturdy and reproducing, with a birth rate able to offset the deaths among older people. But that raised the possibility that the natives of the place might be increasing, and would therefore have plans of their own for the land the English thought they could easily enter and cultivate.

White (and Harriot) also represented what would have been, to English eyes, some less attractive features of the Roanoke natives. Most significant, they were not Christian. The ceremony in which they dance would have struck the English as idolatrous – why did prayer need dance of any kind, and why should it be done around carved images? Protestants would have accepted neither rhythmic bodily motion nor ceremonial idols as conducive to a truly Christian form of worship. Then there is the portrait of 'One of their Religious men' and one of 'The Flyer' or conjuror (nos 15, 17). Each man was a facilitator of idolatry, an indication that, in Roanoke villages, sin was organized and systematic.

Even more disturbing was the charnel house, shown as part of Secoton village and then in another of White's 'close-ups'. In the close-up, the mats that would ordinarily cover the charnel house are rolled back, revealing the flayed and dried remains of the 'cheife personages' who merited such preservation (no. 10). To the side of the mummified bodies sits an idol. 'Theire Kywash which is an Image of woode keeping the deade' is a life-size manikin, clothed and hatted, which sits with hands on knees. It was graphic evidence, for the English, of Indians' lack of true religion. Whatever the Roanoke natives' cleverness at making a way of life in Virginia, their idolatry revealed their clear inferiority to the English. In this, they would be not partners to the colonizers but objects of their religious solicitude. Harriot said as much when he conceded that the Indians had some religion, 'although it be farre from the truth', which would make it possible for their beliefs to be 'reformed' by the Protestant English.[19]

On a more reassuring note, White stressed the abundance of America in the studies he did of its natural products. His was an early English contribution to a long European tradition of cataloging natural phenomena. White's illustrations fell into

several distinct categories. There are sixteen images of fish and shellfish, and six plants or fruits, including a pineapple, a mammee apple, and a horn plantain, the latter possibly the first European depiction of that fruit. There are eight birds, six insects (including two versions of a swallowtail butterfly), and five reptiles, the latter including snakes, turtles, and an iguana. Many of these drawings were made in the West Indies on the way to 'Virginia' but there were others, of North Carolina fish and birds, of which we now have only copies (see pp. 230–33). If White painted mammals, these images are also now lost. Many of these pictures record varieties of things unfamiliar to an English audience – they are novelties or marvels. Again, however, there may have been a more practical intention. At least thirteen of these plants or creatures would have been considered, by the English, to be edible; the Indians ate still more of them, including alligator and iguana.[20]

Finally, White gave several maps or topographical representations (nos 2-6). (It is possible that he had trained as a surveyor – he had a good map-making eye.[21]) He began with two depictions of English fortifications on Puerto Rico, a painstaking overview of English efforts to protect themselves on an island too near the Spanish for comfort. With Thomas Harriot, he then surveyed the south-eastern coast of North America, from Florida up to Chesapeake Bay. Another map was a close-up of the Virginia coastline itself. No fortifications are present here, though the barrier islands or Outer Banks, as they would later be named, protect against intruders who would, if approaching by sea, have to pick their way through the small inlets between the islands. That was the only way to approach Roanoke, the fatter, interior island, which White indicated by colouring it pink.

Would the Indians also help protect the English from the Spanish? White did hint at their military capacity. The palisade around Pomeiooc showed their protection of themselves, as did their weapons, including their bows and arrows. Harriot was not so sanguine. The natives lacked iron or steel, he observed, and had weapons made of mere wood. In any case, their ability to make war was ambiguous. Were the Roanoke natives equipped against English invaders or against a possible, shared Spanish foe? Were there less friendly and helpful Indians in the interior, enemies of the Roanoke natives and perhaps also of the English? Neither White nor Harriot gave a clear answer.[22]

INVISIBLE COLONISTS

It is hard to determine where the English fit into the picture for the simple reason that White did not put them in his pictures. The colonists were interacting – peacefully, violently, neutrally – with the Indians, but you would never know it from White's watercolours. That may have been the case because many of the interactions were so violent, something that clearly undercut all the hopes for a peaceful reception. White had admitted the hazard when he recorded how the Inuit violently rebuffed the English in the Arctic. A copy of one of White's now lost images from the Arctic shows a skirmish between the natives and the English (p. 164). The former shoot arrows down from a cliff, below which the English return fire from a boat. It

could easily have described many of the interactions around Roanoke, where the English and Indians were, after several fatal encounters, in a wary standoff. For White to have painted such an episode would have put the lie to all the rest of his images.[23]

White's work is in this regard quite different from that of several contemporaries who represented American colonies. Both Jacques Le Moyne de Morgues and the anonymous artists of the Drake Manuscript, 'Histoire Naturelle des Indes', produced images in the late sixteenth century, around the time White did his, and White had seen copies of Le Moyne's work. Le Moyne had accompanied a party of Huguenots, French Protestants, on a doomed settlement to Florida. The Drake Manuscript had been executed to illustrate some parts of the Caribbean and North America around the time of Drake's 1577–8 circumnavigation (see fig. 41). Both sets of images show natives and Europeans interacting. One image based on Le Moyne, for example, depicts a native man showing expedition leader Laudonnière a column erected by earlier French explorer Ribault; groups of Indians and Frenchmen watch the scene (see p. 132). Several of the Drake Manuscript's images show Europeans, and two show them together with Indians. Comparable scenes are absent from White's portfolio, even though interaction between the Indians and the English did in fact occur.[24]

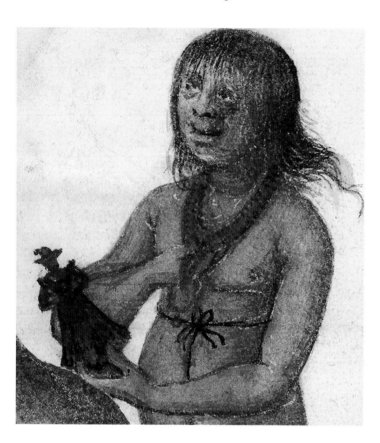

32. *The daughter of a 'werowance' or chief of Pomeiooc*, c.1585. Watercolour with bodycolour and gold, by John White, detail. She is showing her mother a European doll and necklace possibly of red glass beads with a gold pendant. Detail of no. 14

Harriot gave a much better sense of that interaction – and of reasons why White shied from portraying it. Harriot claimed that any Indian town that had made 'any subtile deuise … against us' would invariably suffer. 'Within a few dayes after our departure from euerie such towne, the people began to die very fast, and many in short space.' Even worse, the malady 'was so strange, that they neither knew what it was, nor how to cure it'. Though Harriot did not make a connection between the English presence and the arrival of diseases unfamiliar to Indians, the Indians did. They suspected, he claimed, that the English had shot them with 'inuisible bullets' in order to make them ill with something their own physicians could not cure. In a few sentences, Harriot had identified the constant fear and animosity that accompanied Anglo-Indian interaction, a dark undercurrent that ran through all narrative accounts but was remarkably absent from White's illustrations. Which are more striking: Harriot's invisible bullets or White's invisible colonists?[25]

White painted only one clue to the English presence among the Roanoke Indians. It was a characteristically cheerful detail. In the image of a Roanoke woman

and her daughter, the girl carries a toy, a doll in English clothing – the doll's Elizabethan ruff is the giveaway (fig. 32; see no. 14). As with many of the details in White's watercolours, the meaning is not immediately clear. Why this small indication that the Indians were no longer alone in Virginia? Perhaps it was a sign that White and the other colonizers expected the Indians to come to resemble them. That would have matched the plans to evangelize the Indians, to convert them to English religion. English missionaries would always want the Indians to renounce many of their customs, the idolatrous dancing, the multiple wives, the semi-migratory way of life, the lack of clothing. The girl who carries the doll is a miniature version of her mother, down to her strands of beads and her hand upon them. But the doll is a miniature version, perhaps, of what the English expected her to grow up to be – an Englishwoman, quite unlike her mother.

That may not have been what the girl herself wanted, but her independent wishes, indeed her reactions to whoever gave her the doll, are nowhere present in White's work. He had presented Indians as he wanted them to be, not as they were. Had he wanted to portray the complexity of colonization, he would have presented the other actors in the drama: the English, including himself.

White's decision to separate spectators and spectacle paralleled a change in the way the English were portraying their colonial footholds in Ireland. In 1581 John Derricke had, in his *Image of Ireland*, shown the invaders and the natives in violent contact: the English make war on the Irish, take them captive and bear their heads on pikes. By 1611, when John Speed published his *Theatre of the Empire of Great Britain*, the violence takes place off stage. The Irish instead appear in the kind of costumed portraits that White created of the Roanoke Indians; their towns appear as panoramas or maps, peaceful cityscapes rather than embattled territories. It is an intriguing possibility that White may have come from Anglo-Irish stock. His possible knowledge of Irish affairs, and the way that his images signalled a new view of English colonization, indicate that England's Irish and Virginia incursions had fruitful interplay.[26]

White shows the Indians as if they were actors in a drama that the English watched – appreciatively. His experience with dramatic presentations in London had had an unintended outcome. Virginia's Indians are allowed to walk on stage only when they agree to arrange smiles on their faces or hold food in their hands. That the Roanoke Indians were 'counterfeited according to the truth' made them counterfeit versions of their real selves. But the truth was that they were entirely consistent with English expectations for England's first American colony. From Roanoke onward, authorities in England (later Britain) would expect colonization to be done inexpensively and at the risk of private individuals or corporations. Those people and companies would always regard land – land depopulated of Indians – as a significant imperial prize. Indians would be useful, up to a point, and only if they fit easily into the colonizing venture. As in Ireland, and in contrast to other European New World empires, settlers kept their distance from the natives. We see Roanoke's Indians alone with themselves. It was a falsehood yet also, quite sadly, entirely true.[27]

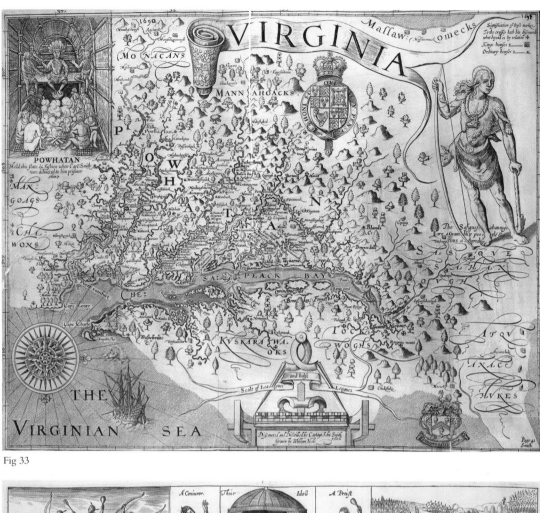

Fig 33

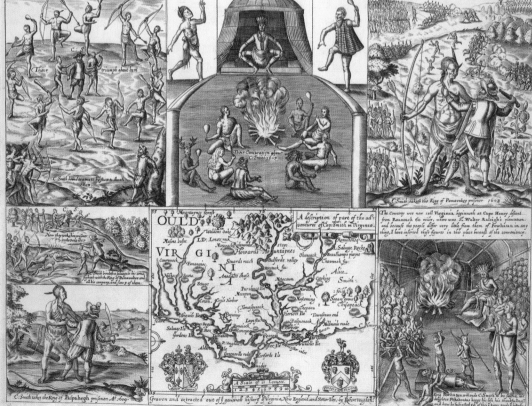

Fig 34

CHAPTER 5
JOHN WHITE'S NEW WORLD

CHRISTIAN F. FEEST

33. *Virginia*, 1612. Engraving by William Hole, based on John Smith's 1608 account and manuscript chart, published with the account in 1612 as *A Map of Virginia*. This area around the Chesapeake was Powhatan's territory and is where White intended to establish his colony. Roanoke is off the map to the left but Jamestown and over two hundred Indian settlements are visible. By permission of The British Library, London (G.7037)

34. *Ould Virginia and various episodes*, from John Smith's *The generall historie of Virginia, New England, and the Sumer Isles*,1624. Engraving by Robert Vaughan. The map and all of the Indian figures illustrating Smith's 1607–9 adventures in Virginia are based on the engravings by de Bry in his 1590 edition of Harriot's *Briefe and true report*. By permission of The British Library (G.7037)

Among the artists who shaped the image of the New World and its indigenous inhabitants, John White holds a special place.[1] Through the engravings published in 1590 by Theodor de Bry[2] of his striking visual record of the Algonquian-speaking peoples of Sir Walter Raleigh's 'Virginia' in present-day coastal North Carolina, White contributed to the emerging European perception of American 'otherness' like few other artists working before the nineteenth century. After the rediscovery of his original watercolour drawings, commentators with rare unanimity agreed on the unusually convincing nature of his ethnographic representations, especially when compared to the heavily European-ized features encountered in the works of others.

In order for us to appreciate his contribution fully, White's work first needs to be placed in the context of the early history of ethnographic illustration. This genre emerged during the century following the European discovery of a 'New World' beyond the Atlantic and the associated prominence of a new humanist discourse on alterity and identity. In its early stage it was characterized by the creation of visual conventions and categories of cataloguing and representing cultural difference in the form of illustrated travel accounts, costume books, cosmographies, maps etc., in part by the same artists who set similar standards for illustrating botanical and zoological specimens.[3] This process was accelerated by the diffusion and multiplication of images through the printing press, particularly new techniques of mechanical reproduction from woodcut to copperplate engraving.[4] We can then consider in detail John White's role as ethnographer and documentary artist especially of coastal North Carolina in the 1580s and assess his legacy for European traditions of ethnographic representation, in the fields of both iconography and composition.

ETHNOGRAPHIC ILLUSTRATIONS OF THE AMERICAS BEFORE JOHN WHITE

While the unexpected encounter with the Americas had a significant influence on the European perception of itself and others during the Early Modern Age, it was far from being the only impetus for the prefiguration of the as yet unborn and unnamed discipline of ethnology or cultural anthropology.[5] The rediscovery of classical antiquity from the 'perspective distance' of the Renaissance and the

increased secular mobility (as opposed to the spiritual pilgrimage dominant in the Middle Ages) between the urban centres of Europe encouraged a new curiosity about differences across time and space within the framework of socialization and integration of knowledge. The mid sixteenth century saw the emergence of a new discipline – *ars* or *methodus apodemica* – dealing with the methodology of travel – which encouraged the observation and recording of the unusual and outstanding in the form of chronological travel narratives and the systematic analysis of these observations under categorical headings. The method combined the production of two complementary kinds of text: one that was empirical and specifically tied to events in time and space, and another that was broadly comparative and accumulative.[6] Among the texts relating to the Roanoke voyages, Ralph Lane's 'Discourse on the First Colony' (1589)[7] represents the event-driven narrative, whereas Thomas Harriot's *Briefe and true report* (1588)[8] supplies the summary account. But for obvious reasons this neat separation is somewhat misleading, since generalizations depend upon specific observations, and the narratives are in constant need of new concepts to describe new realities.

The same observation may be made with regard to sixteenth-century ethnographic illustrations in general and images of the New World in particular.[9] Most of the early and often rather crude woodcuts illustrating the European discoveries across the Atlantic Ocean were produced by artists without the benefit of personal acquaintance with American realities. Native peoples were depicted according to prevailing notions about domestic 'others' (such as the hairy and ferocious Wild Men of medieval thought)[10] or the blemmiae, one-legged or dog-headed monsters reported by John Mandeville as inhabiting the far corners of the known world. Local colour is supplied by the addition of increasingly stereotypic ethnographic details, especially feather ornaments, weapons and references to cannibalism, mostly derived from encounters with the Tupinambá, a group of related tribes living along the northern and central coasts of eastern Brazil and belonging to the Tupi-Guaraní language family.[11] The same is true of Albrecht Dürer's 1515 drawing of a young man dressed in Brazilian feather clothing[12] and two post-1519 drawings of armed American men (fig. 35) attributed to Hans Burgkmair the elder[13] as well as his 'People of Calicut' from the Triumph of Maximilian I (1526),[14] all of which depict actual transatlantic artefacts worn or carried by non-American (and sometimes bearded) men.

To avoid such disconcerting hybridity in the absence of reliable likenesses of

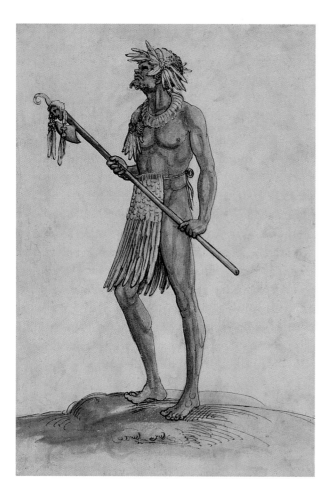

35. *Standing black man dressed in a feather skirt*, c.1520. Pen and ink drawing with grey, brown and green wash, by Hans Burgkmair the elder, based on knowledge of Tupinambá and their artefacts, but not an actual portrait. British Museum (P&D SL,5218.129)

aboriginal Americans, one solution was to show artefacts more or less isolated from their use. Gonzalo Fernández de Oviedo y Valdéz's *De la natural hystoria de las Indias* (1526, also known as the 'Sumario')[15] first followed this alternative by illustrating a hammock (fig. 36) and a fire drill and thus provided a model for illustrating cultural difference through artefacts – in a manner related to the decontextualized museum mode of representation.

The largest body of ethnographic illustrations from the Americas in the sixteenth century owes its origin to the activities of a German and two Frenchmen in Brazil in the 1550s and again relates to the Tupinambá, who were at that time actively involved in the struggle of the Portuguese and French for colonial domination of eastern Brazil. The sedentary Tupinambá, who in addition to hunting and fishing raised a variety of crops, such as manioc and corn, on slash-and-burn fields adjoining their villages made up of communal longhouses, attracted the particular attention of European observers and commentators because of their practice of ceremonial cannibalism.[16] Hans Staden, a Hessian mercenary in Portuguese service, was captured in 1553 by a group of Tupinambá and stayed with them for a year before being able to escape. Staden's published account of his captivity, combining a chronological narrative with an ethnographic summary of Tupinambá culture, was printed in 1557, illustrated with forty woodcuts based on his own rather poor yet interesting drawings.[17] The same year saw the publication of *Les Singularitez de la France Antarctique* by André Thevet[18] (the Franciscan cosmographer of the King of France, who had spent three months in 1555–6 in the ill-fated colony at the site of present-day Rio de Janeiro led by Nicolas Durand de Villegagnon), illustrated with seventeen engravings of ethnographic subject matter, which appear to reflect the efforts of the professional Flemish engravers at least as much as those of the original artist (fig. 37). Some of them were also adapted by Jean de Léry, a Calvinist member of the same colony, who published his own account in 1578. His images in turn were copied by John White (see pp. 226–7).

None of these works (nor in fact any ethnographic illustration relating to the Americas) had been published in England prior to the Frobisher and Roanoke voyages, although John White could have had access to them through Richard Hakluyt. The illustrations published in Léry (1578) are clearly reflected in White's versions, which creatively deviate from the published prints. The notion that the

drawings derive from a now lost source on which the prints were also based (rather than on the prints themselves) is not supported by any evidence or convincing arguments.[19] The absence of copies from any of the other works mentioned may indicate either that he was unaware of them or that had been especially introduced to Léry's book by someone like Jacque Le Moyne de Morgues, the Huguenot emigrant artist living in London, who had himself produced a still unpublished corpus of illustrations based on his experiences as a member of the short-lived French colony among the Timucua in northern Florida in 1564–5. Unfortunately, Le Moyne's ethnographic work is almost exclusively known from the engravings published in 1591 by Theodor de Bry,[20] in which the relative contributions of the artist and the engraver are often hard to tell apart. Ironically, by far the best indication of the quality of Le Moyne's drawings of indigenous Americans may be gleaned from two watercolour copies made from now lost originals by John White (nos 19–20).[21]

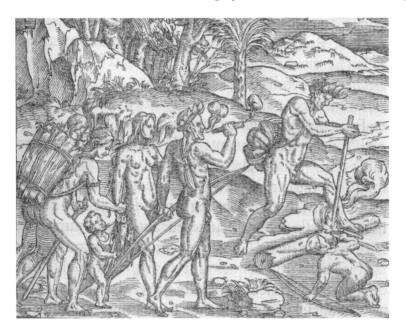

37. *Comme les Amériqains font feu ...*, 1557. Woodcut in André Thevet, *Les Singularitez de la France Antarctique*, Paris. Tupinambá women and children returning from fishing, man with bow and neck-worn knife case smoking a cigar, and drilling fire. By permission of The British Library (c.107.d.1)

The only other major visual contribution to the ethnography of the Americas published before 1590 was Girolamo Benzoni's *La Historia del mondo nvovo* (1565). In sixteen small woodcuts it illustrates a wide range of events and typical activities (such as water transportation, food preparation, fire making, healing, music and dance, architecture) of various indigenous peoples in Central and South America.[22]

To bring order to (and in fact extract from it) the knowledge embedded in the visual record of a widening world and the new experiences it offered to the curious, categories had to be created that would allow for systematic comparison. A genre of this kind which became popular during the second half of the sixteenth century was the 'book of costumes' in which man and/or women were shown in standardized poses. Focusing on the differences in the dresses reflecting local origin or social status of their wearers, the images suggested an implicit relationship between costume and custom (or between the two meanings of 'habit').[23] Although often based on the depiction of specific persons, the intention of these proto-ethnographic images (two centuries before the invention of the term 'ethnography') was the representation of generic types. While early books of costumes frequently focused on the different dress codes in the countries and cities of Europe, their usefulness for integrating the growing information about the peoples of the Americas quickly became apparent. The published books of costume by Deserpz (1562; fig. 38), Sluperius (1572), Weigel (1577), de Bruyn (1582), Amann (1586) and Vecellio (1590)[24] also featured American images adapted from the illustrated travel literature. John White probably became acquainted with this continental European

genre through his contacts with Protestant emigrants to England, and his watercolours include images not only of Pictish and ancient British men and women but also of Greek, Turkish, Tartar and Brazilian subjects in the manner of these books of costume (see nos 25–34).

In summarizing the increasingly specific production of ethnographic illustrations prior to John White, the emergence of several distinctive modes of representation may be observed. The depiction of decontextualized artefacts (as in the works of Oviedo and Staden) was about to develop into a separate genre in connection with illustrations published in catalogues of Kunstkammer-type collections, and even later in composite visual summaries of the material culture of specific peoples. Scenic representations of activities should be seen in connection with the gradual formulation of cultural categories, such as warfare, religion, subsistence (including the preparation and consumption of food), habitations and settlement patterns. In keeping with the genre of books of costumes, figures of individuals (men, women or families) focused on dress and other features that could be interpreted as symbolic of social status; very rarely (as in the case of Thevet's *Vrais Pourtraits*, a collection of the biographies of famous European and some non-European men) was an attempt made to portray outstanding individuals in exotic societies.[25] In ethnographic illustrations the curiosity aroused by the relational difference of cultural practices regarded as unusual by outside observers was mellowed by a desire to generalize these features as typical for the cultures to be represented and to domesticate them by means of western categories. Thus, Quoniambec, a leader of the cannibalistic Tupinambá, is transformed by Thevet into a naked, giant cannibal king, who nevertheless epitomizes the authority of the monarchy and makes him a worthy ally of the King of France. The ambivalence of such constructions is revealed by Léry's view of Tupinambá society as egalitarian, whereas its cannibalism compares favourably with the atrocities committed by the Catholic King of France against the Protestants.[26]

38. *La bresilienne*, 1562. Woodcut from François Deserps [Deserpz], *Recueil de la diversité des habits, qui sont de present en usage, tant es pays d'Europe, Asie, Affrique & Isles sauuages*, Paris. (Deserps and Deserpz may be misprints for Desprez/Despres.) Shows the carrying band in which the woman is transporting her child and a misplaced feather ornament (which should be above the buttocks). Based on a woodcut in Thevet. The Bodleian Library, University of Oxford (Douce CC 129 (2) G8r)

JOHN WHITE AND ETHNOGRAPHY

On the whole, John White's images of Baffin Island Inuit and of North Carolina Algonquians appear to be less obviously burdened by ideological concerns, although the latter especially may echo Arthur Barlowe's remark made in 1584 that the people of Roanoke Island 'liued after the manner of the golden age'.[27] Isolated representations of artefacts are absent in the corpus of his work (the two watercolours devoted to cooking were seen in relation to the plants and fish in the original layout of the album, see nos 42–3).[28] The almost encyclopaedic treatment of fishing methods, the two depictions of ceremonies, the charnel house, and the domestic dinner for two[29] are well-constructed and closely focused ethnographic vignettes. White's views of the two villages Secotan and Pomeiooc not only

represent two basic types, open and stockaded but were in fact the first realistic representations of American settlement patterns (rather than single habitations).[30]

Just as there is no convincing explanation why White chose to illustrate the specific cultural practices of the North Carolina Algonquians that he did, the absence of other equally important and readily observable subject matter is equally puzzling. Although he depicted single men, husband and wife, and women with children, no families are shown; Léry (whose work was known to White) provided a classic depiction of Tupinambá family life, conceivably as a symbol for the shared basic values and institutions of humanity even among cannibals. The absence in White's visual record of battles, combat and warfare, which were so much part of the colonial experience and so common in early illustrations of the peoples of the Americas, could be seen as propaganda suggesting the peacefulness of colonization. The inexplicability of the presence or absence of certain themes may ultimately be merely a reflection of the lack of a clearly defined canon of the emerging field of visual ethnographic representation.

What makes John White's drawings so unusual in their sixteenth-century ethnographic context, however, is the large proportion of images of individuals, distinguished by gender, age, rank and profession. This differentiation, however, generally stops short of focusing on the individual person, and prefers to interpret the differences as generic types, such as 'The flyer', 'One of their Religious men', 'The aged man in his winter garment', 'A cheife Herowans wife of Pomeoc', or 'One of the wyues of Wyngyno'. We know that the Baffin Island Inuit brought to England by Martin Frobisher were called Kalicho, Arnaq and Nutaaq. In White's pictures they are nameless, although others who presumably copied from him give their names.[31] White's practice of generification of individual portraits is directly opposed to Thevet's approach, who in *Vrais Pourtraits* assigned individual identities to basically generic portraits.[32] In a similar manner, a plate accompanying John Smith's *Generall Historie of Virginia* would later adapt images from de Bry's engravings after White to illustrate Smith's narration of his adventures in the Jamestown colony (fig. 34).[33]

Although it has been suggested that White's physiognomies were not accurate,[34] his drawings are nevertheless the closest we get to actual portraits of native inhabitants of the Americas in the sixteenth century and may, in fact, be depictions of specific individuals, rather than generalized 'types'. If 'A cheife Herowan' was in fact 'A cheiff Lorde of Roanoac', as the engraving suggests, it would be easy to identify him as Wingina (Pemisapan) of the written record.[35] On the generic level, the watercolours seem to fit Harriot's description of the facial features of the local women as having 'small eyes, plaine and flat noses, narrow foreheads, and broade mowths'.[36] Indeed, Hulton remarks that 'White's portrait studies … show considerable ability to convey the Indian cast of feature and the grave dignity of these individuals'.[37] This ability becomes especially obvious when White's watercolours are compared to de Bry's much more 'Europeanized' engraved versions. It may, in fact, be possible to attribute this greater accuracy to his lack of training as a portrait painter, which would have made it more difficult for him (as it did for others) to overcome the acquired assumptions about the basic anatomical structure of faces. In the absence of

independent images of his sitters, White's reliability as portraitist can be measured only in relation to the genre of ethnographic portraiture at large. Independent proof of White's gifts as an observer is supplied by the evidence from the body postures illustrated in his drawings, some of which are obviously not typical for Europe but are known from other parts of the world.[38]

Unfortunately, next to nothing is known about the circumstances surrounding the artist's work in coastal North Carolina. Pressure could hardly have been exerted on the members of prominent families or religious functionaries on Roanoke island and the adjacent mainland to have their pictures taken by White. The Croatoan Manteo, who had been to England and returned to help the English, probably played a role here as mediator. Especially from nineteenth-century accounts we learn about the awe and fear in which non-native artists and photographers were often held by Native Americans, who associated the ability to produce (and control) likenesses of human beings with supernatural power and magical practices. Sometimes portraiture was even suspected of causing soul loss, disease and even death.[39]

White's long-term success as an ethnographer appears to rest firmly on his ability to transform specific observations into recognizable 'types' (and/or on the ability of his audience to accept them as such for more than four centuries). Yet the question may reasonably be asked what they were 'typical' of in White's own time as well as today. In order to assess the significance of his work for our knowledge of the historical ethnography of eastern North America, it will be useful to look at the broader historical and ethnographic context of the 'New World' he encountered in the 1580s in coastal North Carolina, and to provide some background on his association with the Baffin Island Inuit.

In his search for a Northwest Passage to Asia, Martin Frobisher in 1576 and 1577 made brief and largely hostile contact with the Inuit of south-eastern Baffin Island – the earliest recorded encounter between Europeans and the small family bands of sea mammal hunters scattered along the rugged and inhospitable coasts of the island, whose life-ways were subsequently changed dramatically first by the rise and fall of commercial whaling and later by the rise and fall of trapping. These developments were accompanied by a substantial decline of the population through introduced diseases.[40]

A male captive taken to London in 1576 by Frobisher died after two weeks from a cold, but not before having been painted 'with his boat, and other furniture, both as he was in his own, and also in English apparel' by the Flemish painter Cornelis Ketel. None of the five versions produced by Ketel has survived, but two presumably derivative copies by two other Flemish artists, Lucas de Heere and Adriaen Coenen, give some impression of what they may have looked like.[41] In 1577 a man and a woman with a small child were taken hostage on two different occasions and also taken to England; all of them died within six weeks in Bristol; Ketel was again commissioned to paint them, but, since the surviving bills are only for the woman and child, he may have arrived in Bristol from London after the man's death. As in the case of the 1576 captive, none of Ketel's paintings has been preserved, but there are thirteen other surviving images that relate to them (with the man possibly represented by the 1576 captive). Two of these are watercolours by John White (nos

35–6), and three are copies after White, the rest being various engravings and drawings directly or indirectly derived from White's work. Whereas the possible relationship between White's watercolours and Ketel's paintings must remain in doubt, another watercolour copy after White depicts the 1577 fight between Frobisher and the Inuit (p. 164), and is generally thought to indicate that White had accompanied at least Frobisher's second voyage.[42]

If, however, White had been with Frobisher in 1577, he probably would not have had to copy the Inuit portraits by Ketel. The Flemish artist Coenen's claim that his drawing, which suspiciously looks like White's versions associated with the 1577 group of images, actually depicted the 1576 captive may have been mistaken. But if Coenen was right, the circumstantial evidence would turn against White having been in Baffin Island in 1577; it would also suggest that de Heere's drawing was not a copy after Ketel. If Coenen was wrong, either all known versions of the 1577 captive are ultimately based on White's work – or White himself may not have been on Baffin Island at all.

Despite these uncertainties, however, the visual record of the 1577 captives which has survived on the basis of John White's work (whether original or copied from Ketel) is of substantial value. Given the fact that most of our ethnographic knowledge of this region is based upon data collected between 1860 and 1884 and since 1960, any reliable information from other periods is of potential interest.[43] For the whole American Arctic, these images as realistic representations of Inuit and their material

39. *Warhafftige Contrafey einer wilden Frawen mit ire[m] Töchterlein* …, 1750. Woodcut and letterpress broadside by Hans Wolf Glaser, Nuremberg. By permission of The British Library (1750.c.2.4)

culture are preceded only by three versions of a broadside published in Germany in 1567 announcing the display of an Eskimo woman and child, most likely from Labrador (fig. 39).[44]

Sir Walter Raleigh's colony of 'Virginia' in the north–eastern part of present–day North Carolina was located in the territory of a group of culturally and linguistically related, but politically independent indigenous peoples.[45] Collectively designated today as 'North Carolina Algonquians', they were the southernmost speakers of the eastern branch of the Algonquian language family, which inhabited the tidewater region of the Atlantic coast all the way to the Canadian Maritimes. Speakers of Siouan and Iroquoian languages were their neighbours to the south and west,[46] and, while their cultures are poorly known, it appears that they shared with them and with their Algonquian relatives in Virginia[47] a regional cultural pattern

based upon a sedentary lifestyle in small villages adjoining to fields on which they raised corn, beans, squash and a few other domesticated plants (including a local variety of tobacco). Throughout the region hunting and the gathering of wild food plants provided a significant addition to their subsistence, whereas fishing and the use of other aquatic resources were obviously of greater importance in the tidewater region than in the hinterland. The local polities are best described as chiefdoms, in which the authority of hereditary leaders was legitimated through religious beliefs and practices centred on a priestly temple cult celebrating and reinforcing the special relationship of the ruling families to the supernatural world. In a broader view, this pattern was a marginal or provincial version of the Mississippian chiefdoms to the west and south, whose much larger urban centres were marked by monumental earthworks or 'mounds'. The Algonquians shared with the Mississippian chiefdoms, perhaps on a more modest level, distinctions of class based upon wealth and inheritance supported by a tributary system and other economic privileges governing the accumulation and redistribution of goods.

Thanks to the greater permanence of the Jamestown colony, we are much better informed about the cultural specifics especially in south-eastern Virginia, as well as about the rapid changes in the life-ways following the uprising of the indigenous populations against the colony in 1622 (and again in 1644). By contrast, very little is known about comparable changes in the seventeenth century in coastal North Carolina, where local aboriginal groups had also been greatly reduced in number by around 1700. Reservations established after 1648 in tidewater Virginia for what remained of the once powerful tribes provided the basis for the continued assertion of a separate identity into the twenty-first century. In the absence of similar institutions in coastal North Carolina, the indigenous remnants faded more quickly from public view. Epidemics, inter-tribal warfare, the effects of colonial domination and the resulting dislocation and amalgamation of villages and tribes have added to the difficulty of tracing the subsequent fate of the peoples immortalized in White's drawings and have promoted the proliferation of imaginative and often contradictory accounts of the fate not only of the 'Lost Colony' left behind on Roanoke island, but also of its Algonquian neighbours.[48] The record of indigenous cultures assembled during the early contact period, although relatively rich when compared with the subsequent centuries, is highly fragmentary and often difficult to interpret. Additional information may be gleaned from archaeology, especially when it pertains to the proto-historical period, but regrettably our information about coastal North Carolina from this source is particularly weak, because of both environmental conditions and limited research.

In terms of our knowledge of the historical ethnography (and especially of its material aspects, which are usually better represented in artefacts and images than in writing), John White's drawings pose a particular problem because nothing even vaguely comparable exists for the immediate and even wider neighbourhood. His exceptional status as a British ethnographic illustrator is underlined by the fact that his work remained unparalleled throughout the seventeenth and eighteenth centuries. Visual material of broadly comparable quality and quantity was at best

40. *Een jongheling uyt de virginis:
Eikintamino in the park with
animals and birds*, 1616.
Watercolour from Michael van
Meer *Album amicorum*. By
permission of Edinburgh
University Library. (La.III.283,
fol. 254v)

produced by French artists (such as Jacques Le Moyne in Florida or Louis Nicolas and others in New France)[49] or by an occasional German visitor.[50] The vast majority of images of the native inhabitants of coastal Virginia can be shown to have been derived from John White's drawings through the engravings published by Theodor de Bry in 1590.[51] Even the only Virginia Indian images of ethnographic interest not derived from this source, produced from life models taken to London in 1614 (compare fig. 40), betray the influence of the imagery created by John White.

For coastal North Carolina itself, there is only one other contemporary image of a native hunter, associated with Francis Drake's voyage of 1586 (fig. 41). Artistically inferior to White's work, the 'Hinde de Loranbec' closely parallels the clothing, hairstyle, tattoos, bow, arrow and quiver made of reeds depicted in White's 'The manner of their attire …' and the related plates in de Bry's volume.

Another nearly contemporary illustration sheds some light on a detail in John White's drawings (and more especially the engravings derived from them) that has been considered somewhat problematic by past commentators. It relates to the image of the 'Idol Kewasa' (or 'Kywash' in the rendering of the artist) dimly seen squatting in 'The Tombe of their Cherounes or cheife personages' and more prominently figured in a separate plate in 1590 (see p. 114), where the pointed hat of the drawing is rendered much like the Timucua hairstyle depicted in Le Moyne's drawings as copied by White. Although Thomas Harriot's caption to the plate also likens it to the 'heades of the people of Florida', Paul Hulton (among others) has suggested that this may have been the engraver's contribution to the composition (also suspect because of the domed shape of the tabernacle).[52] A very similar head, however, is illustrated in the 1626 edition of Lorenzo Pignoria's *Seconda parte delle Imagini de gli dei Indiani*, published as an appendix to a book about the gods of classical antiquity (fig. 42).[53] According to Pignoria, who on account of its 'beard'

compares it to an Egyptian image, the drawing was based on a presumably Mexican artefact in the Munich Kunstkammer, received as a gift from the Archbishop of Toledo; the 1598 Munich inventory, however, clearly describes it as 'A wooden head of an idol from Florida'.[54] Pignoria's picture indicates that de Bry's rendition of the head was not merely an interpolation by the engraver but that, in fact, such heads of idols existed in 'Florida' (in the broad meaning of the term common in the sixteenth century). While the similarity to the Timucua men's hairstyle now supports the view of a 'diffusion from the south',[55] it is not impossible that head could in fact have come to Europe as a result of the Spanish activities in the Chesapeake Bay area in 1560 and 1570–72.[56]

White's depiction of the charnel house, in which the deceased chiefs (*werowances*) were preserved, provides unique visual documentation of a more widespread practice.

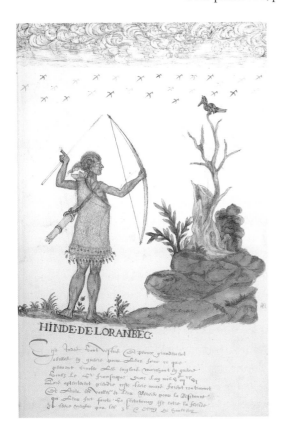

41. *Hinde de Loranbec*, c.1586. Watercolour from anonymous manuscript 'Histoire naturelle des Indes ("Drake Manuscript")'. The Pierpont Morgan Library, New York; Bequest of Miss Clara S. Peck (MA 3900, fol. 90)

It illustrates the treatment of the mortuary remains of the local upper class, while commoners were interred – a difference that would not be apparent from the archaeological record.[57]

Notably absent from John White's visual ethnographic record is any image relating to the drilling of fire, which since Fernández de Oviedo (1526) had been a frequent subject in the representation of the aboriginal inhabitants of the Americas (fig. 37).[58] But what at first appears to be an omission may turn out to be evidence for the absence of the practice. According to the written sources on early Virginia and North Carolina, throughout the area fire was made by the less spectacular mode of rubbing against one another two sticks held in the hands.[59]

White's depiction of men's and women's costumes may serve as an example for the value of his work for the ethnography of North America in general. Apart from what appear to be ceremonial dresses made of leaves and branches, two basic forms of skin dresses are shown in use by both sexes: rounded aprons suspended from a belt covering the genitals (and less commonly also the buttocks) of the wearer; and shirts (or 'mantels') of skins generally worn over the left shoulder (and, as shown clearly in 'Theire sitting at meate' and 'The aged man in his winter garment', sewn together at the right side of the body).[60] Both types were fringed and sometimes beaded at the lower edge.

Thomas Harriot's account merely mentions 'loose mantels of Deere skins, & aprons of the same round about their middles'; neither their shape, construction nor manner of wearing is described. With reference to the 'aged man', he claims that the mantles consisted of 'a large skinne which is tyed upon their shoulders on one side',[61] although White never shows such a tie or knot. 'Mantels' and aprons are likewise mentioned for the Virginia Algonquians, again without indication of shape, construction, and manner of wearing. At least one of the two Virginian men seen in London in 1614 (fig. 40) had their skin dresses tied over one shoulder. In the absence of adequate records it is impossible to state the distribution of these types of

garments. Among the Timucua of Florida (as seen in Le Moyne's drawings, pp. 132–5) and in other parts of the south-east, breechclouts passing between the legs, rather than aprons, were worn;[62] far to the north, in the St Lawrence River valley and the Great Lakes region, aprons were rectangular. There is only limited evidence for skin shirts worn over one shoulder anywhere in eastern North America, although cloth or feather mantas of this type are known from the American south-west and from Mexico.

JOHN WHITE'S VISUAL LEGACY

For nearly three centuries John White enjoyed an enormous, yet anonymous popularity. Although Theodor de Bry had given credit to the artist when publishing the engravings after White's watercolours in 1590, those who copied from de Bry were hardly interested in the original author. What attracted the compilers of books of costumes and other ethnographic summaries was their focused representation according to an underlying neat system of classification. Of de Bry's later volumes in his series on the Americas, only the work by Le Moyne proved to be similarly popular, although it contained fewer 'types' of individuals and many narrative rather than summarizing images.

42. *Head of an idol from 'Florida' in the Munich Kunstkammer (left centre) and comparative material,* 1626. Engraving in Lorenzo Pignoria's appendix, *Seconda parte delle Imagini de gli gei Indiani,* to Vincenzo Cartari's *Seconda Novissima Editione delle Imagini de gli dei delli Antichi,* Padua. By permission of The British Library (88.c.6, p. 562)

Since his own work was partly patterned upon the 'book of costumes' genre, it is not surprising that White's images themselves quickly found their way into such compilations, where they diversified the representation of the Americas which had so far been dominated by Brazil. Already in 1592, versions of 'A weroan or great Lorde of Virginia' and 'A cheiff Ladye of Pomeioc' were included in Piero Bertelli's *Diversarum nationum habitus* as a Virginian man and woman, with backgrounds taken from other plates in de Bry (fig. 50).[63] These images in turn were adapted in 1593 by Alexandro de Fabri.[64] Five years later, four of de Bry's plates after White made their entrance into Cesare Vecellio's *Habiti antichi, et moderni.*[65] Because of their convincing stylization as generic types, however, White's Virginians also came to be featured in other print forms, including maps, allegorical title pages of books and coats of arms, where they stood for American Indians at large.

The long-term use of these 'costume pictures' extended to the eighteenth[66] and nineteenth[67] centuries, which also illustrates the transition from 'books of costume' to 'comparative ethnology' (a discipline engaged in the cataloguing and explanation of the differences between the peoples of the world and their ways of life). In two related developments, 'books of costume' (and their sources) were mined for costumes to be worn at court feasts (fig. 43),[68] while in the 1640s Wenceslaus Hollar extracted from de Bry's plates two of White's images for a series of exotic portraits (see fig. 51).[69]

Other pictures that aroused enough interest to be used in different contexts were especially the ones relating to religious practices. The idol Kiwasa was reprinted

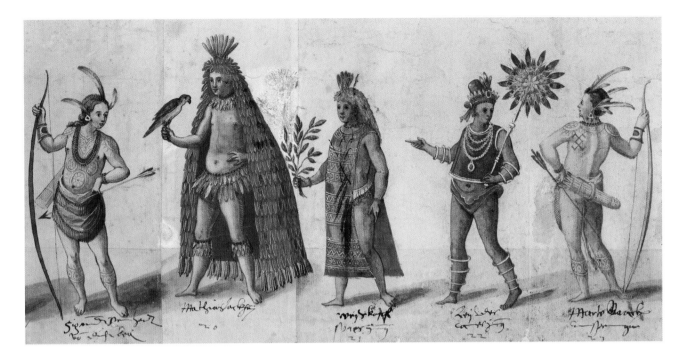

43. *Section from a group of drawings depicting a court parade in Stuttgart, c.1600. Pen and ink with watercolours, bodycolour and gold (410 × 298 mm, detail). The figures on the far left and right are derived from de Bry's engravings; another section features White's Pictish man. Stiftung Weimarer Klassik und Kunstsammlungen, Weimar (KK 205)*

outside its original context in 1597,[70] while a much broader range of images found its way into the same later compilations as the costume pictures.

One of the most significant developments, however, was the use of White's pictures (after de Bry) to illustrate the new Virginia founded at Jamestown in 1607. Almost all of the illustrative material printed during the early years of the colony was derived from White (figs 33, 34).[71] And towards the end of the first century of the colony, Robert Beverley's *History and Present State of Virginia* makes full use the whole body of de Bry's engravings.[72] Changes made to account for the difference in time and space were relatively minor, thus reinforcing the notion of a virtual identity of the native peoples of the 'old' and 'new' Virginia. The compilers of books of costume and later of ethnography never stopped to reflect upon the fact that the two colonies bearing the same name were indeed two different places.

It was by coincidence that Laurence Binyon published his first account of White's drawings in 1907, the year of the three hundredth anniversary of the Jamestown colony. In the same year David Bushnell used three of the drawings to illustrate his contribution to the commemoration of this event, thus reinforcing the trend established since the seventeenth century. Largely by default, partly by tradition, John White's pictures have thus become nearly synonymous with the celebrations of the founding of Virginia in 1607, offering striking views of – well, not quite of – the native inhabitants who greeted Captain John Smith four hundred years ago.[73]

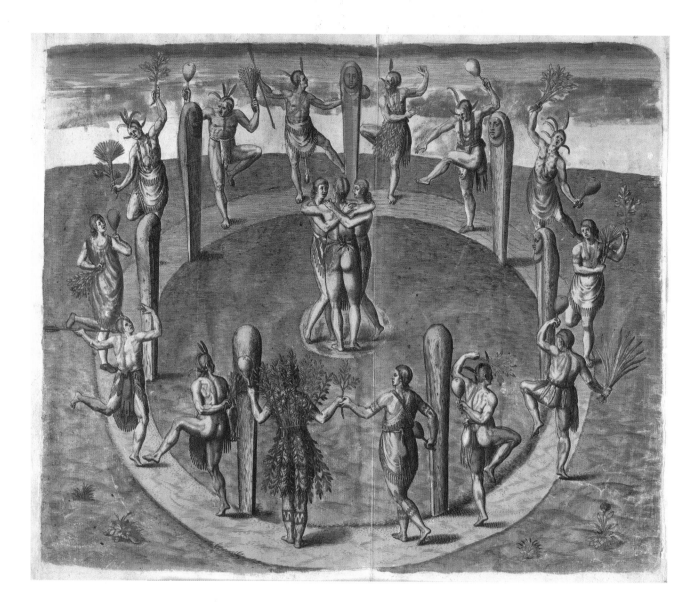

CHAPTER 6

BETWEEN REPRODUCTION, INVENTION AND PROPAGANDA: THEODOR DE BRY'S ENGRAVINGS AFTER JOHN WHITE'S WATERCOLOURS

UTE KUHLEMANN

44. *A Festive Dance*, 1590. Hand-coloured engraving by Theodor de Bry, pasted in William Strachey's 1610–12 manuscript 'Historie of travaile into Virginia Britannia'. Strachey made several copies of his manuscript; this one was illustrated throughout with de Bry's 1590 engravings, all hand-coloured, and was presented to Francis Bacon. By permission of The British Library London (MS Sloane 1622, fol. 4)

When John White and Thomas Harriot set off to America, their orders must have included instructions to observe and record all things strange and of interest to their English patrons.[1] Subsequently, Harriot produced a written account focusing on the economical potential of this part of the New World, while John White recorded his impressions in more than fifty drawings, covering various botanical, zoological and ethnographical subjects.[2] Although Harriot's and White's impressions must have been influenced by both their own and their patron's expectations, both men approached their tasks relatively scientifically and produced in most ways 'objective' records.[3] In the case of John White, the vast majority of his drawings are extremely focused, concentrating on one subject and its key features only.[4]

As discussed in Chapter 1, John White's original drawings remained largely unknown until the twentieth century, and it was only due to a printed illustrated publication of Thomas Harriot's *A briefe and true report of the new found land of Virginia* (from here onwards referred to as *Virginia*) by Theodor de Bry in 1590 that White's visual records became widely known and copied throughout Europe. This publication is generally credited with having forged the European concept of American Indians until the eighteenth century. Today, the engravings are often appreciated, for example, as illustrations of the North Carolina Algonquians.[5] However, one has to be cautious not to mistake de Bry's engravings for reproductions of White's original drawings. As this chapter will demonstrate, White's original designs and de Bry's engravings differ greatly not only in their iconographies, but also in their implied messages and intended functions. Hence, it is imperative to distinguish carefully between White's contribution and that of de Bry, in particular when it comes to evaluating the impact of de Bry's engravings.

This chapter will provide some contextual details on the personal and professional

life of Theodor de Bry, followed by the key details of his famous publication. A comparison of the original watercolours and their engraved counterparts will demonstrate their essential differences, followed by a brief summary of the impact and legacy of de Bry's engravings.

45. *Theodor de Bry, Self-portrait aged sixty-nine*, 1597. Engraving by Theodor de Bry from J. J. Boissard, *Pars Romanæ urbis topographiæ et antiquitatum*, Frankfurt. British Museum (P&D 1862,0208.94)

THEODOR DE BRY (1527/8–1598)

Theodor de Bry's life is representative of the mobility forced upon Protestants of all denominations in post-Reformation Europe, where the political landscape was constantly changing, and with it the official religious alliances of its various states and cities.[6] Born in Liège and trained as a goldsmith, the Calvinist de Bry and his family spent almost two decades in Lutheran Strasbourg. In 1577, after the city became increasingly less tolerant towards Calvinists, de Bry moved to the prosperous city of Antwerp, which had recently welcomed again members of the Reformed churches. In Antwerp, de Bry enrolled in both the St Luke's Guild Liggeren (for painters, sculptors, print makers and publishers) as well as the Goldsmiths Guild, reflecting his professional interest in both goldsmith work and copper engraving.[7] At this time Antwerp was one of the leading print making and printing centres in Europe, already supporting around seventy active printers and publishers, among others the printer and publisher Christopher Plantin, a prolific publisher with strong links to Philip Sidney, Ortelius and various leading humanists of the sixteenth century.[8] However, probably in response to the imminent political and religious changes prompted by the advancing Spanish (Catholic) army, de Bry decided to leave Antwerp in 1585. We know that de Bry eventually and finally settled in Frankfurt am Main, where he applied for citizenship in 1588.[9] De Bry had many reasons to settle in Frankfurt; it was the hometown of his second wife and a favoured destination for the about forty thousand exiles from Antwerp.[10] Most significantly, however, Frankfurt, like Antwerp, was a leading printing centre and renowned for its important book fairs frequented by an international clientele.

Although officially recorded as a goldsmith, de Bry did not enrol as a goldsmith master in Frankfurt, signalling that his professional transition from goldsmith to publisher was about to be completed.[11] Soon after his arrival in Frankfurt, de Bry started to set up what was to become a renowned and most prolific publishing house. After his death in 1598, the business was continued by his two sons Johann Theodor and Johann Israel de Bry, and later by Matthaeus Merian and his heirs. The publishing house Officiana Bryana ceased to exist in 1734.[12]

DE BRY IN ENGLAND

Before finally settling in Frankfurt, de Bry did spend some time in England, where in 1587–8 he produced an impressively large print of *The Procession at the Obsequies of Sir Philip Sidney*. It consisted of over thirty plates after drawings by Thomas Lant depicting the magnificent funeral procession with nearly the entire English court in their fineries.[13] Frustratingly little is known about the details of de Bry's stay in England, and we do not know his motivation for coming or the duration and location of his stay. However, it appears that de Bry, in London as well as in Frankfurt, was instantly well-connected: this was probably made possible by an extremely efficient and reliable network of exiles.[14] Besides potential print commissions, de Bry's trip to England may also have been motivated by his attempt to obtain designs for future publications. According to Hind, de Bry had seen the French edition of René Laudonnière's account on the settlement attempts of the French Huguenots in the 1560s, which was published in Paris in 1586 under the title *L'Historie notable de la Floride*.[15] The manuscript of the text was in the possession of Richard Hakluyt, an English scholar and clergyman who was closely connected to the circle of Raleigh and well acquainted with the Sidney family.[16] Hakluyt edited and published various travel discoveries; amongst others he translated and published in London in 1587 the first English version of Laudonnière's account.[17] However, both publications were not illustrated, despite the existence of original drawings illustrating the described events. These drawings were made by the miniaturist and cartographer Jacques Le Moyne de Morgues, a survivor of the failed French Huguenot colony in Florida, and now a well-connected exile living in London, who was working in the service of Sir Walter Raleigh and acquainted with the Sidney family. When de Bry approached Le Moyne about his Florida drawings, the artist, however, was yet not willing to part with his work.[18]

It was only after Le Moyne's death in 1588 that de Bry obtained the drawings and Le Moyne's account of the events from his widow, apparently with the help of Richard Hakluyt.[19] Not only was Hakluyt instrumental in securing the material for de Bry's anticipated Florida volume, but he also seemed to have persuaded de Bry to delay this publication and instead to publish first the English travel experiences to 'Virginia'.[20] Harriot's account had already been published in London in 1588, with a preface by Sir Ralph Lane, the first Governor of Virginia.[21] The same account was also included in Hakluyt's own edition of a book with various English travel accounts.[22] However, neither publication was illustrated, and, according to de Bry, it was Hakluyt who had advised him to publish an illustrated version, and who assisted him in obtaining the designs from John White.[23] Hakluyt may not have made use of the images for his own 1589 publication because, judging from contemporary comments, publishing illustrated books in London at that time was an extremely costly enterprise and stood in sharp contrast to the conditions available in Frankfurt.[24]

Since John White probably produced various sets of his drawings (see pp. 94, 225), it is most likely that he provided de Bry with a very similar, if not identical set to the one in the British Museum. Although that set does not seem to have survived, there

are strong indications that it must have been with de Bry's family and printing business at least until 1617 (see below). Soon after de Bry had obtained the required material, he left England for Frankfurt, where he started to embark on what was to become the most remarkable publication of illustrated travel accounts.

THE *GREAT* AND *SMALL VOYAGES* (*GRANDS* AND *PETITS VOYAGES*)

The book with Harriot's and White's accounts, to which I shall return later, was the first of an impressive set of fourteen volumes which was published between 1590 and 1630 by Theodor de Bry, his sons and later Matthaeus Merian. The common subject of the volumes was to recollect the various discovery journeys to the New World, to America. Generally these volumes are referred to as the *Great Voyages*, or simply *America*.[25] Although the first volume was originally not conceived as part of a series, it already announces the next volume on the French settlement attempts in Florida (which was published in 1591). After that volume, all the subsequent volumes were to carry 'America' and a volume number in their title, which underlines the concept of a larger series. All volumes were published in Latin and German; only the first volume of 1590 was ambitiously published in four languages at the same time: Latin, German, English and French.[26] From 1597 Theodor de Bry's two sons independently embarked on a parallel project, focusing on the voyages to Africa and East Indies. This series is generally known as the *Small Voyages*.[27] Often simply referred to as 'de Bry's *Voyages*', both series became soon a desideratum for any serious bibliophile, and the descriptions of great libraries and collections generally include a comment on the presence and state of completeness of their de Bry series.[28]

DE BRY'S *VIRGINIA* VOLUME: ITS PRODUCTION AND AUDIENCE

From the very beginning, de Bry's *Voyages* were extremely successful. Their success can be well documented with the numerous re-editions. For example, the 1590 Virginia volume saw two later German (1600, 1620) and two later Latin editions ([1608], 1634). Additionally, the first volume was included in two later summaries: in 1617 a volume with the text of the first nine parts of de Bry's *Great Voyages* abridged by Philipp Ziegler; and in 1631 (and a second edition in 1655) a version by Johann Ludwig Gottfried based on de Bry's volumes 1–14.[29]

We know that various people were involved in the actual production of the Virginia volume. Besides the original author Thomas Harriot, the designers John White and, in one instance, Joos van Winghe, there were three translators involved: Richard Hakluyt (from Latin into English), Charles de L'Ecluse, also known as Clusius (into Latin and French), and a translator only known as Christ[off] P. (into German).[30] The engravings were made by Theodor de Bry and his sons, and in four instances by Gysbrecht van Veen.[31] According to the title page, the book (i.e. the letterpress) was printed by Johannis Wechel, and sold by Sigmund Feyerabend.[32] Additionally, there are indications that the engravings were printed by Jakob

Kempener.[33] The Wechel printer family was acquainted with the Sidney family in England and it is quite possible that this contact had helped de Bry to secure the earlier commission of Sidney's funeral print (see above).[34]

No exact publication figures of the Virginia volume are known, but at this time the usual, and most economic, edition size would have been fifteen hundred to two thousand copies; however, one can assume that elaborate and costly publications such as de Bry's *Voyages* would have been printed in much smaller editions, estimated at about five hundred copies.[35] These kinds of edition figures would correspond with the average life-span of a copperplate, which can be stretched to about fifteen hundred impressions.[36] On the basis of recorded figures for a later publication by Merian, it has been calculated that the early volumes of de Bry's *Great Voyages* must have been sold for between one and three guilders, which equals three to six weeks' pay for a typesetter in the late sixteenth century.[37] It is important to note that in addition to complete books, the plates would have circulated as individual prints and sets.

As far as the audience is concerned, we know that de Bry's *Voyages* were offered regularly on the twice yearly book fair in Frankfurt am Main. The Frankfurt Fair was instrumental for international book-dealing throughout the sixteenth century, attracting booksellers from all parts of Europe. Until 1598 there were no official records of the books that were offered at Frankfurt, but Johann Willer, a bookseller from Augsburg, published regularly from 1564 his own sales catalogues with books from the Frankfurt Fair.[38] According to these catalogues, the Latin and German editions of de Bry's *Virginia* volume were offered and traded in Frankfurt at the 1590 spring fair.[39] De Bry's volumes would have appealed to a wide audience: courtiers, princes, serious book collectors and intellectuals appreciated the intriguing contents and the high-quality execution, whereas artists and craftsmen marvelled at the engravings for their rich and exotic visual information.[40]

Generally, most copies survive in extremely good condition, and their wealthy owners often enhanced the preciousness of the volumes by elaborate bindings and embellishments, as well as colouring of the plates. A census of the Latin, English, French, and German versions of the 1590 Frankfurt printings of *Briefe and true report* has revealed that these prized volumes were given highly individualized treatment in the arrangement, display and colouring of de Bry's engravings, which were amended according to personal taste and utilized for individual purposes.[41] For example, several copies in German libraries include engravings with paint covering apparently offensive nudity.[42] In other instances, the engravings were cropped off their letterpress and used as illustrations in not necessarily the correct context: for example, William Strachey pasted coloured images of the engravings into his manuscript account on the later Jamestown settlement.[43] (fig. 44).

THE STRUCTURE AND FUNCTION OF DE BRY'S *VIRGINIA*

At first glance, de Bry's *Virginia* volume appears rather conventional, with the letterpress text being followed by a section of engraved plates. As letterpress and

intaglio printing are two distinct processes which require the use of different printing presses, illustrative intaglio plates were for practical and economical reasons traditionally not incorporated into the text but printed on separate sheets to be bound either interspersed with the text sheets or, gathered as a group, after the text. De Bry's book is quite different from these conventions in that the engravings with their accompanying letterpress title and explanatory captions constitute a rather independent, though complementing entity to Harriot's main letterpress text. It is important to note that the engravings and their accompanying texts are, like broadsides, printed on one side only, which allowed greater flexibility of the use of the engravings. Consequently, one can safely assume that the plates were appreciated and sold in their own rights, either as single sheets or as complete sets.

If one compares the text with the 'illustrations', it becomes apparent that the images refer only to one part of the text, a six-page segment which deals with the 'description of the nature and manners of the people of the countrey'. The preceding nineteen pages of the main text are dedicated to commodities, ranked and categorized according to their importance for potential settlers: first, there are six pages on 'merchantable' goods suitable for trading, and which 'will enrich yourselves the providers; those that shal deal with you; the enterprisers in general; and greatly profit our owne country men'. The second section of nine pages deals with foodstuff, i.e. 'victuall, and sustenance of mans lives'. The last part lists on two pages other commodities which might prove useful to potential settlers, mainly relating to building and other necessary uses, and, as already stated, information on the 'natural inhabitants'. After a final summary, the text section is followed by a plate section on the people of that part of the America, which changes the emphasis of the whole book. This change of emphasis is already indicated in the title page of the publication (fig. 2). First of all, the originally convoluted title of Harriot's 1588 booklet, *A briefe and true report of the new found land of Virginia: of the commodities there found and to be raysed, as well marchantable, as others for victuall, building and other necessarie uses for that are and shal be the planters there, and of the nature and manner of the natural inhabitants* … has been reduced to the most essential aspects: *A briefe and true report of the new found land of Virginia, of the commodities and of the nature and manners of the of the naturall inhabitants* …'. Furthermore, the prominent role of the natives is blatantly advertised in the engraved architectural frame of the title; the five American Indian figures are all visual quotations from the plate section. (see nos 10, 13–15, 17). The title page leaves no doubts on the visual and verbal contents of the book, and, when displayed for advertisement purposes, it certainly must have stirred a lot of interest in the publication.[44]

The plate section has its own title page, which describes the following plates as

46. *Adam and Eve*, 1590. Engraving by Theodor de Bry after Joos van Winghe to accompany the foreword, 'To the gentle reader', before the plate section of de Bry's 1590 edition of Harriot's *Briefe and true report*, n.p. By permission of The British Library, London (G 6837)

'The True Pictures and Fashions of the People in that parte of America now called Virginia …', which were 'Diligentlye collected and draowne by Iohn White who was sent thiter speciallye for the same purpose … now cutt in copper and first published by Theodore de Bry …'. After a list of contents, the images do not start, as expected, with the Indian images but with an engraving after Winghe, showing Adam and Eve in the Garden of Eden taking fruits from the forbidden Tree of Knowledge (fig. 46). The consequences of their disobedience can be seen in the background: non-paradisiacal human life dictated by physical pain (child rearing) and labour (husbandry). In the foreword that faces this engraving, de Bry compares the early privilege-deprived humankind and its capability to thrive to the humble, but satisfying lifestyle of the 'sauage nations', which deserves the recognition and admiration of the English. After this introduction there are two plates with maps providing the geographical context (see p. 104, 106). These maps are followed by various plates with details on the Algonquian Indians. First, there are nine single-page plates which introduce individual social types of Indians (for de Bry's plates III–XI see nos 13, 22, 15, 18, 21, 14, 23, 16, 17). These plates are followed by seven more descriptive plates which place the Indians in a broader context, showing them being engaged in a specific action or task, such as making boats, fishing, preparing food, eating, and socialising (de Bry plates XII–XVIII, see nos 7, 43, 42, 24, 12, 11). These scenes are put into an even broader context with the help of two further plates which depict Indian community life in the villages of Pomeiooc and Secotan respectively (de Bry plates XIX, XX, see nos 9, 8). The last three plates are dedicated to aspects of the Indian religious, historical, and social life, showing their God, the veneration of their ancestors (de Bry plates XXI, XXII, see no. 10) and their tribal body markings (fig. 47). All these plates were clearly perceived as a set, to be viewed in the above-described order. De Bry ensured that this order was followed, even if the engravings were to be cropped off their letterpress text, by numbering the image as well as each title. Significantly, the Indian images are followed by a second set of plates, its title page announcing 'Pictes which in the olde tyme dyd habite one part of great Bretainne' (de Bry part 2, plates I–V, see nos 30–34). According to de Bry, these images are included 'for to showe how that the Inhabitants of the great Bretannie haue bin in times past as sauuage as those of Virginia'.[45]

With these plates, de Bry closes his cycle of illustrations, which in its entirety acquainted Europeans with American Indians and their lifestyle by relating the exotic world to familiar concepts such as God's initial creation and earlier European civilizations. The full propagandistic potential of this cycle becomes apparent if one considers not only the wider historical context of the English voyages to America

The Marckes of sundrye of the XXIII.
Cheif mene of Virginia.

He inhabitits of all the cuntrie for the moft parte haue marks rafed on their backs, wherby yt may be knowen what Princes fubiects they bee, or of what place they haue their originall. For which caufe we haue fet down thofe marks in this figure, and haue annexed the names of the places, that they might more eafelye be difcerned. Which induftrie hath god indued them withal although they be verye fimple, and rude. And to confeffe a truthe I cannot remember, that euer I faw a better or quietter people then they.
The marks which I obferued amonge them, are heere put downe in order folowinge.
The marke which is expreffed by A. belongeth tho Wingino, the cheefe lorde of Roanoac.
That which hath B. is the marke of Wingino his fifters hufbande.
Thofe which be noted with the letters, of C. and D. belonge vnto diuerfe cheefe lordes in Secotam.
Thofe which haue the letters E. F. G. are certaine cheefe men of Pomeiooc, and Aquafcogoc.

47. *The marks of sundrey Chief men of Virginia*, 1590. Engraving by Theodor de Bry, plate XXIII of his edition of Harriot's *Briefe and true report* Frankfurt. By permission of The British Library, London (c.38.i.18)

and the political and religious situation within Europe (see Chapter 4) but also de Bry's personal and professional situation. One must recall that de Bry felt the consequences of religious prosecution throughout his life. These experiences seem to have contributed to his positively pro-Protestant position which is underlined by the fact that his *Great Voyages* series focuses almost exclusively on voyages undertaken by Protestants.

The association of his series with anti-Catholic sentiments was apparently so strong that his son Johann Theodor de Bry felt the need to publish a disclaimer, probably in order to mollify any Catholic clients and patrons.[46] The religious message imbedded in de Bry's series, as well as the political, artistic and gender issues, have been analysed in various publications and therefore will only be touched on briefly below.[47]

THE PLATES ON THE AMERICAN INDIANS

If one turns now to the individual plates, it becomes obvious that the propagandistic message of the book, as well as de Bry's own perception and interpretation, have influenced his translation of John White's drawings into engravings. Reflecting the basic tone of Harriot's account, all plates by de Bry portray the Indian life as encountered by the English as a peaceful existence in balance with nature. For example, the background scenes of all plates on individual Indians document the alleged abundance of food, each referring either to hunting or fishing, or to agriculture. Not only can the Indians thrive on what nature provided, but they also display intelligent humbleness and efficiency when making use of nature with simple but efficient means such as bow and arrows, fish traps, husbandry etc. Their social life bears various parallels to European civilizations, such as working in teams, building orderly and well-maintained villages, performing rituals, hosting banquets. Although not Christians, they are depicted as faithful people, implying their potential for future conversion.

Considering the suggestive nature of the messages imbedded in the individual plates as well as the entire set, it is important to discuss in how far the designs are the works of John White or rather of Theodor de Bry. As described above, almost all the engravings relate closely to the surviving drawings by John White.[48] However, hardly any engraving can be considered as a faithful reproduction. If one compares, for example, de Bry's plate VIII with John White's original drawing (see no. 14), one can establish general similarities but also great differences regarding the composition as well as the treatment of details. The subject is an Indian mother carrying a gourd for fetching water. She is accompanied by her daughter, who is holding a European doll. White depicts a self-content, proud and vigilant woman, whose feet are set firmly on the ground. Her right hand relaxes in the sling of pearls, but her eyes are alert, attentively observing her surroundings. She is accompanied by her daughter, who is depicted in closest proximity to the mother, separated only by the gourd. The figures and the object form a powerful visual unit, advocating content and harmony between humankind and nature. Even the 'alien' European doll cannot disturb this

harmony; in fact, neither the child nor the mother actually looks at it. The strangeness of the doll is further underlined in that it does not face the Indians, but rather the (European) onlooker. The presence of the doll and its outward 'gaze' symbolize the Algonquians' openness for cultural exchange, but also their cultural independence. White's respectful and sensitive image, or rather portrait, was greatly altered in de Bry's engraving. Not only are the features and shapes of both figures highly Europeanized but their body language is also weakened: the mother is now depicted in classical *contrapposto*, a chaste woman whose attention is entirely directed to her daughter who is depicted in considerable distance and actively playing with the European gifts. In contrast to White's depiction, this group lacks all contentedness, confidence and harmony, which, as a result, leaves the onlooker with a strong feeling of cultural superiority.

Another important difference between the drawing and engraving is the setting of the figures. White chose to depict the individual Indians without any background or foreground details, which reveals a quasi-scientific, almost 'objective' approach towards the subject. Visual information on the environment and lifestyle of the depicted figures is recorded in separate, more contextual drawings such as the fishing scene and the village scenes (nos 2–9). In contrast, de Bry consistently places the figures of White's detailed studies into a concrete context, here a landscape. The strongly engraved foreground consists of a narrow strip of even ground characterized by some obligatory stones and non-descriptive plants, whereas the lightly engraved background shows a flat, fertile landscape with other Indians being engaged in hunting or fishing. Using this kind of rather formulaic background suggests a narrative which may appeal to the average European viewer but equally undermines the significance and importance of White's scientific, objective observations.

On the basis of these kinds of differences, some scholars have assumed that the engraver used another set of drawings more detailed than those that have survived.[49] Unfortunately, we do not know what kind of art works de Bry took with him to Frankfurt, but he was probably working with a set of drawings that was more or less identical to that which is kept in the British Museum. This impression can be supported by various observations and facts. First of all, evaluating the above-mentioned differences between White's drawings and de Bry's engravings, it is difficult to imagine that White would have willingly falsified his careful records to such an extent. On the contrary, one has the impression that he tried to avoid stereotyping by depicting the Indians as individuals, giving the images an almost portrait-like quality. The features of his sitters are distinctively non-European, and so are their attire, gestures and interactions. If John White had wanted to present the figures in contextual settings, he certainly would not have limited himself to hunting and fishing scenes. Instead of repeating visual information, he would have used the opportunity to show, for example, various aspects of Indian village life and social engagements. Furthermore, some of de Bry's engravings are ethnographically incorrect, hence cannot be based on John White's observation. A good example is White's drawing of the cooking of food and de Bry's plate XV featuring the same

48. *Nine Virginia Indians and a child*, 1617. Engraving (unsigned) in Philipp Ziegler, *America, Das ist, Erfindung und Offenbahrung der Newen Welt* …, published by Johann Theodor de Bry, Oppenheim. By permission of The British Library, London (G.6831, p. 230)

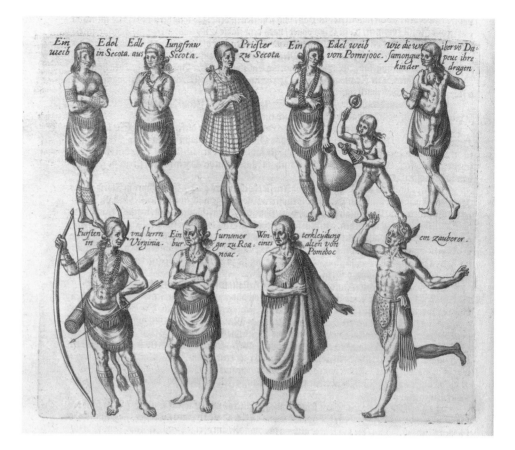

subject (no. 42). As pointed out by Greve, the Indian woman on the left wears the same loincloth as White's conjuror (no. 17), an implausibility which suggests that the woman and her attire are additions by de Bry, who had no first-hand knowledge of the Indian culture.[50] Other inaccuracies are pointed out in the catalogue entries. Additionally, the style and composition of the engravings seem to betray the hand of somebody properly trained in, or at least aware of, European art conventions. Although we do not know much about John White's training, and although he certainly was a very gifted and careful observer and draughtsman, he nevertheless seems to have lacked the routine of a properly trained artist. Otherwise it would be difficult to explain why he made, and failed to correct, the faux-pas of depicting one Indian woman with two right feet (no. 18).

Finally, it is possible to deduce from later works produced in de Bry's workshop that Theodor de Bry must have possessed a set of drawings similar to that of the British Museum. In 1617 Johann Theodor de Bry published a summary of the first nine volumes, the text being abridged by Philip Ziegler, who reduced the original Virginia volume to eight text pages and three plates.[51] While two plates are the same as in the *Virginia* volume, one is a completely new design. (fig. 48).[52] This engraving is essentially a visual summary of the nine images showing the individual types of Indians. Interestingly, this print records details that are to be found not in de Bry's engravings but in John White's drawings only. For example, the mother and girl are

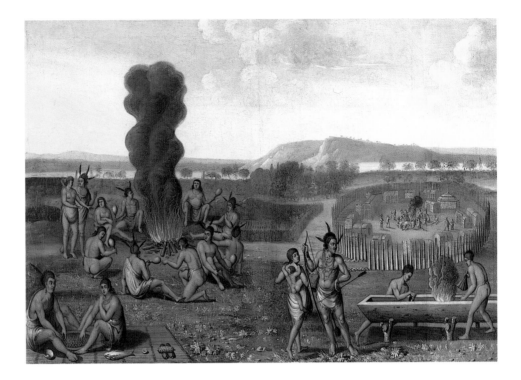

49. *Indians of Virginia and North Carolina*, c.1675, by James Wooldridge. Oil painting on linen, 29⅝ × 42⅝ inches (c. 752 × 1092 mm), signed 'J Wooldrig', the figures based on de Bry's engravings of 1590. Possibly commissioned by First Earl Conway, whose family was involved in the Virginia Company, for the first Ragley Hall, Warwickshire. James 'Wooldridge'appears in the Painter Stainers' records from 1660 to 1678. Courtesy of a private collection.

depicted here in their original proximity and proportions, and the doll, very tellingly, is shown from the front as in John White's original drawing. This fact supports the theory that John White had parted with a set very similar to the one in the British Museum, and that Theodor de Bry created from these drawings his designs, which, although largely based on John White's designs, reflect also de Bry's personal taste and interpretation of the images.[53]

THE LEGACY OF JOHN WHITE (OR RATHER OF THEODOR DE BRY?)

Theodor de Bry knew that his engravings would find many admirers, warning potential copyists in his foreword to the plate section of *Virginia* 'I hartlye Request thee, that yf any seeke to Contrefaict thes my bookx, (for in this dayes many are so malicious that they seeke to gayne by other men labours) thow wouldest giue noe credit vnto suche conterfaited Drawghte. For dyuers secret marks lye hiddin in my pictures, which wil breede Confusion vnless they bee well obserued'.[54] De Bry's warning seemed to have been effective, and there seem to be no exact copies. Instead, however, there are numerous later works that clearly derive from de Bry's engraving and instrumentally contributed to the European concept of American Indians until the eighteenth century. Although these works constitute part of the legacy of John White,[55] it is important to question how far they really reflect not White's designs but rather de Bry's interpretation and presentation of the same. The legacy works fall into three basic groups.

The first group of images follow the engravings very closely, copying John White's drawings in the same interpretative mode as set by de Bry. A good example is a

50. *Mulier Virginie Habitatrix* and *Vir Virginie insule Habitatav*, 1594. Engravings (etchings?) in Pietro Bertelli, *Diversarum nationum habitus*, Padua. By permission of The British Library, London (810.c.2, pls 27, 28)

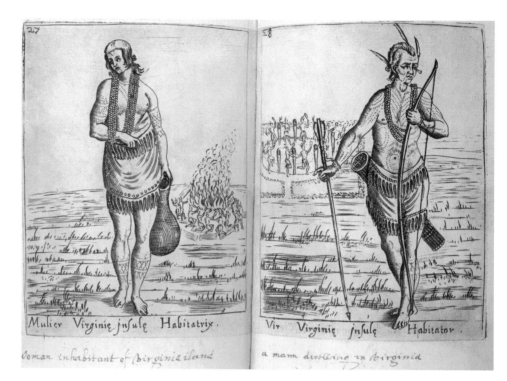

painting by an unknown seventeenth-century English artist, James Wooldridge, showing various North Carolina Algonquian Indians in an Arcadian outdoor scene (fig. 49).[56] The various elements of the composition derive from seven de Bry engravings (nos 7–9, 12, 13, 16, 24), with the figures being adapted to contemporary taste. The landscape is not so much based on de Bry's engravings, but seems to be a even more anglicized version invented by the artist. These kinds of works carry not only the basic, though distorted ethnographical information of John White's drawings but also de Bry's positive presentation of the Algonquian Indians as peaceful, humble humans living in harmony with nature. It should be pointed out that these kinds of images conform to the slightly later notion of the 'noble Savage'.[57] The engravings and their ethnographical information were also appreciated and adapted for numerous historical accounts. Robert Beverley's book *The History and Present State of Virginia* (1705), for example, contains plates that are essentially composites based on de Bry's engravings with subtle but telling differences.[58]

The second group of images also adapts the imagery of de Bry's engravings, although for quite different purposes, hence distorting not only the original ethnographical information but also the original function of the engravings. Two good examples can be found in publications by John Smith. His map of Virginia of 1612 turns White's idol Kiwasa into Powhatan seated with his wives, and the Chief of the Roanoke into a giant Susquehannock (see fig. 33). John Smith's travel book *The Generall Historie of Virginia* (London, 1624) included a map of 'Ould Virginia' which is surrounded by five scenes using de Bry's engravings to illustrate the adventures of John Smith in 1622 (fig. 34).[59] The plate was engraved by Robert

Vaughan, and quotes from various de Bry's illustrations. The top right scene shows Smith taking the king of Pamaunkee prisoner, and the king is a close copy after de Bry and John White (no. 13). The figures of the conjuror, the idol and the priest, and the fire scene in the top central image also derive from de Bry's plates (nos 17, 15, 12, 10); the scene on the left with the capture of John Smith is based on de Bry's ceremonial dance (no. 17). De Bry's peaceful coastal Algonquians have been taken out of their context and turned into a more wild and aggressive tribe.

The third, and by far the largest group of works after de Bry's engraving comprises those which copy only the main subject, i.e. the figures of the Indians. For example, images of John White's North Carolina Algonquians were almost instantly incorporated in the then popular genre of costume books (see pp. 68–9). In the 1590s two very substantial and important costume books feature derivates of John White's Indians. In 1591–6 Pietro Bertelli depicted a woman and man of Virginia (fig. 50), the figures clearly deriving from de Bry's *Virginia* publication, taken either from the title page (fig. 2), or from the corresponding plates (nos 13, 14).[60] The two background scenes derive from de Bry's plates XVII and XVIII (see nos 17, 12). Almost at the same time, Cesare Vecellio's costume book contains various Indian images, which ultimately derive from de Bry.[61] These costume books were a very popular source for all kinds of artists and craftsmen, and uncountable depictions of Virginia Indians are based on these derivatives well into the eighteenth century.[62] Additionally, some artists seemed to have worked after de Bry's engravings but chose to concentrate on the key subject. In some instances it is not quite clear whether de Bry's engravings, Merian's compilation print or an intermediary costume book was the source. For example, Wenceslaus Hollar (1607–77) included in his series 'Theatrum Mulierum' and 'Aula Veneris' of c.1640 an etching of a woman from Virginia (fig. 51), which combines features of two Algonquian women, which may be based on a costume book, on de Bry's engravings (nos 18–22) or on the compilation print in Ziegler's summary (fig. 48).[63] The same uncertainty regarding the actual source applies to the popular usage of White's or de Bry's Indians in map making as representatives of certain parts of America. A good example can be found in the map 'America' of 1662, which shows in the margins ten different native Americans, amongst other images, 'Virginian' Indians, one with a breastplate which derives from White or de Bry.[64] It is interesting to note that these type of works not only belong to the largest legacy group but also constitute those works which come closest to John White's original drawings which, though scientifically conceived, are in essence costume studies as well (see nos 85–8).

Although one can find numerous examples of adaptations of White's or de Bry's North Carolina Algonquians, it is debatable how strongly these images have affected the European perception of American Indians. As stated above, White's ethnographical images were rather objective, and, in those who had a chance to

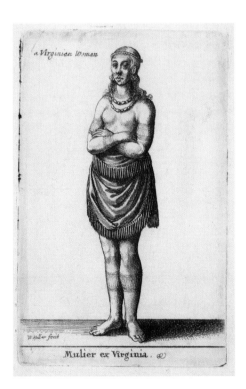

51. *Mulier ex Virginia*, c.1643–4. Etching by Wenceslaus Hollar, from 'Theatrum Mulierum' / 'Aula Veneris', British Museum, London (P&D Q,5.243 (P.1907))

view one of the sets of drawings, they may have stirred interest and satisfied curiosity about the New World (see also Chapter 4). De Bry's engravings turned these rather scientific images into propagandistic images, projecting and advertising the peaceful tribe, the economic potential of Virginia, and the ethical conduct of Protestant nations. However, despite all the details, de Bry's engravings did not conform to the emotion-laden European fantasies and concepts of the American Indian. From the fifteenth century, American Indians had generally been associated with material riches (gold) and exotic attires. In particular, prominent feather headdresses and feather skirts were strong and well-established symbols, with which the average European would instantly associate American Indians. However, de Bry's engravings of the Virginia volume were lacking these signifiers, which explains why these Indians, for example, were not widely adapted for allegorical fine art or for popular printed images, such as broadsides or tobacco advertisements. Instead, it was the more dramatic images in the following volumes of de Bry's *Great Voyages* which were to execute greatest impact on European minds.[65]

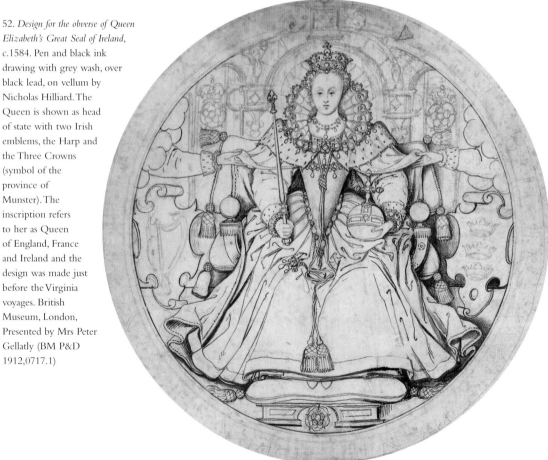

52. *Design for the obverse of Queen Elizabeth's Great Seal of Ireland*, c.1584. Pen and black ink drawing with grey wash, over black lead, on vellum by Nicholas Hilliard. The Queen is shown as head of state with two Irish emblems, the Harp and the Three Crowns (symbol of the province of Munster). The inscription refers to her as Queen of England, France and Ireland and the design was made just before the Virginia voyages. British Museum, London, Presented by Mrs Peter Gellatly (BM P&D 1912,0717.1)

CATALOGUE

1 Title page

Inscribed: 'THE pictures of sondry things collected
and counterfeited according/ to the truth in the
voyage made by Sr: Walter Raleigh knight, / for the
discouery of La Virginea. In the 27th. yeare/ of the
most happie reigne of our Soueraigne lady Queene /
Elizabeth. And in the yeare of or Lorde God. / 1585'

Pen and brown ink, 80 × 164 mm

1906,0509.1.1

This is the original title to this collection
of 'pictures of sondry things collected and
counterfeited according to the truth'.
Today the word 'counterfeit' has negative
connotations including 'forgery' or 'fake'
and at the time it could also be used in
that manner (see Chapter 4). Here,
however, it means to 're-present' some-
thing that is real in nature, or, from the
French, to 'make again', in the form of an
image on paper – 'according to the truth',

as a witness of something seen in reality.
Rather than 'pictures', we now describe
them as 'drawings', 'watercolours' or both;
they are executed with ground pigments
mixed with water and a fixative, applied
with a brush (made with hairs held in a
quill, called a 'pensil' at the time), over a
preliminary drawing made with black lead
(the Elizabethan term for graphite, also
sometimes referred to as a 'pensil', as the
lead was held in a quill in the same
manner as a brush) (see pp. 234–5). They
are on sized paper datable by its
watermark to c.1580; they were originally
mounted in an album with a thin blank
sheet bound in over each drawing to
protect its surface.

The reference to the voyage 'made by
Sir Walter Raleigh' has puzzled many
writers, as he did not go on the voyages
himself: the meaning here is that he

organized, sponsored and sent the voyages
under his patent of discovery.

Two major factors mean that we no
longer see these watercolours as they were
originally created and should be taken
into account when attempting to view
them through the eyes of John White or
his contemporaries. The pigments used
included silver, as well as lead which was
added to some of the pigments to give
them more 'body' – opacity or depth.
Contact with the air has caused the silver
and the lead to alter chemically so that
many of the elements which appear black
or grey (the eyes, jewellery, tattoos) were
originally silver, white, pale blue or pink.
In addition the watercolours were at one
point soaked and blotted under pressure
(see below) and the depth of colour is in
some cases approximately only 80 per
cent of the original.

A BRIEF HISTORY OF THE DRAWINGS

The seventy-five drawings in watercolour which followed this title page and are all now in the British Museum were presumably made by John White for one of his patrons or friends. Either they were assembled into an album by White himself for presentation or the drawings were handed over as loose sheets to his patron. The latter would then have them mounted into a bound album for his library where such drawings were usually kept for reference along with atlases, cosmographies and works of natural philosophy. Sir Walter Raleigh seems an obvious patron for whom one set of watercolours may have been intended and whose set Thomas Harriot might have referred to when writing the captions for the engraved versions, but equally Sir Francis Walsingham and Lord Burghley who supported the venture, or a wealthy merchant such as William Sanderson who helped to fund it, or even Queen Elizabeth may have received a set. It was common for more than one set of such drawings to be made, just as manuscripts were copied and circulated. The subjects of the drawings and the quality of the

pigments used to make them were far more important than the hand of the artist and people were not as concerned about owning 'the original' as they are today. The Sloane volume versions of some of the images which are in different pigments and probably by a different hand may have been part of one of these sets (see pp. 224–5). It is probably safe to say that, for a few years from around 1586 when they may have been painted, the various sets were circulated amongst this circle and others whom Raleigh would have wished to keep interested in his American projects, including men such as Henry Percy, the 9th Earl of Northumberland whom Raleigh and Harriot came to know around this time, or Richard Hakluyt who may not have owned a set himself but ensured that one was made available to Theodor de Bry, who engraved them as illustrations to his 1590 publication of Thomas Harriot's account of the 1585 voyage: *A briefe and true report of the new found land of Virginia*.

These watercolours first resurfaced in an album in the 1788 catalogue of the London bookseller Thomas Payne the

elder. The album was catalogue number 284, titled as given here and described as '75 drawings coloured in the original binding. Folio – fourteen guineas'. It was purchased from Payne in March that year by James Caulfield, 1st Earl of Charlemont (1728–99), a great collector and patron of the arts, on the advice of Edmund Malone, a theatre critic and collector who sometimes advised him on his purchases. It joined Charlemont's important collection of Elizabethan and Jacobean plays and manuscripts as 'the original coloured drawings by John White for Sir Walter Raleigh's Account of Virginia'. It remained in Charlemont's library in Dublin until the 3rd Earl sent it to London for sale by Sotheby, Wilkinson and Hodge in 1865. A fire broke out in an adjoining warehouse, which scorched the spine of the album. The album then lay saturated under other books for three weeks before being salvaged and placed in their sale on 11 August as 'A most interesting and highly important collection of co[n]temporary drawings, beautifully executed in colours heightened with gold and silver. The delineations of

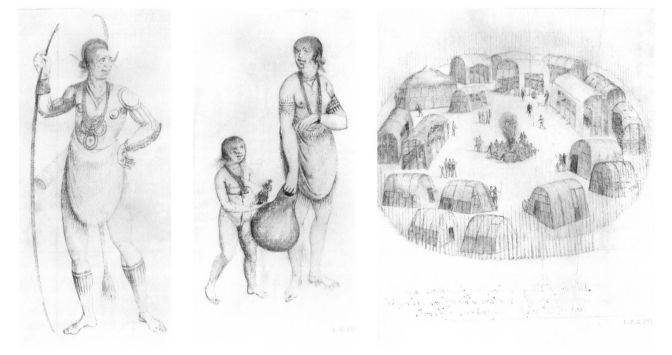

53–55. Offsets of nos 13, 14, 9. Watercolour and particularly bodycolour pigments and gold were transferred (offset) on to the sheets interleaving the watercolours in the original album when it was saturated after the fire in 1865. The images in the offsets are therefore reversed. British Museum (P&D 1906, 0509.2)

the natural history show that Mr White must have been a first-rate naturalist.'

The album was purchased for £125 by Henry Stevens of Vermont, who was a great collector and bibliographer of Americana and whose large collection of various editions of de Bry's *Great* and *Small Voyages* eventually came to the National Maritime Museum in Greenwich. Stevens removed the pages from the album, trimmed the sheets to reduce the scorching and bound them again in a new album. Into a separate album he bound the original blank sheets that once interleaved the drawings, now offset with much of their colour (figs 53–55). F. Bedford, the binder, discarded the original binding, thus destroying any clues to earlier owners. Stevens had hoped to sell them to an American purchaser but when they failed to interest him he offered them on 22 March 1866 to Anthony Panizzi, the Principal Librarian (i.e. Director) of the British Museum. The Trustees approved the purchase of the drawings for 200 guineas and the offsets for 25 (£236.25). Panizzi placed the two volumes in the Library next to the Grenville copy of the English edition of de Bry's *Briefe and true report* (*America* part I) and the drawings remained there until 1905 when they were included in a supplement to the catalogue of Printed Books.

This must have brought them to the attention of Laurence Binyon, who was nearing completion of the fourth and final volume of his *Catalogue of Drawings by British Artists in the Department of Prints and Drawings in the British Museum*, and the following year they were transferred to that department (thus the registration number begins 1906 rather than 1866, their original date of acquisition by the Library). This was a fairly regular occurrence at the time; in 1893 the Sloane volume of White's drawings (SL5270, see pp. 224ff) had already been transferred from the Department of Manuscripts to Prints and Drawings.

John White's watercolours have been made known to a wide public from the time they came off the Grenville Library shelves and into the Department of Prints and Drawings at the British Museum near the beginning of the twentieth century. They have been reproduced in part

innumerable times and in full twice, by Paul Hulton and David Beers Quinn in 1964 (with a full descriptive and discursive catalogue with reproductions in the form of colour-printed collotypes with pouchoir stencilling which left small inaccuracies in detail and colour) and again with a summary text by Paul Hulton in 1985; both editions are now out of print. The watercolours have been examined in many ways, but above all to provide more accurate information than de Bry's engravings about the lives of the North Carolina Algonquians who disappeared, through disease, migration and amalgamation, within a few generations of the Lost Colonists themselves (see Chapter 5 and nos 7–24).

The reception and legacy of de Bry's publication of Harriot's text has been considered by several historians, and the engravings and their differences from the watercolours have also been considered; a new examination of de Bry's publication is provided in Chapter 6.

A NOTE ON THIS CATALOGUE

Apart from this title page, the format of the presentation of the watercolours in the original album has been lost. We know from Payne's catalogue that when they were sold to the Earl of Charlemont they were in the original album, in the order they were mounted there by White or his patron. They might have been rebound for the Earl's library but it is doubtful that they would have been reordered. When they were remounted by Stevens after the fire their order may have changed a little but this is the order recorded by the register numbers and by Laurence Binyon (LB). When David Quinn listed them in his book on the *Roanoke Voyages*, however, he placed them in what he believed to be their chronological order – the order in which he thought they would have been drawn – and that order has been maintained in all discussions or cataloguing of them since (ECM, PH&DBQ, PH). However, by examining the drawings in registration number order and looking carefully at the offsets, burn marks and bleed-through of colours, it is possible to attempt to reconstruct the order in which they were mounted in the original

Elizabethan album. This has been reproduced as far as possible in the catalogue here, which presents us with a very Elizabethan view of the world, as the sequence follows that of most cosmographies and travel accounts published at the time. White's album began with the inscribed title page, followed by the large map depicting the voyage, images recording the activities of the English in the West Indies, the map of Virginia, then scenes depicting the Indians' way of life, followed by their apparel and weapons along with those of other people, ancient and modern, then flora, fish and fauna.

A note is required here about the spelling used in this book. There are many quotations and reproductions from de Bry's edition of Harriot's *Briefe and true report* in the entries that follow and many variations in spelling of Indian names and words. With the assistance of Manteo and Wanchese who were brought to England after the 1584 voyage and returned with them in 1585, Thomas Harriot developed a phonetic method for recording the Algonquian language. However, spellings used by him and by White were not consistent and this has resulted in some conflicting information in White's inscriptions and the accounts in de Bry. In addition, it is important to note that, although Harriot wrote the captions for White's images, they were written in Latin, translated into English by Hakluyt and into French by Clusius and then put into type by de Bry's German printers. This has resulted in some very strange words in addition to the usual old English use of *u* for *v* and *v* for *u* according to position. Rather than modernizing the quotations, we have transcribed them as they were originally printed where possible.

A summary of previous catalogue numbers is given for each drawing along with references to recent literature most relevant for the particular subject. These have been kept to a minimum; a list of abbreviations and select bibliographical references is on p. 246–8.

Lit.: LB 1(1); Quinn, pp. 390–8; ECM 1; PH&DBQ 1(a); PH 1; for Charlemont see Cynthia O'Connor; for reception of de Bry see also Hodgen, pp. 163–87; for Harriot, the Algonquian language and spelling see Kupperman 2000, pp. 79–83 and for de Bry's various translations see Quinn, p. 401

2 La Virgenia Pars: a map of the east coast of North America from Chesapeake Bay to the Florida Keys

Pen and brown ink over black lead, with watercolour, heightened with white, silver (altered) and gold, 370 × 472 mm

Inscribed: 'La Virgenia Pars' and with names of villages

1906,0509.1.2

Unfortunately this map was folded in half in the original album and the water damage has left confusing shadowy offsets. Nevertheless, in addition to being an important cartographic record, this map acts as a decorative frontispiece to the 1585 voyage Raleigh sent to Virginia, led by his 'General' Richard Grenville in his ship the *Tyger* and recorded in the drawings by John White that follow. The arms of Sir Walter Raleigh are firmly planted in 'La Virgenia Pars' which occupies what is now the entire area of North and South Carolina. The detailed information about Florida and the French names for its settlements presumably came from Jacques Le Moyne who had been in Fort Caroline in 1565 (marked 'Carline' just below a red dot half-way down the coast). White depicts Grenville's *Tyger* arriving from its swift crossing of the Atlantic (departed Plymouth 19 April, sighting Dominica 7 May) in the lower right, and adds dolphins, dorados and flying fish next to the greatly enlarged Bahamas they passed through (the island inscribed 'Cigateo' is now Great Abaco). The ship is then shown sailing northwards along the Florida coast and south-east of Cape St Helen. They 'were in great danger of a Wracke on a breache called the Cape of Feare' (Quinn, p. 118), before anchoring off the Outer Banks at Wococon (the white island between two red ones). Here on 29 June, the ship entered the harbour but struck the banks repeatedly and was badly damaged along with many of the supplies and provisions. The *Tyger* is shown again at anchor further up the banks off Port Fernando, the passage through the Outer Banks that the pinnaces and smaller boats used to reach Roanoke and the inner coastal waters. Finally, the *Tyger* is shown sailing back across the Atlantic to England. The tip of Noram[bega], as New England was then called, is just visible in the north-east corner.

For mapping of the type produced by John White, Elizabethans worked in measured drawn plans. The best known are Christopher Saxton's 1570s maps of English counties, with standard symbols for features of the landscape. This is particularly clear in White's more detailed map of Virginia (no. 6) and in de Bry's engraving. White's maps also show his debt to medieval world mapping as produced by cosmographers, where the inhabitants, flora and fauna were a proper part of the map which was regarded as a visual encyclopaedia (see Descelier's fig. 6). In his *Book Named The Governour*, Elyot noted apropos of such maps 'the pleasure … in one hour to behold those realms … that … in an old man's life cannot be journeyed and pursued; what an incredible delight is taken in beholding the diversities of people, beasts, fowls, fishes, trees, fruits and herbs' (cited in Barber). White's inclusion of *real* rather than imagined monsters places him firmly in this tradition.

White appears to have had access to a number of earlier maps such as Ortelius's *Theatrum orbis terrarum*, and Le Moyne's of Florida. He has incorporated information from them here along with the results of his and Harriot's own surveying. The distortions and erroneous latitudes (Roanoke is at about 36°) are probably not the result of faulty map making. It is more likely that Virginia has been enlarged to flatter White's patrons, or that they have been intentionally misrepresented on this display map for reasons of security – particularly if the Chesapeake was their next intended destination. Spanish spies were everywhere at court and maps were the greatest treasures on board any captured English ship. This may be why this particular map was not included in the series of drawings given to de Bry for publication in 1588. Its discoveries were eventually recorded by Emery Molyneux at the behest of William Sanderson around 1590 and put on Molyneux's famous globe engraved by Hondius in 1592.

Lit.: LB 1(1); Quinn, pp. 460–1; ECM 59; PH&DBQ 110, pp. 55–6; PH 59; Cumming, pp. 53–4, Quinn, pp. 841–50; Baldwin, pp. 17–25 and Barber, p. 31

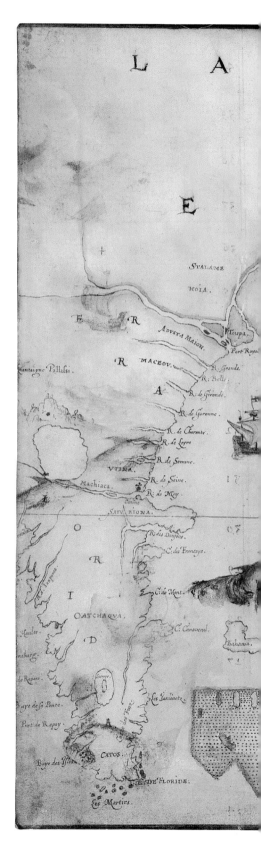

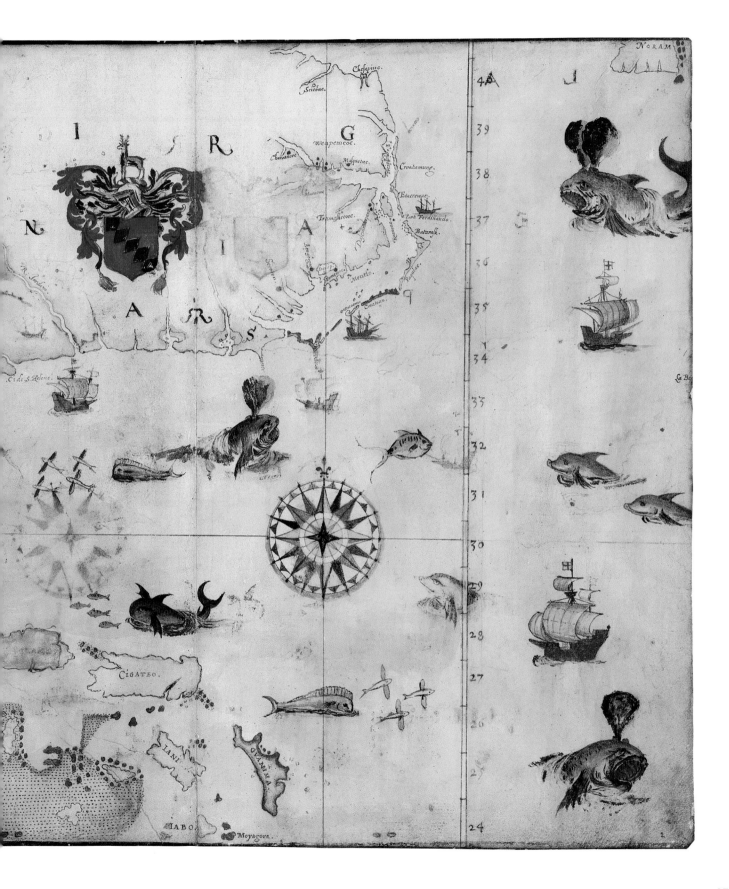

3 Coastal profiles of Dominica and Santa Cruz

Pen and brown ink over black lead, with watercolour, 243 × 217 mm

Inscribed in brown ink: 'The Risinge of the Ilande of Dominica'; above the scale, 'This Scale Contaynethe xxx: myles'; and at bottom, 'The Risinge of the Ilande of Santicruse'

Verso: a faint profile of the same part of the coast of Dominica, in black lead

1906,0509.1.36

Coastal profiles were essential records for any voyage, as they helped mariners to recognize the land they were approaching and assisted them in steering a course through islands or along a coast. In the West Indies they were also particularly important for identifying sites where English ships could land to take on water and provisions and avoid encountering the Spanish. Like charts, such drawings were probably circulated; when a ship was captured, the most valuable of the prizes on board were the charts and maps for navigation. From the seventeenth century when drawing was taught professionally to young seamen in the British navy, coasting prospects were an important part of their lessons.

According to the scale given here, each of these profiles represents about 40 miles of coastline. The course across the Atlantic from the Canaries and the Cape Verde Islands was directed by the currents towards Dominica and the recognition of its coastline was a cause for celebration.

White's expedition made landfall there on 7 May 1585, when this drawing was probably made; from there the course lay towards St John's Island (now Puerto Rico), via Santa Cruz (St Croix) as seen in the chart of Drake's voyage below.

The handwriting on this drawing is not the same as that on the rest of the drawings and for this reason the attribution of the drawing to White has been doubted. However, as the official artist, White was probably required to make many of these prospects for future use by Raleigh's mariners and they might have been labelled by the captain, navigator, master or another member of the ship's crew.

Lit.: LB 1(37); Quinn, pp. 159–60, 403; ECM 2; PH&DBQ 2; PH 2; H. Miller, pp. 30, 35–6

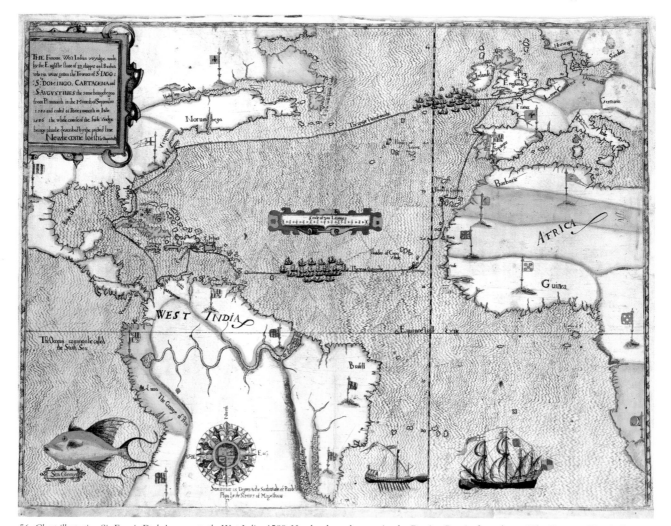

56. *Chart illustrating Sir Francis Drake's voyage to the West Indies*, 1589. Hand-coloured engraving by Baptista Boazio from the set 'The Famouse West Indian Voyadge…', Leiden, 1588, London, 1589 (see also figs 57, 120). Also Bigges' 1589 account. Drake's route (stopping at Virginia) was similar to Grenville's, apart from the detour Drake made to sack the Spanish towns. The 'Sea Coney' is based on no. 57. National Maritime Museum, Greenwich (Caird Library, C4053)

The Risinge of the Ilande of Domınica

This ſcale Comaynethe xxx: myles

1	2	3	4	5																									
		5				10				15			20			25			30										
		10						20						30															

The Risinge of the Ilande of Santicruſe.

4 Plan of a fortified encampment at Mosquetal (Tallaboa Bay), Puerto Rico

Pen and brown ink over black lead, and watercolour, on two conjoined sheets, 363 × 445 mm

Inscribed in brown ink: within a red border, 'THE xjth of Maie the Generall in the / Tyger arriued at St Iohns Iland where / he fortified in this manner, toke in fresh / water, and buylt a Pynnes, And then / departed from thence the xxiijth of the / same moneth. 1585.'; with various items labelled on the image and to right, 'The manner of / drawing in of tymber, / into the fort for the / buylding of a Pynnes.'

1906,0509.1.4

This bird's-eye view depicts the fortified camp set up on the Spanish-held Puerto Rico (then called St John's by the English) where they would rendezvous with the rest of the fleet, scattered during the crossing. The Spanish were keeping an eye on them from nearby San German and the English needed protection while taking in water and building a new pinnace for the *Tyger*. The drawing shows clearly the extensive entrenchments they had quickly thrown up after their arrival on 11 May and the area cleared around the camp's inside edge. It also shows horses they had captured from the Spanish and the buildings they erected for the General (Grenville) in the south end and for Mr Lane to the north. Water was provided from the river (a boat is bringing barrels on the left) and from the small lake to the north-east, here filled with crabs, ducks and a heron. They began building the pinnace, as depicted here, on the 13th and it was finished on the 23rd, the day after

Grenville returned from an expedition to arrange a truce with the Spanish who had been harrying them. He foresaw a threat from them and he fired the buildings and tore down the embankments the next day before leaving with the *Elizabeth*, which had arrived on the 19th.

The complicated earthworks and fortifications and all their elements are described clearly and accurately using appropriate shading and colouring. The activity of each man is carefully delineated, from those standing guard at various points inside the fort to those working the forge to make nails, building the pinnace, bringing wood from the forest, providing an armed escort, or the party emerging from the woods to north. The *Tyger* is shown at anchor and to the right of it are offsets of the men shown on the left, welcoming Grenville (on horseback) and his party back from their expedition by firing their muskets.

The scene is not engraved in de Bry's account of Virginia but is very similar to those engraved by Boazio to relate Drake's victories in Santiago, St Augustine, etc. (see figs 56, 57). With the image of the fort erected while they gathered salt (no. 5), it demonstrates beyond doubt that White was already accomplished at the type of measured, scaled, cartographic drawing required by the military as well as the navy – as described in the various requirements for the draughtsmen-cum-surveyors-cum-cartographers who were to accompany these expeditions (see p. 41).

Lit.: LB 1(3); Quinn, pp. 160–62, 181–3, 403–4; ECM 3; PH&DBQ 3; PH 3

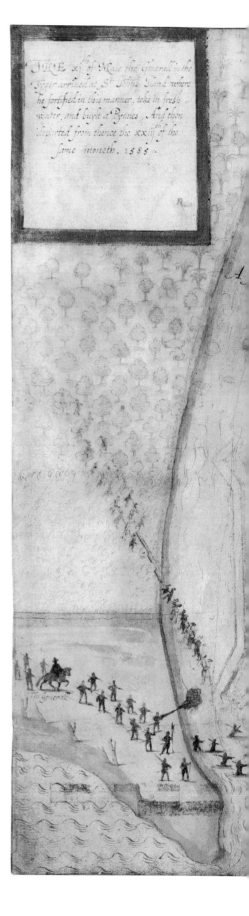

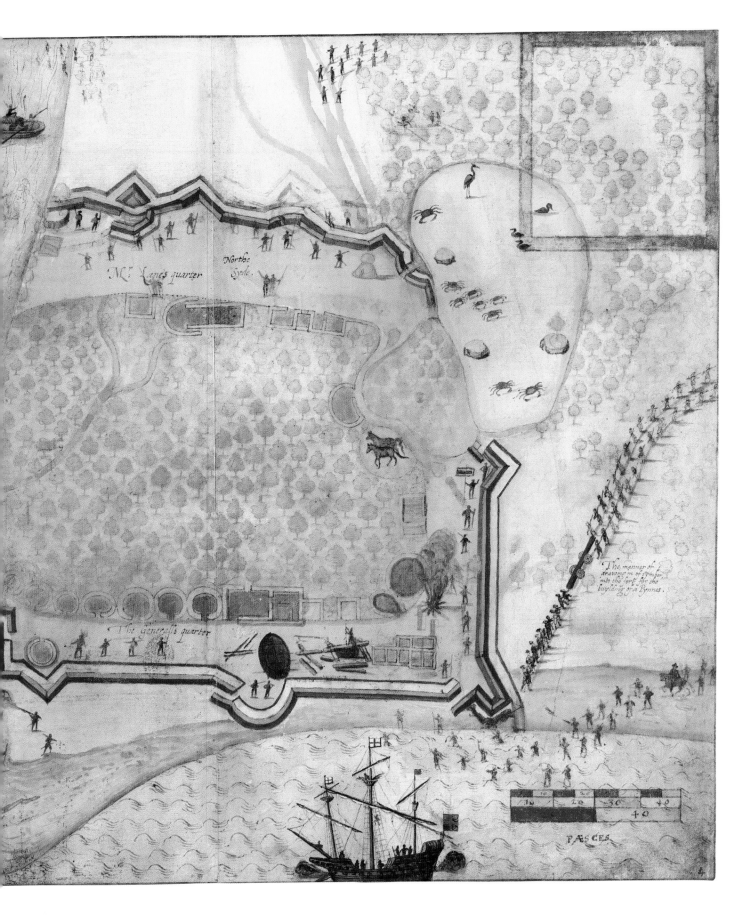

5 Plan of an entrenchment near Cape Rojo, Puerto Rico

Pen and brown ink over black lead, with watercolour and white bodycolour, 315 × 220 mm

Inscribed in brown ink: 'The forme of a fort wch was made by M: / Ralfe Lane in a parte of St Iohns Ilande / neere Capross where we toke in salt / the xxvjth of May. 1585.'

1906,0509.1.5

The form of the ship at anchor is different from the *Tyger* depicted in the previous image because it is a captured small Spanish frigate. On the 26th, after they left the earlier encampment, Grenville anchored in San German Bay and instructed Lane to take the ship and its Spanish pilot to direct him to a place around Cape Rojo to collect salt. The six Spanish prisoners and Lane's own twenty-five men are shown collecting the salt within entrenchments they had hastily erected around the precious mounds of salt, one in the centre and another in the bastion at the top. Some men stand guard while others remove the salt with pickaxes and put it into bags to carry to the ship. The entire operation, including erecting the remarkable entrenchments which apparently were enough to dissuade the Spanish who found them from even attempting to stop them, only took three days – Lane rejoined the English ships on the 29th when they all departed for Hispanola. Salt was a vital commodity as a preservative on voyages and for the future colony; taking from the Spanish supplies was a bold and, according to Lane, a dangerous move and it created friction between himself and Grenville which was to cause problems later.

White's attention to the details of the events and to the exact form of the entrenchments as well as the care he takes to show the correct flags, sails and particular design of the Spanish ship, all indicate an intimate familiarity with this type of record, whether through printed examples he may have seen in manuals or through examples by others. They are clearly not the work of a novice and appear to indicate this was not the first voyage he had accompanied as a draughtsman.

In Hispanola they were able to trade for supplies without hostility and White, no longer required to record encampments or fortifications, could concentrate on his natural history drawings of the exotic and useful plants, fish and birds they encountered.

Lit.: LB 1(4); Quinn, pp. 161–2, 183–5, 404–5; ECM 4; PH&DBQ 4; PH 4

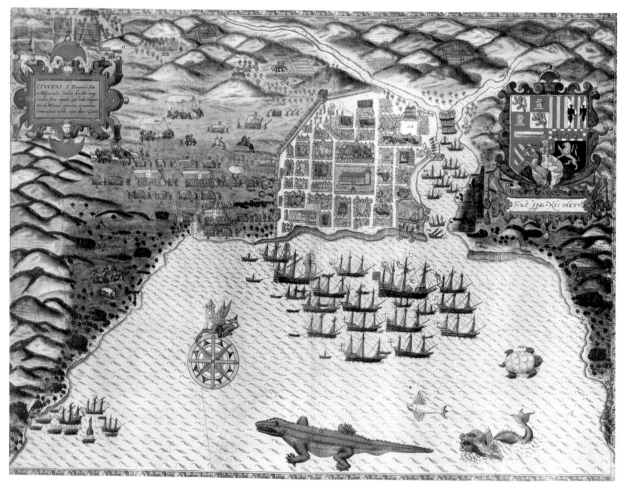

57. *Drake's capture of Santo Domingo*, 1589. Hand-coloured engraving by Baptista Boazio from the set describing Drake's voyage (see fig. 56). Boazio, an Italian artist working in London, knew White's natural history drawings. National Maritime Museum, Greenwich (Caird Library, C 4053 (245:8))

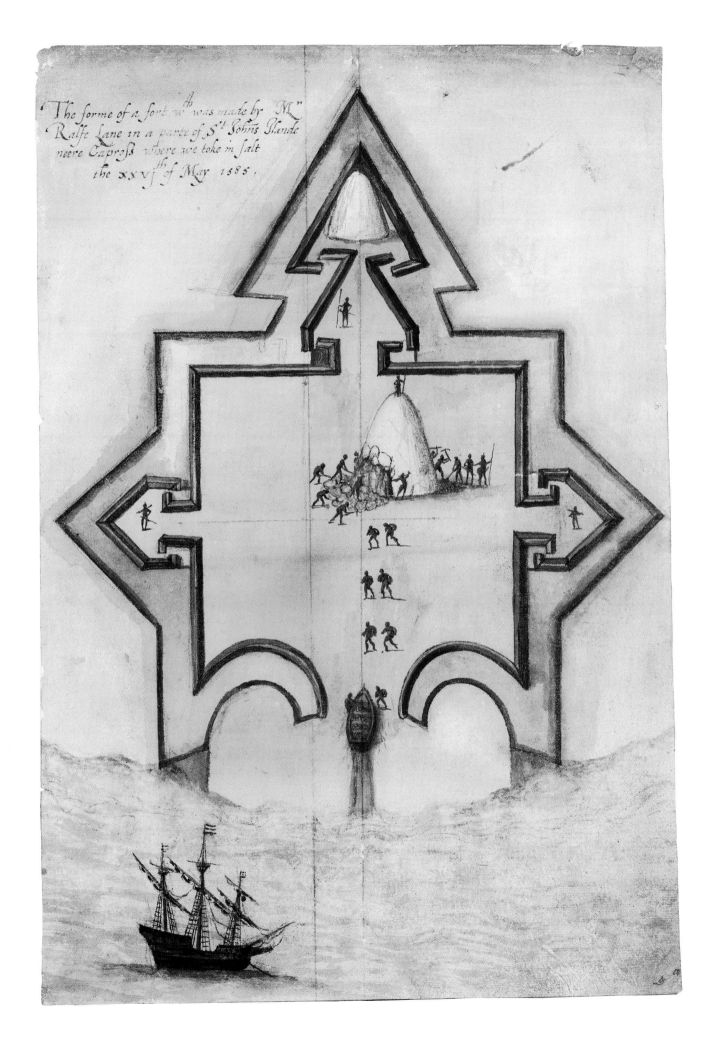

The forme of a fort w^{ch} was made by M^r Ralfe Lane in a parte of S^t Johns Ilonde neere Caproß where we toke in falt the $xxvj^{th}$ of May 1585.

6 La Virginea Pars: map of the East coast of North America from Chesapeake Bay to Cape Lookout

Pen and brown ink with watercolour over black lead, heightened with silver (altered) and gold, 480 × 235 mm

Inscribed: 'La Virginea Pars' and with names of villages, lakes, coastal features and scale

1906,0509.1.3

The first professional surveyors appeared in the sixteenth century alongside deep-sea navigation and new engineering for fortification and siege artillery, all of which went hand-in-hand with advances in mathematics, instrument making and mapping. The instructions to Bavin for Gilbert's voyage (see p. 42) did not only describe what to survey and draw on maps charting the coastline from the southern tip of Florida northwards, but also specifically mentioned the instruments to be used for surveying and the symbols to be used for trees, hills, rivers, and how to devise new ones for things 'strange to vs in England'. The surveying method used was probably the triangulation method, carried out on board ship, on small flat boats in coastal waters and also on land. A uniform scale for all measurements and drawings was essential and the cross staff, compass and, for surveying on land, the theodolite or plane table would have been the most useful tools to the team involved in their recording of capes, headlands, hills, inlets and rivers, land elevation and use. It has often been stated that Harriot took the measurements and White drew the maps but it was not as simple as that and it is likely that a team was involved and these beautiful final coloured maps by John White were based on numerous more detailed surveys and sketches.

This map of the area explored by Lane and Grenville, and mapped by Harriot and White, was described by Quinn as 'the most careful detailed piece of cartography for any part of North America to be made in the sixteenth century' (pp. 847–8). Its accuracy has been proved by being overlaid with a modern satellite photograph of the area, only the shifting shapes and breaks in the Outer Banks having changed over time. Grenville's larger ships, the *Tyger* and *Elizabeth*, are shown sailing past Cape Lookout and Wococon, another at anchor north of 'Hatrask' and smaller pinnaces and Indian canoes in Pamlico Sound to the south and Albermarle Sound to the north. Chesapeake is the large unnamed bay to the far north above England's coat of arms firmly planted in an area which is now, indeed, the state of Virginia. Raleigh's arms are just to the west of a lake labelled Paquippe (now Mattamuskeet). The towns of 'Pomeyooc' (on the north-east corner of the lake) and Secotan (on an inlet below the lake), both drawn by White, are clearly marked with red dots, along with others including Aquascogoc (just above Secotan) and Dasemunkepeuc, which is on the mainland opposite the island of 'Roanoac', entirely shaded red, as is Croatoan; the inhabitants of both these islands were of great assistance to the English.

Although this is similar to the one map included in de Bry's illustrated edition of Harriot's *Briefe and true report* (below), it was not the direct source. The cartouche on the left credits John White with the original which de Bry has engraved, incorporates elements from the larger map (no. 2), such as the mountains and inland extents of the rivers that are not included in this detail. De Bry also adds images taken from the series of drawings he also engraved, including the Pomeiooc mother with her child shown near the Chesapeake which is filled with English ships. In addition, the map is reoriented so that it appears as it would if one were facing the coast from England looking east, directly accessible to English ships, with friendly Indians greeting the colonists and rivers providing direct open access to the mineral-bearing mountains in the interior. England's coat of arms is firmly planted above the area called Secotan and Raleigh's surmount the cartouche over Chesapeake Bay, which echoes the words of White's own manuscript title page (no. 1) when translated from the Latin: 'Part of America now called Virginia, first discovered by the English at the expense of Sir Walter Raleigh in the year of our Lord 1585 in the twenty-seventh year of the reign of Queen Elizabeth. The true history of this is described in the separate book (Harriot's?) with the addition of picturing the inhabitants.'

Lit.: LB 1(2); Quinn, pp. 53, 461–2; ECM 60; PH&DBQ 111(a); PH 60; R&R, no. 56 (for satellite image); Cumming, pp. 55–6

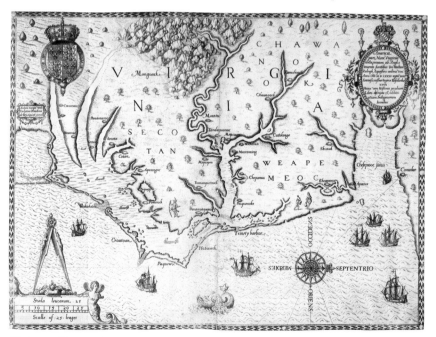

58. *A Map of that part of America, now called 'Virginia'*, 1590. Engraving by Theodor de Bry from Harriot, *A briefe and true report*, Frankfurt. Based on John White's maps (nos 2 and 6), although reoriented so that in the engraved map north is to the right. By permission of The British Library, London (c.38.i.18)

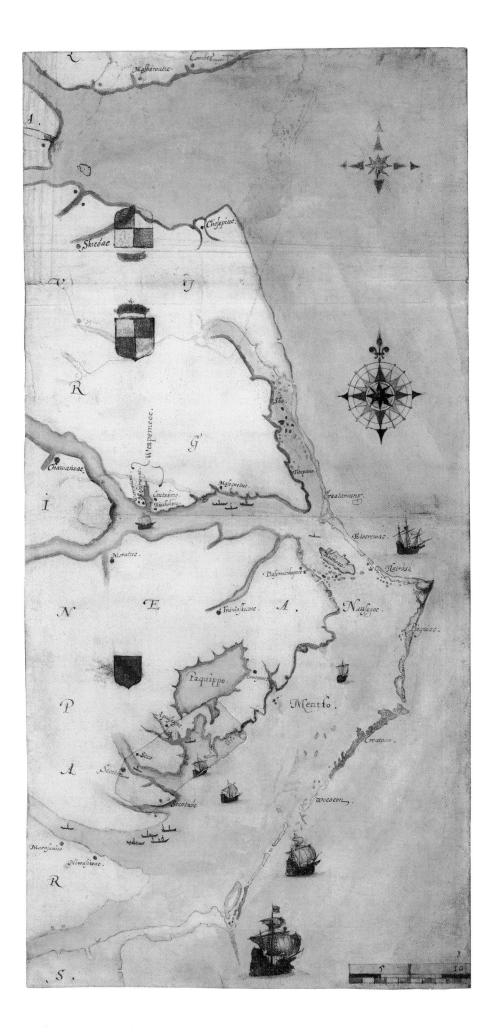

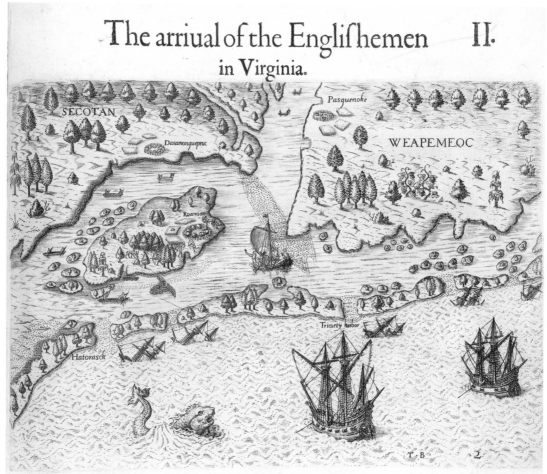

THe sea coasts of Virginia arre full of Iláds, wehr by the entrance into the mayne lãd is hard to finde. For although they bee separated with diuers and sundrie large Diuision, which seeme to yeeld conuenient entrance, yet to our great perill we proued that they wear shallowe, and full of dangerous flatts, and could neuer perce opp into the mayne lãd, vntill wee made trialls in many places with or small pinnesí. At lengthe wee fownd an entrance vppon our mens diligent serche therof. Affter that wee had passed opp, and sayled ther in for a short space we discouered a migthye riuer fallnige downe in to the sownde ouer againft those Ilands, which neuerthelesse wee could not saile opp any thinge far by Reason of the shallewnes, the mouth ther of beinge annoyed with sands driuen in with the tyde therfore saylinge further, wee came vnto a Good bigg yland, the Inhabitante therof as soone as they saw vs began to make a great an horrible crye, as people which meuer befoer had seene men apparelled like vs, and camme a way makinge out crys like wild beafts or men out of their wyts. But beenge gentlye called backe, wee offred thé of our wares, as glaffes, kniues, babies, and other trifles, which wee thougt they deligted in. Soe they stood still, and perceuinge our Good will and courtesie came fawninge vppon vs, and bade us welcome. Then they brougt vs to their village in the iland called, Roanoac, and vnto their Weroans or Prince, which entertained vs with Reasonable curtesie, althoug the wear amased at the first sight of vs. Suche was our arriuall into the parte of the world, which we call Virginia, the stature of bodee of wich people, theyr attire, and maneer of lyuinge, their feasts, and banketts, I will particullerlye declare vnto yow.

59. *The arrival of the Englishmen in Virginia*, 1590. Engraving by Theodor de Bry, pl. II in Harriot, *A briefe and true report*, Frankfurt. The scene shows the Englishmen approaching in a ship's boat, with pinnaces and larger ships sunk in the shoals and at anchor further offshore. There may not have been an original drawing of this map by White, de Bry basing his engraving instead on White's other drawings, the written account and the map in fig. 58 where the three villages of Pomeiooc, Aquascogoc and Secotan are clearly marked. By permission of The British Library, London (c.38.i.18)

On 11 July 1585 Sir Richard Grenville, leader of Raleigh's expedition to Virginia, set out from Wococon in the pinnace and three boats with sixty men, presumably including White and Harriot, to explore this part of the mainland across Pamlico Sound. They arrived at Pomeiooc the next day. It is not clear whether the people there were part of the Secotan tribe or the Roanoke who inhabited that island and the land around it. The party visited Aquascogoc (of the Secotan tribe) on the 13th and arrived at Secotan two days later. The village of Secotan was the chief town of the people of that name (later called the Machapunga) in the Pamlico area to the west of Wococon. All these villages are clearly marked on White's map (no. 6).

The party set out to return the next day, exploring the Neuse River *en route*, but one boat was sent back to Aquascogoc under Philip Amadas to recover a missing silver cup. When they failed to find it, they burnt the then deserted village and its cornfield. This was the beginning of deteriorating relations with the people of this area, which later worsened as the English demanded food and the Indians exposed to diseases carried by the English began to die everywhere they had passed through (Harriot, p. 28).

The English party arrived back at Wococon on 18 July and, in the meantime others had begun to build the small fort and buildings on the island of Roanoke under Ralph Lane. Manteo, a man from Croatoan who had been brought back from England (where he had been taken in 1584), helped to negotiate with the Indians. These included Wingina, the king or *werowance* ('he who is rich') of the village of Dasemunkepeuc on the mainland and of Roanoke on the island where his brother Granganimeo was *werowance*. The English were not clear whether the title meant chief or king; they seemed to use the title for any member of the Indian aristocracy and the Indians in turn used the title for all the English, whose dress, weapons and 'magic'

scientific instruments clearly indicated their wealth and status.

Some exploration of the north bank of the Albermarle Sound was also made, and White's map shows the villages there, but none of his drawings is of the people there; this may indicate that others did the surveying and he recorded the information on his maps later. All of White's watercolours depict people and scenes he would have encountered in July and August, on the mainland and Roanoke, which, as discussed in Chapter 3, seems to indicate that he returned to England at the end of the summer, rather than staying over the winter with Harriot and Lane's men, as has always been assumed.

The many layers and purposes of his approach to depicting the North Carolina Algonquians and their villages are discussed in Chapters 4 and 5. In some ways they are depicted as though acting out their lives on a stage for the English – a theatre of the New World. But White also presents their culture as complex and sophisticated, using categories that his English audience would recognize: they live in villages that resemble English ones with central greens and lanes and protective walls, their lives were led by a civil government supported by an official agricultural system and an organized religion with an annual round of ceremonies. They were technically proficient and interested in new products. They were loving parents and recognized distinctions of rank, age and gender – many of them indicated by their clothing and jewellery, just as clothing in Elizabethan society was regulated by sumptuary laws.

It is worth noting that the order of White's drawings as they were in his original album, which has been reconstructed in the present book, also reveals something of the English attitude. Travel accounts and cosmographers employed a taxonomic tradition that was followed by all sixteenth-century humanist 'collectors of customs', engaging

in social enquiry that was a kind of early 'ethnography' – collecting manners and customs and filing and arranging them in different categories, just as they did with the flora and fauna and the practical information about commodities, trade, military or geographic issues. Costume books and cosmographic atlases which showed the costumes of the world, such as Ortelius's *Theatrum orbis terrarum* (1570), illustrated this English and European attitude and approach to understanding people around the world, not only those of the New World. As early as 1516 Thomas More, in his description of the Utopians, described their religion, institution of marriage and family, rites of the dead, dwelling, apparel etc. In his *Divers Voyages* published in 1582 Richard Hakluyt provided such a list for the guidance of merchants and travellers who needed to report back with cultural information: marital customs, funeral and religious rites, dress, dwellings, diet. These are indeed the categories listed in the manuscript instructions intended for Gilbert's voyage discussed on p. 42. In the caption for the map opposite, Harriot accordingly states his intention to describe their attire, manner of living, feasts and banquets. Nearly every one of White's drawings is carefully labelled with a brief explanation of the information conveyed and an occasional Algonquian term, spelt phonetically. White's categories in his scenes of Indian life cover hunting, fishing, eating, religion, burial rites and other ceremonies, and family and society groups. But it is also important to note that this information is conveyed through sympathetically drawn portraits of real (although unnamed) individuals which not only provide information about their status, stature, apparel and weapons but also something of their personal character, just as a portrait of a contemporary English person would do.

Lit.: See introductory essays to PH&DBQ and to PH; see also Hodgen and more recently see Chaplin 2000 and especially Kupperman 2000

7 Indians fishing

Watercolour over black lead, touched with
bodycolour and gold, 353 × 235 mm

Inscribed: 'The manner of their fishing' and 'A
Cannow'

1906,0509.1.6

The people of Secotan and Pomeiooc
were surrounded by a wealth of natural
provisions in the land and the sea but it is
doubtful that the sea ever proved quite as
easy to harvest and as plentiful as John
White depicts here or the even more
bounteous scene in de Bry's engraving
intended to encourage English colonists.
But from February to May the North
Carolina Algonquians were dependent
upon it and upon hunting, as their corn
was planted then and not ready for harvest
until later in the summer. Each village
probably contained one to two hundred
souls to feed, so the inhabitants had to be
industrious and the food was probably
never really plentiful enough in the
immediate area to support a further one
hundred hungry Englishmen with whom
they were asked to share.

Various methods of fishing are shown
here and described by Harriot in the text,
including night fishing with a fire to
attract the fish to the boat, spears barbed
with fish bones or king crab tails, nets
(which Harriot does not describe) and
weirs or traps, which Harriot describes as
of a more complicated form than the
simple square seen here. In fact, Ralph
Lane's account stated that the English
were later dependent upon the weirs the
Indians built for them for food and, when
relations soured, Indians came at night and
destroyed them and the English were not
able to repair them.

The varieties of fish depicted here
include a catfish (far left), a burrfish (in
front of the trap), a skate in the trap,
hammerhead shark, sturgeon and king
crab, and in the engraving a gar,
loggerhead turtle and land crab. Some of
these extra fish in the engraving may have
been in lost drawings by White; others
may have been in drawings de Bry owned
by other artists, such as Le Moyne, of other
parts of America. White himself added
hermit crabs to the foreground for artistic

effect, forgetting that he had seen them in
the West Indies but not here. He correctly
depicts a brown pelican, swans, geese and
ducks in the sky above and more canoes
and wading fishermen in the distance. The
dug-out canoe is of the type shown being
made in another engraving by de Bry (fig.
61), which depicts a method in use in this
area for thousands of years. A group of
thirty of these canoes was recently
discovered in the mud of Lake Phelps (in
what is now Pettigrew State Park, north of
Lake Mattamuskeet) where they had been
stored over the winters between 2400 BC
and AD 1400. They were made by splitting a
cypress log, then burning and scraping out
the interior with shells, a lengthy and
laborious process. Some were over 35 feet
long. There is no original drawing of this
canoe-making scene by White and there
may not have been one: Harriot's description
is so clear it would have been
straightforward for de Bry to create this
composition from the images he had to hand.

Lit.: LB 1(5); Quinn, pp. 432–5; ECM 43; PH&DBQ
46(a); PH 43; for Lane's account see Quinn, pp. 282–3

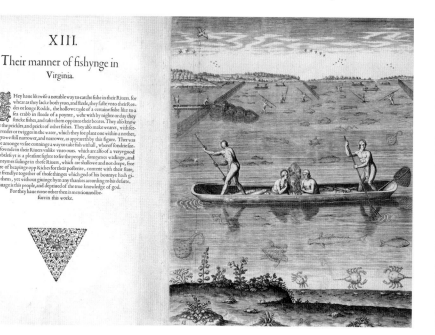

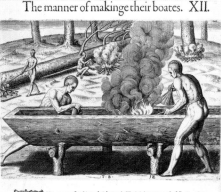

60–61. *Their manner of fishing in Virginia* and *The manner of making their boats*, 1590. Engravings by
Theodor de Bry after John White, pls XIII, XII in Harriot, *A briefe and true report*, Frankfurt. By permission of The British Library, London (c.38.i.18)

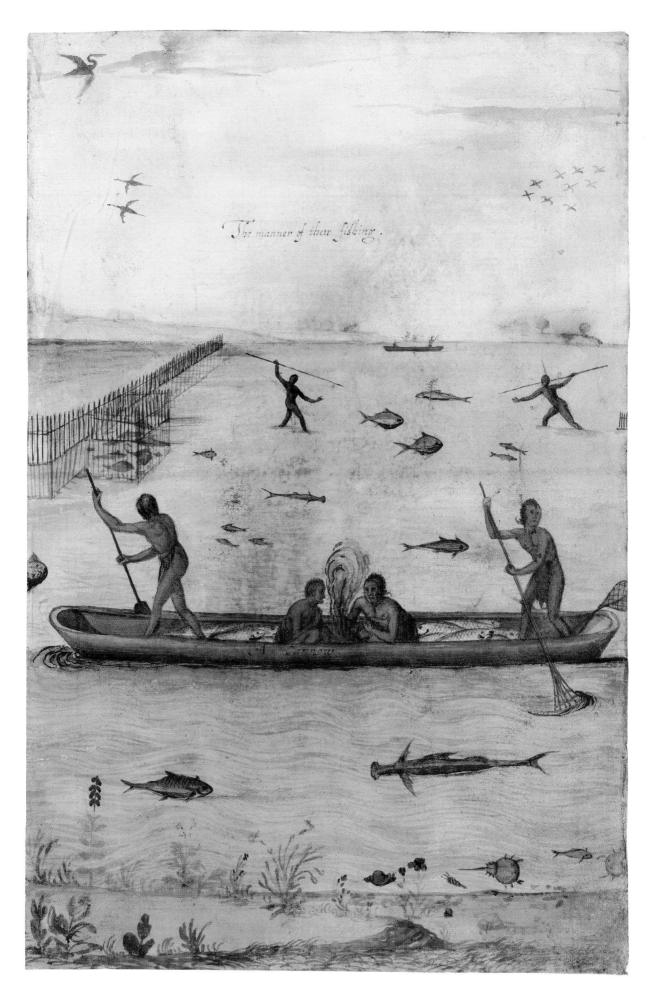

The manner of their fishing.

8 The town of Secotan

Watercolour over black lead, heightened with bodycolour (altered), 324 × 199 mm

Inscribed in brown ink with notes

1906,0509.1.7

The two towns recorded by White, Secotan and Pomeiooc, represent the two main types found in the area – palisaded (similar to a type found in Florida to the south) and open, as represented here. They contained a few dozen houses at most around a central open space with no rigid plan. The towns were sited near the coast or inland waterways for fishing and transportation. Soil near water was also richer and thus better for growing corn; but rainfall in the summer in this area is not reliable enough to guarantee several harvests every year (and the time of White's visits has been documented as a time of drought), and the people also hunted and gathered wild herbs and plants, carefully recorded for their medicinal, food and commercial properties by Harriot. They did not occupy their towns all year round or always return to the same site. Corn cultivation was relatively new to the inhabitants (introduced around AD 900) but they had developed a way of growing it in mounds surrounded by beans which gave nitrogen to the soil and increased the yield – far greater than the European method of ploughing and planting alone in rows. Maize was used in a variety of ways and provided a good proportion of their food (see no. 24).

The houses were made of bark or reed mats, which could be lifted for ventilation. The roofs were rounded for greater stability and the various shapes of the buildings seen here are probably indicative of different functions, with closed structures for storage and ceremonial purposes and open-sided houses for living spaces, especially in the summer. They were mainly for sleeping and storage, with a central hearth used for cooking and smoking fish. There were sheds providing shelter from sun or rain for drying frames and for carrying out group work, although none is visible in White's views.

White took most care here in depicting the activities of the people in the town: guarding the corn, which he indicates was sown in three stages (so it was ready for harvest from late July until September); 'sitting at meate'; their place 'of solemne prayer'; the 'Tombe of their Herounds'; and the 'Ceremony in their prayers' around posts carved with faces, while others rest on the sides. Some detail was lost through water damage to the drawing, but Harriot's accompanying written account has led de Bry to add further details including a hunting scene and plots of tobacco, sunflowers and pumpkins, and he has tidied up the scene considerably to make neat pathways and gardens rivalling those of an English country house.

Lit.: LB 1(6); Quinn, pp. 420–23; ECM 36; PH&DBQ 38(a); PH 36; Kupperman 1980, pp. 45–6; Rountree & Turner, pp. 14–22

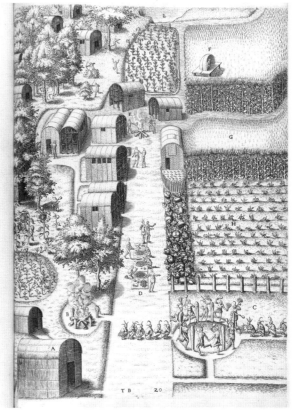

62. *The town of Secotan*, 1590. Engraving by Theodor de Bry after John White, pl. XX in Harriot, *A briefe and true report*, Frankfurt. By permission of The British Library, London (c.38.i.18)

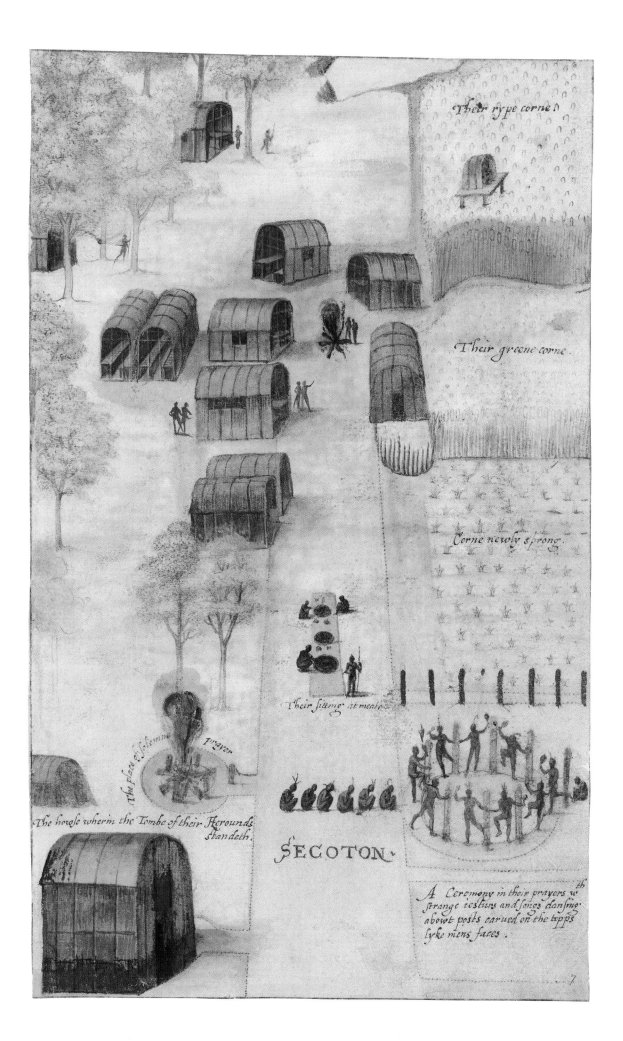

Their rype corne

Their greene corne.

Corne newly sprong.

Their sitting at meate.

The place of solemne prayer.

The howse wherin the Tombe of their Herounds standeth.

SECOTON.

A Ceremony in their prayers wth strange iestures and songes dansing abowt posts carued on the topps lyke mens faces.

7

111

9 The town of Pomeiooc

Watercolour and bodycolour over black lead,
heightened with gold, 222 × 215 mm

Inscribed in brown ink: 'The towne of Pomeiock and
true forme of their howses, couered / and enclosed some
wth matts, and some wth barcks of trees. All compassed /
abowt wth smale poles stock thick together in stedd of a
wall.'

1906,0509.1.8

Some of the houses in the fortified town of
Pomeiooc are longhouses, the furthest
south this distinctive type has been
recorded in North America, their sides
open to show the long sleeping benches
inside. There are also some oval or round
houses of the type described in use by the
Powhatans in Chesapeake. The engraving
after the drawing labels only the 'king's
lodging', the largest longhouse and the
'tempel', the strangely pointed roof of
which is covered with skins rather than
bark or mats. The description provided by
Harriot mentioned a pond dug to provide
water and three can be seen in the Sloane
volume version of this drawing, along with
fields of corn at various stages and people
seated in the large central house which
here has a pointed roof like the temple. De
Bry included a pond and sunflowers and
one field of corn, indicating that the
drawing he had from White was closer to
the album version. The fire in the centre of
the town acted as a social focal point;
people in the various versions are shown
with bows, an axe and a dog – an important
record of the domestic dog kept by Indians
in North America before they began to
breed with the large hunting dogs brought
by the English.

The people in this town and Secotan are
shown involved in all kinds of activities that
support civil life. As Karen Kupperman has
noted, 'White and Harriot together argued
in the most forceful and effective way that
the American natives were social beings,
possessing all the characteristics necessary
to civility: community life and the family
structure, hierarchy, and orderliness that
made it possible; care for the morrow by
cultivating and preserving foods; and all
informed by a religious sensibility that
honoured the human dependence on
supernatural forces in the universe.'

Lit.: LB 1(7); Quinn, pp. 415–17; ECM 32; PH&DBQ
34(a); PH 32; Kuppermann 1984, pp. 73–5; and
Kupperman 2000, p. 144

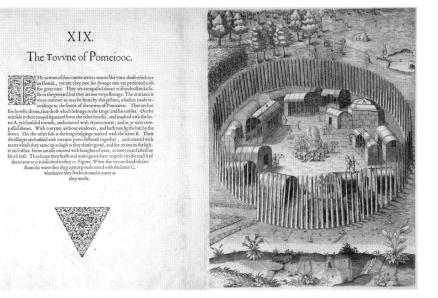

63. *The town of Pomeiooc*, 1590. Engraving by Theodor de Bry after John White, pl. XIX in Harriot, *A
briefe and true report*, Frankfurt. By permission of The British Library, London (c.38.i.18)

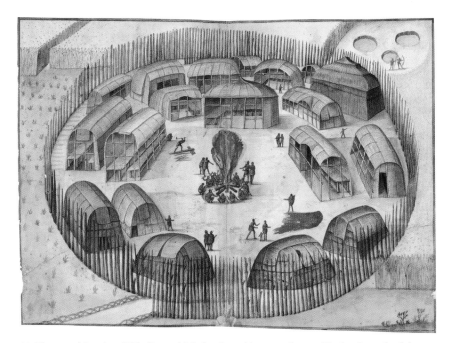

64. *The town of Pomeiooc*, 1580s. Pen and ink drawing with watercolour and bodycolour, after John
White?, from the Sloane volume. There is an eighteenth-century copy made for Sloane in the BL
(Add MS 5253,14). British Museum (P&D SL,5270.2v, 3r)

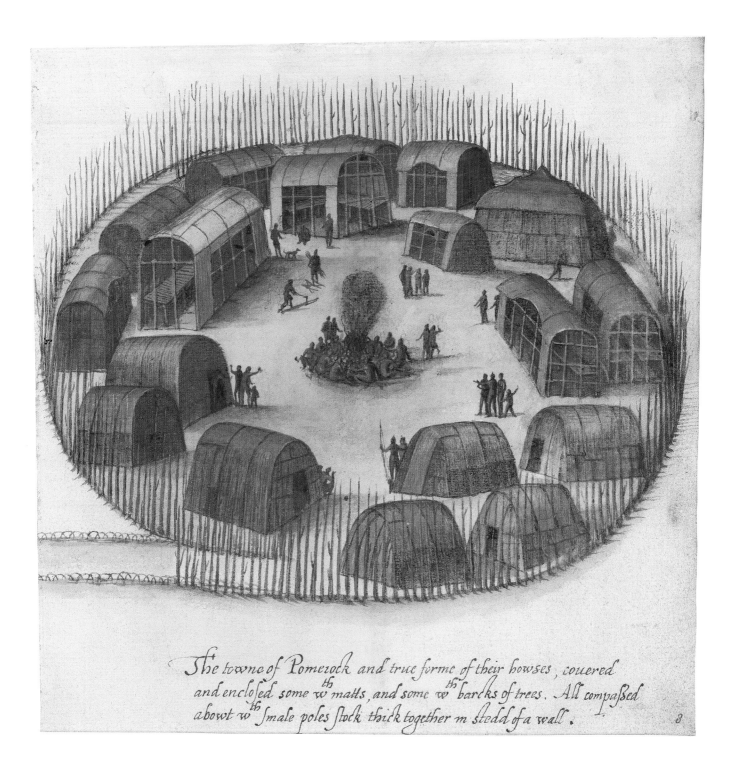

The towne of Pomeiock and true forme of their howses, couered
and enclofed some w^th matts, and some w^th barcks of trees. All compaſſed
abowt w^th ſmale poles ſtock thick together in ſtedd of a wall. 8

10 An ossuary temple

Watercolour over black lead, touched with bodycolour and gold, 295 × 204 mm

Inscribed in brown ink: 'The Tombe of their Cherounes or cheife personages, their flesh clene taken of from the bones saue / the skynn and heare of theire heads, wch flesh is dried and enfolded in matts laide at theire / feete. their bones also being made dry, ar couered wth deare skynns not altering / their forme or proportion. With theire Kywash, which is an / Image of woode keeping the deade.'

1906,0509.1.9

This drawing by White is an important record of the North Carolina Algonquians' veneration of their dead chiefs or *werowances* and the preservation or mummification of their bodies. The skin on their bodies was pulled back and the flesh inside removed, sun-dried and placed in the mats that were laid at their feet. The skeletons were then covered with leather and the skin replaced. They were laid in the temple on a platform with a ceremonial fire kept in front and a painted wooden idol, Kiwasa, sat guard. The temple, shown in the view of Secotan, was not open as depicted here; White has drawn the reed mats up in order to help see inside. De Bry added a priest, mentioned in the text, and inserted the entire structure on stilts inside another building not indicated in the drawing.

There is no original drawing by White for the de Bry engraving titled 'Ther Idol Kivvasa' and there are no buildings depicted in any of the towns that resemble the round one here – in the caption, the idol is described as in the temple 'as the keper of the kings dead corpses'. Harriot's text describes the idol fully but not quite well enough to provide the details given here, and it seems therefore that an original drawing once existed, though probably of the idol only. Harriot pointed out that the head resembled that of the Florida Indians and certainly the style appears to be similar to those found in Le Moyne's drawings, which White was familiar with (see no. 19) (see also fig. 42 and pp. 74–5). As in many of the other captions, Harriot uses this one to further his Protestant message that the people were ignorant of the Christian God but already 'verye Desirous to know the truthe' and might easily be brought 'to a knowledge of the gospel'.

Lit.: LB 1(8); Quinn, pp. 425–7; ECM 38; PH&DBQ 41(a); PH 38; Kupperman 1980, pp. 53–6; and see also Michael Gaudio, 'The space of idolatry: reformation, incarnation and the ethnographic image', *Res* 41, Spring 2002, pp. 72–91

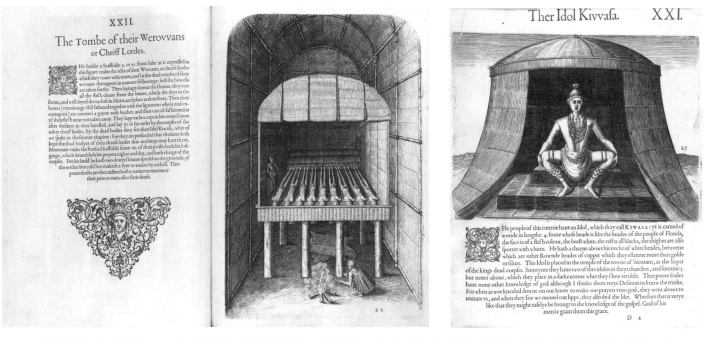

65–66. *The tomb of their 'werowances' or chief lords* and *Their idol, Kiwasa*, 1590. Engravings by Theodor de Bry after John White, pls XXII, XXI in Harriot, *A briefe and true report*, Frankfurt. By permission of The British Library, London (G.6837 and c.38.i.18)

The Tombe of their Cherounes or cheife personages, their flesh clene taken of from the bones save
the skynn and heare of theire heads, wth flesh is dried and enfolded in matts laide at theire
feete. their bones also being made dry or couered wth deare skynns not altering
their forme or proportion. With theire Kywash, which is an
Image of woode keeping the deade. ✕ ✕ ✕ ✕ ✕

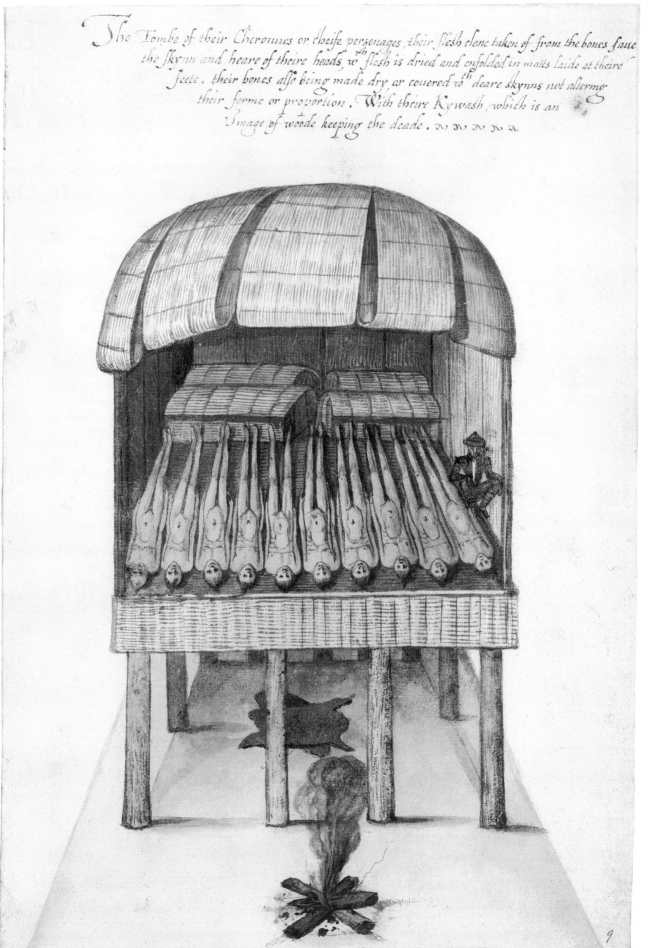

11 A festive dance

Watercolour over black lead, touched with
bodycolour including white (altered), on a folded
sheet with offsetting, 274 × 358 mm

1906,0509.1.10

In July John White painted Secotan (no.
8), where this same religious ceremony,
possibly a Green Corn Festival, is shown
in the village context. They probably did
not rotate crops as has sometimes
mistakenly been suggested (originally in
Barlowe's 1584 account), by planting
early, harvesting and then planting again.
Instead, as is clear in White's view of
Secotan, the corn was planted in
successive fields through the spring, a few
weeks apart, so that it ripened through the
summer and into the fall.

Harriot records that the special feast
recorded here was attended by people
from neighbouring towns, 'euery man
attyred in the most strange fashion they
can deuise hauinge certayne marks on the
backs to declare of what place they bee'.

They danced and sang, shaking gourds or
small pumpkin rattles and arrows and
using the strangest gestures they could
devise with three 'fair virgins' in the
centre. The offsetting here on this sheet
that was folded down the centre creates a
rather confusing effect, but many of the
figures are shown wearing or carrying
branches with leaves, which actually
resemble tobacco or branches from trees
more than corn, and several have pouches
at their belts, containing tobacco and
personal items. Women joined the men in
the dancing, which must have been
strenuous, as they went out of the circle
when tired and rested before coming in
again, as is seen clearly in the town scene
(no. 8). Englishmen would have been
familiar with Maypole dancing and
mummers, so would not have found this
quite as strange as we might assume. The
virgins in the centre were not necessarily
connected with fertility or with the 'three
sisters' ritual recorded amongst Iroquoian
tribes who used the term for corn, beans

and squash. The veiled heads carved on
the poles were not explained by Harriot
but they presumably had a religious
symbolism connected with their deities.
Similar poles were described in later
accounts of other tribes in various
locations throughout the east.

In the following century, Englishmen
at Jamestown on the Chesapeake
recorded dancing nearly every evening
amongst the Powhatan Indians, who
danced to celebrate harvest or victories,
greet guests or simply because they
enjoyed it. The latter was probably a
mistaken assumption, as most dances were
largely religious in nature. It was a useful
way to promote community spirit and
cohesion within a tribe and to use up
excess energy which might otherwise be
channelled into aggression.

Lit.: LB 1(9); Quinn, pp. 427–8; ECM 39; PH&DBQ
42(a); PH 39; see also Feest 1978, pp. 278–9;
Kupperman 1980, pp. 53–4; Rountree 1989, pp. 98–9

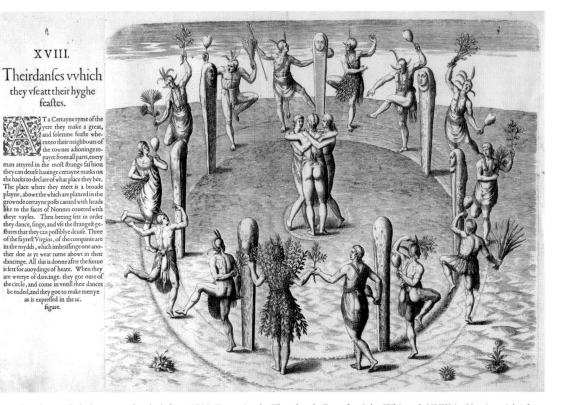

67. *Their dances which they use at their high feasts*, 1590. Engraving by Theodor de Bry after John White, pl. XVIII in Harriot, *A briefe
and true report*, Frankfurt. By permission of The British Library, London (c.38.i.18)

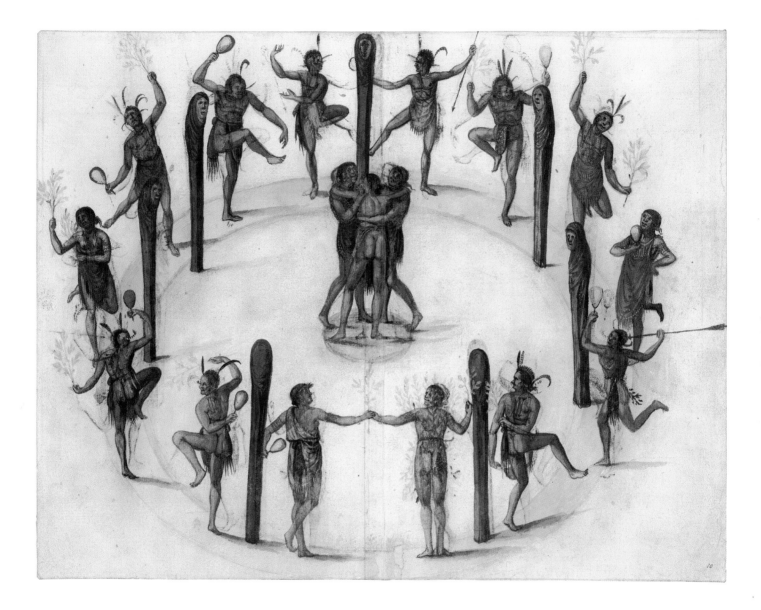

12 A fire ceremony

Watercolour and bodycolour over black lead,
heightened with white and gold, 218 × 202 mm

1906,0509.1.11

Harriot recorded that one of these thanksgiving fire ceremonies, which celebrated escaping danger or when returning from war, took place while he was amongst the villagers; this is also recorded in the watercolour of Pomeiooc (no. 9). The de Bry engraving is set by the water rather than in the village, further evidence that White's watercolours used by de Bry did not have landscape backgrounds and the engraver supplied them using the caption for clues and his own skill and imagination. The man (or woman) with long hair who seems to be conducting the ceremony from behind the fire is omitted in the engraving. There was a cross reference from the Pomeiooc village caption to this engraving, but in the caption for the print here the ceremony is described as a manner of praying, while in the Pomeiooc view it was described as keeping a feast and making good cheer. There may have been some confusion with the 'place for solemn prayer' shown in the Secotan village scene.

The figures in the watercolour and the engraving are the same, but, unusually, they are reversed. White has paid particular attention to the facial gestures in this watercolour but unfortunately the details have been lost in the water damage. Here an extensive amount of gold has been used to depict the flames.

Lit.: LB 1(10); Quinn, p. 429; ECM 40; PH&DBQ 43(a); PH 40

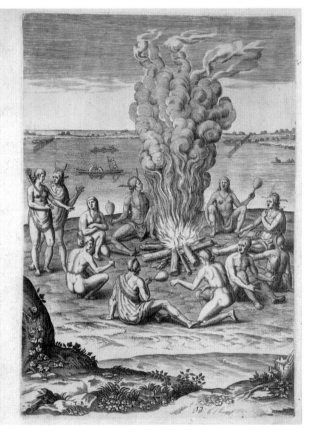

68. *Their manner of praying with rattles about the fire*, 1590. Engraving by Theodor de Bry after John White, pl. XVIII in Harriot, *A briefe and true report*, Frankfurt. By permission of The British Library, London (c.38.i.18)

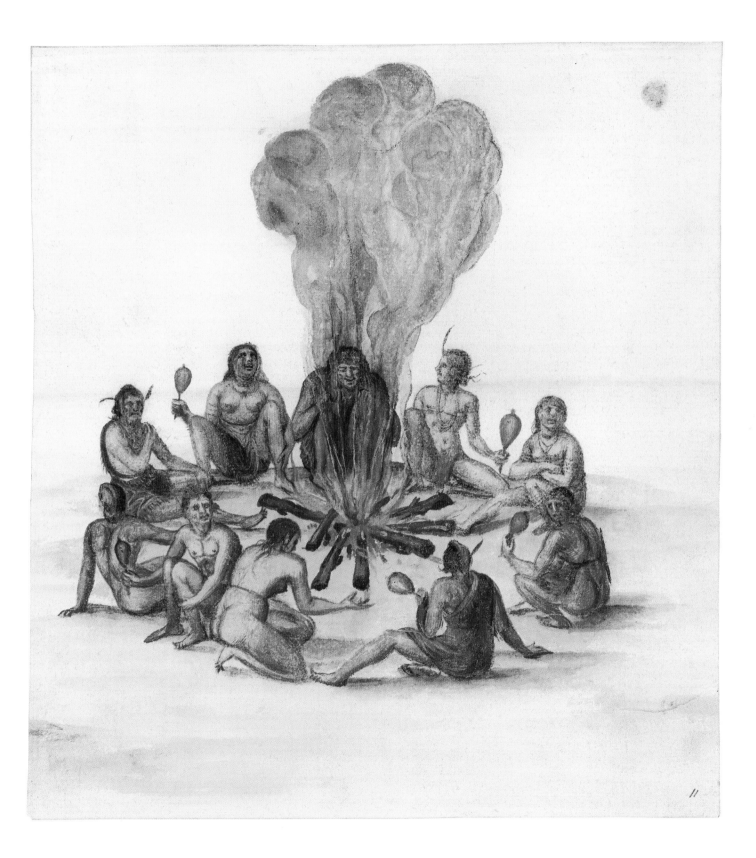

13 An Indian *werowance*, or chief, painted for a great solemn gathering

Watercolour over black lead, touched with bodycolour, white (altered) and gold, 263 × 150 mm

Inscribed in brown ink: 'The manner of their attire and / painting themselues when / they goe to their generall / huntings, or at theire / Solemne feasts.'

1906,0509.1.12

For over four hundred years, since this figure of a North Carolina Algonquian was painted by John White, it has been an iconic image, sometimes used to symbolize all North American Indians as they were at the point of contact with Europeans. For the first of those centuries it was known only through the engraving by de Bry, which became the source for countless variations in print and paint, which in turn were copied by others. The version in Sir Hans Sloane's volume (below) and the copy he had made after it were known only to those who used his library, such as Catesby and other natural philosophers. But now, from the early twentieth century when the watercolours in Prints and Drawings began to be published, the watercolour itself has been reproduced countless times. Used to represent not only the North Carolina tribes' near neighbours, the Virginia Powhatans, variations have appeared in books on various tribes, and the reality of what this man represents has become increasingly difficult to separate from the fiction.

He is a mature man, although the painted red lines on his face (forehead, cheeks, chin and around his eyes) look like wrinkles and make him appear to be much older (see also p. 235). His body is painted with white and red circles and lines, but the version in the Sloane volume is not, and the painting on the calves in the engraving has additional circles. The engraving is reversed and also shows him from the rear; it is possible that the rear view has been deduced by the engraver and was not provided by White, as it does not show the back markings that are evident on similar figures in the festival scene. Harriot's caption for the engraving indicates that the skin apron is connected with the tail that hangs down the back and also holds the quiver. The tail appears to be puma but the apron does not seem to be of puma fur but of dressed, fringed deer skin. Harriot also described his hair, cut with a central crest (or roach) and shaved on the right side so it does not get caught in his bow, the other side grown long and tied up, adorned with feathers. In his ears he wears what may be a metal disk (or pearls, or 'whatever they fancied', including birds' claws mentioned by Harriot), and strings of copper or pearl beads around the neck and wrist, and an archer's wrist-guard of skin. The caption mentions that they also tattooed their skin but the watercolour appears to show only paint.

There are additional small pale circles under the breast and around his belly which Harriot indicates are scars, stating

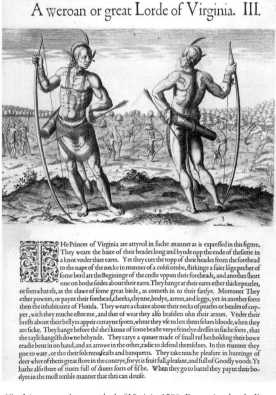

69. *A 'werowance' or great lord of Virginia*, 1590. Engraving by de Bry after John White, pl. III in Harriot, *A briefe and true report*, Frankfurt. By permission of The British Library, London (c.38.i.18)

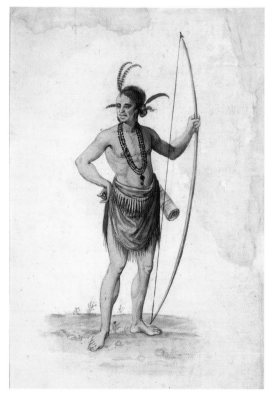

70. *A 'werowance' or great lord of Virginia*, 1580s. Pen and ink, watercolour and bodycolour, after John White?, from the Sloane volume. Sloane copy in the BL (Add MS 5253,15). British Museum (P&D SL,5270.6v)

that it was their practice to bleed themselves for medicinal purposes; certainly sucking or cupping blood was known among other tribes. The bow is long and plain and probably of maple or witch-hazel and the quiver is made of reeds or rushes, also recorded amongst New England Algonquians but unlike the skin quivers found amongst the Florida Indians and elsewhere.

The background of the engraving shows several identical men all hunting deer – again from the engraver's imagination, as it is doubtful whether they would all have puma tails and the same number and placing of feathers in their hair. His posture is probably borrowed from European portraits as this pose was conventionally used to convey power and authority and was reserved for aristocrats and military commanders and others who could command respect. The man depicted here is described by Harriot as a 'weroan', 'great Lorde' or 'prince' and it is likely that the puma tail and feathers, his jewellery and painting all helped to distinguish his high social rank from the other members of his tribe. It is possible that, although he is intended to represent a generic type of a 'Prince of Virginia' dressed for a ceremony, this drawing may actually be a portrait of the *werowance* or chief of the Secotan, as it is grouped in engravings with other figures from that tribe. The festive dance is located in Secotan and the men in the larger image of the feast are similarly attired to the figure here. In addition, in the engraving of the feast, only one of the men, the central figure at the top, is shown with a puma tail. Secotan was the chief's town of a tribe which included three or four nearby villages on the Pamlico River named on White's map. Some of the early accounts indicated that Wingina, 'King of Wing-andacoa' (which included Roanoke, Dasemunkepeuc and several villages on the mainland as well) ruled over Secotan as well; others indicate that the Secotan were a separate tribe with their own leader, whose name was not recorded but who was often at war with Pomeiooc and its leader Piemacum (Barlowe's account of the first voyage of 1584 in Quinn, pp. 111–13).

Lit.: LB 1(13); Quinn, pp. 440–41; ECM 1960 48; PH&DBQ 52(a); PH 48; Kupperman 1980, pp. 50–51; Miller, pp. 263–7; Kupperman 2000, pp. 63–4

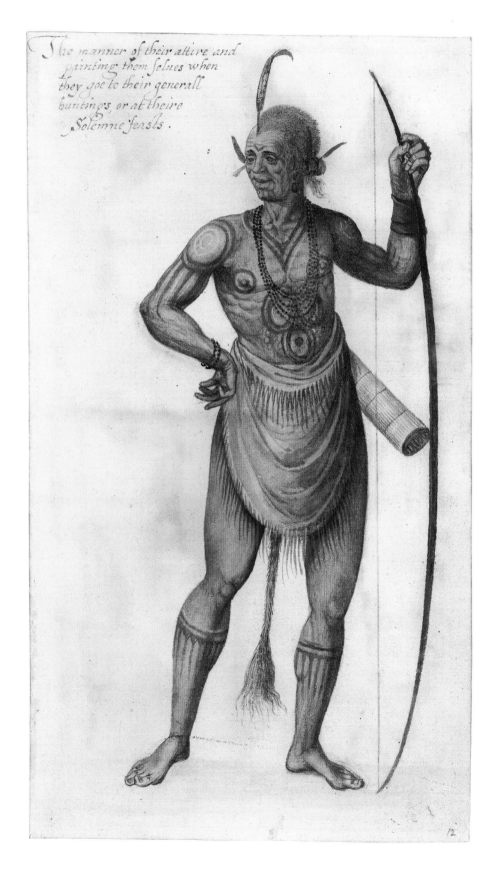

The manner of their attire and painting them selues when they goe to their generall huntings, or at theire Solemne feasts.

14 A wife of an Indian *werowance* or chief of Pomeiooc, and her daughter

Watercolour over black lead, touched with bodycolour, white (altered) and gold, 263 ?149 mm

Inscribed in brown ink: 'A cheife Herowans wyfe of Pomeoc . / and her daughter of the age of .8. or. / 10. yeares .'

1906,0509.1.13

This watercolour, and even more so the engraving after it, was to serve as a reminder for the readers in England and Europe that there was money to be made by investing in these voyages of plantation, not just from the crops that might be grown or the minerals that might be found but also from the new commercial market the people of Virginia provided. In 1585, after the Amadas and Barlowe exploratory expedition to Virginia, Raleigh encouraged his friend Richard Hakluyt to write a tract which circulated in manuscript to publicize his next venture and drum up support for it. In these 'Inducements to the liking of the Voyage intended towards Virginia', Hakluyt argued that the Indian trade would provide 'ample vent of the labour of our poor people at home, by sale of hats, bonnets, knives, fish-hooks, copper kettles, beads, looking-glasses, bugles & a thousand kinds of other wrought wares'. Glass beads, including bugles, which were tube-shaped glass beads sewn onto dress etc. for ornament, were eventually to become one of the main staples for trade with Indians. Glass beads were highly valued by Indians, who knew the difficulty of making shell beads and valued them for their uses as badges of rank, for carrying messages and especially for their spiritual meaning. Their value, like that of pearls for example, was determined in part by the difficulty of appropriation, which was different on both sides of the Atlantic.

In the caption to his very first image of Virginia, depicting the coastline of Roanoke and the first meeting of the English with the Indians, Harriot recorded: 'We offred the[m] of our wares, as glasses, kniues, babies, and other trifles, which wee thougt they delighted in' (fig. 59). Explaining the engraving of this image, Harriot wrote that the young girls were 'greatlye Diligted with puppetts, and babes which wear brought oute of England'. The girl in White's image shows her mother a fully dressed doll of an expensive type available only to wealthy English children, not the cheap wooden 'Bartholomew babe' or tin variety that most children in London would have had to play with. No doubt the cheaper variety was mainly what was traded but this was the daughter of a chief and her gift would have been of an appropriate status. White used gold and silver on the dress of the doll (see p. 235). In the drawing the child is also showing her mother her necklace, which must also have been a gift – it is red and of double strands with a gold or copper pendant, not similar to any of the Indian necklaces shown in the other images which were all stated to be of pearl, shell, copper or bone. No mention of it was made in the caption because the pendant had disappeared in the engraving where the child has grown in size and waves a European rattle instead. Red was a common colour for bugles – is the red necklace the earliest representation of glass beads in America, given to an Indian child as a plaything by the English but bearing a deeper symbolic meaning for the Indians?

The caption explains that she is eight to ten years of age and the engraver has made her larger than in White's watercolour where, in spite of the inscription, she is the size of a four- or five-year-old. She wears a moss or milkweed pad held by a cord, and has a tattoo or paint on one cheek. Her mother has a decorated headband and facial, neck and arm tattoos and a fringed apron worn high and long, covering the front only, and decorated with what appear to be pearls but may be shells. She is a woman of high status, the wife of a *werowance*, and therefore wears several strands of copper, pearl or bone necklaces. Harriot notes that she carried her arm in them, certainly a non-European gesture which may have been particular to this tribe and is not mentioned elsewhere. Her hollowed gourd was used to carry 'some kinde of pleasant liquor'; in fact such gourds were generally used to carry water and its presence reinforces the fact that, even as the wife of a chief, she was expected to take part in women's work in the town.

Lit.: LB 1(14); Quinn, pp. 417–18; ECM 33; PH&DBQ 35(a); PH 33

71. *A chief lady of Pomeiooc*, 1590. Engraving by Theodor de Bry after John White, pl. VIII in Harriot, *A briefe and true report*, Frankfurt. By permission of The British Library, London (c.38.i.18)

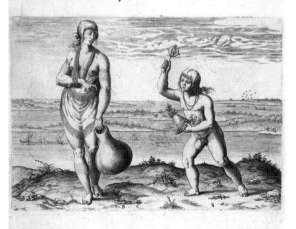

A cheiff Ladye of Pomeiooc. VIII.

About 20. milles from that Iland, neere the lake of Paquippe, ther is another towne called Pomeioock hard by the sea. The apparell of the cheefe ladies of dat towne differeth but litle from the attyre of those which lyue in Roanaac. For they weare their haire trussed opp in a knott, as the maiden doe which we spake of before, and hane their skinnes pownced in thesame manner, yet they wear a chaine of great pearles, or beades of copper, or smoothe bones 5. or 6. fold obout their necks, bearinge one arme in the same, in the other hand they carye a gourde full of some kinde of pleasant liquor. They tye deers skinne doubled about them crochinge hygher about their breasts, which hange downe before almost to their knees, and are almost altogither naked behinde. Commonlye their yonge daugters of 7. or 8. yeares olde do waigt vpon them wearinge abowt them a girdle of skinne, which hangeth downe behinde, and is drawn vnder neath betwene their twiste, and bownde aboue their nauel with mose of trees betwene that and thier skinnes to couer their priuiliers withall. After they bee once past 10. yeares of age, they wear deer skinnes as the older sorte do. They are greatlye Diligted with puppetts, and babes which wear brought oute of England.

A cheife Herowans wyfe of Pomeoc.
and her daughter of the age of. 8. or.
10. yeares.

13

15 An Indian priest

Watercolour over black lead, touched with white (altered), 262 × 151 mm

Inscribed in brown ink: 'One of their Religious men .'

1906,0509.1.14

This religious man of Secotan has wrinkles and prominent veins rather than tattoos, and this with his tiny beard indicates that he is an older man. Harriot noted that there was more than one priest in the town and that they had 'more experience than the common sort' of people. He also seems to indicate they hunted wildfowl in particular and on their own rather than with the other men. Their hair and clothes also distinguished them, as they had a central roach shaved on both sides, leaving only a fringe in front. Their cloaks were made of rabbit skins, finely sewn, with the fur on the outside – better depicted by Veen in the engraving than by White in the watercolour. His ear ornament is difficult to make out, which Harriot describes as 'somewhat'. It is thought to be made of skin with something binding the ends. His gesture has been described as 'European' but, since White is careful to record his other arm under his cloak, the gesture is probably an accurate record and may have some religious significance unknown to White or Harriot.

Harriot had a 'special familiarity' with some of their priests, from whom he learnt a great deal about their religion. He knew that an account of their religion was one of his most important duties and he devotes two pages to a description of it in his *Briefe and true report* (pp. 25–6). He reassured his staunchly Protestant audience that with good governance the Indians 'may in short time be brought to ciuilitie, and the imbracing of true religion. Some religion they haue alreadie, which although it be farre from the truth, yet beyng at it is, there is hope it may bee the easier and sooner reformed.' He noted they believed in one chief god who made many other gods first in human shape in order to make the world, that woman was made first in order to conceive children to populate the earth, and that the soul lived on with the gods after death or went to a great hole in the far west where the sun set. As a result, people were careful to show great respect to their rulers and took care to behave in order to avoid punishment after death. How much of this was a true account of the Algonquian religion and how much was intended as a moral lesson to Harriot's audience or a reflection of what they wanted to hear is open to debate.

However, apart from the priests' duties in the charnel house looking after the bodies of the deceased chiefs, he tells us only that they were 'notable enchanters'. They seem to have been greatly respected and were probably thought to have a closer connection to their gods than others. They were another high-ranking element of society in addition to the chiefs and their wives, the wealthier hunters and the conjurors who were the seers and magicians (*powwow*) (see no. 17).

Lit.: LB 1(15); Quinn, pp. 430–32; ECM 42; PH&DBQ 45(a); PH 42; Feest 1978, 278; Kupperman 1984, pp. 53–7; Rountree, pp. 101; Kupperman 2000, p. 125

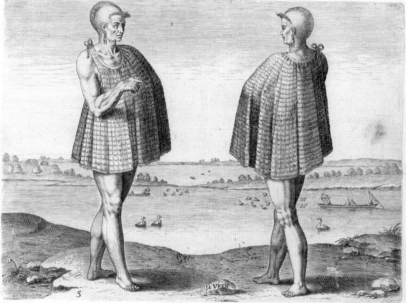

72. *One of the religious men of Secotan*, 1590. Engraving by Gysbrecht van Veen after John White, in Harriot, *A briefe and true report*, Frankfurt. By permission of The British Library, London (c.38.i.18)

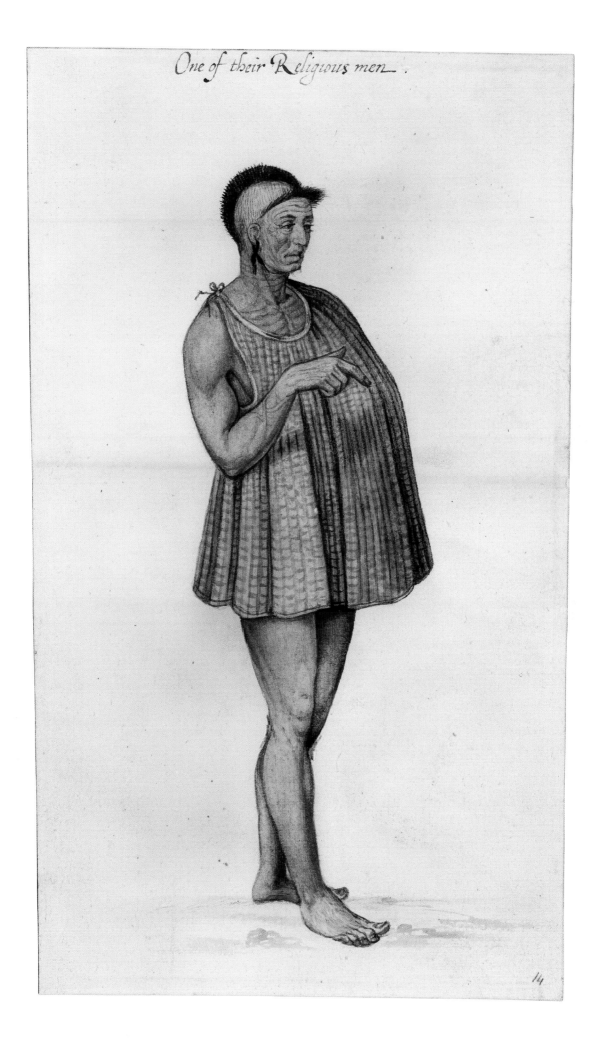

14

16 A wife of a *werowance* or chief of Pomeiooc carrying a child

Watercolour over black lead, touched with white (altered), 257 × 141 mm

Inscribed in brown ink: 'The wyfe of an Herowan of Pemeiooc .'

1906,0509.1.15

It was important to understand all aspects of Indian life, and White was careful to represent people of all ages, from as wide a spectrum of towns and villages as he had visited. But in his and Harriot's efforts to represent all the towns, they have clearly become confused. Harriot says that this woman is from Dasemunkuepeuc, which is on the mainland opposite the island of Roanoke, and compares her to the women of Roanoke who wear wreathes and tattoo their legs – but the woman who wears a wreath and leg tattoos is identified as from Secotan. White's inscription indicates that she is from Pomeiooc, so there are four towns or villages which she might be from.

Her most interesting characteristic however is not her clothes, hair or decoration but the way she carries her child, which the English did not seem to have encountered anywhere else. There is no mention or description of cradle boards, which were used further north. There are not many children depicted in White's scenes and Harriot does not mention numbers, but we know from the Powhatans and other tribes in Virginia a few years later that children were breast-fed longer, meaning that women did not become pregnant again swiftly as English women did, and that men were often away, hunting or at war, which also involved purification through abstinence before and after. Harriot's and White's experience was too brief to have become aware of such customs and effects.

Lit.: LB 1(16); Quinn, pp. 419–20; ECM 35; PH&DBQ 37(a); PH 35; Rountree & Turner, pp. 89–90

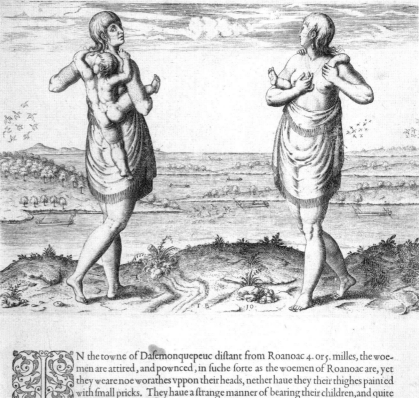

73. *Their manner of carrying their children and attire of the chief ladies of the town of Dasemonquepoc*, 1590. Engraving by Theodor de Bry after John White, pl. X in Harriot, *A briefe and true report*, Frankfurt. By permission of The British Library, London (c.38.i.18)

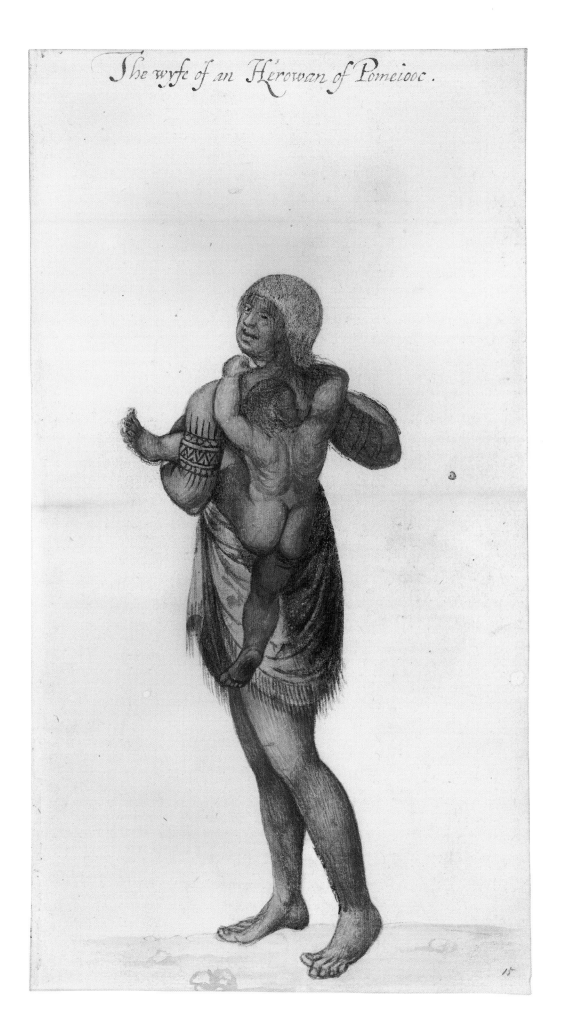

15

17 An Indian medicine man: 'The flyer'

Watercolour over black lead, touched with
bodycolour, white (altered), 246 × 151 mm

Inscribed: 'The flyer .'

1906,0509.1.16

White used a label for this figure which at
first seems objective, in that it is
descriptive of the ritual dances he
performed, but his pose also recalls
representations of Hermes, the ancient
messenger of the gods who was also
associated with medicine. Harriot
described these men as conjurors –
soothsayers who were 'familiars' of the
devil, foreseeing the future by asking him
what their enemies were doing. In fact
these men fulfilled both roles, healer and
conduit of sacred knowledge; but in the
latter they appeared as magicians, of
course deeply suspicious in the eyes of
Protestant English and hence the change
of title in Harriot's description in de Bry.
This figure joined the priest shown
worshipping the Kiwasa idol on the
pediment of de Bry's title page (fig. 2),
translating them into figures understood
by his European audience.

Their hair was roached, without any
longer locks or crests, and they often wore
a bird above their ear as a 'badge of their
office'. This one does not appear to be
tattooed but seems to have the scars for
bleeding that the chief in no. 13 bore. He
does not wear a breechcloth but instead
an animal skin hanging from his belt and
also a pouch – many figures are shown
with one strung through their belts,
which probably contained tobacco. His
may have contained other herbs, plants or
powders. The tobacco that grew locally
was the stronger *Nicotiana rustica*, which
has a high nicotine content (18 per cent);
the milder *Nicotiana tabacum* favoured in
Europe was imported from South
America. *Rustica* was ingested in enor-
mous quantities by shamans to trigger an
ecstatic visionary-trance state. They
believed it was beloved of their gods and
cast the precious powder on the water and
in the air as a sacrifice to them: 'but all
done with strange gestures, stamping,
somtime dauncing, clapping of hands,
holding vp of hands, & staring vp into the
heauens, vttering therewithal and chatter-
ing strange words & noises' (Harriot, p.
16). It may be one of these ceremonies
that is being depicted here.

Harriot does not mention or was not
aware that some Spanish had taken up
smoking cigars, which they had encoun-
tered amongst the Indians further south,
but he was completely convinced of its
curative powers, as it was smoked in pipes
by the Algonquians. He stated that it
purged phlegm and other gross humours,
opened the pores and passages of the body
and rid them of 'obstructions'. He
credited the Indians' good health and lack
of disease to tobacco and noted that the
English began to 'suck it after their maner'
while they were there and since their
return '& haue found manie rare and
wonderful experiments of the vertues
thereof; of which the relation would
require a volume by itselfe: the vse of it by
so manie of late, men & women of great
calling as else, and some learned Phisitions
also, is sufficient witnes'. Sadly Harriot did
not follow his own frequent advice that
moderation was the key to the success of
the health of the Indians. Thirty-five years
later he was to die from cancer of the
nose caused by his faith in this plant. By
then it had become the foundation of the
economy of the first successful English
settlement at Jamestown, where South
American *Nicotiana tabacum* was brought
to viable cultivation as a cash crop by John
Rolfe, the husband of Pocahontas.

Lit.: LB 1 (17); Quinn, pp. 344–6, 442–3; ECM 49;
PH&DBQ 53(a); PH 49; Solmon, passim; Feest 1978,
p. 280; Kupperman 1980, p. 48; Kupperman 2000, p.
125; Shirley, pp. 425–60, for Harriot's cancer; and
Furst, pp. 279–81, on tobacco

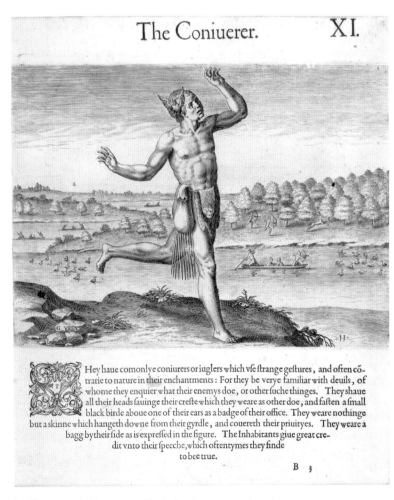

74. *The conjurer*, 1590. Engraving by Gysbrecht van Veen after John White, pl. XI in Harriot, *A briefe and true report*, Frankfurt. By permission of The British Library, London (c.38.i.18)

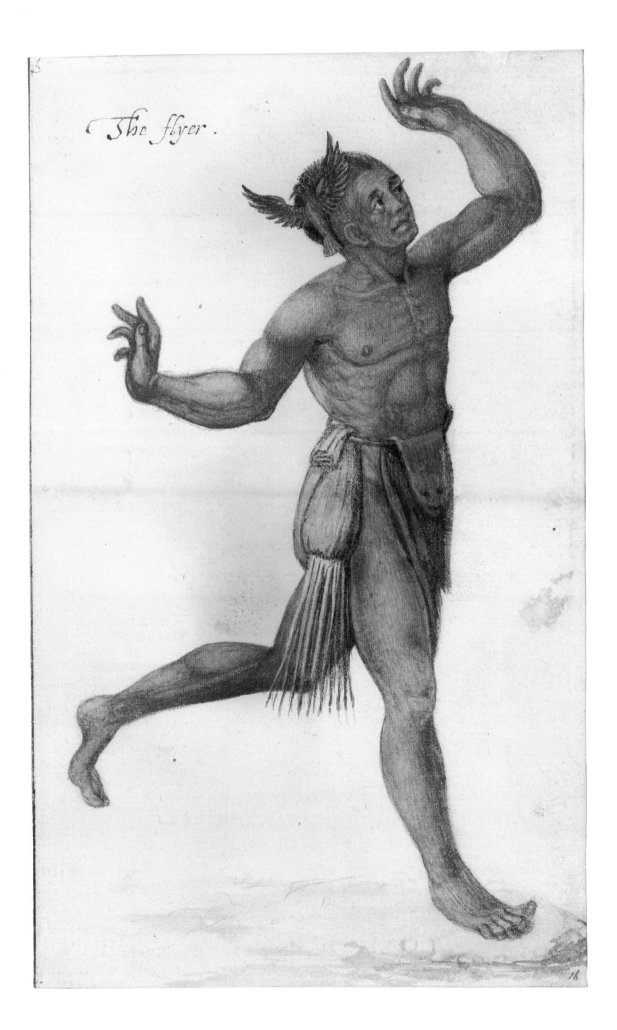

The flyer.

18

18 A wife of the *werowance* or chief, Wingina

Watercolour over black lead, touched with bodycolour, white and gold, 234 × 135 mm

Inscribed: 'One of the wyves of Wyngyno'

1906,0509.1.17

There is a great deal of confusion surrounding the identity of this woman. The inscription on this drawing states quite clearly that she is one of the wives of Wingina, who was the chief lord of Roanoke. His territory covered other towns, but it is not certain how far his control extended (see no. 21). It included Dasemunkapeuc on the mainland opposite the island and he moved frequently from one town to another, so his wife may have lived in any of them. The version of this drawing in the Sloane album is clearly labelled 'Of Aquascogoc', which was a village on the Pamlico River half-way between Secotan and Pomeiooc. Harriot's caption for the engraving indicates that she is a generic type – a virgin of gentle parentage – and that they all dressed like the women of Secotan, with aprons that covered them front and back. Whether she is a virgin or the wife of a chief, she is certainly a young woman from the area around the Pamlico River area, and her clothes, tattoos, hair and jewellery all mark her as high-born or at least of wealthy status.

Harriot's text in de Bry notes that such young women often modestly covered their breasts in this fashion but this may be reading European ideas of modesty into a gesture that meant something else to the tribe. However, there were conventions of posture in European portraiture for depicting women of status with their arms 'self-enclosing' and men of status with their legs crossed (European women's legs were not visible) and the use of these gestures here may have been to indicate the woman's high status. Harriot noted that the women had broad mouths and 'reasonable fair black eyes',

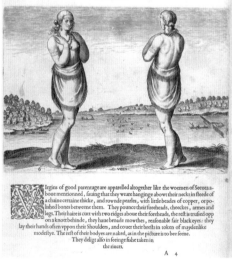

75. *A young gentle woman daughter of Secotan*, 1590. Engraving by Gysbrecht van Veen after John White, pl. VI in Harriot, *A briefe and true report*, Frankfurt. By permission of The British Library, London (c.38.i.18)

close to his description of the women of Secotan. Her jewellery consists of pearls, copper beads and polished bones and she is decoratively painted and tattooed. The tattoos in the Sloane version are more extensive, covering areas under her eyes and on her chest. Her hair is knotted at the back with a double fringe over her forehead and, in the drawings, with a band on her forehead as well. She wears a fringed apron-skirt of skin, tied around her waist, and in the Sloane version it clearly covers her buttocks as well. The artist has added touches of gold to the fringe, perhaps indicating the presence of tiny copper beads.

The Sloane volume version of this drawing repeats the artist's mistaken depiction of two right feet; this is corrected by the engraver, who reduces her body paint and tattoos even further and also provides a view from behind. This is probably the invention of the engraver – the back cloth should be tied, bound or rolled in some way at the back, as shown in the engraving for no. 22 and in the Sloane version, which lacks the upper fringe. On the whole, both engravers have altered the body types of the women: in the drawings they appear tall and well-proportioned, while the Mannerist training of the engravers led them to depicting tiny feet and muscular limbs. The engraver's landscape background is an elaboration of White's fishing and village scenes and reflects the final sentence of the text which describes their activities – 'they delight also in seeinge fishe taken in the riuers' – in the Westernized manner of a 'pastime', much as he had done mistakenly for the women of Secotan (see no. 22).

Lit.: LB 1(18); Quinn, pp. 439–40; ECM 1960 47; PH&DBQ 51(a); PH 47; Kupperman 1980, pp. 50–51 and Kupperman 2000, p. 64

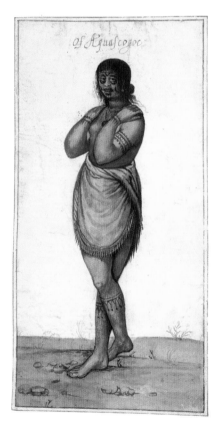

76. *A young woman of Aquascogoc*, 1580s. Pen and ink drawing with watercolour and bodycolour, after John White?, from the Sloane volume. There is an eighteenth-century copy made for Sloane in the BL (Add MS 5253,17). British Museum (P&D SL,5270.6r)

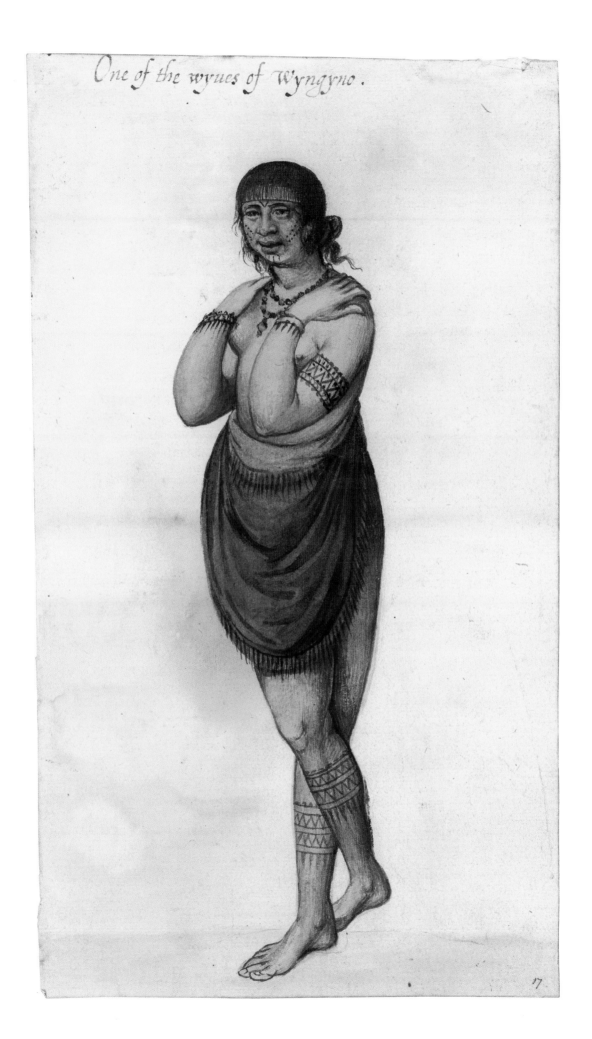

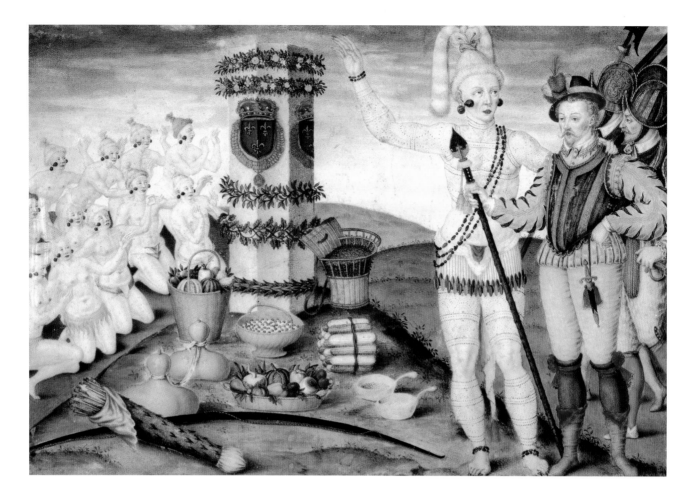

77. *Laudonnierus et rex althore ante columnam a praefecto prima navigatione* …, c.1564? Watercolour and bodycolour with gold over chalk outline on vellum (175 × 257 mm) attributed to Jacques Le Moyne de Morgues. Print Collection, Miriam and Ira D. Wallach Division of Art, Prints and Photographs, The New York Public Library, Astor, Lenox and Tilden Foundations (John H. Levine Collection)

78. *Athore showing Laudonnière and his men Ribault's column*, 1591. Engraving by Theodor de Bry after Le Moyne, pl. VIII in *Brevis narratio eorum quae in Florida America provincial Gallis acciderunt* (*America*, part II), Frankfurt. National Maritime Museum, Greenwich (Caird Library, PBE 7832)

Columnam à Præfecto prima navigatione locatam VIII. venerantur Floridenses.

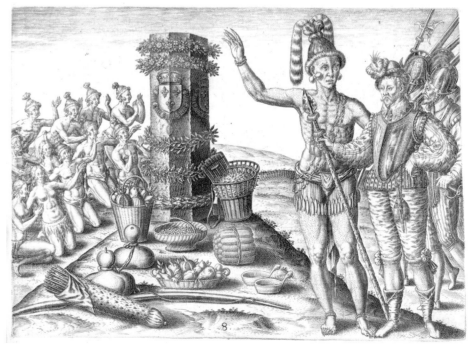

John White's Watercolours of Timucuan Indians of Florida

As in his drawings of the North Carolina Algonquians, White's two watercolours of a Timucuan man and woman are vitally important records of the appearance of a group of Indians before their way of life was changed irrevocably by contact with Europeans. They are probably copies after another artist, the Huguenot Jacques Le Moyne de Morgues (1533–1588) who was sent by his king, Charles IX of France, to the New World with instructions to chart and map the country and record the people found there. Under the command of René Laudonnière, they arrived in the St John's River area of north-east Florida in 1564. Le Moyne recorded Athore, the son of the local chief, showing Laudonnière a commemorative column which had been set up by an earlier French commander, Jean Ribault, in 1562 (fig. 77). Then, as White was to do, Le Moyne charted the coast, recorded the building of a fort, drew the inhabitants, their villages, agriculture, hunts and ceremonies, explored and mapped Indian settlements further inland and became involved in wars between rival chiefs and indeed between rival commanders amongst the French themselves. Just as the English would be at Roanoke, the French were dependent upon the Indians for provisions and inevitably found themselves clashing with them. Relief arrived in August 1565 with Jean Ribault who, in attempting to capture Spanish ships offshore, left Fort Caroline undermanned and open to assault from the Spanish. Le Moyne was one of only two Frenchmen who managed to escape the fort with his life and rejoined the French ships with Laudonnière, returning to France via Swansea, Bristol, London and Calais early in 1566.

The next record we have of him is in Blackfriars in 1581, having arrived in England with his wife over a year earlier as a religious refugee. Hakluyt mentions him in 1587 when he published his translation of Laudonnière's account of his expedition. Hakluyt prefaced his *Notable Historie* with an *Epistle* to Walter Raleigh which mentions 'things of chiefest important liuely drawn in coulours at your no smale charges by the skilfull painter Iames Morgues' and also notes that Le Moyne himself had written his own account 'which he meaneth to publish together with the purtraitures before it be long, if it may stand with your good pleasure & liking' (Hulton, *Le Moyne*, p. 11). De Bry was in London that year and, although Le Moyne was not willing to part with his drawings at that point, they must have discussed this publication, as Le Moyne's widow gave him the completed account the following year, 1588, which was also the year he collected John White's watercolours and Harriot's accompanying text for them, translated from Latin into English for him by Hakluyt. In 1590 Hakluyt published Harriot's and Le Moyne's accounts without illustrations, having encouraged de Bry to publish illustrated versions in Frankfurt. White's was to be published first, to assist with continued attempts to encourage further voyages to Virginia by the English, and Le Moyne's account of the French expeditions the following year in 1591.

The main difficulty concerning Le Moyne's illustrations of his account is that, unlike White's watercolours, either one or none of his survive. Christian Feest and others have argued that the colours used in fig. 77, the blonde hair, pale skins and red and blue colours of their clothes, reflect the view of someone who had never actually seen the Timucuan Indians. This might be explained by artistic and aesthetic convention of the time overriding realistic truth to nature; but on the other hand artistic convention of the time very seldom led to an engraver copying a drawing with the kind of detailed exactitude found here. More often, as in the case of the John White drawings, a set of drawings was provided from which the engraver would create compositions to fit the text. Even John White's most detailed compositions, the fishing or the village scenes, were adapted by de Bry, with the addition of figures and foreground and background landscapes. Given the appropriate number and variety of images of the inhabitants of Florida and their villages, ceremonies etc. along with charts and images of the French and their fort and ships, de Bry would have created compositions the same way he had done from the John White drawings to fit the narratives. Alternatively, one could argue that de Bry had a set of fully finished complete images with landscapes by Le Moyne of the type that survive. But it would be very unusual for such a large series of such detailed works on vellum as the example here to be produced by any artist at this time, particularly for an engraver, rather than for a very wealthy patron.

In *America* part I concerning Virginia, de Bry did not try to relate the events of a narrative but to give portraits of the land, the people and their villages, elaborating the drawings only enough to provide the appropriate scenery and details given in Harriot's text. Neither the narrative nor the artist was explicit about the interaction between the English and the Indians, and only one scene, for which we have no original, shows them together (fig. 59). The French narrative on the other hand was greatly concerned with the interaction between the two, and de Bry undoubtedly manipulated and repeated elements of the relatively small group of drawings provided to create the story he needed to tell, using European artistic conventions for the poses, details of some artefacts, landscape and battle scenes.

The two Florida Indians by John White do not fit any of the individual figures in any of the engravings by de Bry after Le Moyne, although there are similarities to one or two figures in the crowded compositions. Thus, either John White created his own images of these Florida Indians in a style to fit his existing collection of studies of Inuit, Greeks, Turks and Virginia Indians from more complex original compositions by Le Moyne, or he made straightforward copies of a series of watercolours by Le Moyne which were of the same sort as White's own. In either case, John White's copies probably tell us more about the Timucuan Indians and Le Moyne's lost originals taken to Frankfurt by de Bry in 1588 than the one 'surviving' miniature watercolour on vellum or even many of the engravings based on them by de Bry.

Lit.: Hulton, *Le Moyne*; see also Feest 1988 and Keazor, pp. 134–5

19 A Timucuan chief of Florida after Jacques Le Moyne

Pen and brown ink and watercolour over black lead, with bodycolour touched with white and silver (altered) and gold, 268 × 137 mm

Inscribed in brown ink: 'Of Florida'

1906,0509.1.22

John White's images of the Timucuan Indians from the St John's River area of north-east Florida are accurate records of this farming people who lived in small chiefdoms of four or so villages and frequently warred amongst themselves. The Spanish set up missions and military posts in St Augustine and spread outwards from there in 1565, the year after Le Moyne recorded them. Until then, they had no metal except copper and possibly gold and silver salvaged from Spanish wrecks, which they hammered into the type of ornaments seen here, the number and abundance probably denoting this man's status as a chief. They supplemented their maize, beans, squash and tobacco crops with hunting and fishing, much as the North Carolina Algonquians. They also had palisaded villages, but with round houses rather than long houses and with burial mounds rather than a tomb for their dead chieftains. The respect allocated to living chiefs depicted in the engravings after Le Moyne's drawings included their use of litters and stools and tributes of food. The tribes were named after their chiefs; the French knew the Saturiwa and their neighbouring enemies, the Utina.

The chief here wears copper or gold ornaments and a bracer around his wrist which appears to be copper rather than the usual hide or fur. The pendants from his belt appear to be of shell or stone as described in written accounts, where in de Bry's engravings and the Le Moyne miniature (fig. 77) they appear to be gold or silver and even red and blue. His fingernails are long, he wears his hair bound in a roll around his face from which it is caught up in a knot with an animal tail and his breechclout is formed of two pieces, one as a belt around his waist with another drawn up between his legs and inserted into the belt. He appears to have a solid type of bi-conical ear-plug but the pigment has altered to black and was probably white or silver perhaps indicating it was made of shell. The nearest archaeological equivalents that have been found are made of wood covered with copper. His bow is probably accurate but his arrow is too barbed and his quiver is of a type appearing in other engravings.

The chief's face is painted but his body is tattooed, denoting his status – tattooing was limited to the chief and his wife, though usually the patterns were different rather than the same as here. The curious pattern does not appear in any of the de Bry engravings and is quite different from the patterns clearly drawn from life in the images of the Algonquians. Instead here it resembles the lozenges and strapwork found on Elizabethan parcel gilt tilting armour (see fig. 21) – if Le Moyne was drawing the tattoos from memory, it is unlikely he would recall the pattern in such detail and this is probably evidence that Le Moyne or White were not averse to adapting European conventions they were familiar with to fit missing details in their recollected views of the New World.

Lit.: LB 19(23); Quinn. p. 462; ECM 61; PH&DBQ 112(a); PH 61; Hulton, *Le Moyne*, pp. 15, 184–5

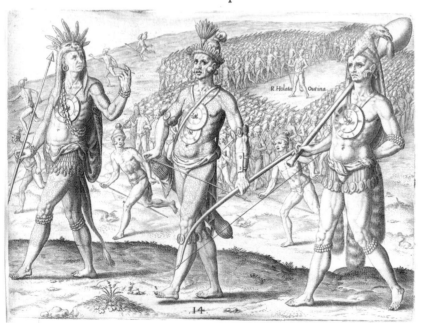

79. *Florida Indians going to war*, 1591. Engraving by Theodor de Bry after Le Moyne, pl. XIIII in *Brevis narration eorum quae in Florida America provincial Gallis acciderunt* (*America*, part II), Frankfurt. National Maritime Museum, Greenwich (Caird Library, PBE 7832)

Of Florida.

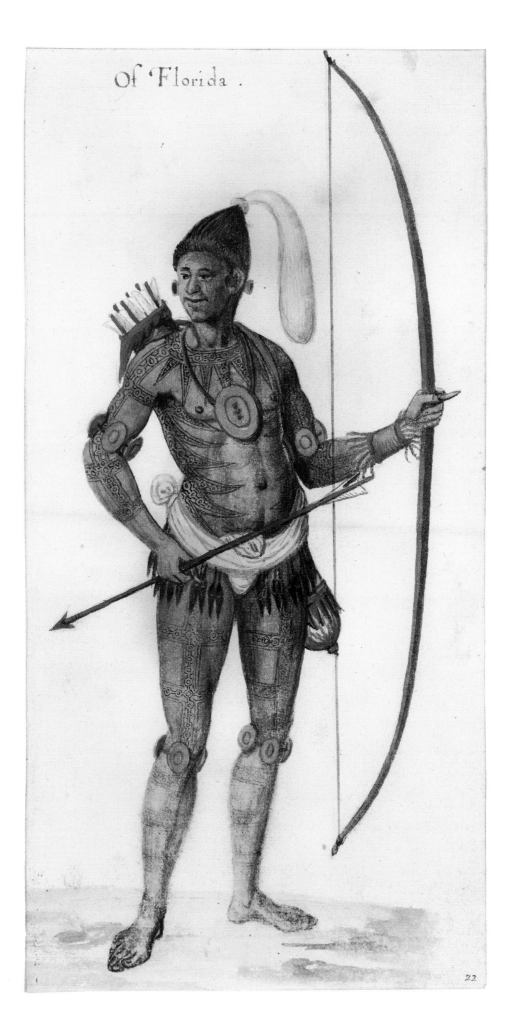

22

20 The wife of a Timucuan chief of Florida after Le Moyne

Pen and brown ink and watercolour over black lead, with bodycolour, touched with gold and silver (?) (altered), 261 × 135 mm

Inscribed in brown ink: 'Of Florida .'

1906,0509.1.23

Heavily tattooed like her husband, with additional lines on her forehead and from her mouth to her chin, the woman wears oblong inflated fish bladders in her ears, as described in the French accounts. Her fingernails are also long like her husband's; some European writers noted that the Indians expressed surprise that Europeans trimmed theirs, destroying the useful tools and weapons with which nature had provided them. Bead necklaces are recorded but gold ones were not; though certainly copper would be possible. She offers maize and possibly prickly pears in a pottery bowl of a shape known in the region. She wears a garment made of Spanish moss, usually a bluish-grey, described in other accounts, but the red and white border is unique.

Lit.: LB 1(24); Quinn, p. 462; ECM 62; PH&DBQ 113(a); PH 62; Hulton, *Le Moyne*, p. 185

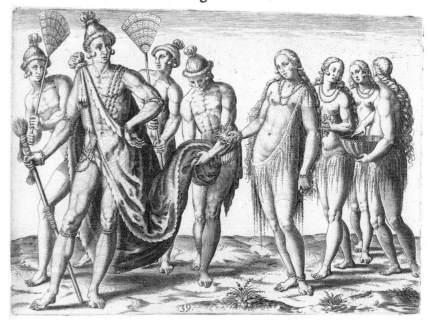

Regis & Reginæ prodeambulatio recreandi XXXIX. animi gratia.

80. *Florida chief with his wife and attendants*, 1591. Engraving by Theodor de Bry after Le Moyne, pl. XXXIX in *Brevis narration eorum quae in Florida America provincial Gallis acciderunt* (*America*, part II), Frankfurt. National Maritime Museum, Greenwich (Caird Library, PBE 7832)

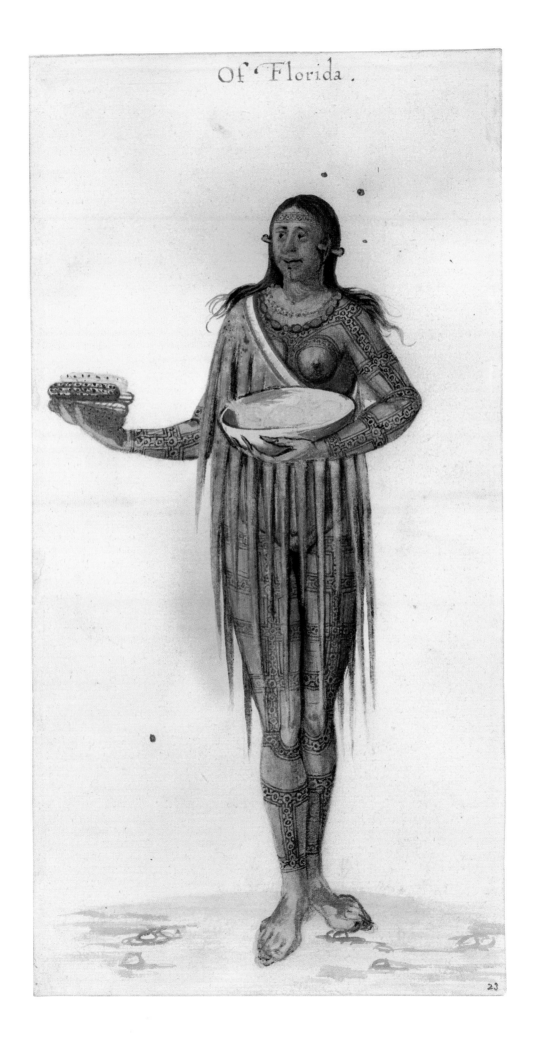

21 Portrait of an Indian chief (possibly Wingina)

Watercolour over black lead, touched with white (altered) and gold, 262 × 147 mm

Inscribed in black ink: 'A cheife Herowan'

1906,0509.1.21

This may be a portrait of the *werowance* or chief of Roanoke whose name was Wingina. White has inscribed this drawing as a 'cheife Herowan' which is open to two interpretations: either he is a generic chief, or *werowance* in their language, or he is the chief of all the *werowances*. Harriot's caption makes this figure representative of a generic type – the 'cheefe men' of the island and town of Roanoke. If he is intended to be Wingina, then he ought to have his identifying mark of four vertical arows on his back in the engraving (see fig. 47) – but we have indicated that the back views were probably the invention of the engraver and none of the engraved figures wears the mark.

It is unclear whether he shaves one or both sides of his central roach but part is allowed to grow and is caught in a knot at the nape. His decorated apron is double-fringed and covers him front and back. He does not paint or tattoo his body; instead his authority is clear from his jewellery –

81. *A chief lord of Roanoke*, 1590. Engraving by Theodor de Bry after John White, pl. VII in Harriot, *A briefe and true report*, Frankfurt. By permission of The British Library, London (c.38.i.18)

pearls, copper and smooth bone beads at his ears, wrist and neck. His main symbol of his status was the copper plaque he wore suspended from a thong around his neck. Copper was the Roanoke's most prized commodity, as it reached them only through trade with tribes who lived much further inland and as far away as Lake Superior. Not knowing this, the English saw such decorations as this chief wore as evidence that the Algonquians had access to copper. The English had brought with them Joachim Ganz, a specialist from a distinguished family of Jewish metallurgists in Prague. He experimented with local copper that was found in very small amounts and succeeded in separating silver from it. But his findings indicated that silver and gold were not as available as they had hoped initially: they were very anxious to locate the source of the Algonquians' supply and searched exhaustively in the area, without success.

On the first voyage, Arthur Barlowe wrote that Wingina was the 'King' of the country of Wingandacoa, which he believed included Secotan, his 'chief town' and the villages around it, as well as Dasemunkapeuc opposite Roanoke island where Wingina's brother Granganimeo lived as the *werowance*. Barlowe wrote that

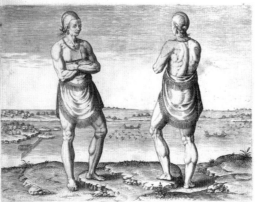

A cheiff Lorde of Roanoac. VII.

He cheefe men of the yland and towne of Roanoac reace the haire of theyr crounes of theyr heades cutt like a cokes côbe, as the other doe. The reft they wear lôge as woemen and truß them opp in a knott in the nape of their necks. They hange pearles ftringe oppon a threed att their eares, and weare bracelets on their armes of pearles, or fmall beades of copper or of fmoothe bone called minfal, nether painting nor powncings of themfelues, but in token of authoritye, and honor, they wear a chaine of great pearles, or copper beades or fmoothe bones abowt their necks, and a plate of copper hinge vpon a ftringe, from the nauel vnto the midds of their thighes. They couer themfelues before and behynde as the woemê doe with a deers skynne handfomley dreffed, and fringed, More ouer they fold their armes together as they walke, or as they talke one wjth another in figne of wifdome. Theyle of Roanoac is verye pleifant, ond hath plaintie of fiffhe by reafon of the Water that enuironeth thefame.

all the towns or villages between, including Pomeiooc and Aquascogoc, were part of Wingina's country and he was at war with Pomouik, which was furher inland on the Pamlico River (visible as Panauuaioc in fig. 3). His allies were the Weapemeoc and Chawanoke on the north side of the Albermarle Sound. The country of Wingandacoa was referred to also as Secotan, naming the kingdom after the main town. In the seventeenth century this 'kingdom' was known as Machapunga and it was separate from Roanoke, which then consisted of the island and the mainland opposite only. More recently Quinn and later writers have argued that Secotan and Roanoke were already separate and even enemies in the sixteenth century and that Wingina was chief only of the latter – which is why this image with its caption indicating that he is from Roanoke has sometimes been identified as Wingina.

Both arguments are strong and we can deduce from them and from Harriot and White's accounts only that there were different levels of *werowance* – some were the most powerful men in a village and others were the leaders of a confederation of villages or a tribe, which might have had a capital town. But the *werowances* of tribes did not remain only in their capital but moved about regularly from one of their villages to another. As we have already discussed, towns and villages were not necessarily permanently inhabited. Boundaries, both physical (land) and political (allies), were constantly changing. It was difficult for the English to understand these complicated relationships and it is not surprising that the identification of watercolours which were originally portraits of individuals were changed in the publication into generic types intended to represent different levels of society in different towns.

Later, as towns were destroyed by the English through fire or by disease, tribes shifted, created new allegiances and merged with others; we will probably never understand fully the relations between villages and tribes as they stood when the English first arrived in 1584.

Lit.: LB 1(22); Quinn, pp. 98–101, 110–11, 438–9; ECM 46; PH&DBQ 50(a); PH 46; Feest 1978, pp. 272–3; Kupperman 1980, pp. 50–51, 74–5

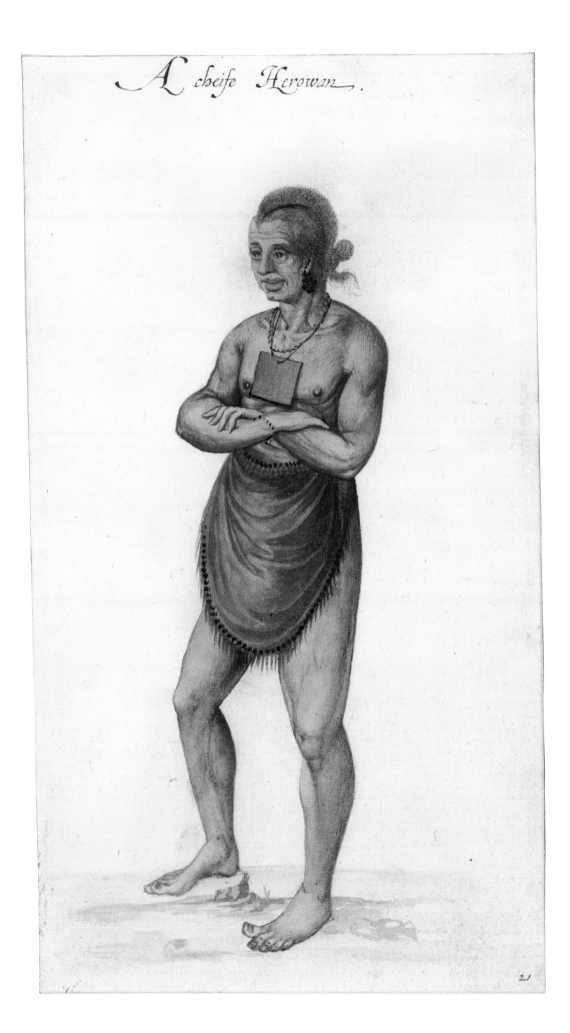

2.1

22 The wife or a chief or *werowance* of Secotan

Watercolour over black lead, touched with
bodycolour, white (altered) and gold, 260 × 139 mm

Inscribed in brown ink: 'The wyfe of an Herowan of
Secotan .'

1906,0509.1.18

If the *werowance* depicted in no. 13 is from
Secotan then this is probably a portrait of
his wife. The engraving of this figure
follows the *werowance* in de Bry's book
and is followed by the priest of that
village. Necklaces of beads or copper may
have been confined to the men in this
village, and the women instead had a
painted or tattooed necklace and were
tattooed on their foreheads, cheeks, chins,
legs and arms. The tattoos here were
probably intended to be a pale blue but
have lost some of their pigment in the
offset and have also partly altered
chemically. The design of the tattoos is
much clearer on the version from the
Sloane album where additionally there
may be an indication that the forefinger
and thumb of her right hand were also

painted. The women of Secotan wore
pearls or bones in their ears and their hair
was not tied but instead fringed at the
front and worn loose with a wreath,
perhaps of twisted deerskin. She wears a
double apron, which covers her buttocks,
unlike most of the other single ones
depicted in the series. It is elaborately
fringed, to which White adds touches of
gold (although the one in the Sloane
volume does not have the upper fringe)
and decorated with a double row of
copper beads or pearls as in the man's
necklace – but they may also be small
shells. The pigment has altered to black.

Harriot is very clear about facial
features and posture in his accompanying
text, indicating the women had small eyes,
plain, flat noses, narrow foreheads and
broad mouths – the first description of
the physical appearance of the North
Carolina Algonquians. This is indeed how
John White has attempted to depict them.
His portraits indicated the difference
between the facial types here and those of
his Florida Indians or Inuit. He has shown
her with her arms crossed – not out of

modesty, as she does not cover her breasts,
but in order to provide an accurate
account of their gestures. Harriot had
earlier stated that men folded their arms as
an indication of wisdom. But we have also
noted earlier (no. 18) that women of high
status in European art were often depicted
with their arms enfolding them and this
may just be a European convention for a
woman of high status. Harriot mentions
that they let their arms down by their
sides when walking. He seems to imply
they had leisure time to walk in the fields
and by the rivers (where in fact they were
probably gathering water, herbs, plants
and wood) and to watch the hunting and
fishing of the men. He was no doubt mis-
reading what he saw – even the wife of a
werowance would have been constantly
busy most of the time gathering, growing
and preparing food, and she would have
had additional responsibility when there
were visitors, as she would have had to
provide the guests' food.

Lit.: LB 1(19); Quinn, pp. 423–4; ECM 37; PH&DBQ
39(a); PH 37; Rountree & Turner, pp. 92–9; for
posture see Kupperman 2000, pp. 63–9

82. *One of the chief ladies of
Secotan*, 1590. Engraving
by Theodor de Bry after
John White, pl. IIII in
Harriot, *A briefe and true
report*, Frankfurt. By
permission of The British
Library, London
(c.38.i.18)

83. *A woman of Secotan*,
1580s. Pen and ink
drawing with watercolour
and bodycolour, after John
White?, from the Sloane
volume. Sloane did not
have this drawing copied.
British Museum (P&D
SL,5270.5r)

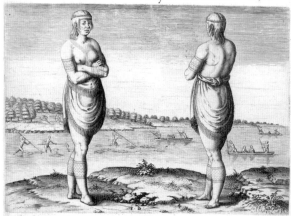

On of the chieff Ladyes of Secota. IIII.

He woemé of Secotam are of Reasonable good proportion. In their goinge they
carrye their hâds danglinge downe, and air dadil in a deer skinne verye excellétlye
wel dreffed, hanginge downe frô their nauell vnto the mydds of their thighes, which
alfo couereth their hynder partz. The refte of their bodies are all bare. The forr parte
of their haire is cutt fhorte, the reft is not ouer Longe, thinne, and fofte, and falling
downe about their fhoulders: They weare a Wrrath about their heades. Their foreheads, cheeks,
chynne, armes and leggs are pownced. About their necks they wear a chaine, ether pricked or
paynted. They haue fmall eyes, plaine and flatt nofes, narrow foreheads, and broade mowths. For
the moft parte they hange at their eares chaynes of longe Pearles, and of fome fmootht bones.
Yet their nayles are not longe, as the woemen of Florida. They are alfo deligfted
with walkinge in to the fields, and befides the riuers, to fee the
huntinge of deers and catchinge of
fifche.

A 2

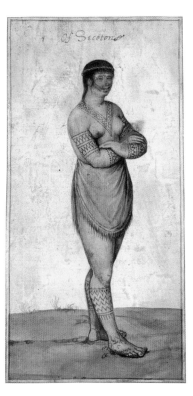

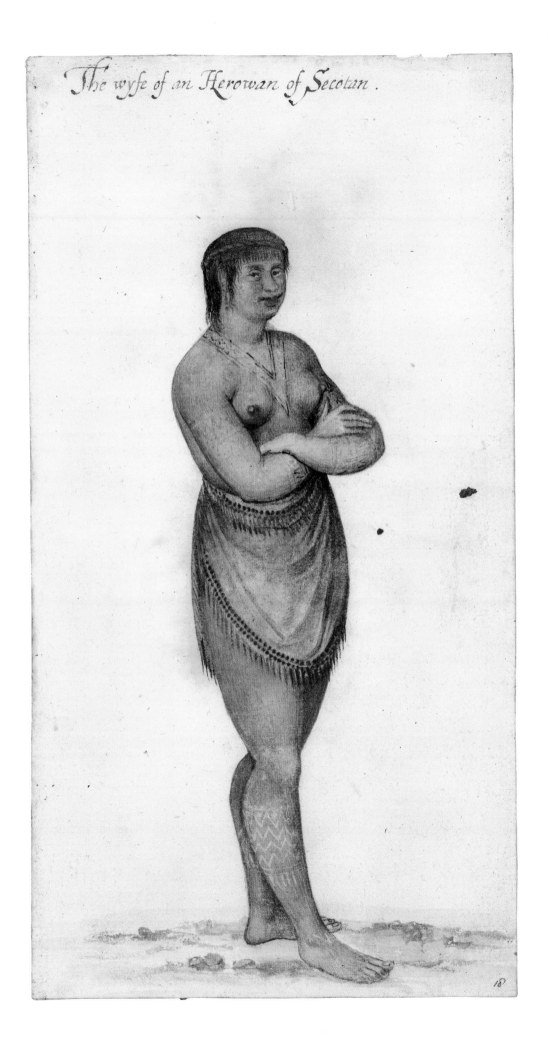

23 An elder from Pomeiooc in his winter clothing

Watercolour over black lead, touched with white (altered), 261 × 150 mm

Inscribed in brown ink: 'The aged man in his wynter garment.'

1906,0509.1.19

The caption by Harriot identifies this elder as from the village of Pomeiooc, which is depicted in the landscape background of the engraving. His garment is substantial and was a common one amongst most Indians of eastern North America, made of skins with the fur left on and fastened over one shoulder. A longer thicker of piece of skin hangs from the fringe behind his bent arm, which may be the tail of an animal and is clearer in the engraving, where he is also depicted wearing moccasins. There is a seam shown in the watercolour here and in the Sloane version, where feathers and necklaces have been added. The man is clearly old, his roached hair grey and his chin sprouting wisps of beard, which older men did not pluck or shave.

Elder members of the tribe would be men over forty and would no longer be expected to take part in hunts or war. They were the holders of history and experience in tribal relations and were greatly respected for their advice and the wisdom deemed to have come with age.

Lit.: LB 1(20); Quinn, pp. 418–19; ECM 1960 34; PH&DBQ 36(a); PH 34; Rountree & Turner, pp. 121–2

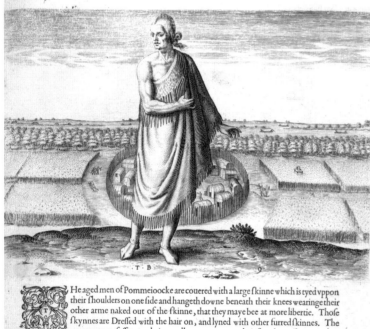

84. *An aged man in his winter garment*, 1590. Engraving by Theodor de Bry after John White, pl. IX in Harriot, *A briefe and true report*, Frankfurt. By permission of The British Library, London (c.38.i.18)

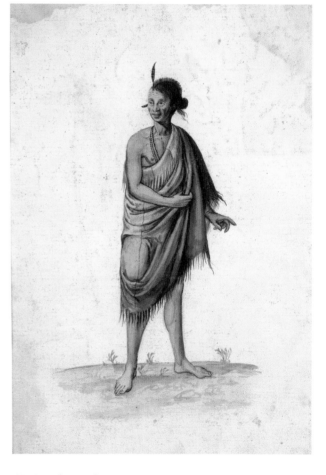

85. *An aged man in his winter garment*, 1580s. Pen and ink drawing with watercolour and bodycolour, after John White?, from the Sloane volume. There is an eighteenth-century copy made for Sloane in the BL (Add MS 5253,16). British Museum (P&D SL,5270.10v)

The aged man in his wynter garment.

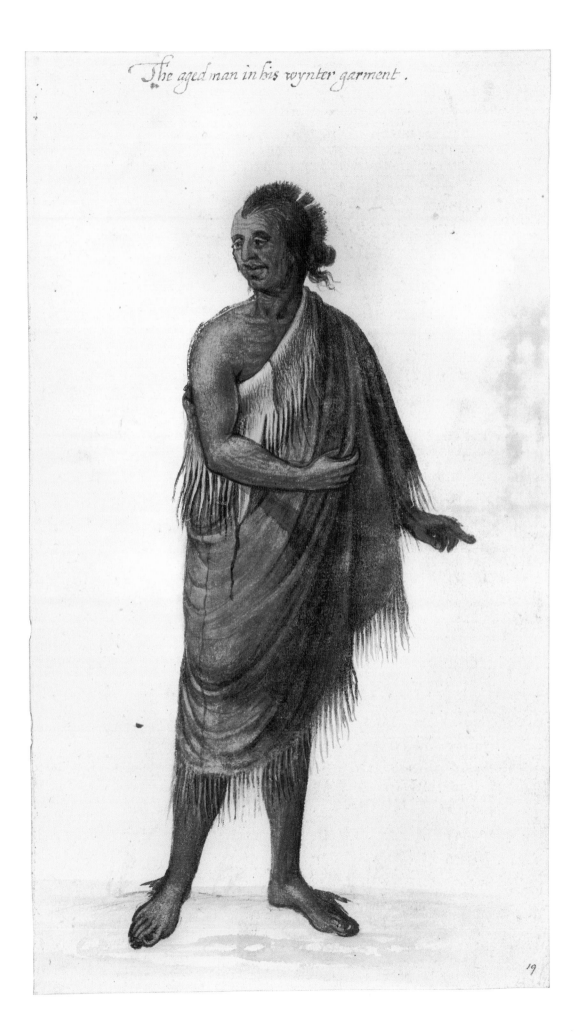

19

24 An Indian man and woman eating

Watercolour over black lead, touched with bodycolour, and gold, 209 × 214 mm

Inscribed in brown ink: 'Theire sitting at meate .'

1906,0509.1.20

The man in this watercolour is dressed like the old man of Pomeiooc (no. 23), but is showing the shaved side of his head, an ear ornament similar to the Priest's (no. 15) and a feather, which may indicate that he is younger. The woman is also young and her skin apron also seems to rise up her back and front to join on her shoulder which is covered by her hand. She is not tattooed as the other women are and her beads are not elaborate; the couple are probably not as high-ranking as the others depicted by White. They are sharing a meal, probably of hulled corn (soaked until the skins come off and then boiled until they puff up), on a wooden platter, seated on a reed mat similar to the ones shown in both village scenes.

In his engraving de Bry added a significant number of artefacts to this scene which are not mentioned by Harriot in the caption but are referred to in his main text, and include a gourd for carrying water, a tobacco pouch and clay pipe, walnut, fish, corn and shell, perhaps the invention of the engraver and intended to indicate the contents of their dish, as assumed from Harriot's main account.

The most significant comment appended to this image by Harriot is that the Indians ate 'soberly' and did not overindulge as he implies the English tended to do, and were healthier and longer-lived as a result.

Lit.: LB 1(21); Quinn, pp. 429–30; ECM 41; PH&DBQ 44(a); PH 41; Rountree, p. 51; Kupperman 2000, pp. 159–65

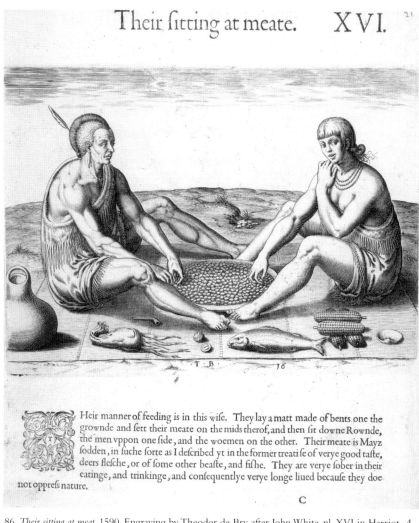

86. *Their sitting at meat*, 1590. Engraving by Theodor de Bry after John White, pl. XVI in Harriot, *A briefe and true report*, Frankfurt. By permission of The British Library, London (c.38.i.18)

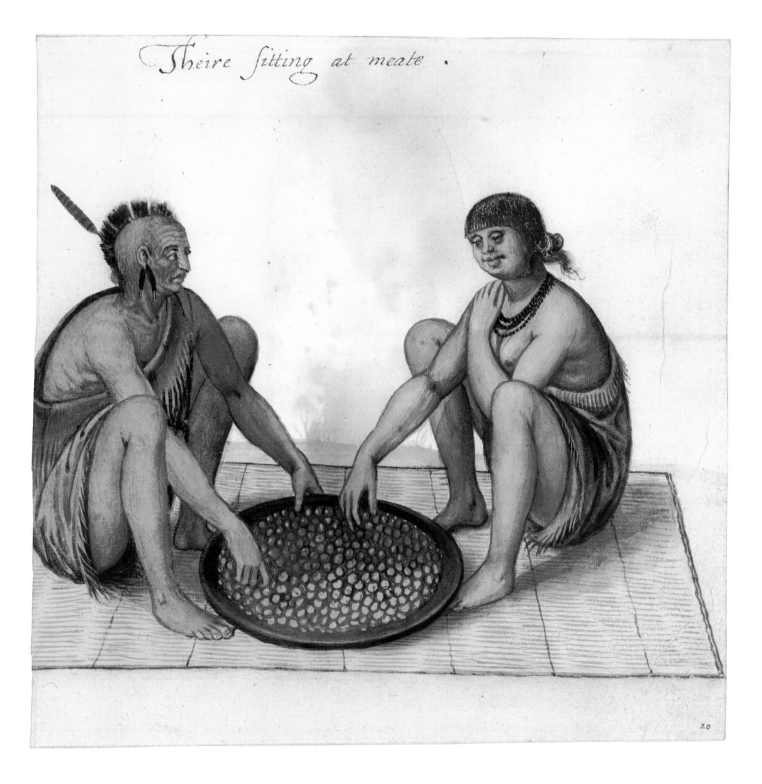

Theire sitting at meate.

Fig 87

Fig 89

Fig 88

87. *A Roman soldier*, 1570s or 1580s. Pen and ink drawing with watercolour and bodycolour, after John White?, from the Sloane volume. It appears to have been copied from Guillaume Du Choul, *Discours sur la castrametation et discipline militaire des anciens Romains*, Lyons, 1567, p. 16. There is a Sloane copy in the BL (Add MS 5253,1). British Museum (P&D SL,5270.8r)

88. *A medieval man*, 1570s or 1580s. Pen and ink drawing with watercolour and bodycolour, after John White?, from the Sloane volume. The gown and hood may be those of a barrister; the source of this image was probably an early fifteenth-century illuminated manuscript. Sloane did not have this drawing copied. British Museum (P&D SL,5270.4r)

89. *The Doge of Genoa*, 1575? Pen and ink with watercolour and bodycolour, gold and silver, after John White?, from the Sloane volume. The source may have been fig. 90, from Weigel's costume book. There is no Sloane copy. British Museum (P&D SL,5270.8v)

COSTUME STUDIES

In his *Lives of Illustrious Netherlandish and German Painters* (1604) Karel van Mander related the following account of a commission for a gallery of 'all the costumes and clothings of the nations' which Lucas de Heere painted for the Earl of Lincoln: 'When all but the Englishman were done, he painted him naked and set beside him all manner of cloth and silk materials, and next to them tailor's scissors and chalk.' When asked what he meant by it, de Heere replied 'he had done that with the Englishman because he did not know what appearance or kind of clothing he should give him because they varied so much from day to day … and I have therefore painted the material and tools to hand so that one can always make of it what one wishes'. But as van Mander went on to note, it was not only the English but most

90. *The Doge of Genoa*, 1577. Woodcut by Hans Weigel, pl. CXII in *Habitvs praecipvorvm popvlorvm, tam virorvm qvam foeminarum Singulari arte depicti. Trachtenbuch …*, Nuremberg. British Museum (P&D 1850,0511.283)

Europeans who shared this passion for fashion and copied 'the costume of different peoples far too much' (see the figure for Europe in fig. 91).

Van Mander, who had been de Heere's pupil, noted that his master had also been a poet and a collector and 'great lover of antiquities'. Appended to de Heere's manuscript history of the costumes of England, Scotland and Ireland was a summary of histories of England and it is this combination of contemporary fascination with ancient, historical and modern fashion, costume and customs from around the world, Old and New, that this series of costume studies by John White reflects.

As Christian Feest and Ute Kuhlemann have discussed in Chapters 5 and 6, printed costume books proliferated throughout Europe in the second half of the sixteenth century. The three images on the left from the Sloane volume obtained from White's descendants owe debts to some of the prints in these books (for reproductions see PH&DBQ). As Margaret Hodgen pointed out, these books were part of an early form of ethnography, an attempt to understand people not only through their government and buildings but also through their social and religious customs, manner and rites and dress (see p. 107) – a new way of understanding the world as a *theatrum mundi*, through people rather than through historical events. The images were incorporated into cosmographies and atlases like Ortelius's popular *Theatrum orbis terrarum*, travel and history books, paintings and theatre.

In Elizabethan England, clothes made and defined a man or woman. Society was changing swiftly, merits and rewards followed the dissolution of the monasteries and appropriation of lands in Ireland, privateers and merchants made fortunes, and elevation in wealth and status in society or at court was meteoric, as witnessed by Raleigh's rise and later fall. Sumptuary laws were created to help

determine people's status at a glance, the same way as emblems and coats of arms. Cloth of gold or silver for example was limited to royalty and the very high born, and red and black, from expensive dyes, were almost as exclusive. The laws set fines for people who wore clothing above their station – although they were difficult to enforce.

The proliferation of prints and drawings of costume studies also reflects the rich and various creations for Elizabethan public processions, theatre, tournaments and masques where the business of the Office of Revels 'resteth speciallye in three poyntes, In making of garmentses, In making of hedpeces, and in payntinge. The connynge of the office resteth in skill of devise, in understanding of historyes, in judgement of comedies tragedys and showes.'

The three images on the left here are from the Sloane volume, where they were included with the images of the Tupinambá (figs 148–52), the additional images of Inuit (figs 102, 104–6) and the copies after the Indians (figs 64, 70, 76, 83, 85). Whether they are copies after originals by John White or early work by him from the 1570s, they are certainly connected with his work. Along with the watercolour costume studies that follow, they provide a brief history of the costumes and customs of the Old World, from ancient Picts, through the Romans and medieval to modern Europe, and the exotic people on its fringes in Turkey, Tartary and Meta Incognita; other cultures and civilizations with which to compare the people in the New World of Virginia.

Lit.: For van Mander's *Schilder-boeck* see Hessel Miedema, ed., Karel van Mander, *Lives …*, vol. 1, Doornspijk, 1994, pp. 281–2; for de Heere see Frances Yates, *The Valois Tapestries*, London, 1975; Jo Anne Olian, 'Sixteenth-century costume books', *Dress*, III (1977), pp. 20–48; Edmund Kerchever Chambers, *Notes on the History of the Revels Office under the Tudors*, London, 1907, p. 37; see Ann Rosalind Jones and Peter Stallybrass, *Renaissance Clothing and the Materials of Memory*, Cambridge, 2000

25 A Turkish man, with scimitar

Watercolour over black lead with some white bodycolour, 226 × 156 mm

1906,0509.1.31

Lit.: LB 1(32); ECM 73; PH&DBQ 136

26 A Turkish woman

Watercolour and bodycolour over black lead, 222 × 153 mm

1906,0509.1.32

Lit.: LB 1(33); ECM 75; PH&DBQ 137(a)

England was interested in Turkey was not only because it was 'exotic' but because, like Cathay, it was the potential source of great riches for English merchants who formed the Levant Company in 1581. But during the reign of Süleyman the Magnificent, the Turks were the 'present Terrour of the World' and many Elizabethans, including John Smith who was later to help found Jamestown, had experience in the wars between the Muslim Ottoman Empire and the Christian Holy Roman Empire. They were a menace at sea, and journals and captivity narratives led to a fascination that resulted in the Levant making appearances in many guises in paintings and in plays in Elizabethan theatre and in the characters of court masques. One of these figures (no. 27) may represent a Tartar or Uzbek who, like the Turks, represented another exotic and potentially terrifying nation with which England had recently begun to trade through the Muscovy Company. Thus, as in John White's images of the Picts, these figures represent people from cultures that were non-Christian and to be feared; in comparison to them, the Indians depicted by White appeared to be a much less threatening, even civil society.

Lit.: For English attitudes to Turkey see Pompa Banerjee, 'The white Othello: Turkey and Virginia in John Smith's *True Travels*', in Applebaum and Sweet, p. 136

91. Title page of Hans Weigel, *Habitvs praecipvorvm popvlorvm, tam virorvm qvam foeminarum Singulari arte depicti. Trachtenbuch …*, 1577. Woodcut by Hans Weigel, Nuremberg. One of the more popular costume books; the figure of Europe is based on de Heere's description of a drawing in his manuscript and America is based on a Tupinambá. British Museum (P&D 1850,0511.283)

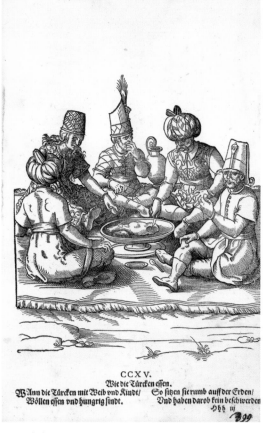

92. *Turkish men and women seated on a mat, eating*, 1577. Woodcut by Hans Weigel, pl. CCXV in *Habitvs praecipvorvm popvlorvm …*, Nuremberg. Costume books often included images of customs and eating habits, as John White did of the Indians (no. 24). British Museum (P&D 1850,0511.283)

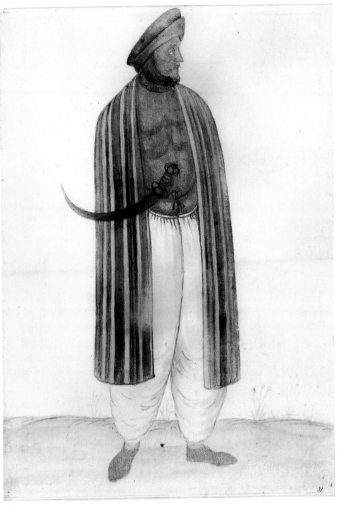

25

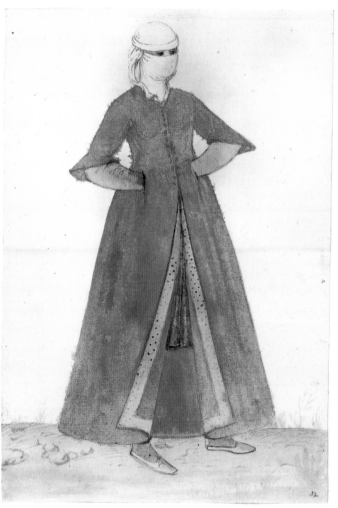

26

27 A Tartar or Uzbek man

Watercolour and bodycolour over black lead, 243 × 139 mm

1906,0509.1.33

Lit.: LB 1(34); ECM 72; PH&DBQ 135

28 A Turkish woman with black veil

Watercolour and bodycolour over black lead, heightened with white, 211 × 163 mm

1906,0509.1.34

Lit.: LB 1(35); ECM 74; PH&DBQ 138(a)

29 A Greek or Turkish woman, with rose and pomegranate

Watercolour and bodycolour over black lead, touched with silver (?) (altered), 210 × 94 mm

1906,0509.1.35

Lit.: LB 1(36); ECM 76; PH&DBQ 139

John White's source for these five images of 'Turkish' men and women has not been identified. There was a general fascination for Oriental subjects, and many images of them available, such as Hans Eworth's painting of *A Turk on Horseback*, 1549, or Pieter Coecke van Aelst's long sequential woodcut 'Les Moeurs et fachons de faire de Turcs …' or his drawings made in Istanbul on which it was based (see Hearn, *Dynasties*, p. 64). White's figures do not match any of these figures exactly, but his own images might have been based on one of the many costume books circulating in the form of printed books and as albums of drawings throughout Europe in the second half of the century. The style of these particular watercolours by White has been described as 'flat and stiff', as if they were drawn from engravings. Nicolas de Nicolay's *Les Quatres Premiers Livres des Navigateurs et*

93. *A Turkish common woman*, 1577. Woodcut by Hans Weigel, pl. CCVIII in *Habitvs praecipvorvum popvlorvm …*, Nuremberg. British Museum (P&D 1850,0511.283)

Peregrinations Orientales, published in Lyons in 1568, has been suggested as the closest example for the women, perhaps indicating that the engraver and White shared a common prototype (PH&DBQ 137, 138) Smaller versions of the illustrations appeared in the 1585 London edition of Nicolay's work *The Navigations, peregrinations and voyages, made into Turkie*, entitled 'A woman Turk going through the Citie' (p. 63) and 'A woman Turk dressed a la Moor' (p. 56).

The same images of Turkish men and women, mostly taken from Nicolay's engravings, were repeated constantly through the century with little significant change; but not only are White's women different from all the existing images but the men do not relate to any of the engravings at all. White has taken some pains with these studies; the two men are almost portraits, their features, caps and stoles are carefully drawn, clearly indicating a pose characteristic of the type of men represented. The facial features of the woman wearing a cloth wrapped around her head are indicated underneath and the figure of the woman with a black veil was fully drawn before the veil and white semi-transparent cloak were painted over her. Sadly the vermilions have bled and the smalt blue of the Tartar has lifted. None of the engravings indicates the transparency of any of the cloaks or dresses visible below them, indicating that White must have drawn these from painted rather than from printed sources.

27

28

29

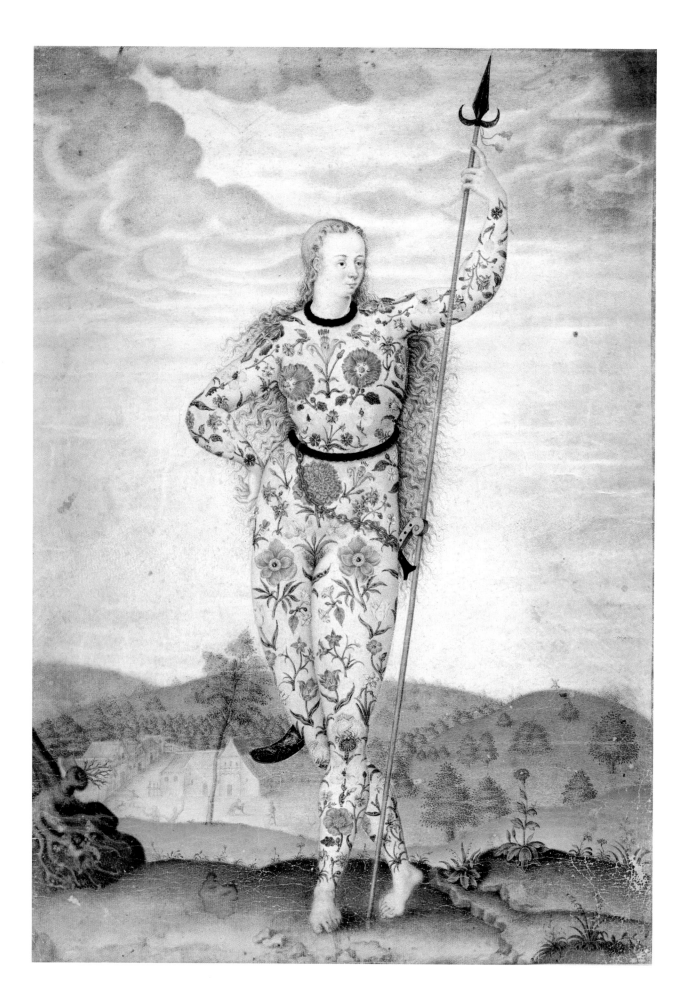

Immediately after his engraving of 'The Marckes of sundrye of the Cheif mene of Virginia' (fig. 47), Theodor de Bry published an appendix to his illustrated edition of Harriot's *Briefe and true report*. He gave two explanations for the inclusion of these images which he stated he had received from John White, 'fownd as hy did assured my in a oolld English cronicle, the which I wold well sett to the ende of thees first Figures, for to showe how that the Inhabitants of the great Bretannie haue bin in times past as sauuage as those of Virginia'. In the first 'trvve picture of one Picte' (fig. 96) he noted 'In tymes past the Pictes, habitans of one part of great Bretainne, which is nowe nammed England, wear sauuages, and did paint all their bodye after the maner following … And when they hath ouercomme some of their ennemis, they did neuer felle to carye a we their heads with them.' Their women 'wear noe worser for the warres than the men'.

As Joyce Chaplin has commented in Chapter 4, White's fantastically painted warriors and Harriot's captions written for them seemed to be indicating that the English should have no fear of the North Carolina Algonquians, since they were much more civilized than the earlier inhabitants of Britain itself. The Indians were partially clothed, not naked, and decoratively tattooed and painted their bodies with patterns resembling gilding on armour or with identifying marks of their 'Princes' (similar to a badge, emblem or coat of arms), rather than painting themselves all over as ancient Picts had done. The contemporary English historian John Speed argued that the name Pict meant 'painted or stained' and believed that they went naked so as not to cover up

their 'painting and damasking' which made them look more terrible in war. The Picts took heads as trophies, and they and their neighbours, men and women, bristled with weapons.

The phrases 'Brytish Empire' and 'Greate Briteigne' were beginning to be used with more regularity during this period, with Elizabeth claiming sovereignty over England, France, Ireland and Virginia (see fig. 24). There has been a great deal of debate concerning how much the Picts and their neighbours represented by White, Harriot and de Bry were intended to refer to the Scots or to the 'wild and savage' Catholic Irish whom the English were currently attempting to evict and subdue in order to plant English settlers on Irish land that Queen Elizabeth claimed to rule. The English had been no less savage themselves in these attempts, with Humphry Gilbert lining the path to his tent with Irish heads and books published with illustrations celebrating

similar grisly victories. Andrew Hadfield (p. 175) has noted: 'It was a commonplace that Ireland was at the same stage of development as England had been when conquered by the Romans, the invaders in each case providing much needed law, order, and civilization.' If the Picts represented the Scots or drew parallels with the Irish, then history was reassuring, as the English would provide the same civilizing process for the Indians as the Romans had done for them and they would have a much easier time of it, as White's images of the Indians indicated they were already a civic society with their own organized government, agricultural society and religion.

Lit.: For Indians and Picts see Piggott, pp. 73–85, and Kupperman 2000, pp. 59–62. For Scots, Irish and Picts, most recently see Miller 1998, pp. 50–85, David Armitage, 'Making the empire British: Scotland in the Atlantic world 1542–1707', chapter VIII in Armitage 2004, pp. 39–45, and Andrew Hadfield, 'Irish colonies and the Americas', in Applebaum and Sweet, pp. 172–91

94. *A young daughter of the Picts*, c.1580s? Watercolour and bodycolour with gold and silver (altered to black) on vellum, attributed to or after Jacques Le Moyne de Morgues. For the engraving after it by de Bry see fig. 98. Yale Center for British Art, Paul Mellon Collection, New Haven. (Bridgeman Art Library)

95. *Irish men and women*, 1573–5. Pen and ink and watercolour with bodycolour, by Lucas de Heere from his illustrated manuscript, 'Der Beschrijving der Britische Eilanden …' ('A short description of England, Scotland and Ireland'); the barefooted men on the right are labelled 'Wild Irish'. De Heere was in England c.1567–77. By permission of the British Library, London (Add MS 20330,34)

30 A Pictish warrior holding a human head

Watercolour and bodycolour over black lead, touched with pen and ink, 243 × 169 mm

1906,0509.1.24

John White was not the first to depict ancient Picts or Inuit in watercolour in England; Lucas de Heere made drawings of Stonehenge and of ancient Britons when he visited London in 1575 and drew the Inuit brought there by Frobisher the following year (see p. 165). De Heere was part of a circle of Dutch and Flemish Protestant refugees in London in the 1560s and 1570s with a larger circle of correspondents on the continent, which included Ortelius, the publisher Christopher Plantin, the botanist Clusius and many artists – Ketel, Gheeraerts, de Critz, Hoefnagel and Hogenberg. They were all well known to John Dee, Philip Sidney and other members of their circle, including William Camden. Ortelius, in London in 1577 to learn about Frobisher's voyages, persuaded Camden to write his history of Britain. It was undoubtedly in this milieu in the mid-1570s and on the receipt of a commission to paint a gallery of costumes of different nations that de Heere was inspired to create the two

albums of watercolours of people of ancient and modern Britain that are now in the British Library (with a Dutch description) (see fig. 95) and the University Library of Ghent (in French). Both included drawings drawn from life, from prints and possibly from early manuscripts, and both included images of Irish and of ancient Picts, described as 'les premiers Anglois comme ils alloyent en guerre du tems du Julius Cesar'.

The title of the Dutch manuscript in the British Library translates as a 'Short Description of England, Scotland and Ireland' and is followed by a 'Short Description of the English Histories Compiled from the Best of Authors'. The latter may have provided the source for White's images of the Picts. De Heere's and White's Picts are not identical but are similar enough to make one wonder whether they knew each other or at least shared a common source – White's 'oolld English cronicle' (see p. 153), which was probably a fairly explicit description or manuscript illustration in a classical source. Stuart Piggott has argued that the captions for this group of engravings in de Bry's publication (which may have been written by de Bry, Harriot or White) seem to cite descriptions from two Greek

authorities, Herodian (fl. AD 235) and Dio Cassius (AD 160–230), on the Severan campaigns against the Caledonii and Maetae of North Britain in AD 208–9. These texts were available to scholars: John Stow published a *Summarie of Englyshe Chronicles* in 1565 and William Camden printed them in full in his *Britannia* of 1586. Herodian mentions the iron torcs, the sword chain is mentioned by Diodorus Siculus, and the narrow oval shield, twisted torcs, nakedness, head-hunting and body painting are all described. Herodian wrote: 'They paint their bodies with sundry colours, with all kinds of animals represented in them.'

It is also worth noting that the paintings and tattoos on this Pict in particular resemble some of the more elaborate sculpted and gilded decorations on court armour of the period, which employed similar fantastic beasts on shoulders, helmets and breastplates.

Lit.: LB 1(25); ECM 67; PH&DBQ 124, PH 65; for Flemish in London see J. A. van Dorsten, *The Radical Arts: First Decade of an Elizabethan Renaissance*, Oxford, 1970, pp. 15–54; Hearn, pp. 117, 154; and Meganck 2004, *passim*; for ancient sources see Piggott, pp. 74–85, and J. A. Bakker, 'Lucas de Heere's Stonehenge', *Antiquity* 53, 1979, pp. 107–11.

96. *The true picture of one Pict*, 1590. Engraving by Theodor de Bry after John White, pl. I of the appendix to the illustrations of Indians after John White in Harriot, *A briefe and true report*, Frankfurt. By permission of The British Library, London (G.6837)

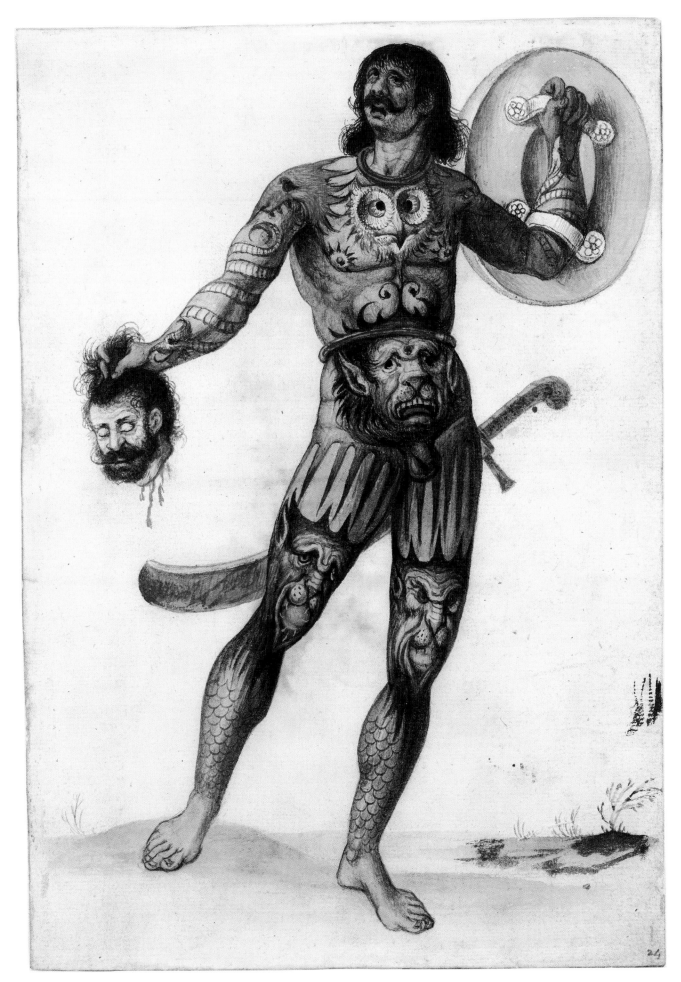

31 A 'woman neighbour to the Picts'

Pen and brown ink and watercolour over black lead, 221 × 153 mm

1906,0509.1.25

Because of its association with Turks, the curved scimitar was a weapon to be feared more than a straight sword. Neither Picts nor early Britons were ever mentioned carrying them in ancient sources, and the ones shown here were probably White's own invention, as de Heere depicts straight ones on his images of Picts. But, as a result of de Bry's engravings after White's watercolours, the curved swords became associated with early Britons and were used for men and women in the illustrations for John Speed's *Theatre of the Empire of Great Britain* (1611). When depicting an 'Ancient British Woman', Speed took the figure of the tattooed Pictish woman (no. 33) and clothed her in the tunic of this neighbour of the Picts, lengthening her skirt and adding a long cloak, and retaining the long curved sword and spear but adding chains around her neck. Her tattoos were of birds and beasts and her hair loose and almost to the ground. Speed paired her with the tattooed Pictish man (no. 30), who was shown with two severed heads and a spear with a ball on the end (both are elements seen in de Bry but not in White) and a shield, the side of which is clearly visible. The man's pose was altered considerably so that the hair from the head he is holding covers part of his nudity, and here too the pose is much changed – White's woman is much less dynamic and her sword behind her. De Bry's strides across the landscape, her tunic and hair waving in the wind, and, once adopted by Speed, undoubtedly was the source for many later images of warrior queens such as Boudicca.

Lit.: LB 1(26); ECM 68; PH&DBQ 128(a); PH 69; see Piggott, pp. 79–85

The trvve picture of a vvomen nigbour to the Pictes V.

Heir woemen wear apparelled after this manner, butt that their apparell was opne before the breft, and did faften with a little leffe, as our woemen doe faften their peticott. They lett hange their brefts outt, as for the reft the dyd carye fuche waeppens as the men did, and wear as good as the men for the warre.

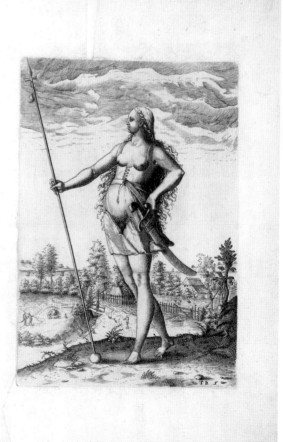

97. *The true picture of a woman neighbour to the Picts*, 1590. Engraving by Theodor de Bry after John White, pl. V of the appendix to the illustrations of Indians after John White in Harriot, *A briefe and true report*, Frankfurt. By permission of The British Library, London (G.6837)

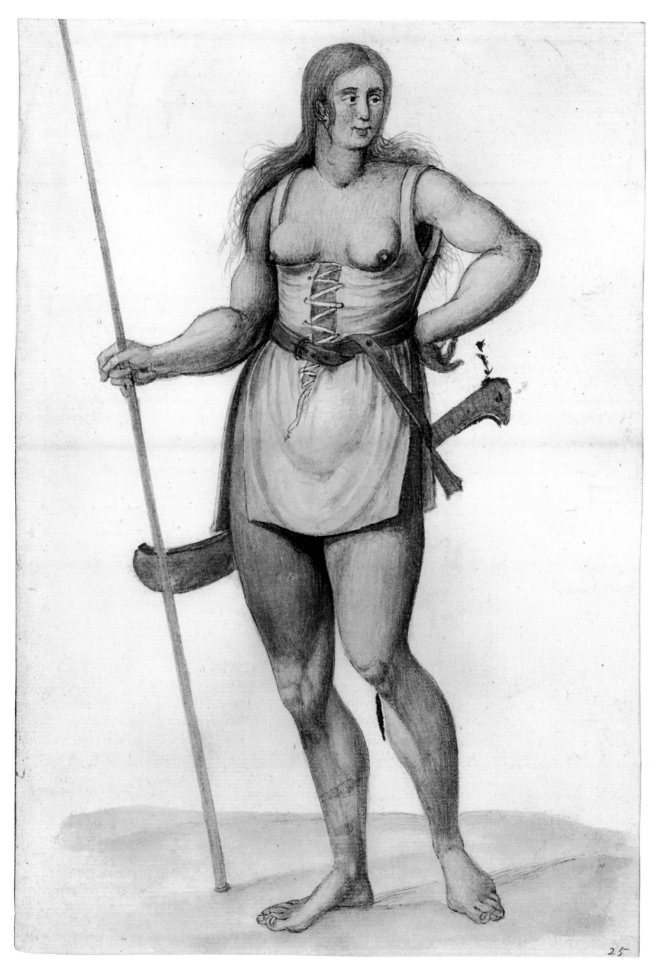

25

32 A 'Pict warrior'

Pen and brown ink and watercolour and bodycolour
over black lead, touched with white (altered), 242 ×
152 mm

1906,0509.1.26

Dio Cassius (see no. 30) is the only
classical author to mention a 'short spear
with a bronze apple on the end of the
shaft, so that when it is shaken it clashes'.
De Bry did not engrave this second figure
of a Pictish man, but took the example of
the spear here, adding a tasselled point and
gave it to his engraving of the Pictish man
with a head, adding another head as well
to increase his ferocity. De Bry's image
was used by John Speed and other
historians who followed their example.
There is archaeological evidence of this
spear as a peculiarly Scottish type found in
examples from East Lothian to Orkney.

Through Speed especially, later authors
came to rely upon these images of Picts
and they completely altered the view of
the ancient Briton, visually and
conceptually, after 1590. Even in 1815,
Charles Hamilton Smith relied upon it as
well as classical sources and archaeological
evidence, producing something very close
for his own images of a Maeatea and
Caledonian in his Costumes of the Original
Inhabitants of the British Isles (fig. 99).

Instead of this second image of a Pictish
man, de Bry included an engraving of 'a
yonge dowgter of the Pictes' (fig. 98), the
'original' watercolour for which does not
survive amongst the group in the British
Museum. In the 1960s, however, an
anonymous painting in bodycolours on
vellum clearly related to the engraving
was acquired by Paul Mellon (see fig. 94).
It was later attributed to Le Moyne by
Paul Hulton on the grounds of style,
because it was clearly related to the
Florida work in the same medium in
New York (fig. 77), and because he argued
that only Le Moyne could have executed
the exquisite flowers that covered her
body. There are many unanswered
questions remaining about this work and
its relation to the John White series and to
the de Bry engravings. The tattooing on
the other Picts is closely copied by de Bry,
whereas her tattooing in this plate is quite
different from the original. The image is
identical to the print in every other detail,
however (just as the Florida image is),
down to the cloud pattern, the dogs and
people in the distance and the windmill
on the distant hill. In this book we have
argued that the backgrounds in the other
de Bry engravings are his own inventions
and not White's, and this might be
assumed for the Picts too, as they show
castles and ships and two-storey dwellings
inappropriate for what was known about
the Picts by historians at the time such as
Camden and Speed. It is not possible to
discover the relationship of this drawing
to the rest, except for its unusual similarity
to the engraving but with an additional
virtuoso performance in the way of
miniature paintings of flowers that had
recently arrived in Europe. Perhaps all of
White's Picts are based on originals by Le
Moyne, but de Bry probably would have
known and mentioned this.

Lit.: LB 1(27); ECM 69; PH&DBQ 125; PH 66;
Piggott, pp. 75–85; for the daughter of the Picts see
Hulton, Le Moyne, pp. 14, 15, 164, and Feest 1984

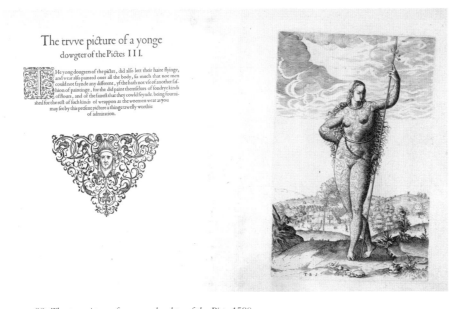

98. *The true picture of a young daughter of the Picts*, 1590.
Engraving by Theodor de Bry after John White? or after
Le Moyne?, pl. III of the appendix to the illustrations of
Indians after John White in Harriot, *A briefe and true
report*, Frankfurt. By permission of The British Library,
London (G.6837)

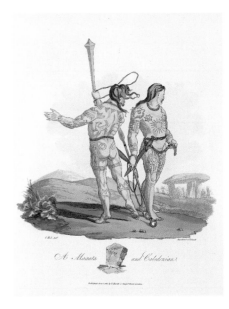

99. *A Maeatea and Caledonian*, 1815. Hand-
coloured aquatint by R. Havell after Charles
Hamilton Smith in S. R. Meyrick and C. H.
Smith, *Costumes of the Original Inhabitants of the
British Isles*, London. British Museum (PD
c.170★ a 9; 1913,0331.174)

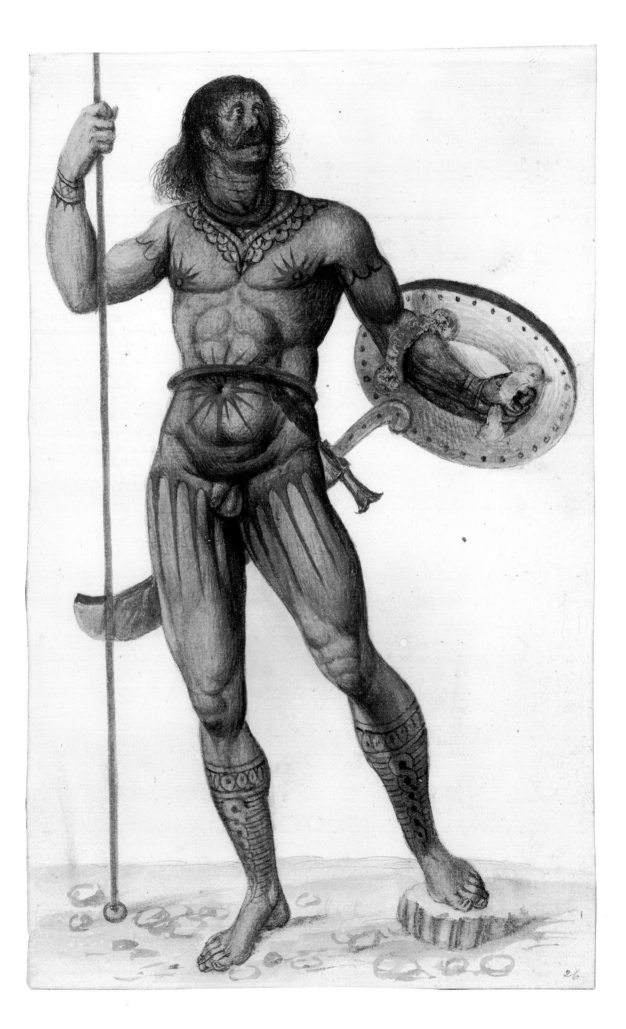

159

33 A Pictish woman

Watercolour over black lead, touched with bodycolour and white (altered) and pen and ink, 230 × 179 mm

1906,0509.1.27

There is an element of theatre and particularly of Elizabethan masques in John White's images of the Picts. It is doubtful that any performer in a masque would be as completely naked as the figures here, but diaphanous materials and the types of short and revealing costumes shown in drawings that do survive indicate that they were more daring than we might imagine. The paint or tattoos cover their bodies completely, creating a kind of second skin that is also reminiscent of armour such as that worn by the Earl of Cumberland for a tournament (see fig. 22). Men showed off their shapely legs to their upper thighs in silk hose until near the end of the century.

In John Speed's 1611 *Theatre of the Empire of Great Britain* the image of this Pictish woman was incorporated with the image of a woman neighbour of the Picts (no. 31) into an 'Ancient British Woman' with long flowing skirts and hair over a body completely tattooed with small birds and animals. The type of tattoos shown in this later image and those found on the 'Daughter of the Picts' (figs 94, 98) are also reminiscent of the elaborate and exquisitely fine embroidery found in Elizabethan dress. The 'Rainbow portrait' of Queen Elizabeth at Hatfield House, the home of the Cecils, Lord Burghley's family, depicted her dress covered with spring flowers and her cloak strangely embroidered with eyes, ears and mouths to symbolize 'those who watched and listened to purvey their intelligence to her' while a serpent on her sleeve, similar to the strapwork pattern on the previous Pict's legs, indicated her wisdom. The Elizabethan court and its portraits were full of symbolism, and stars and crescents as seen here were often used to refer to Diana or Cynthia, goddess of the moon (see fig. 17) or to Astraea, the just virgin of Virgil's *Fourth Eclogue* who inaugurates a golden age bringing peace and eternal springtime. It is entirely possible that there is a further layer of meaning in White's image of the Picts alluding to the Queen and 'Virginia' that has yet to be unravelled.

Lit.: LB 1(28); ECM 70; PH&DBQ 126; PH 67; for symbolism in the Queen's portraits see Strong 1999, pp. 47–50, Frances Yates, *Astraea: The Imperial Theme in the Sixteenth Century*, London, 1975, 1993, and an extensive literature by Karen Hearn, Tarnya Cooper, Susan Doran and others

The trvve picture of a vvomen
Picte II.

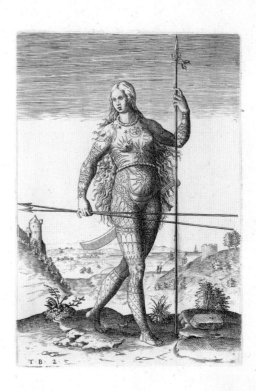

100. *The true picture of a woman Pict*, 1590. Engraving by Theodor de Bry after John White, pl. II of the appendix to the illustrations of Indians after John White in Harriot, *A briefe and true report*, Frankfurt. By permission of The British Library, London (G.6837)

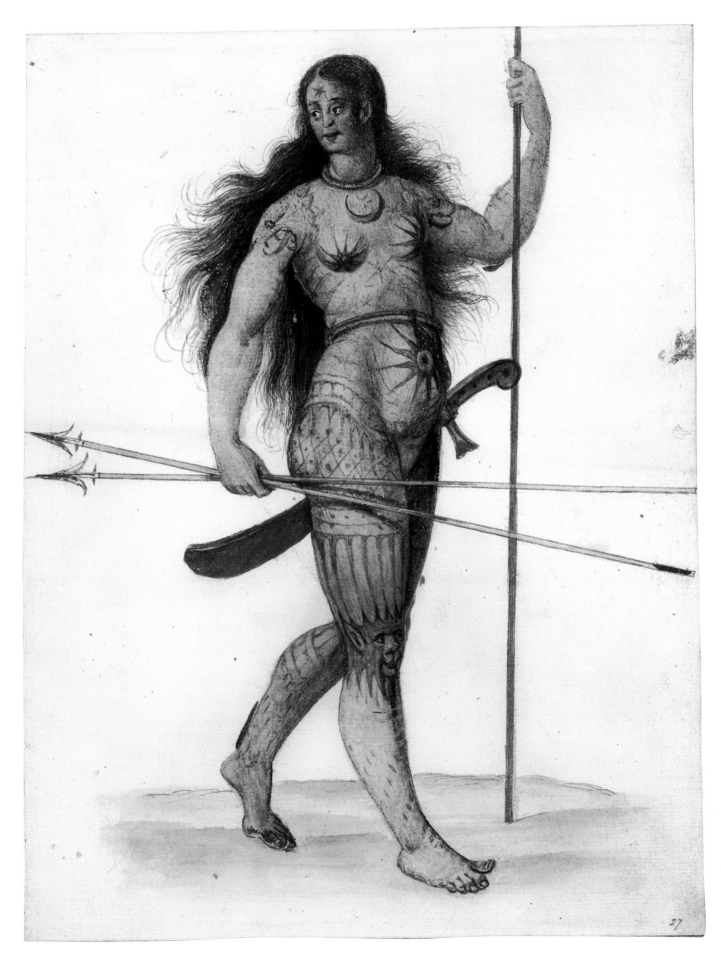

34 A 'Warrior neighbour of the Picts'

Pen and brown ink and watercolour over black lead, heightened with white, 236 × 154 mm

1906,0509.1.28

In a statement well known to all Elizabethan historians and antiquaries, Julius Caesar wrote that 'all the Britons, without exception, stain themselves with woad, which produces a bluish colouring'. We are not certain which warrior neighbours of the Picts this man and the woman in no. 31 are meant to represent but they can be taken to be generic early Britons. Antiquaries were already fascinated by Stonehenge, and Lucas de Heere drew the stone circle in his manuscript description of England, Scotland and Ireland (British Library). De Heere was a collector of antiquities, and his friends included many others interested in ancient texts and monuments such as Ortelius, and he may have visited the stones in the company of the artist Joris Hoefnagel (see fig. 23). In his manuscript de Heere recorded Geoffrey of Monmouth's account of the stone circle being brought over from Ireland by Merlin and set in place by St Ambrosius after the Saxons defeated the early Britons under Hengist and Vortigern. If, as seems likely, White was also familiar with these accounts, it may be that his warrior neighbours of the Picts represent these early painted Britons.

As in the woman neighbour of the Picts (no. 31), de Bry has altered the image considerably. The sword is curved and a spear has been added but the stance is still the strong firm pose of a warrior confidently surveying the land. It is somewhat reminiscent of Gheeraerts's later famous bare-legged portrait of Captain Thomas Lee in the guise of an Irish foot-soldier (Tate).

Lit.: LB 1(29); ECM 71; PH&DBQ 127(a); PH 68; on woad see Piggott, p. 62, and on Stonehenge see Piggott, pp. 102–3, and Bakker, p. 108; for the portrait of Lee, see Hearn, no. 120

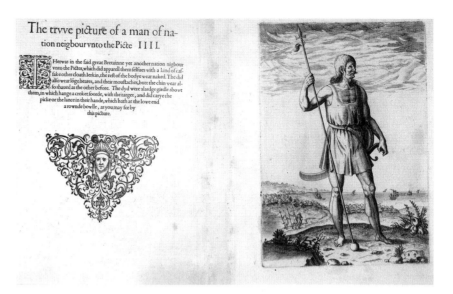

101. *The true picture of a man of nation neighbour to the Picts*, 1590. Engraving by Theodor de Bry after John White, pl. IIII of the appendix to the illustrations of Indians after John White in Harriot, *A briefe and true report*, Frankfurt. By permission of The British Library, London (c.38.i.18)

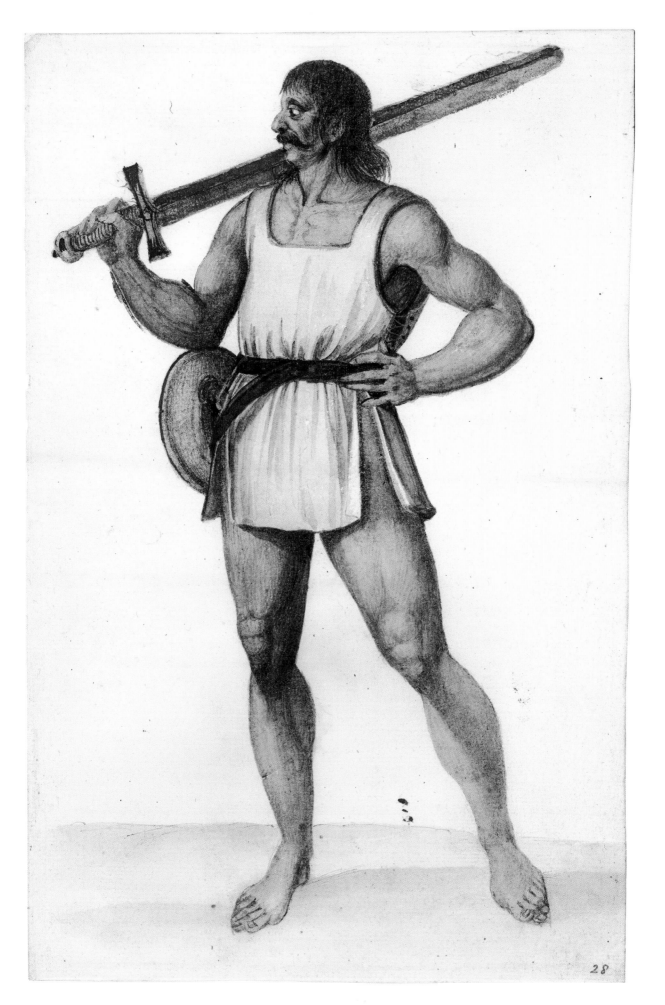

28

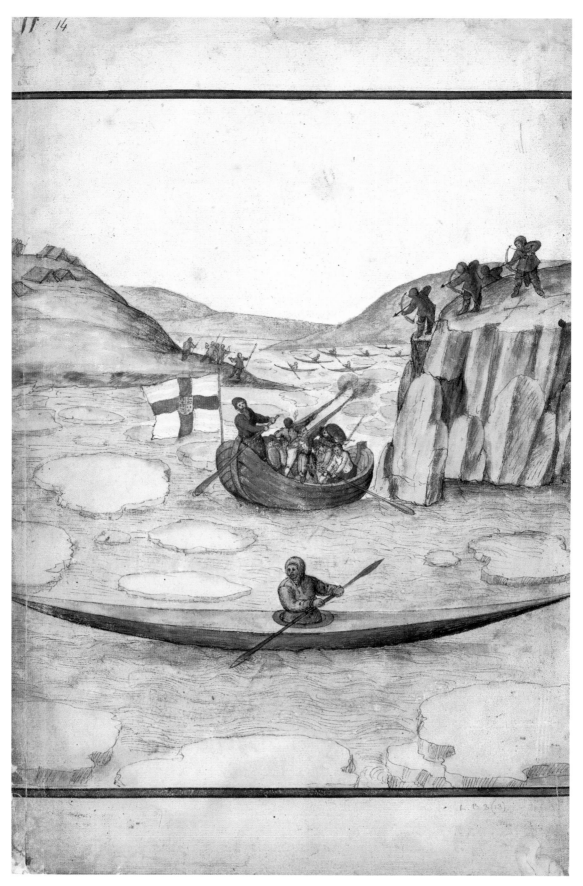

102. *The skirmish at Bloody Point*, 1570s or 1580s. Pen and ink drawing with watercolour and bodycolour, after John White?, from the Sloane volume, 386 × 266 mm. There is an eighteenth-century copy made for Sloane in the BL (Add MS 5253,8). British Museum (P&D SL,5270.12)

John White's Watercolours of Inuit

There are six watercolours of Nugumiut Inuit from Frobisher Bay on Baffin Island that are associated with John White: two of them, of the man Kalicho (no. 35) and the woman Arnaq and her child Nutaaq (no. 36), are by John White and four (figs 102, 104–6) are from the Sloane volume of watercolours associated with him.

Martin Frobisher made three visits to Baffin Island in his exploration of Meta Incognita, the 'unknown boundary' between Europe, Greenland, America and Asia. The first was in 1576 to find the Northwest Passage to Cathay where new markets and goods beckoned for the merchants of London. John Dee provided advice on routes, Humphrey Cole supplied the instruments, and the Queen and Lord Burghley their support (see pp. 16–18). Frobisher was distrustful of the Inuit from the time he encountered them on what is now Frobisher Bay, but had been trading with them and obtaining advice about a passage through the islands when five of his men disobeyed orders and rowed out of sight and were not seen again. Frobisher then needed captives to exchange for his men and boat but succeeded only in getting close to one Inuit who he plucked with his kayak from the sea after enticing him close to the ship. He returned to England with what he believed to be gold and 'this new prey (which was a sufficient witness of the captain's far and tedious travel towards the unknown parts of the world, as did well appear by this strange infidel, whose like was never seen, read, nor heard of before, and whose language was neither known nor understood of any)' (George Best, 1578). Frobisher returned to London with this 'strannge man & his Bote, which was such a wonder vnto th[e] whole City, & to the rest of the Realm that heard of yt, as seemed neuer to have happened the like great matter to any mans knowledge' (Michael Lok). He died shortly afterwards, probably from a European disease to which he had no resistance, but not before his 'counterfeit' had been 'drawn, with his boat, and other furniture both as he was in his own, and also in English apparel'. He was buried in

St Olave's Churchyard in London. There are payments to Cornelis Ketel, a Flemish artist living in London, for large and small, full-length and portrait, 'pictures' of the Inuit man, some for the Queen and the Cathay Company, but none survives (see p. 168). However, Lucas de Heere was in London at this time, and his watercolour of the man is in his album in Ghent, but it is not certain whether it was drawn from life.

Frobisher gained a great deal of celebrity and support from the fame of the Inuk and 'was called to the Court and greatly embraced and liked of the best.' On the second voyage he immediately attempted to capture more Inuit in order find the men he had lost the previous year. Soon after they landed, one man, Kalicho, was caught through trickery (see no. 35). Later an old woman and a young one with her infant who had been wounded in the arm were taken when they were found hiding because they could not run after a skirmish at a place described as Bloody Point, near York Sound on the south shore of Frobisher Bay, probably the event described in the watercolour illustrated here. The landscape is apparently correct for Frobisher Bay, and other details, such as the royal ensign, kayaks, tents, ice floes and Inuit are

accurate. The accounts indicate that there were about sixteen to eighteen Inuit in an *umiak* (which carried many people) and a *kayak* and there about thirty to forty Englishmen in two pinnaces. There is no sign here of the *umiak* or the second pinnace. One Englishman was wounded and five or six Inuit killed, three by drowning after jumping off a cliff to avoid capture after being wounded. The old woman was released after having her shoes pulled off 'to see if she were cloven footed' but the man and the woman and child (who were not related to the man) were brought back to England and were drawn by John White.

The fact that the portraits of the three Inuit might easily have been drawn in Bristol, and that the skirmish drawing is from the Sloane volume, and that it could have been drawn by a talented artist from a description given in the accounts or by one of the unnamed gentlemen-companions who had been there, all indicate that there still must remain some doubt whether White accompanied Frobisher on this voyage.

Lit.: For Frobisher and the Inuit he brought back see especially Sturtevant and Quin, pp. 61–140; see also W. A. Kenyon, *Tokens of Possession: The Northern Voyages of Martin Frobisher*, Toronto, 1975, and Morison, pp. 516–31

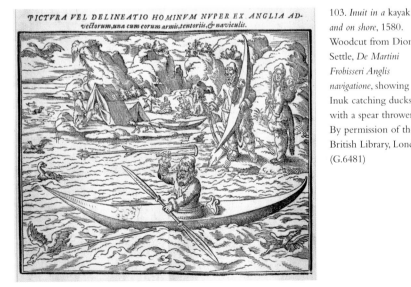

103. *Inuit in a* kayak *and on shore*, 1580. Woodcut from Dionyse Settle, *De Martini Frobisseri Anglis navigatione*, showing an Inuk catching ducks with a spear thrower. By permission of the British Library, London (G.6481)

35 Kalicho, an Inuk from Frobisher Bay

Watercolour over black lead, touched with bodycolour and white (altered), 227 × 164 mm

1906,0509.1.29

Although we cannot condone or understand such behaviour today, living people were 'collected as evidence, trophies, and objects of curiosity' in sixteenth-century Europe and later (Sturtevant and Quinn, p. 69). Instead of having information about Inuit of this date as a result of observation and co-operation, our only knowledge of them today comes as the result of violence, coercion and curiosity. Kalicho was caught on Hall Island at the northern opening of Frobisher Bay on 19 July 1577 after Frobisher had enticed him and another man to come and trade with them. He wanted to capture and bring two men on board in order to give trade items to one and return him to act as an advocate of future trade with the English and to keep the other as an interpreter. But the two men had escaped before getting to the boat and Kalicho was recaptured with a 'Cornish trick' by a

wrestler who broke his ribs (after he died he was found to have an infected collapsed lung and an unspecified head wound). He was kept captive with the woman Arnaq and her infant who were captured later (no. 36). His name was recorded by the English at the time and is now thought possibly to have been Kaliksaq, which means 'hauling something'.

The Inuit were carefully observed by the English, who recorded their social relations with each other, their courtesy and modesty with each other, and particularly their food, as they were not able to digest English food and the English accepted food for them from Inuit on shore. They were especially fascinated by the fact that they ate their meat 'raw' (although it may have been merely less cooked than the English were accustomed to) and that they ate 'carrion' – meat and fish hung longer than the English would eat.

On 9 October, after they arrived in Bristol, Kalicho displayed his skill in the *kayak* and killed two ducks with his 'dart' on the River Avon before the mayor and others. He gave other displays and carried

his kayak on his back through the city, and learnt a few phrases of English before a doctor was called to treat him for his shortness of breath, deafness and head pains. He died early in November, an autopsy was performed and he was buried on the 8th in St Stephen's Church in Bristol. Arnaq was taken forcibly to watch his burial to prove to her that the English did not practise sacrifice or cannibalism, as the Inuit were believed to do.

At some point he and Arnaq were drawn by John White in detail that provides us with a great deal of information about the Inuit in Frobisher Bay at this time. The Sloane volume includes two further views of him from the front and the back with a bow, paddle and arrow (figs 104–5) which are certainly not by the same artist and appear to be copies after different originals by White or another, unknown, artist.

Lit.: LB 1(30); Quinn, pp. 463–4; ECM 63; PH&DBQ 114(a); PH 63 and figs 40–41; see Sturtevant and Quinn, pp. 76–112; for an account of Kalicho's injuries see Sir James Watt and Ann Savours, 'The captured "Countrey People": Their depiction and medical history', in Symons, pp. 553–62

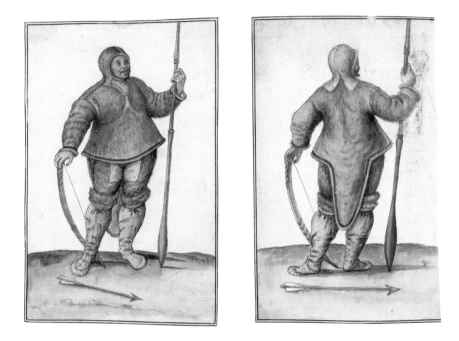

104, 105. *Kalicho, an Inuk from Frobisher Bay, seen from the front and from the rear*, 1570s or 1580s. Pen and ink drawings with watercolour and bodycolour, after John White?, from the Sloane volume. There are eighteenth-century copies made for Sloane in the BL (Add MS 5253,9, 10). British Museum (P&D SL,5270.11r, 5v)

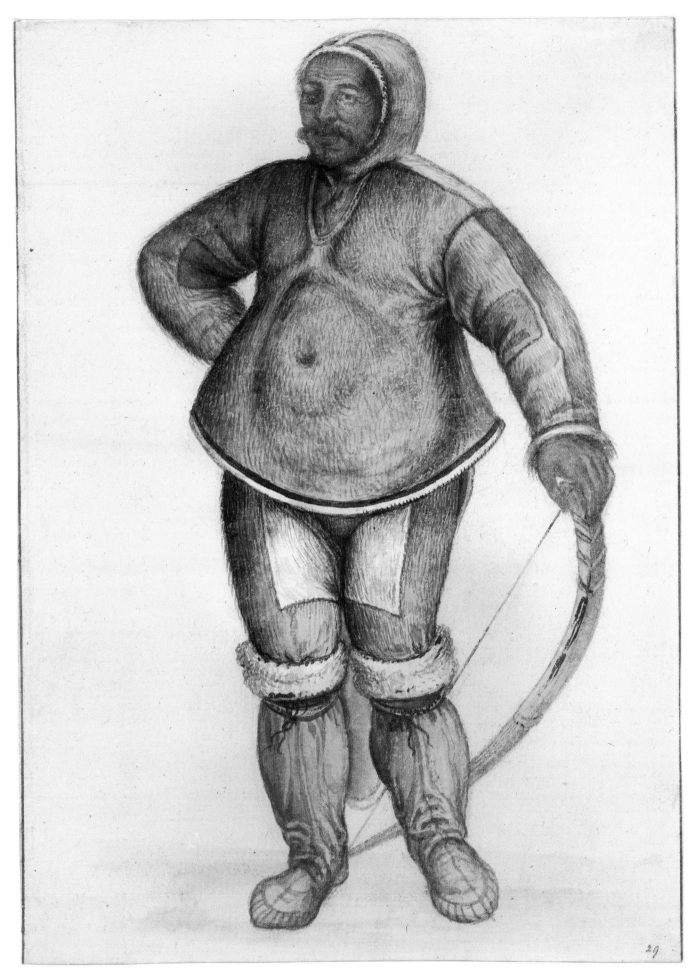

36 Arnaq and Nutaaq, Inuit from Frobisher Bay

Watercolour over black lead, touched with bodycolour and white (altered), 222 × 166 mm

1906,0509.1.30

English accounts indicate that the infant Nutaaq was about twelve months old when he and his mother were captured in August 1577. He was wounded in the arm by an arrow and, although the surgeon applied salves, she pulled them away and healed his arm by licking it. They were held in captivity with Kalicho, who had been abducted earlier, until Frobisher sailed to Bristol. Kalicho died probably from injuries caused when he was captured, and Arnaq died only a few days later from a disease which caused boils to erupt all over her skin. She was buried in the same churchyard in Bristol on 12 November and a nurse was hired to take Nutaaq to London to show him to the Queen but he died soon after arriving there and was buried in the same churchyard as the man captured on the previous voyage (see p. 166). The English were careful to record what they believed to be their names, but Arnaq probably meant 'woman' and Nutaaq 'child'.

John White's portrayals of Kalicho, Arnaq and Nutaaq are sympathetic and realistic, recording their individual features, including his facial hair and her tattoos (more easily seen in the offset), and

fine details of their clothing, including the texture of the fur and the toggle of her thong harness used to support the baby in the back of the parka. Their parkas have long dorsal flaps at the back and are the type of summer sealskin ones recorded as worn by people in this area in the nineteenth century (the next reliable record available), with lighter patches representing local decoration rather than repairs. However, the prominent belly-buttons seem to be an added European Mannerist stylistic convention and the attachment of the hoods is problematic and may not all be correctly drawn. The trousers and skin boots are similar to those found in the area until recently, and the bow and paddle are accurate but the arrow has been conventionalized.

The young William Camden saw Arnaq and Nataaq in London in 1577 and described them later in his *Annals of Great Britain under Queen Elizabeth* 'with black hair, broad faces, flat noses, swarthy coloured, apparelled in sea-calves' skins, the women painted about the eyes and balls of the cheek with a blue colour like the ancient Britons', a comparison that is interesting in light of the images of the Picts and ancient Britons in de Bry.

Arnaq's portrait, presumably with Nutaaq, was painted by Cornelis Ketel in Bristol and presented to the Queen and to the Cathay Company. It hung at Hampton Court in the seventeenth century but is

now lost. There are many variations of drawings and prints of the four Inuit who were brought back to England by Frobisher in 1576 and 1577 and, particularly as the Ketel oil paintings have disappeared, it is nearly impossible to establish which images were drawn by artists from the life (see p. 165). The two Sloane versions are very similar to drawings by Adriaen Coenen (now in The Hague) and to several woodcuts published the following year in Germany. There are also drawings that might be related to others by Lucas de Heere that no longer exist, including an engraving of *America* by Phillipp Galle after Marc Gheeraerts the elder which seems to incorporate elements from de Heere's watercolour of the 1576 captive and White's of Arnaq and Nutaaq. The engraving was one of eight allegorical engravings representing the Elements and Continents, which were later used as the basis for stained glass windows at Gorhambury, commissioned either by Sir Francis Bacon or possibly by his mother, née Anne Cooke, some time before 1610.

Lit.: LB 1(31); ECM 64; PH&DBQ 116(a); PH 64 and fig. 42; see Sturtevant and Quinn, pp. 76–112; and for the Gheeraerts print see Michael Archer, '"Beest, Bird or Flower": Stained glass at Gorhambury House – I', *Country Life*, 3 June 1976, pp. 1451–4, '"Elements and Continents": Glass at Gorhambury, Hertfordshire – II', *Country Life*, 10 June 1976, pp. 1562–4 (I am very grateful to Paula Henderson for this reference); and on Camden see Piggott, pp. 73–6

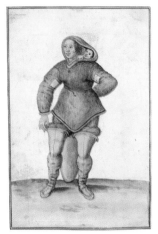

106. *Arnaq and Nutaaq, Inuit from Frobisher Bay* (see figs 104, 105). Sloane copy in the BL (Add MS 5253,11). British Museum (P&D SL,5270.11v)

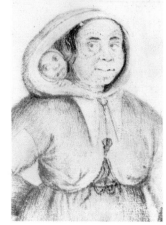

107. Detail of the offset of watercolour opposite, showing Arnaq's tattoos and harness. British Museum (P&D 1906, 0509.2)

108. Stained glass window from Gorhambury, now in fragments but originally based on an engraving by Phillipp Galle of *America* after Gheeraerts. The figures of the Inuit man and woman (left and right) are similar to a number of published and drawn images. Courtesy of Paula Henderson and Lord Verulam.

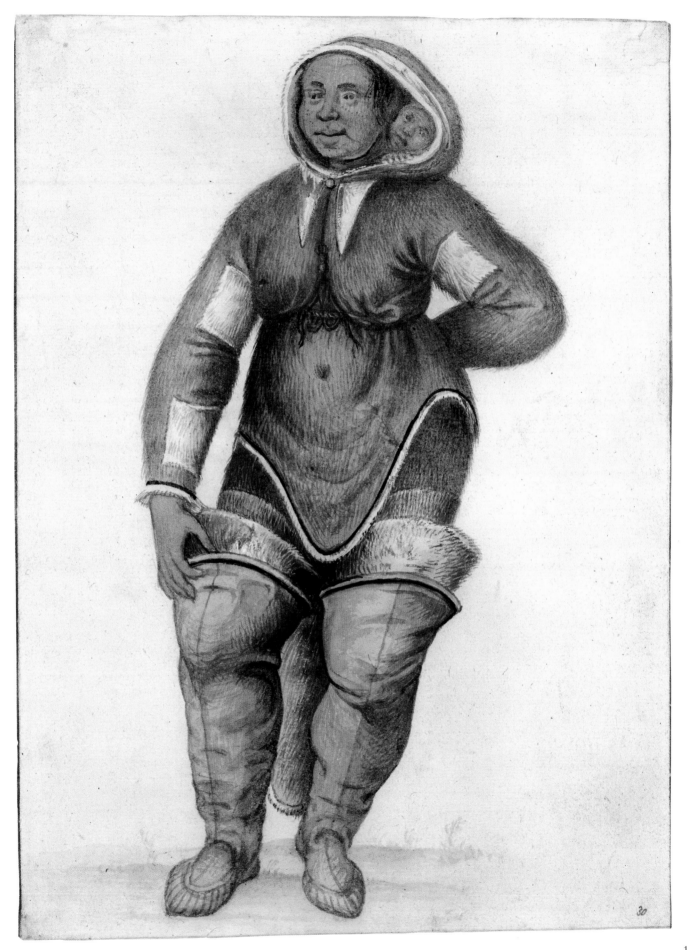

30

Fig 109

Fig 110

FLORA, FISH AND OTHER FAUNA

John White's surviving watercolours of flora and fauna follow here, but there may have been more that are now lost. Clues to some of these might be provided by the watercolours of fish and birds with Algonquian names in the Sloane volume (see pp. 230–33). Those that remain have been arranged in the following pages in the order they appeared in the original album of John White watercolours and not by the order in which he may have encountered them on his voyage as they have been in the past. The plants (apart from the mammee apple) are badly stained as they were all in the centre of the album and either were on different paper or suffered more from the water and pressure after the fire.

When attempting to view natural history through John White's eyes, it is important to bear in mind that he was looking at flora and fauna as a gentleman with an interest in natural philosophy and not as a scientist would today. We must also recall that his images of the customs and costumes of various nations (see p. 197) were part of this same vision and he was attempting to understand and convey all of them through the same medium – watercolours with labels that named and briefly described each image. The immediate audience for his watercolours was a small courtly one, but he may also have had in mind their eventual use as the basis of engraved illustrations for a written account of the type useful for diplomatic and merchant travellers and for gentlemen who studied the world through books.

109. *Daffodils*, c.1585. Watercolour and bodycolour drawing from an album of flower drawings with a manuscript sonnet by 'Jacques Le Moyne, called Morgues, Painter. 1585', 217 × 148 mm (see also figs 113, 114). British Museum (P&D 1962,0714.1.5)

110. *Dead blue roller*, c.1583–4. Bodycolour on vellum by Hans Hoffmann. Inscribed probably by Hoffmann with the date 1521 and Dürer's monogram. One of four copies of Dürer's 1512 watercolour now in the Albertina but then in Nuremberg. British Museum (P&D G,2.220)

His approach was not entirely objective and empirical. That more modern way of viewing natural philosophy was still evolving out of the Renaissance humanist method during White's time and would change completely during the next century through the ideas of men such as Francis Bacon. Bacon was still a young man during the Virginia voyages but was to become the clearest exponent of this new empirical approach not only for natural philosophy but also its use for improving and empowering the English Crown and nation through knowledge of the world. White's way of studying natural philosophy still contained elements of what we might describe as a courtly approach, which had its basis in a study of ancient texts by Pliny, Aristotle and Dioscorides in particular for flora and fauna, mediated through the illustrated publications of seventeenth-century humanists such as the Swiss Conrad Gessner (1516–65). His encyclopaedic *Historia animalium* was part-published in the 1550s with woodcut illustrations and text for every example based on an enormous collection of images and information gathered from all over the world. The uses of each specimen and its occurrences in place names, history and poetry, in other words its cultural history, was also provided. Some of the birds in White's watercolours, the pelican and hoopoe in particular, are posed exactly the same way as the woodcuts in Gessner (III, 1555, pp. 605, 31).

Gessner's work on insects was carried on after his death by the Reverend Thomas Penny (c.1530–88), one of the greatest botanists and zoologists of his day, who included information on drawings of American specimens provided by White (see nos 63, 67). Gessner also planned a *Historia plantarum* and had collected fifteen hundred coloured drawings of plants which included their morphology, details of stems, seeds, roots etc. as seen in some of White's botanical drawings and the florilegium in the Sloane volume. Like White's watercolours, these were rediscovered only centuries later and are accompanied with notes by Gessner and Penny. Here we have a direct connection

between White and two of the greatest natural historians of his day; we also know of his direct connection with the English herbalist John Gerard (see p. 172).

The natural history drawings of Dürer in the early sixteenth century had inspired a new passion for the visual description of nature and he had many amateur and professional followers in Germany and inspired artists and patrons elsewhere. But there are surprisingly few precedents for John White's watercolours of the flora and fauna of the New World. Nicholas Monardes's description of American plants was published in Seville in 1569 and 1571 and translated into English in 1577 as *Joyfull Newes out of the Newe Founde Worlde*; it contained woodcut illustrations which presumably helped Harriot to identify the plants he described, as he took a copy with him. He was followed by Francisco Hernandez, the physician to Philip II of Spain, who was instructed by the Council of the Indies to take a team of observers and artists to make the first official survey of the popular antiquities and natural history of Spain's new colony in Mexico from 1571 to 1577. The results were bound into sixteen folio volumes kept in the magnificent library of the Escorial; they were intended to be published but most of the volumes were destroyed in a fire in 1671. Drake was said to have taken a draughtsman on his circumnavigation of the globe in the 1570s, but the only evidence is the album now in the Pierpont Morgan Library, the authorship of which is not known but might even be Drake himself rather than a professional artist (see fig. 41).

There were skilled artists available at every court to make collections of natural history drawings for the libraries of their patrons, not necessarily by travelling themselves and drawing from nature, but instead based on specimens, living or dead, descriptions brought back by travellers, from publications and mainly by copying the works of other artists. Jacopo Ligozzi was probably the finest natural history artist in Italy and executed beautiful watercolours of plants and animals for the Grand Duke of Tuscany and for Ulisse Aldrovandi, professor of philosophy at Bologna, in the 1580s, whose *Storia naturale* began to be published in the following decade. An album attributed by an eighteenth-century owner to Giovanni da Udine in the Natural History Museum Library (ZRBR 327) contains sixteenth-century watercolours of European birds that are comparable in style and technique to White's but appear to be copied from other printed or drawn examples and are not 'portraits' of real specimens as White's are. Dürer, Hoffman (fig. 110) and Hoefnagel made watercolour or exquisite limned natural history drawings, sometimes on vellum, for European courts, especially the Rudolphine court in Prague where the Lutheran botanist Charles de l'Ecluse (Carolus Clusius), the translator of Le Moyne's account of the Florida expedition for de Bry, compiled thirteen volumes of Flemish botanical studies, the *Libri picturati* (now in Cracow). Jacques Le Moyne worked for the French court before being exiled as a Protestant to England in the early 1580s and it is his with drawings that White's can most constructively be compared (see pp. 174, 229).

White's approach to natural philosophy imparted knowledge of the flora and fauna of the New World, yet it presented that knowledge in a courtly way which was diverting and pleasant, with lively, colourful and rich images bejewelled with vermilion and smalt, gold and silver. At the same time he was also to some extent objective in his careful observation and recording from nature, from living specimens where possible, and in his taxonomic grouping, labelling and recording of local names.

White's instructions were to 'draw to life' all 'strange' birds, beasts, fish, plants, herbs, trees, and fruits and to bring home specimens of each (see p. 42). Specimens often changed shape and colour when they died therefore the drawings were important for recording their living colour and shape and, in any case, we know that few if any specimens gathered by White or Harriot arrived safely back in England, so the drawings were an invaluable record. There are indications that records of natural history on paper such as these, which might be called 'paper museums' were preferable in some instances to collections of dead specimens. But in order for the new and exotic to be understood, there had to be references to the known world and it had to be readable in European terms, most clearly provided here in the labels but also in the format used for the portrayal of the specimens. Just as some of the figures of Indians contained references to poses familiar through art, the profile views of the fish and birds with little ground and no background and the format for depicting plants recall woodcuts and engravings found in herbals and encyclopaedias like Gessner's throughout the sixteenth century.

When viewing these watercolours it is also important to recall that artists and engravers were only just becoming aware during this period that exact truth to nature was not always the most useful way to depict specimens for a natural philosopher. We should also remember that White's drawings not only were made for the frisson provided by viewing the exotic but also had practical and commercial purposes for recognizing useful species for medicine and food and for markets at home and abroad. These dictated style to some extent, in that they required clarity, instantly recognizable shape and form, details and colour. In order to use the image to identify other examples when they were encountered in nature, as a field guide, the idiosyncrasies of an individual specimen should be sublimated to some extent in order to depict a more generic one that represented the type rather than the individual. On the whole White had drawn portraits of real individual animals just as he drew portraits of individual Indians. In other instances White has given fish for example a tail that he believes is typical of all fish, rather than the tail he actually saw. Both of these examples indicate how far natural history illustration had come in the sixteenth century but also how far it still had to go.

Lit.: For Bacon's new approach to natural philosophy and as assessment of Harriot and White's see Solomon, pp. 515–18; for Penny see Desmond 1986, p. 62; and for Gessner see Hoeniger, pp. 131–45; for Dürer and other collectors and paper museums see Smith and Findlen, pp. 7–19; for Hernandez see Desmond 2003, pp. 25–6; for the Drake manuscript see Klinkenborg and O'Brian; for Clusius see Claudia Swan, *The Clutius Botanical Watercolours: Plants and Flowers of the Renaissance*, New York, 1998

37 Wysauke

Asclepias syriaca Linn. (commonly milkweed)

Watercolour over black lead, touched with white (altered), 356 × 209 mm

Inscribed: 'Wysauke .' and 'The hearbe wch the Sauages call Wysauke / wherewth theie cure their wounds wch / they receaue by the poysoned arroes / of theire enemyes.'

1906,0509.1.37

Asclepias syriaca is no longer found on the Outer Banks although other varieties occur locally. The pod on the left is slightly open to reveal the seeds with their silky tails of white down but the pigment has altered and now appears dull grey. The long root would not fit on the page so has been cut off and drawn separately to the right, a familiar convention of herbals. The saturation of the sheet after the Sotheby's fire caused the sizing on the paper to pool and discolour but the other version of this drawing in the Sloane volume (below) has a stronger outline and shows the details much more clearly. It is labelled with a slightly different Indian name, 'Wisakon'. In fact it is now believed that *wisakon* is connected with the Algonquian words for

'bitter' and probably meant medicinal herbs in general.

Harriot did not mention this plant in his discussion of new and useful commodities in his *Briefe and true report*; but after his return to London John White was in contact with John Gerard whose name appears on the list of merchants of London who came forward to support the deserted colonists on 7 March 1589 (Quinn, p. 570). He was Keeper of the Physic Garden at the Royal College of Physicians and from 1577 superintendent of Lord Burghley's gardens in London and at Theobalds. He also set up a nursery in Holborn, from which he had produced a list of plants in 1596 including 'strange trees, herbes, rootes'. He called non-native plants 'strangers' and claimed that they flourished in his gardens (new plants from the New World in the late sixteenth century included sunflowers, nasturtiums, potatoes and tobacco). He had in 1587 obtained Dodoens's herbal, which he translated and incorporated into his own vast *Herball* ten years later. It included a few additional New World plants such as the potato and information on the

character of the sarsaparilla root provided by 'Master John White an excellent painter who carried very many people into Virginia … there to inhabite' (PH &DBQ 49). Only sixteen of the eighteen hundred illustrations in Gerard's *Herball* were original and new (not woodcuts already used in other publications) and one of these, the milkweed, was based on a drawing evidently provided by John White and is labelled '*Wisanck, siue Vincetoxicum Indianum* Indian Swallow wort'. The description of its silky properties provides Gerard with an opportunity for an exegesis on its potential as clothing to cover the people of Virginia in their nakedness compared to its current use by the people of Pomeiooc and elsewhere as a kind of moss to cover 'the secret parts of maidens that neuer tasted man' (Quinn, p. 752).

Gerard explained that it grew in Virginia, 'where are dwelling at this present Englishmen, if neither vntimely death by murdering, or pestilence, corrupt aire, bloodie flixes, or some other mortall sicknes hath not destroied them', proof of his continued concern for the colony White had left on Roanoke. He knew of no 'phisicall vertues' of the plant; but it was not yet growing in England so it is not surprising that he was unaware of its possible uses as a diuretic and expectorant. But he was also apparently unaware of the knowledge of its healing powers as an antidote to poison conveyed clearly in White's inscription on the present drawing. White drew the root carefully, indicating that may have been the relevant part. It is clear from Gerard's text that it was not growing in his garden; because there were no living specimens available (only dried ones and seeds) and, because White's drawing does not depict it, only a handful of Europeans at this time would have been aware that the living plant secrets a white sap (hence its current common name, milkweed). Knowledge of its properties as an antidote to poison therefore remained with the Indians and the person who owned the present drawing with its unique inscription.

Lit.: LB 1(38); Quinn, pp. 444–6; ECM 50; PH&DBQ 55(a); PH 50; Rountree, p. 127; Henderson, pp. 119–20; Saunders, p. 22

111. *Wisakon (milkweed)*, 1580s. Watercolour and bodycolour, after John White?, from the Sloane volume. There is an eighteenth-century copy made for Sloane in the BL (Add MS 5289,228). British Museum (P&D SL,5270.26r)

112. *Indian swallow wort (milkweed)*, 1597. Woodcut from John Gerard, *Herball*, London, p. 752. By permission of The British Library, London (449.k.4)

The hearbe wth the Sauages call wysauke
wherewth theic cure their wounds wth
they receaue by the poysoned arroes
of theire enemyes.

Wysauke.

37

173

38 Sabatia

Sabatia stellaris Pursh (commonly rosegentian, sea pink, marsh pink or rose-of-Plymouth)

Watercolour and bodycolour over black lead, heightened with white, 349 × 179 mm

1906,0509.1.38

Although this herbaceous wild flower was once found in salt marshes and on sandy coasts along the Atlantic seaboard, it is now an endangered species in Massachusetts and Connecticut. Like the milkweed, it is not mentioned by Harriot – nor does notice of it seem to have been passed to Gerard. The colour of the petals was once a much deeper blue-purple pink but a substantial amount of pigment was transferred to the offset. The oxidization of the lead white in the pigment distracts from the fact that White's drawing was very detailed and accurate (see the modern diagram reproduced in PH & DBQ).

All the other drawings of flora that White made on this journey that survive, whether described by Harriot in his account or not, were 'useful commodities'. As this plant is neither mentioned nor inscribed, its use is not clear. However, Harriot recorded that he had gathered several 'Apothecary drugges' which he had hoped to have examined by 'such men of skill in that kynd' but they were thrown overboard by Drake's men when they were leaving Roanoke. Either the Indians told them of the use for this plant but it was not inscribed on the drawing as it was for the milkweed or Harriot or White recognized the plant as a member of the gentian family, a herb whose properties as an aid to digestion and use against fevers, worms and poison were described by Galen, Pliny and Dioscorides.

It is clear from the details recorded here and in his watercolours of the fauna, particularly the reptiles, that White was a skilled natural history painter, almost as good as Jacques Le Moyne who is considered the best of his time, and it is to be regretted that more of his drawings of the plants of North Carolina did not survive. The floreligium that occupies the centre of the Sloane album may provide a hitherto unexplored clue to his training as a natural history painter and more evidence of his connection with Le Moyne (see figs 145–7, 154–64). Although some of them are very rough and crude and obviously based on woodcuts, some are probably copies of other watercolours and yet others are extremely fine and clearly drawn from life; precisely the mix we find in flower drawings by Le Moyne.

Lit.: LB 1(39); Quinn, p. 447; ECM 51; PH&DBQ 56; PH 51; Stuart, pp. 10, 20–22, 37–8

113. *Dog violet and damselfly*, c.1585. Watercolour and bodycolour drawing from an album of flower drawings by Jacques Le Moyne. British Museum (P&D 1962,0714.1.3)

114. *Pine*, c.1585. Watercolour and bodycolour drawing from an album of flower drawings by Jacques Le Moyne. British Museum (P&D 1962,0714.1.46)

38

39 Horn plantains on the stalk (bananas)

Musa paradisiaca Linn.

Watercolour over black lead, 324 × 221 mm

Inscribed in black ink: 'Platano. or Planten.'

1906,0509.1.39

Bananas and plantains are high in carbohydrates and a good source of minerals and vitamins. Ripe bananas are easily eaten raw while the starchy unripe fruit, often called plantains, must be cooked. They originated in south-east Asia and were introduced into Africa as early as the fifth century. From there the Portuguese imported them into the Canary Islands and the Spanish introduced them from there to the West Indies in 1516, mainly to feed the slaves they had brought from Africa to work the new plantations of sugar cane, another crop introduced by the Spanish which was to completely change the ecology and life of the Islands.

Bananas or *plantanos* as the Spanish called them were well established by the time White arrived in the 1580s. A Spanish prisoner recorded that, when they landed in May 1585, the English 'took away with them many banana plants and other fruits which they found along the coast, and made sketches of fruits and trees'. No doubt their intention was in part provisions for the journey and the colony but they probably also intended to see whether such a useful crop might be suitable for planting in the new colony. In fact, acting on Hakluyt's suggestion, in his *Briefe and true report* Harriot recorded that they had carried sugar cane to Roanoke to plant, but the specimens were not well enough preserved and it was the wrong time of year. Noting the similar climate, he wrote that there was hope that further experiment would prove successful and 'likewise for *Orenges,* and *Lemmons,* there may be planted also *Quinces*' imagining that in the future the colony might produce '*Sugers, Sucketts,* and *Marmalades*' (p. 12).

Lit.: LB 1(40); Quinn, p. 408; ECM 14; PH&DBQ 14; PH 14; Bedini, pp. 274–6

40 Horn plantain (banana)

Musa paradisiaca Linn.

Watercolour over black lead, 294 × 177 mm

Inscribed in black ink: 'Platano. or Planten.'

1906,0509.1.40

This drawing is probably life-size but the colour has been altered by the water damage to the sheet which caused the sizing of the paper to pool and to cast the sheet with an overall light brown tone. The version in the Sloane volume is a deeper yellow and more strongly shaded. Although at first it appears a much better and more three-dimensional drawing, in fact the artist has not understood the foreshortening of the cut fruit and has drawn a full circle to show the inside rather than White's ellipse.

Lit.: LB 1(41); Quinn, p. 408; ECM 13; PH&DBQ 13(a); PH 13; Sloane copy BL Add MS 5289, no. 160

115. *Platano (plantain),* 1580s. Pen and ink drawing with watercolour and bodycolour, after John White?, from the Sloane volume. There is an eighteenth-century copy made for Sloane in the BL (Add MS 5289,160). British Museum (P&D SL,5270.25)

39

40

41 Pineapple

Ananas comosus (Linn.) Merrill

Watercolour over black lead, touched with white,
258 × 141 mm

Inscribed in black ink: 'The Pyne frute .'

1906,0509.1.41

This drawing was with the group of other plants (apart from the mammee) that were in the centre of the album and were badly damaged by water; the offset contains much of the black and reddish brown pigment. The Sloane volume version (right) is more formulaic but easier to read as it is less sketchy and more carefully finished.

Native to Peru and Brazil, the plant was being cultivated in the West Indies by the time of Columbus, who may have brought some back to Europe. By the middle of the sixteenth century it was being imported into England so White and Harriot may have already been familiar with what Raleigh was later to describe as 'the princess of fruits'. Pineapples were highly regarded in the Caribbean, where they were placed in doorways to welcome visitors, a practice translated to Europe in the form of decorative pineapples on doorways and finials of gates. A 1675 painting attributed to Hendrick Danckerts depicts Charles II being presented with two pineapples in 1661 by his gardener James Rose, who had managed to ripen a fruit-bearing plant which had been brought over in a pot.

Lit.: LB 1(43); Quinn, p. 407; ECM 11; PH&DBQ 11(a); PH 11; see Fran Beauman, *Pineapple, the King of Fruits*, London, 2005

116. *Pine (pineapple)*, 1580s. Pen and ink drawing with watercolour and bodycolour, after John White?, from the Sloane volume. Sloane did not have a copy made. British Museum (P&D SL,5270.24r)

The Pyne frute.

41

42 Cooking in an earthen pot

Watercolour over black lead, touched with gold and white, 150 × 195 mm

Inscribed in brown ink: 'The seething of their meate . in Potts of earth .'.

1906,0509.1.11.a

Pottery shards are one of the very few types of Algonquian artefacts that have been found on the Fort Raleigh (Roanoke) site during archaeological excavations. The remains found there of three pottery vessels, including a large clay pot of this type, validate John White's watercolours, at the same time pointing out where artistic licence has slightly overshadowed the strictest accuracy, as the pots found have slightly less pointed bases. In fact the base might have been quite difficult to observe, as generally it was buried in the sand and coals of the fire for more efficient heating. The pots were made of local clay, tempered with crushed shell, built up with coils which are seen clearly on the pot here. They were usually smoothed over and then incised, stamped or impressed with woven textiles (made from silk grass cords) as decoration. They were then dried out and fired – the process took several days. Hulton and Quinn noted that, given the usual size of the coils, the pot shown here should be about a foot in diameter; but White's sense of scale was generally good and this pot might actually be larger than that, given the size of the cob of corn and the fire the pot is set in. Pots were kept simmering all day and night on the fire in the centre of the house, with additional items thrown in as they were procured – vegetables (maize, beans, pumpkin), herbs and roots, fish and meat – and people ate when they were hungry.

The figures in the engraving were probably added by the engraver, Gysbert van Veen, who based them on others from the group. He has given the woman a breechcloth, which is not otherwise known to have been worn by women, and a spoon, also not otherwise known amongst the North Carolina Algonquians, and the scale of the pot has been exaggerated in relation to the figures. In the caption, Harriot pointed out that the Indians were moderate in their eating, which kept them healthy, declaring, 'I wish to god wee would followe their exemple', castigating his European audiences for their sumptuous and unseasonable banquets, continually devising new sauces and provoking gluttony to satisfy their insatiable appetites.

Lit.: LB 1(11); Quinn, pp. 437–8; ECM 44; PH&DBQ 48(a); PH 44; Rountree pp. 62–5

43 Broiling fish over a fire

Watercolour over black lead, heightened with white (altered) and gold, 146 × 170 mm

Inscribed in brown ink: 'The broyling of their fish ouer the flame of fier.'

1906,0509.1.11b

The grill was usually loaded with layers of fish, and others were hung on sticks beside the fire as seen here. He noted that they did not 'scorch' or smoke and dry their fish for storage as the Florida Indians did, but stated that they ate everything they cooked. Fish were generally plentiful in this area so they may have smoked fish only during a certain season which Harriot may not have observed.

De Bry has used other figures and his imagination to people the scene, and has made errors as a result. Although the fish, probably shad, are large, the scale is incorrect, as they were not as large as here. He has taken the fish in the basket directly from the fishing scene with its incongruous mix of hammerhead shark, gar and catfish. Baskets of this European wicker form were not known amongst the tribes of this area.

Lit.: LB 1(12); Quinn, pp. 435–6; ECM 45; PH&DBQ 49(a); PH 45; Rountree & Turner, pp. 93, 101, Kupperman 2000, pp. 163–4

117–118. *Their seething of their meat in earthen pots*, and *The broiling of their fish over the flame* 1590. Engravings by van Veen and de Bry after John White, in Harriot, *A briefe and true report*. The British Library, London (c.38.i.18)

The seething of
in Potts

their meate.
of earth.

11ᵃ

42

The broyling of their fish ouer th flame of fier.

11ᴮ

43

44 Soldier fish

Holocentrus ascensionis Osbeck
(commonly also squirrel fish)

Watercolour over black lead, heightened with white
and silver (altered) and gold, 132 × 199 mm

Inscribed in black ink: 'Oio de buey .'

1906,0509.1.42

Most of White's watercolours of fish were
probably drawn while he was still in the
West Indies, but many of the species also
range up the coast as far as North
Carolina so he could have seen many of
them there as well. They are presented
here in the order they were in the original
album. Some seem to have been illustrated
because they are edible (the 'commodities'
that Harriot and White were instructed to
search for) while others were strange and
exotic and might please their more
courtly and philosophic patrons.

Of course, John White was not a
specialist fish illustrator, so we find under-
standable common mistakes: he seems to
have in his mind's eye that fish tails are
forked, seeing them that way even when
they were not in reality, as in his puffer
fish. He does not always take care with the
smaller fins, to spread them or to depict
their spines or correct number and
sometimes he gets the shape of the fin
wrong (perhaps because of the condition
of the specimen; his groupers should have
an extra slightly higher part at the back of
the dorsal fin). He sometimes generalizes
and creates patterns that are not there in
life. But the colour of fish changes very
quickly once they are out of the water
and White does take particular care to
draw them in their living colours, adding
gold or silver to their eyes and sides in
order to provide their luminescent effects.

In life, the soldier fish is bright red with
shining streaks along its length, depicted
here with gold or silver pigment which
has altered to grey. The Spanish name
given here means 'ox-eye' but this is the
name for a slightly different fish (*Böops
salpa*) which has similar stripes, and White
may have misnamed it. Mark Catesby in
his *Natural History of Carolina* (II, pl. 3) did
not use Sloane's drawing (fig. 126) as his
model for his similar fish, which he called
the squirrel fish (as noted by Sloane on
the manuscript inscription stuck to the
page in his album); but Sloane was
mistaken in thinking that White's and
Catesby's depicted the same species, as the
squirrel fish is *Holocentrus rufus* Walbaum.
Both are good eating fish.

White may have seen this fish in the
West Indies or North Carolina, as they
range northwards from the tropics. The
version in the Sloane volume (fig. 126) is
easier to read, not just because it is not
damaged but because it is more 'drawn'
with the brush and less sketchy than the
present work.

Lit.: LB 1(44); Quinn, p. 411; ECM 60 25; PH&DBQ
25(a); PH 25; McBurney, no. 18; copy BL Add MS
5267, no. 115

45 Remora or shark-sucker

Remora remora Linn.?

Dorsal view: watercolour over black lead, heightened
with bodycolour and gold, 153 × 197 mm

Inscribed in black ink: 'Rebeso . Two fote and a halfe
long .'

1906,0509.1.53 [check]

There are five drawings of remora in the
collection, one of them the badly
damaged and blurred ventral view (no. 55)
and three in the Sloane album (see figs
129–30). Columbus reported that remora
were used by Indians for fishing as they
attached themselves to large fish and
turtles. Although White records their
Spanish name, indicating that he saw them
in the West Indies, they occur also off the
coast of North Carolina. Their Latin name
(*remora* means to slow down) derives from
the ancient belief that they slowed down
ships by attaching themselves to the hulls.
They also attach themselves to sharks and
sometimes swim close to their mouths but
are never eaten by them, something
which Catesby noted as puzzling in his
comments on this fish. He states that he
once removed five from a shark and that
their suckers were very strong; he
therefore certainly observed them from
life, but, when illustrating one in his book,
he based the image on one of the
drawings in Sloane's album, which are
very clear and detailed in their recording
of the markings on the fish and the
laminae on the disk. Linnaeus cited
Catesby's plate in his *Systema naturae* (10th
ed., 1758, I, p. 260).

Lit.: LB 1(55); Quinn, p. 412; ECM 28; PH&DBQ
28(a); PH 28; Bedini, p. 268

119. *Remora: The Sucking-Fish and
Phylanthos Americana,* 1743.
Hand-coloured etching by Mark
Catesby from *The Natural History
of Carolina, Florida and the
Bahama Islands …*, vol. II,
London, p. 26. By permission of
the British Library, London
(44.k.8)

Oio de buey.

Rebelo. *Two fote and a halfe long.*

44

45

46 Dorado or dolphin fish

Coryphaena hippurus Linn. (now commonly *mahi mahi*)

Watercolour and bodycolour over black lead,
126 × 227 mm

Inscribed in black ink: 'Duratho . Of thes some are .5. foote long.'

1906,0509.1.44

Dorado (from its golden glow at night) is the Spanish and Portuguese name for this type of popular game fish (not the mammal) which now does not often reach the length of 5 feet recorded by White.

One of the highest concentrations of them in the world is off Cape Hateras, where they feast on flying fish. Boazio included an image of it on his map of St Augustine, where the caption recorded 'he is very pleasant to beholde in the sea by day light, and in the night he seemeth to be of the coullour of gold, he taketh pleasure as other fishes do by swimming by the ship, he is excellent sweete to be eaten, this fish liueth most by chasing of the flying fish and other small fishes' (see below).

The version in the Sloane volume, on the same sheet as the remora (see fig. 130), is more highly finished and not oddly tilted in order to show under its gills as in the damaged drawing. The fish here is a male with its characteristic prominent protruding forehead and electric blue-green upper body and sides that appear gold in certain lights.

Lit.: LB 1(46); Quinn pp. 411–12; ECM 26; PH&DBQ 26(a); PH 26; Sloane copy BL Add MS 5267, no. 68, ?82

120. *Drake's capture of St Augustine*, 1589. Hand-coloured engraving by Baptista Boazio from the larger set describing Drake's voyage to the West Indies (see fig. 56). These prints were also published in Walter Bigges's, *A summarie and true discourse of Sir Francis Drake's West Indies voyage*, 1589. Boazio seems to have known White's natural history drawings, as his figure of the dorado is clearly based on White's watercolour. National Maritime Museum, Greenwich (Caird Library, C 4053 (246:2))

Duratho . Of thes some are 5. foote long .

47 Portuguese man–o'–war

Physalia physalis; formerly *Caravella caravella* Linn. (commonly jellyfish)

Watercolour over black lead, touched with bodycolour including white (altered); 305 × 176 mm

Inscribed in brown ink: 'This is a lyuing fish, and flote vpon the Sea, Some call them Carvels'

1906,0509.1.45

Originally named after the shape of a Portuguese ship, the jellyfish is in fact a composite of separate organisms; the small number of tentacles indicates that this is a young specimen. There are more, in a different form, on the version in the Sloane volume, again a stronger image because it retains its original colours and pigment.

White and Harriot do not mention the animal in their accounts, probably because although it was a curiosity, it was a commonly occurring one with no potential commercial use. However, on his voyage to Jamaica in 1687, Sir Hans Sloane spotted one and recorded it at length in his journal. He believed it to be a different one from any described by previous natural historians and gave it a long Latin polynomial (see fig. 123). He recognized it as being the creature described in various travel journals recorded by Hakluyt, Léry and others, and summarized the names they used and their encounters with them. He recorded that they 'burn more violently than those of the North Sea' and 'they do suck themselves so close to the skin that they did raise Blisters', 'stinging much worse than Nettles, Whence it is by some reckoned Poisonous'.

Sloane employed artists in Jamaica to draw specimens for him but had no one on board ship, so when illustrating his journal for publication he was reliant upon his large collection of other natural history drawings. He was originally attracted to the White album because he recognized that the Indian drawings were related to the de Bry publication; but the natural history specimens not published in de Bry, which he would have recognized were of specimens from the New World, were an additional treasure trove, and the watercolour copies he commissioned provided him with the illustration to go with the lengthy account of a caravel in his publication, several years before he was able to purchase the volume from White's descendants.

Lit.: LB 1(47); Quinn 413; ECM 31; PH&DBQ 32(a); PH 31; copy in BL Add MS 5262, no. 27

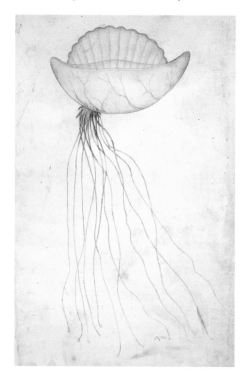

121. *A Portuguese man–o'–war*, 1580s. Pen and ink drawing with watercolour and bodycolour, after John White?, from the Sloane volume. British Museum (P&D SL,5270.19r)

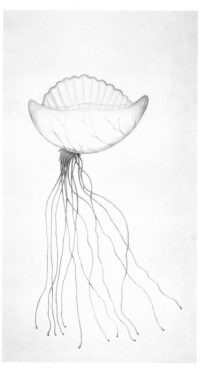

122. *A Portuguese man–o'–war*, 1580s. Pen and ink drawing with watercolour and bodycolour, after fig. 121 in the Sloane volume by an anonymous artist commissioned to make copies by Sir Hans Sloane. By permission of The British Library (Add MS 5262,27)

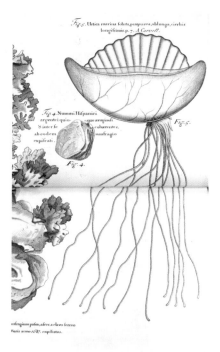

123. *A caravel*, 1707. Engraving by Michael van der Gucht, from Sir Hans Sloane, *Natural History of Jamaica*, vol. I, tab. iii, fig. 6. Sloane did not yet own the volume of versions of White's watercolours (fig. 121), which was still in the hands of White's descendants when he commissioned the copies (fig. 122) and had this figure engraved for his book. House of Commons Library, on loan to the Enlightenment Gallery, British Museum.

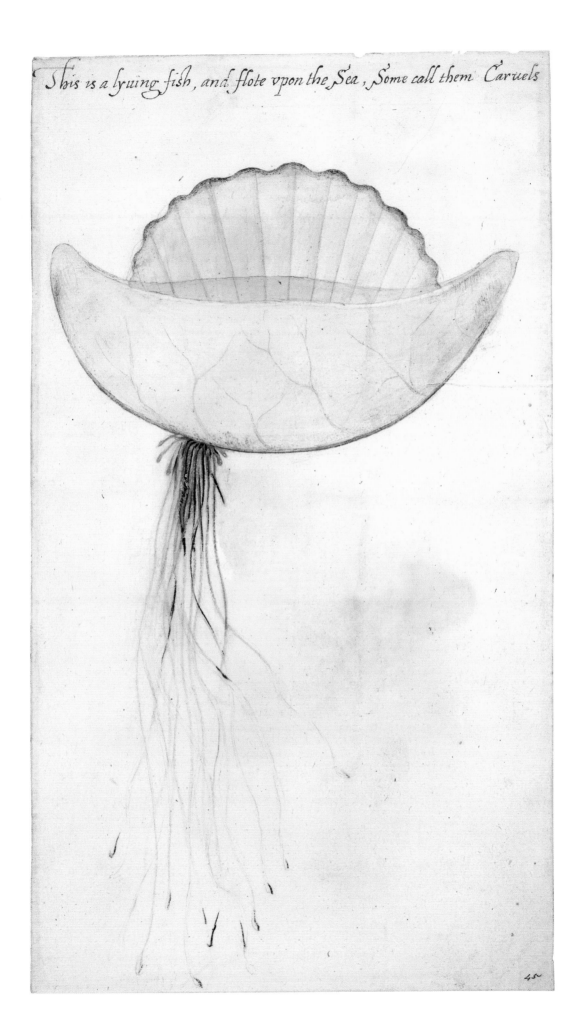

45

48 Flying fish

Exocoetus volitans Linn.

Watercolour over black lead heightened with bodycolour, silver and gold, 274 × 234 mm

Inscribed in brown ink: Bolador.' and 'The flyeng fishe.'

1906,0509.1.46

Harriot does not mention flying fish in his account of commodities available in Virginia, as he was no doubt thinking of fish available to the colony in the coastal waters inside the Outer Banks. However, flying fish concentrate in the sea off Cape Hateras where they attract schools of dorado. They are also preyed upon by birds. They are shown with a dorado in White's map in the sea south of Virginia and also to the east of the West Indies. Catesby included a different version in his *Natural History* (II, pl. 8) and noted that they were 'good eating Fish, and are caught plentifully on the Coasts of *Barbados*, where at certain Seasons of the Year the Markets are supplied with them'. Their Spanish name is *pez volador*.

Not only has the vivid blue pigment offset badly as a result of the water damage but the lead white used to colour the large wing-like fins has altered chemically to a distracting extent. The delicate transparency of the fins is much easier to read in the Sloane album version which is otherwise a direct copy. There is a crude derivative of the drawing in the corner of Boazio's engraving of Santiago (fig. 57).

Lit.: LB1 (48); Quinn, p. 412; ECM 27; PH&DBQ 27(a); PH 27

124. *Boladora (flying fish)*, 1580s. Pen and ink and black lead drawing with watercolour and bodycolour, after John White?, from the Sloane volume. There is an eighteenth-century copy made for Sloane in the BL (Add MS 5267,84). British Museum (P&D SL,5270.21r)

Bolador.

The flyeng fishe.

46

49 Lookdown

Selene vomer Linn. (commonly also moonfish)

Watercolour over black lead heightened with gold and white (altered), 149 × 220 mm

Inscribed in brown ink: 'Polometa. A foote long.'

1906,0509.1.47

This fish is found from the West Indies as far north as Chesapeake Bay. They are generally smaller further north so White may have seen this specimen in the West Indies. Two small dorsal and ventral fins are not depicted here and the gold that White used to catch the silvery-golden colour of this fish has oxidized to grey. Although this fish is sometimes common- ly called a moonfish, in fact the moonfish is a different flat fish (*Vomer setapinnus* Mitchell) which resembles the lookdown but does not have the long dorsal and anal fins so clearly seen here.

Lit.: LB 1(49); Quinn, p. 409; ECM 20; PH&DBQ 20; PH 20; see 'Fishes of the Gulf of Maine' (1953) on www.gma.org/fogm

50 Grouper

?Epinephelus adscensionis Osbeck (commonly rock hind)

Watercolour over black lead, heightened with gold and sliver (altered), 93 × 218 mm

Inscribed in brown ink: Garopa .'

1906,0509.1.48

The inscription is from the Portuguese name for this fish, *garoupa*. The identi- fication of the species of grouper is not certain because the colour is too bright and the fin shapes are not consistent with the usual rock hind, which is abundant in the West Indies and ranges to North Carolina. In the Sloane volume it is depicted on the same page as the burrfish. An attempt to reverse the darkening of the silver pigment using digital photography to re-create the original iridescent appearance of this watercolour can be seen in fig. 184.

Lit.: LB 1(50); Quinn, p. 410; ECM 22; PH&DBQ 22(a); PH 22; copy BL Add MS 5267, no. 104

125. *Gallo (burrfish) and Garopa (grouper)*, 1580s. Pen and ink drawing with watercolour and bodycolour, after John White?, from the Sloane volume. There is an eighteenth-century copy of the grouper made for Sloane in the BL (Add MS 5267,104). British Museum (P&D SL,5270.18r)

Polometa. A foote long.

47

49

Garopa.

48

50

51 Lookdown

Selene vomer Linn. (sometimes mistakenly called moonfish, see no. 49)

Watercolour over black lead, touched with white (altered), 191 × 210 mm

Inscribed in brown ink: 'Crocobado .'

1906,0509.1.49

White clearly considered this to be a different species from no. 49, as he gave it a different name, profile and colours. It has been identified as the same species of fish, a lookdown, but its snout has been pulled up and its gills exposed. White may have found it in a different location and its slight vertical stripes and paler colour may indicate that it was just a younger specimen and its lack of iridescence may be explained by the fact the specimen had been dead some time before he drew it, as fish quickly lose their colour when they are out of the water. There is another version of this drawing in the Sloane album, on the same sheet as the trigger fish (see fig. 131).

Lit.: LB 1(51); Quinn, p. 410; ECM 21; PH&DBQ 21(a); PH 21; copy BL Add MS 5267, no. 88

126. *Mero (grouper) and Oio debvey (soldier fish)*, 1580s. Pen and ink and black lead drawing with watercolour and bodycolour, after John White?, from the Sloane volume. British Museum (P&D SL,5270.22r)

52 Grouper

?Mycteroperca venenosa apua Bloch.

Watercolour over black lead, heightened with bodycolour, white, gold and silver (altered), 131 × 213 mm

Inscribed in brown ink: Mero.'

1906,0509.1.50

This may be the yellow-fin grouper but it may also be the red grouper (*Epinepelus morio* (Cuvier & Valciennes). The Spanish word 'Mero', inscribed here, is used for many types of fish, but the French use 'mérou' for groupers only. There are significant differences between the drawing and these species in colour, fins, shape etc. which make identification difficult. However, White's purpose was not to provide an exact drawing in order to identify the species but instead to enable others to recognize an edible fish. Groupers are members of the sea bass family and provide a high quantity of lean edible flesh; the yellow-fin, however, can be toxic so it is doubtful that it is the variety depicted here. The trigger fish and lookdown were not edible and were no doubt drawn because of their exotic appearance. The Sloane volume version is on fol. 22r with the soldier fish (no. 44).

Lit.: LB 1(52); Quinn, p. 410; ECM 23; PH&DBQ 23(a); PH 23; copy BL Add MS 5267, no. 102

Crocobado.

51

Mero.

52

Fig 127

Fig 128

53 Puffer fish

Spheroides testudineus Linn. (commonly chequered puffer or rabbit fish)

Watercolour over black lead, touched with white (altered), 98 × 169 mm

Inscribed in brown ink: 'A fresh ryuer fish .' (top of page cut away and the inscription 'Tanborel' now at the foot of 62, the brown pelican)

1906,0509.1.51

These fish are found in streams through salt-marshes in the West Indies but also up the Atlantic coast to North Carolina. They are still called 'Tamboril' in Puerto Rico but they do not have forked tails as shown here. Catesby copied the version in the Sloane album, including its incorrect forked tail, and called it the globe fish (*Nat. Hist.* II, pl. 28). He cannot have seen one himself and was perhaps relying on the fact that it was in the Sloane album when he stated it is 'found in *Virginia* and other parts of *America*'. It has been suggested, incorrectly I believe, that it may also represent the smooth puffer (*Lagocephalus laevigatus* Linn.). Other similar fish were frequently found in sixteenth-century cabinets of curiosities, and White may have drawn it for its exotic appearance rather than as a food fish.

Lit.: LB 1(53); Quinn, p. 456; ECM 54; PH&DBQ 100(a); PH 54; copy BL Add MS 5267, no. 42

127. *Mamankanois (Tiger swallowtail butterfly) and Tanborel (puffer fish)*, 1580s. Pen and ink and black lead drawing with watercolour and bodycolour, after John White?, from the Sloane volume. British Museum (P&D SL,5270.21r)

128. *Orbis Laevis Variegatus: The Globe Fish and Cornus, foliis Salicis Laureae acuminatis; floribus albis; fructu Sassafras*, 1743. Hand-coloured etching by Mark Catesby from *The Natural History of Carolina, Florida and the Bahama Islands* ..., vol. II, London, p. 28. By permission of The British Library, London (44.k.8)

54 Blue-striped grunt

Haemuleon sciurus Shaw

Watercolour over black lead heightened with bodycolour and white (altered), 112 × 213 mm

Inscribed in brown ink: 'Pese pica.'

1906,0509.1.52

In the inscription, the letter which looks like an 'f' is actually an 's' so that the Spanish name would mean pike fish or lance fish. There should be more yellow between the too-regular stripes here, and once again White has made the caudal fin too forked. The version in the Sloane volume is on the same page as the hermit crabs (no. 59). Like the crab, the fish is found in the West Indies rather than in the Caribbean.

Lit.: LB 1(54); Quinn, pp. 410–11; ECM 24; PH&DBQ 24(a); PH 24; copy BL Add. MS 5267, no. 128

A fresh ryuer fish.

57

53

Pefe pica.

54

55 Remora or shark-sucker

Remora remora Linn.?

Ventral view – Inscribed in brown ink: Rebeso .'

Watercolour over black lead, touched with white
(altered), 120 ?155 mm

1906,0509.1.43

This is the badly damaged and blurred
ventral view of the remora (no. 45). There
are three other watercolours of the
remora in the Sloane volume (figs 129,
130). They do not seem to be copies of
the surviving works but instead record
two further specimens of the fish.

Lit.: LB 1(45); Quinn, p. 412; ECM 29; PH&DBQ
29(a); PH 29

56 Burrfish

Chilomycterus schoepfi Walbaum (commonly spiny
boxfish)

Watercolour over black lead, heightened with white,
130 × 205 mm

Inscribed in brown ink: 'Gallo .'

1906,0509.1.54

This fish is found in the West Indies and
also on the Atlantic coast where it is called
the burrfish. *Gallo* is used by the Spanish
for the dory, another spiny fish, so White
may have been misinformed about its
Spanish name. The colouring in the
Sloane version and the slightly less forked
tail are closer to nature. There is another
image of this fish in the other group of
fish drawings by a different hand, showing
it more from the top (see p. 233, not
illustrated). In the Sloane volume it is on
the same sheet as the grouper (no. 50; see
fig. 125).

Lit.: LB 1(56); Quinn, p. 455; ECM 53; PH&DBQ
97(a); PH 53; copy BL Add MS 5267, no. 32

129. *Rebeso (remora),
ventral and dorsal
views*, 1580s. Pen and
ink and black lead
drawing with
watercolour and
bodycolour, after
John White?, from
the Sloane volume.
British Museum
(P&D SL,5270.15r)

130. *Deoratho (dorado)
and Rebeso (remora,
dorsal view)*, 1580s.
Pen and ink and
black lead drawing
with watercolour and
bodycolour, after
John White?, from
the Sloane volume.
British Museum
(P&D SL,5270.20r)

Rebeſo.

43

55

Gallo.

54

56

57 Queen trigger fish

Balistes vetula Linn.

Watercolour over black lead, heightened with bodycolour and white, 142 × 223 mm

Inscribed in brown ink: 'Pese porco . Of this, some are .2. fote in length.'

1906,0509.1.55

White shows these being fished in the Carolina Sounds in his drawing of Indians fishing (no. 7) and one on his large map (no. 2) but they do not reach the size recorded here so this specimen, like many of the others depicted, must have been seen in the West Indies. The Spanish is *pese* [*pecé*] *porco*, or pigfish but Catesby calls it the 'old wife' and clearly shows the blue lines radiating from the eye which are characteristic of this fish but not visible in White's drawing or the Sloane volume version. Catesby's image (taken from a different source) is missing the small central dorsal fin seen here. He describes them as 'slow swimmers' and states they are 'tolerable good Fish when their rough Skin is stripped off' (*Nat. Hist.* II, pl. 22). Boazio depicted a rather stylized and decorative image of this fish, labelled 'Sea Connye', on his main chart of Drake's 1585–6 voyages (see fig. 56).

The Sloane volume version below is distinctly brown, while the main version is quite black and grey like Catesby's. The blue pigment in the stripes around its mouth has been completely lifted on to the offset.

Lit.: LB 1(57); Quinn, p. 413; ECM 30; PH&DBQ 31(a); PH 30; Sloane copy BL Add MS 5267, nos 44, 51

58 Land crab

Cardisoma guanhumi Latreille, 1825 (now commonly blue land crab)

Watercolour over black lead, heightened with bodycolour and white (altered), 233 × 276 mm

Inscribed in brown ink: 'A lande Crab .'

1906,0509.1.56

Quinn states that this specimen must have been drawn in Puerto Rico, as several are shown in White's map of the encampment there (no. 4). He also notes that the ones depicted by de Bry in his engraving of the Indian fishing scene, which are not in White's original, are out of place. In fact these crabs live most of their lives in sandy holes inland from the sea and those in the Carolinas have more blue carapaces, though often with pink legs. Their eyes are on stalks that protrude inwards, rather than outwards as here.

Catesby illustrated seven species of crab, mostly from samples he found in the Bahamas, but for the land crab he relied on the drawing in Sloane's album (below), slightly browner than pink and with a more stylized shape on the shell than is visible in White's main version. Catesby also combined his image with a plant on

133. *Land crab*, 1580s. Pen and ink and black lead drawing with watercolour and bodycolour, after John White?, from the Sloane volume. British Museum (P&D SL,5270.16r)

which the crab usually feeds, the *Tapia trifolia*, opening its claws to grasp the plant and fruit. Catesby recorded that in some places in the Bahamas 'the Ground being almost covered with them, so thick they are, when out of their Holes that the Earth seems to move as they crawl about'. Linnaeus cited Catesby's plate in his *Systema naturae* (10th ed. 1758, I, p. 626).

Lit.: LB 1(58); Quinn, p. 405; ECM 5; PH&DBQ 5(a); PH 5; Sloane copy BL Add MS 5262, nos 10, 25

131. *Trigger fish and lookdown fish*, 1580s. Pen and ink, black lead, watercolour and bodycolour, after John White?, from the Sloane volume. British Museum (P&D SL,5270.19v)

132. *Cancer terrestris, the land crab; Tapia trifolia fructu majore oblongo*, 1743. Hand-coloured etching by Mark Catesby from *The Natural History of Carolina*, vol. II, p. 32. The British Library, London (44.k.8)

Pese porco. Of this, some are 2. fote in length.

55

57

A lande Crab.

56

58

59 Purple-clawed (or land) hermit crabs

Coenobita clypeatus Fabricuis, 1787 (also commonly soldier crabs)

Watercolour over black lead, touched with white, 188 × 155 mm

Inscribed in brown ink: 'Caracol .' above each study and 'Thes lyue on land neere the Sea syde, and breede in sondry shells when they be empty.'

1906,0509.1.57

These crabs from the West Indies are shown inhabiting the borrowed shells of snails or whelks or other molluscs, here the *Turritella variegata* Linn. and *Natica canrena* Linn. 'Caracol' is Spanish for a twisted shell. White is mistaken in depicting them in the foreground of his watercolour of Indians fishing, as they do not occur in North Carolina. They migrate annually towards the sea but otherwise are scavengers and are not edible. They are used by fishermen for bait and more recently have been sold in America and Europe as pets; but White's interest in them was clearly as curiosities. In the Sloane volume version the markings on the round shell are less sketchy and more precise.

Lit.: LB 1(59); Quinn, p. 405; ECM 6; PH&DBQ 6(a); PH 6; Sloane copy BL Add MS 5262, no. 19

134. *Peffe pica (grunt) and Caracol (hermit crabs)*, 1580s. Pen and ink and black lead drawing with watercolour and bodycolour, after John White?, from the Sloane volume. British Museum (P&D SL,5270.17r)

Caracol.

Caracol.

Thes lyue on land neere the Sea syde, and breede in sondry shells
when they be empty.

1

60 Loggerhead turtle

Caretta caretta caretta Linn.: Atlantic loggerhead turtle

Watercolour and bodycolour over black lead,
heightened with white, 187 × 260 mm

1906,0509.1.70

This is apparently a male specimen of the
Atlantic loggerhead, the only sea turtle
that breeds in the Carolina Banks, though
it ranges throughout the tropical and sub-
tropical seas. The average length of their
carapace is 90 cm and they weigh around
200 lb or more. They are now an endan-
gered species in the USA and very rare in
North Carolina though more common
further south and in the West Indies,
where White presumably drew his
specimen. Even though the colours in
White's drawings appear very strong, the
offset, reproduced here, shows how much
deeper the original watercolours once
were before they were damaged by water
after the fire in Sotheby's warehouse in
the mid nineteenth century.

Hulton noted that White's drawing was
copied in the Harvard 1589 version of the
John Mountgomery manuscript 'A treat-
ice concerning the nauie of England'. The
treatise was first written in 1570 but was
added to in 1588 with advice on the
coming Armada (cf. the British Library
copy – the two versions have different
illustrations). The artist who illustrated the
treatise was not White, but certainly
already knew his drawings, an indication
they may have been circulating amongst
Raleigh's acquaintances or at court
(illustrated in PH&DBQ 154(b)). The
same turtle appears also in Boazio's
engraving of Drake's attack on San
Domingo in 1585 (engraved in 1589, see
fig. 57).

Lit.: LB 1(72); Quinn, p. 456; ECM 55; PH&DBQ
103(a); PH 55

135. Offset of *Loggerhead turtle*, no. 60.
Watercolour and bodycolour pigments
transferred on to the sheet mounted over the
drawing in the original album. British
Museum (P&D 1906, 0509.2)

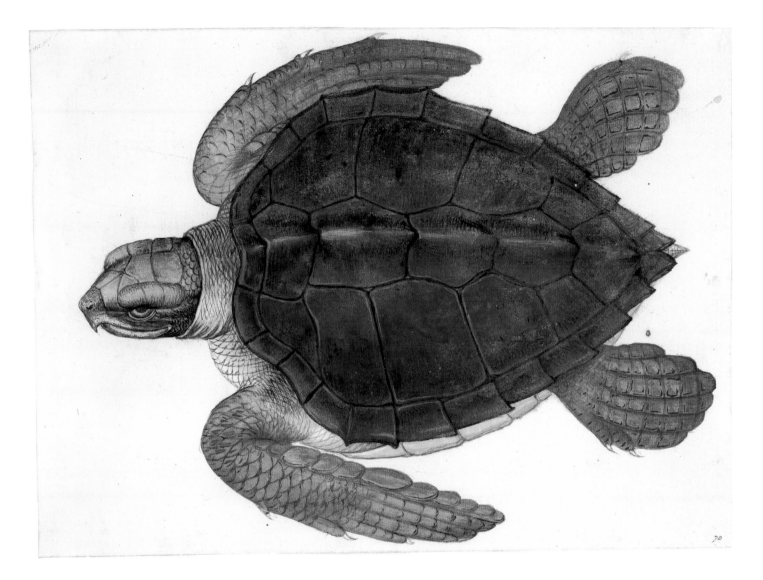

61 Red-footed booby

Sula sula

Watercolour and bodycolour over black lead,
heightened with white, 132 × 231 mm

Inscribed in brown ink: 'Bobo .'

1906,0509.1.63

This is not a brown booby as it has been
described previously. It has a white belly
and pale mask, whereas the red-footed
booby has several colour varieties,
including all-brown as here, also red feet
and a dark mask and bill. Boobies are
mainly found in the West Indies and in
Spanish are called *Boba prieta*. They are
very large birds, with a wing span of about
140 cm and 74 cm long, are related to
pelicans and eat flying fish and feed with
spectacular plunges into the sea. They
build substantial ground nests but recently
have been declining severely in popu-
lation on tropical islands owing to new
predators and development.

Lit.: LB 1(65); Quinn, p. 409; ECM 18; PH&DBQ 18;
PH 18; www.birds.cornell.edu – from A. Poole and F.
Gill, eds, *The Birds of North America*, Philadelphia,
2002, no. 649; and with thanks to Dr Joanne Cooper
of the Natural History Museum, Bird Group, Tring,
who corrected the identification, whose main
references for this and the following birds were S. L.
Scott, ed., *Field Guide to the Birds of North America*, 2nd
ed., National Geographic Society, Washington, 1987,
and P. Harrison, *Seabirds: An Identification Guide*, revised
ed., London, 1985

62 Eastern brown pelican

Pelecanus occidentalis occidentalis Linn.

Watercolour and bodycolour over black lead,
heightened with white, 185 × 223 mm

Inscribed in brown ink: 'Alcatrassa .This fowle is of
the greatness of a Swanne. and of the same forme
sauing the heade, wch is in length .16. ynches.' and at
lower edge 'Tanboril .' and fragment of an inscription
(cut from the top of the image of the puffer fish, no. 53)

1906,0509.1.58

The Spanish name for this bird is *Alcatraz*.
Presumably White did not consider it
necessary to draw the rest of this bird, as
he noted it resembled a swan, except for
the head. But the decapitated head may
have been all he had to draw from; it is
also interesting to note that Gessner's
illustration of a pelican in his *Historia
animalium* (III, 1555, p. 605) is also just the
head, with the same detail where the neck
was cut. The plumage should be more
brown than grey if the bird is immature;
non-breeding adults have white head and
neck and breeding ones have yellowish
crowns and yellow marks on the sides of
their neck. The membrane of the gular
pouch is finely detailed with blood vessels
and hints of texture.

The brown pelican is the only member
of this family that is brown rather than
white, found on ocean shores rather than
on inland lakes and the only one to plunge
from the air into the water to fish. White
shows several of them flying in the Indian
fishing scene. They breed in the West
Indies and Florida and further north; a
number come from Florida to the North
Carolina coast in the summers. The
population declined severely in the 1950s,
was endangered in the 1970s, but increased
again to record levels after the banning of
the pesticide DDT. The latter made the
eggshells thin and they often cracked
when the adult birds incubated them by
placing them under their webbed feet.

Lit.: LB 1(60); Quinn, p. 447; ECM 52; PH&DBQ 57;
PH 52; see www.birds.cornell.edu; from Poole and
Gill, *The Birds of North America*, no. 609; and with
thanks to Joanne Cooper, NHM, Tring

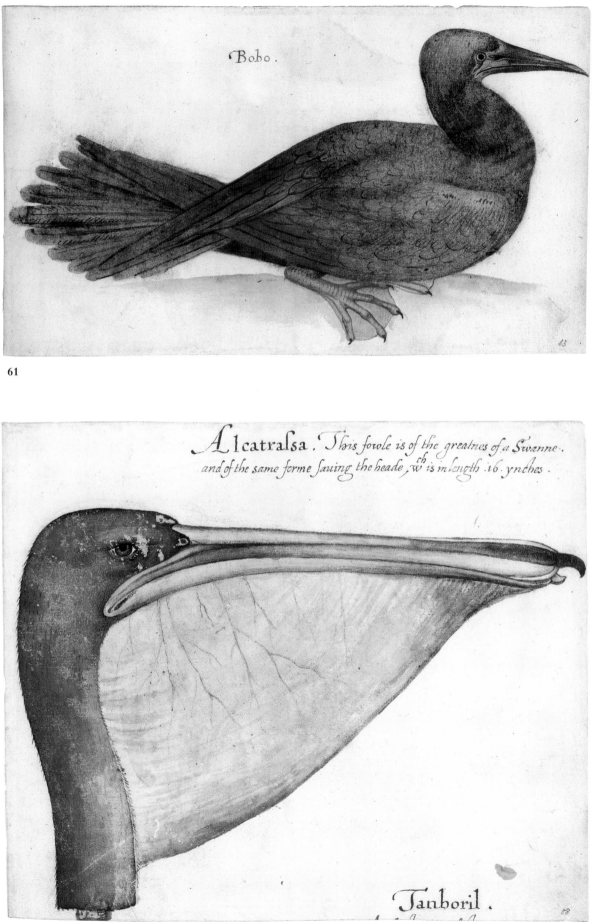

Bobo.

61

Alcatralsa. This fowle is of the greatnes of a Swanne.
and of the same forme sauing the heade, w^{ch} is in length .16. ynches.

Tanboril.

62

63 Tiger swallowtail butterfly

Papilio glaucus Linn.

Watercolour over black lead, with bodycolour and
touched with white, 140 × 198 mm

1906,0509.1.66

This watercolour has become renowned
as the first picture of an American
butterfly. It reappeared in the Sloane
album, on the same page as the puffer fish
(fig. 127), and another version (fig. 136)
was found in the Reverend Thomas
Penny's manuscript edited by Thomas
Mouffet, 'Insectorum … theatrum' where
it was labelled in Latin 'The painter White
brought this back to me from the
American Virginia. 1587' (see no. 67).
Sloane also later owned the Penny/
Mouffet manuscript and inscribed the
drawing with the Indian name he knew
from the version in his White album,
'Mamankanois' (see fig. 127). It was repro-
duced in a woodcut in the 1658 published
version of Mouffet's *Theatre of Insects* (p.
967) and described as 'The first Day-
Butterfly being the greatest of all, for the
most part all yellowish, those places and
parts excepted which are here blacked
with ink. Moreover, the roundles of the
inner wings are sky-colour, insomuch that
you would think they were set with
Saphire stones; the eyes are like the
Chrysolite: the bigness and form is so
exactly set forth in the figure, that there
need no more to be said of it.' Some of
the 'Saphire' blue roundels are visible in
the original drawing but the Sloane
volume version shows them much more
clearly. The stained version in the Penny/
Mouffet manuscript may be the only
'field' drawing by White to survive, but it
is also possible that it is just another
version he made on his return.

Catesby included two drawings of the
Tiger swallowtail (*Nat. Hist.*, II, pl. 83, 97).
One shows it with its 'tail', and without
the blue roundels, and is based on a
specimen he found himself. He made
another copy of it with a part of a sassafras
to give to Sloane for his collection (fig.
137). His other illustration, shown
without its tail, is based on the version in
Sloane's album. Because of the differences,
Catesby believed that they were two
separate species and, uniquely in all the
drawings he had copied from Sloane, he

acknowledged Sloane's 'manuscript of Sir
Walter Ralegh' as his source.

White may have brought back at least
one insect specimen: the Penny/Mouffet
manuscript includes a rough drawing of a
cicada of a species found in Virginia.
When it was published in 1658, Mouffet
(who edited Penny's manuscript) recorded
that Penny had received one specimen
from Guinea and 'also Mr. White a rare
Painter, gave him another brought forth
from Virginia' (pp. 990–1, cited in PH&
DBQ 109).

Lit.: LB 1(68); Quinn, pp. 458–9; ECM 58; PH&DBQ
108(a); PH 58; Mouffet version BL Sloane MS 4014,
fol. 96r; see McBurney, pp. 122–5

136. *Tiger swallowtail butterfly*, c.1585. Watercolour with bodycolour by John White on a separate,
inscribed piece of paper, given by him to the Reverend Thomas Penny and inserted into his
manuscript, later published in Thomas Mouffet's *Insectorum sive minimorum animalium theatrvm*, 1634,
London. By permission of The British Library, London (Sloane MS 4014, 95v)

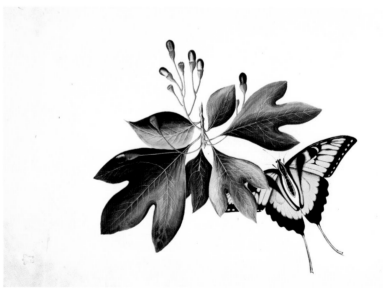

137. *Tiger swallowtail butterfly and sassafrass*, 1730s? Watercolour and bodcolour drawing by Mark
Catesby, presented to Sir Hans Sloane. The butterfly appeared in two plates in Catesby's *Natural
History*, vol. II, 1743, pls 83, 97, the first with tails, as here, and the second, copied from fig. 127,
without tails. By permission of The British Library, London (Sloane MS 5289, 167)

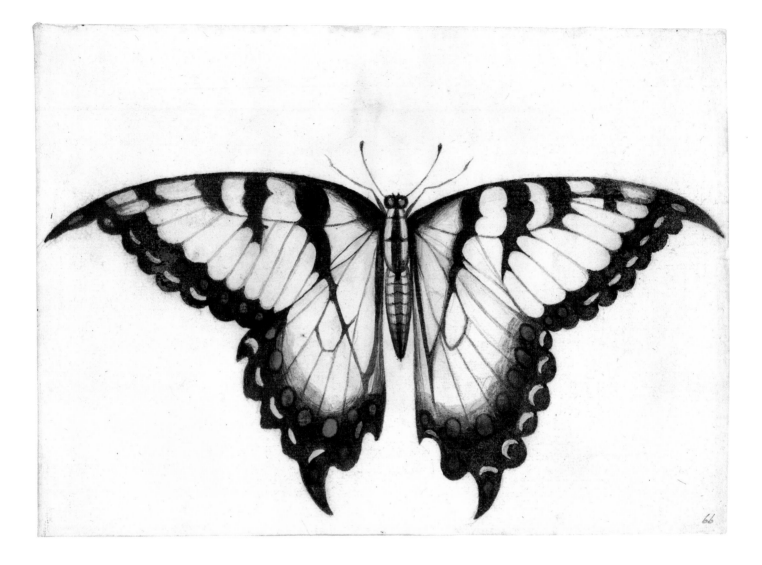

66

64 Common noddy tern

Anoüstolidus stolidus Linn. (commonly brown noddy)

Watercolour over black lead, touched with white (altered), 157 × 234 mm

Inscribed in brown ink: 'Tinosa .'

1906,0509.1.59

The water damage has not only drawn much of the black from the tail and elsewhere and some of the brown, but it has also badly smudged the drawing. The bird has an ash white forehead, as seen here. Like the booby, the noddy tern is common in tropical waters and is a plunge diver, but it is more frequently seen as far north as Carolina. As it is a tern, it is not nearly as large as a booby, averaging a 40 cm wingspan. White probably drew both these specimens in the West Indies.

Lit.: LB 1(61); Quinn, p. 409; ECM 19; PH&DBQ 19; PH 19

65 Diamond-back terrapin

Malaclemys terrapin centrata Lattreille (commonly the southern diamond-back terrapin)

Watercolour over black lead, heightened with white, 174 × 253 mm

1906,0509.1.69

The southern diamond-back terrapin has five toes, not six as shown here. It lives in salt-marshes and it is interesting that White adds shading behind the front legs and tail to indicate its relationship to the ground. There are several sub-species which vary greatly in their colouring – the one depicted by White is probably the one native to the Carolinas, but even within this sub-species their colouring varies. The females are larger than the males which grow to about 120 mm. In the late nineteenth and early twentieth centuries they were considered a great delicacy and nearly became extinct; they are now a protected species.

Lit.: LB 1(71); Quinn, p. 457; ECM 57; PH&DBQ 105; PH 57

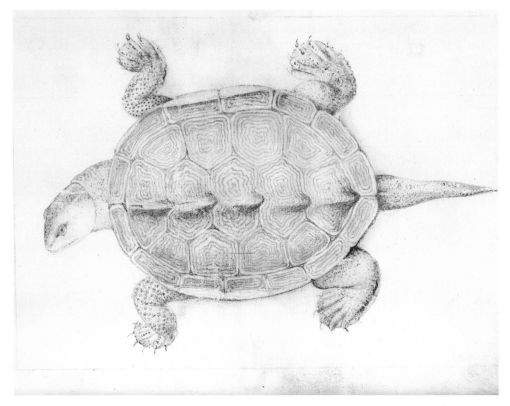

138. Offset of *Diamond-back terrapin*, no. 65. Watercolour and bodycolour pigments transferred on to the sheet mounted over the drawing in the original album. British Museum (P&D 1906, 0509.2)

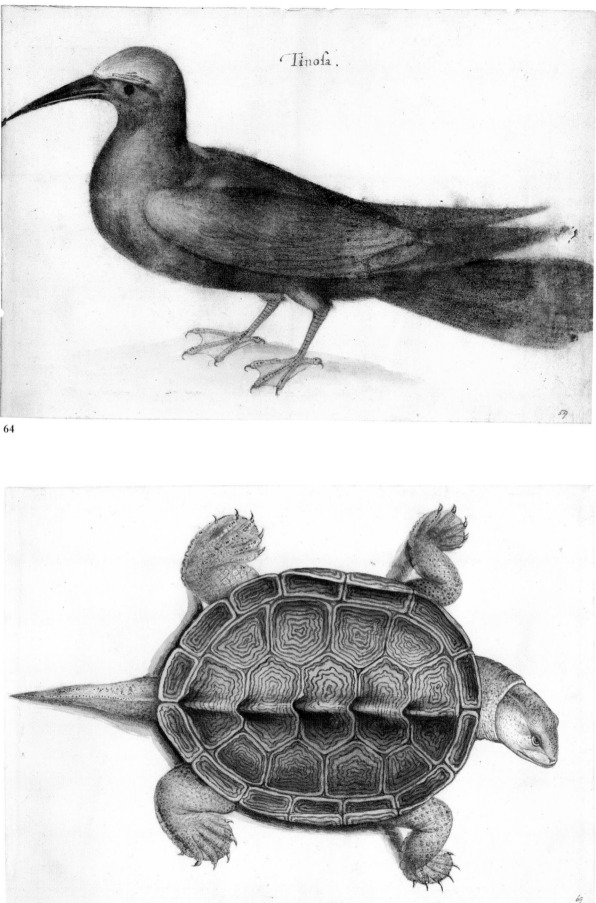

Tinoſa.

64

65

66 Greater flamingo

Phoenicopterus ruber Linn.

Watercolour over black lead, touched with
bodycolour and white (altered), 296 × 197 mm

Inscribed in brown ink: 'A Flaminco .'

1906,0509.1.60

Along with the four bird drawings of the
frigate bird, tropic bird, booby and tern,
this watercolour has been considered to
be connected with White's passage
through the Bahamas or West Indies. The
species comes to Florida but very rarely as
far north as Carolina. The drawing has
been admired by ornithologists for its
delicate depiction of the feathers.

Inhabitants of the islands ate iguanas
and land crabs but, in spite of their large
numbers, birds were not a significant part
of their diet. John White, therefore, was
not recording them for the same purpose
as he was other flora and fauna, for their
use as provision or 'commodities'; instead,
his record was made to capture their
appearance as exotic specimens. Later
voyagers, however, were to note that
flamingos were edible. Sloane's manuscript
catalogue of his bird collection included a
young flamingo from 'the continent of
America'. The catalogue cited Captain
William Dampier's account of his 1681
New Voyage Round the World (1729 ed.):
'The flesh of both young & old is lean &
black yet very good meat, tasting neither
fishy nor any way unsavoury. Their
tongues are large, having a large knob of
fat at the root, wch is an excellent bit. a
Dish of Flamingo's tongues being fit for a
Princes table.'

Lit.: LB 1(62); Quinn, p. 409; ECM 15; PH&DBQ 15:
PH 15; Bedini, p. 268; Clutton-Brock in MacGregor
on Sloane, p. 84

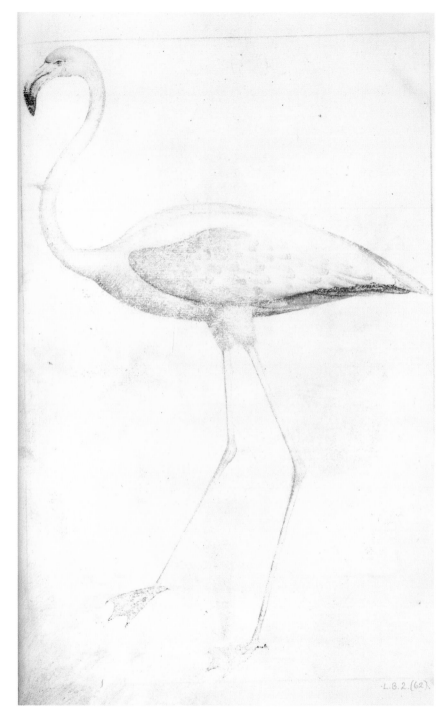

139. Offset of *Flamingo*, no. 66. Watercolour
and bodycolour pigments transferred on to the
sheet mounted over the drawing in the
original album. British Museum (P&D 1906,
0509.2)

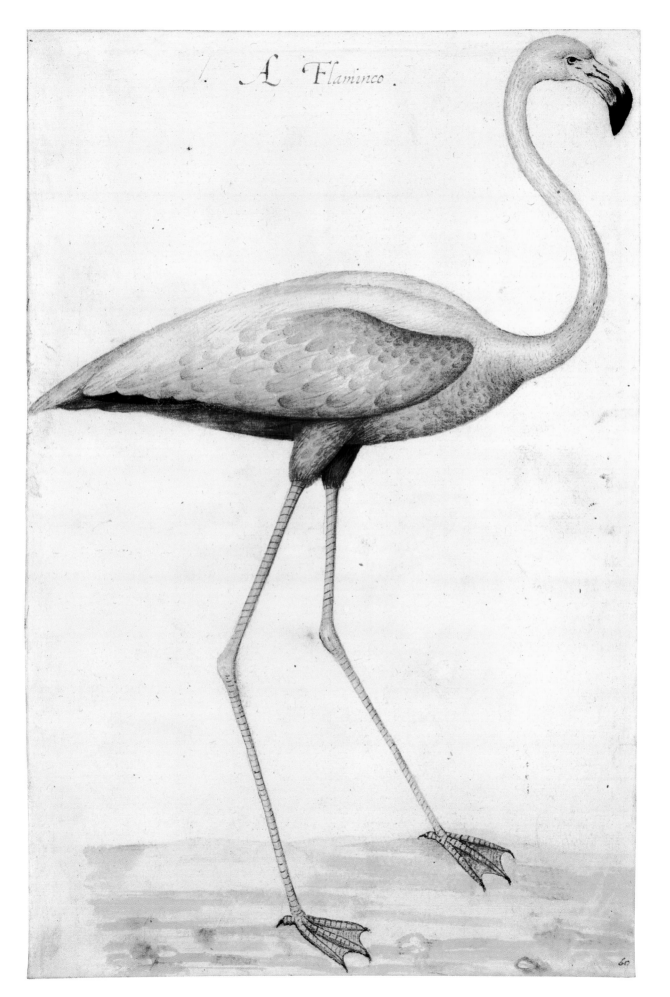

A Flaminco.

60

211

67 Fireflies and a gadfly

Pyrophorus noctilucus Linn. and *Tabanus*

Watercolour over black lead, touched with white,
199 × 187 mm

Inscribed in brown ink: 'A flye which in the night
semeth a flame of fyer.' and 'A dangerous byting flye.'

1906,0509.1.67

The fireflies were found in the West Indies
and the gadfly probably there also,
although it is not detailed enough to
determine its species. Understandably,
White may not have realized that the
fireflies he saw in North Carolina were a
different species from those he had drawn
in the West Indies. None of the wings
should be blue; this is probably the artist's
attempt to depict them as clear.

Conrad Gessner had been preparing a
great work on insects and it was carried
on after his death by the Reverend
Thomas Penny. His work was prepared for
publication within a year of his death in
1588 by Dr Thomas Mouffet (1553–
1604), although it was not actually
published until 1634 as *Insectorum sive
minorum animalium theatrum*, one of the
foundations of modern entomology.
There are versions of two of the drawings
of the fireflies and one of the gadfly on
separate pieces of paper pasted into
Penny/Mouffet manuscript 'Insectorum
… theatrum' (BL Sloane MS 4014, fol.
109r), where they are inscribed in Thomas
Penny's hand in Latin, which can be
translated as 'This firefly, together with the
picture, I [Penny] received from White,
most skilful painter, who very deligently
observed it in Hispaniola and Virginia
alike'. This text appeared in the publi-
cation accompanied by a woodcut
illustration after the watercolours. This has
led them to be considered originals,
whereas in fact their status is probably the
same as the drawings in the Sloane album.
The gadfly was published with a credit to
White 'from Virginia of the Indians', and
Mouffet also recorded that White had
given him a drawing of a cicada. However
the cicada in Mouffet's manuscript is not
considered to be like White's work.

Lit.: LB 1(69); Quinn, pp. 406, 459–60; ECM 7;
PH&DBQ 7(a); PH 7 and p. 77(c)

140. *Fireflies*, c.1585. Pen and ink and
watercolour drawings by John White inserted
into the Penny/Mouffet manuscript on insects
(see fig. 136). By permission of The British
Library (Sloane MS 4014,109r)

A flye which in the night
semeth a flame of fyer.

A dangerous byting flye.

67

68 Magnificent frigate bird

Fregata magnificens rothschildi Matthews

Watercolour and bodycolour over black lead, touched with white, 136 × 223 mm

1906,0509.1.62

Frigate birds, also called man-o'-war birds, nest in the West Indies and Gulf Coast and fly north in the summer, reaching the coast of North Carolina and beyond. The blue tints should be black, glossed with green and purple but some of this may be due to the loss of deep blue pigment to the offset. The males are entirely black with a red throat pouch while the females have white chests; but this is an immature male showing a white head and belly separated by a brown breastband. They snatch food from the surface of the ocean, rather than diving, and they never land on the water. They are generally around 110 cm long, including their long forked tail, with a wingspan of about 220 cm, and their populations are declining. The manner in which it is depicted here, like the tropic bird, clearly indicates it has been drawn from a dead specimen.

Lit.: LB 1(64); Quinn, p. 409; ECM 16; PH&DBQ 16; PH 16; see www.birds.cornell.edu

141. *A Gwano (iguana) and alligator*, 1580s. Pen and ink and black lead drawing with watercolour and bodycolour, after John White?, from the Sloane volume. There is an eighteenth-century copy made for Sloane in the BL (Add MS 5272,22). British Museum (P&D SL,5270.13r)

69 Crocodile or alligator

Possibly *Crocodylus acutus* Cuvier but more likely *Alligator mississipiensis* Daudin

Watercolour over black lead touched with bodycolour and with gold on eye; 111 × 233 mm

Inscribed in brown ink: 'Allagatto . this being but one moneth old was .3. foote. .4. ynches in length . and lyue in water.'

1906,0509.1.72

This species has proved difficult to identify from White's drawing. The word 'Allagatto' is a corruption of the Spanish 'El lagarto' which was applied to any lizard-like reptile. Alligators are not found in the West Indies but crocodiles are, and some have considered that this looks more like the latter. The size given would indicate a reptile of two years rather than one month. In the Sloane volume (below) the iguana and the crocodile or alligator were both drawn on the same sheet; several other images were doubled up in this way and there are indications that some of the original drawings now mounted separately in the Museum's collections were once also two images per sheet (e.g. nos 53, 62, puffer fish and pelican) and were cut up by White to be mounted in the original album or by Charlemont, who may have had them remounted after he acquired them.

Boazio's alligator on his engraving of San Domingo (fig. 57) is similar to but not identical with White's and is described as 'A strange beast drawne after the life, & is called by our English mariners Aligarta, by the Spaniards Caiman'.

Lit.: LB 1(74); Quinn, p. 407; ECM 10; PH&DBQ 10(a); PH 10

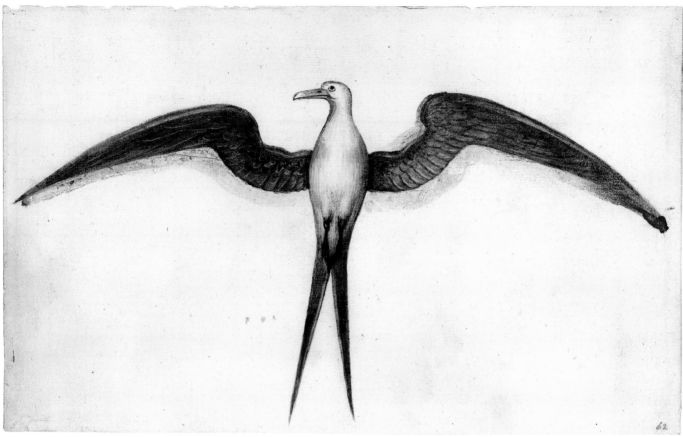

68

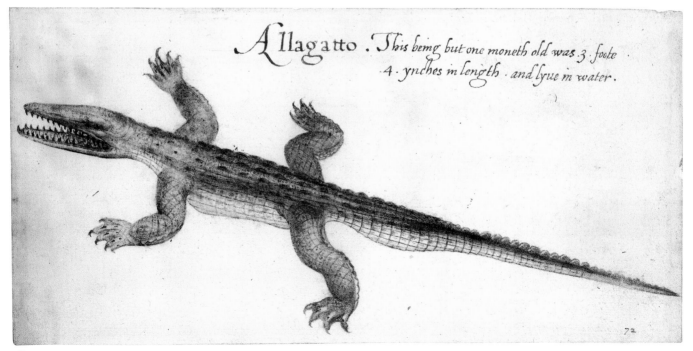

Allagatto . This being but one moneth old was 3 foote 4 . ynches in length . and lyue in water.

69

70 European roller

Coracias garrulus Linn.

Watercolour and bodycolour over black lead, touched with white, 160 × 226 mm, trimmed lower right corner

Inscribed in black lead: 'the Roller'

1906,0509.1.64

This bird is common in Spain and around the Mediterranean but is now almost never seen in Britain. They are currently on a red list as a near-threatened bird species, but it is possible that they were common enough in migration for White to have been able to draw one from a specimen in England. Alternatively, he may have copied a watercolour or illustration by a European artist.

Lit.: LB 1(66); Quinn, p. 464; ECM 65; PH&DBQ 134; PH 71

71 Common hoopoe

Upopa epops Linn.

Watercolour and bodycolour over black lead, heightened with white (altered), 150 × 211 mm, upper left corner trimmed

1906,0509.1.61

Most of White's drawings from the 1585 voyage are labelled – the costume studies and these two watercolours of birds are not, perhaps an indication that they were done at a different time and for a different purpose. The birds are both European varieties. They are quite clearly by the same hand that drew the flamingo and brown booby, but they do not have the same amount of lead mixed in with their pigments and no gold or silver.

The hoopoe is an exotic-looking bird, particularly when its crest is raised, as shown here. It is a ground feeder, its head bobbing as it searches for food. It is very common in Spain and is frequently seen on the English south coast during migration in the spring, especially on Portland Bill in Dorset. Like many species, it may have been far more common in the sixteenth century than it is now.

Lit.: LB 1(62); Quinn, p. 464; ECM 66; PH&DBQ 133; PH 70

the Roller.

64

70

71

217

72 Mammee apple

Mammea americana Linn.

Watercolour over black lead, 210 × 184 mm

Inscribed in black ink: 'Mammea.'

1906,0509.1.40.a

As in his other drawings where it was possible, White has drawn this West Indian fruit life-size. He depicts it stalk down and sadly the water damage has led not only to loss of pigment but also to smudging of the edges of the fruit. The version in the Sloane volume is again more strongly shaded but naive in perspective and it includes a cross-section, showing two ovoid stones. The mammee has a leathery brown skin covering a sweet orange flesh similar in flavour to a mango or apricot, normally with one to four stones which are longer and rougher than shown in the version below.

In his account of the 1587 voyage published by Hakluyt, White recorded that, when they were *en route* to Virginia and near St John's Island, he had pleaded in vain with Fernandez to stop so that they might 'gather yong plants of Oringes, Pines [pineapples], Mameas, and Platonos, to set at Virginia, which we knewe might easily be had, for that they growe neere the shoare, and the places where they grewe, well knowen to the Gouernour [White], and some of the planters' (Quinn, pp. 520–21).

Lit.: LB 1(42); Quinn, p. 408; ECM 12; PH&DBQ 12(a); PH 12; Sloane copy: BL Add MS 5289, no. 158, probably not after White

142. *Mamea (mammee apple)*, 1580s. Pen and ink and black lead drawing with watercolour and bodycolour, after John White?, from the Sloane volume. There is a watercolour among the eighteenth-century copies made for Sloane in the BL which might be after this drawing (Add MS 5289,158). British Museum (P&D SL,5270.23r)

Mammea.

240ᵃ

73 Red-billed tropic bird

Phaethon aethereus mesonauta Peters

White over black lead, touched with watercolour and with white, 162 × 204 mm

1906,0509.1.65

The legs should be yellowish rather than pink as here and the offset has taken grey and brown from the wings and blue from the right side of the body. The wingspan of these birds is around 104 cm and they are around the same length, including the two tail streamers seen here. The hairy structures along the tail are not feathers as such but an attempt by White to depict the structure of the long tail feathers which might have been frayed in appearance. Like the frigate bird, they generally live in the tropics but can be found as far north as Carolina during the non-breeding season.

Lit.: LB 1(67); Quinn, p. 409; ECM 17; PH&DBQ 17; PH 17; with thanks to Joanne Cooper, NHM, Tring

74 Common box turtle

Terrapene carolina carolina (Linn.)

Watercolour over black lead, 144 × 197 mm

Inscribed in brown ink: 'A land Tort wch the Sauages esteeme above all other Torts'

1906,0509.1.68

Harriot noted that tortoises 'both of land and sea kinde' were valuable and that their eggs provided food. Indians used the box turtle in particular for food, medicine, ceremonies and hunting. It is a marsh turtle and can be found also in woodlands and meadows with ponds. The shell is hinged so that they can close it up nearly completely when threatened; few predators can penetrate the shell and they are therefore very long-lived, reaching thirty to forty years or more. They are about the same size as the diamond back terrapin, but unlike them are not considered edible, as they eat poisonous mushrooms which can be passed on. They are now popular as pets.

Lit.: LB 1(70); Quinn, p.456; ECM 56; PH&DBQ 104; PH 56

143. Offset of *Common box turtle*, no. 74. Watercolour and bodycolour pigments transferred on to the sheet mounted over the drawing in the original album. British Museum (P&D 1906, 0509.2)

73

A land Tort ʷᵗʰ the Sauages esteeme aboue all other Torts

74

75 Iguana

Cyclura cychlura Cuvier

Watercolour over black lead, heightened with white (altered) and gold on eye, 144 × 210 mm

Inscribed in brown ink: 'Igwano. Some of thes are 3. fote in length. and lyue on land.'

1906,0509.1.71

White's image of the iguana is the first European watercolour of this West Indian species, which is found widely in the Bahamas where Grenville landed twice on the 1585 voyage out. It was copied by Baptista Boazio in his engraving of Cartagena to accompany Walter Bigges's *A summarie and true discourse of Sir Frances Drakes West Indian voyage* (London, 1589). There it was described as living 'on the land in the woodes and desert places, and is caught by the sauage or Indian people who sell them to the Spaniards, they are of a sad greene collour, and their body of the bignes of a connie, they are eaten by the Indians and Spaniardes, and so likewise by vs for a very delicate meate, in the breeding time the femall is full of eggges in great number, and they of all the rest are esteemed the most delicate'.

It has previously been thought that this borrowing by Drake's artist, as well as the alligator and three fish by White (see figs 56, 57, 120) which appeared in Boazio's engravings, indicated that White had travelled back from Roanoke to England with Drake's artist in July 1586. However, this was not necessary in order for White's images to be borrowed by other artists; Raleigh might have lent his set of White's drawings to Drake, or Hakluyt may have acted as the middle-man for this publication, as he did for de Bry and many others, recommending White's drawings as a source to be copied for the more decorative and exotic elements of these printed plans of Drake's victories.

Mark Catesby copied the drawing in Sloane's volume (see fig. 141 where it was copied with the alligator and appears more green and blue than White's grey and pink original), for his image of '*Lacertus indicus, Senembi & Iguana dictus. The Guana*' (*Nat. Hist.* II, pl. 64. Linnaeus cited Catesby for this species in his *Systema naturae* (10th ed. 1758, vol. I, p. 207) but with a question mark, indicating that the drawing was not clear enough to be certain, and taxonomists today still have trouble identifying the species from White's image.

Lit.: LB 1(73); Quinn, pp. 406–7 ECM 9; PH&DBQ 9(a); PH 9; Sloane copy in BL Add MS 5272, no. 22

76 Two studies of scorpions

Tityus tityinae?

Watercolour over black lead, 104 × 186 mm

Inscribed in brown ink: 'Scorpions.'

1906,0509.1.73

The drawings of the scorpions are not detailed enough for the proper identification of the species but they are probably from the West Indies. The specimen on the left is shown on its back and one similar to the one on the right is illustrated in a woodcut pasted into the Penny/Mouffet 'Insectorum … theatrum' manuscript (fol. 188) and was printed again in Mouffet's published book (p. 204, cited in Quinn).

Lit.: LB 1(75); Quinn, pp. 405–6; ECM 8; PH&DBQ 8; PH 8

144. *Lacertus indicus, the guana; and Anona maxima* … , 1743. Hand-coloured etching by Mark Catesby from *The Natural History of Carolina*, vol. II, p. 64. The British Library, London (44.k.8)

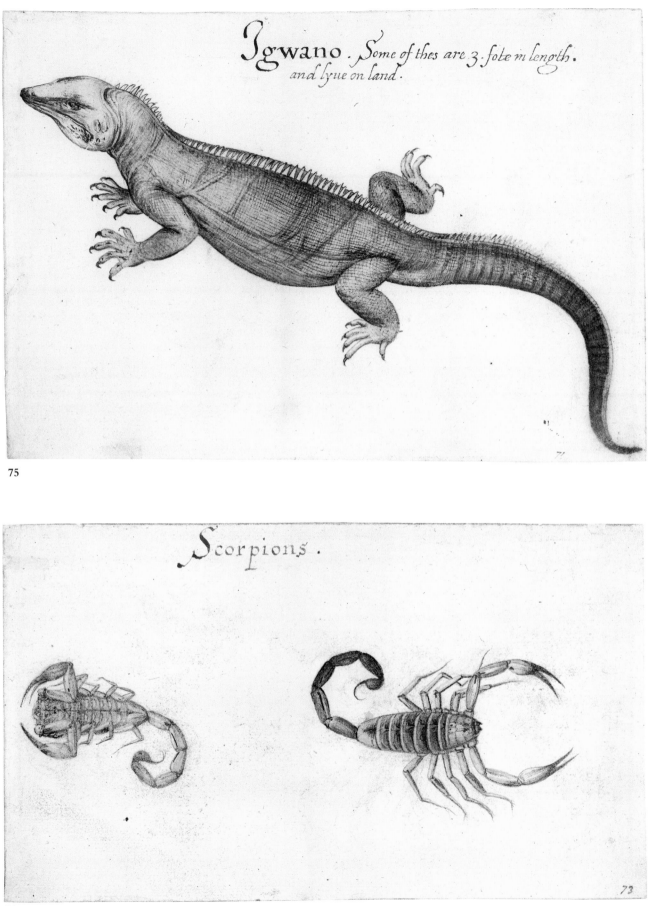

Igwano. Some of thes are 3. fote in length. and lyue on land.

75

Scorpions.

76

THE SLOANE VOLUME OF WATERCOLOURS ASSOCIATED WITH JOHN WHITE

Sir Hans Sloane (1660–1753), a royal physician and president of the Royal Society, was the founder of the British Museum. In the 1680s he travelled to Jamaica and later published a two-volume illustrated account of his voyage with a detailed catalogue of the flora and fauna. He owned the manor at Chelsea on which stood the Society of Apothecaries' Physic Garden and was an encyclopaedic collector and cataloguer of botanical and zoological specimens from around the world for over seventy years. In addition to his natural history collection, he also amassed antiquities, 'artificial rarities', curiosities and objects illustrating the customs and cultures of people from around the world. He acquired entire collections including letters, manuscripts and printed books and at his death his collection and library were offered to the nation and purchased by Parliament with the proceeds of the first national lottery. The British Museum was the originating nucleus of other institutions that spawned from it when they became too large to be accommodated at the site in Bloomsbury, including the Natural History Museum, the National Portrait Gallery and the British Library.

When the British Library was still part of the Museum, parts of the collections were occasionally transferred from one department to another, which is how the John White watercolours, the offsets (transferred in 1906) and the Sloane volume (SL 5270.1–113) (transferred in 1893) came to be in the Department of Prints and Drawings, while the de Bry volumes and Sloane's watercolour copies of the Sloane volume are still in the British Library, now at St Pancras.

Around 1709, Sloane wrote to the Abbé Bignon that a few years earlier he had seen a volume of drawings in the hands of the descendants of the artist John White which were the original drawings on which de Bry had based his engravings in his famous volume of the Virginia voyages. The drawings included several examples of plants, birds, fish etc. which de Bry had not engraved. Sloane valued these records of North American flora and fauna and noted the watercolours of the Indians showed their manners and customs 'in their natural state' before communication with Europeans. Sloane could not purchase the book but he had the drawings copied by a capable artist. These watercolour copies that Sloane had made before 1707 (see figs 122, 123) are now in several large albums in the British Library Department of Manuscripts, where they are bound with other natural history watercolours from his vast collection (they are cited in the following descriptions as 'Sloane copies BL MS Add 5263', etc.).

It was these watercolour copies Sloane had commissioned and which were then in his library that Mark Catesby and others had access to for their own research

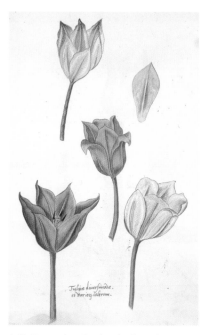

145. *Four studies of pink and yellow tulips (Tulipa cultivar) and of a petal*, c.1580s or 1590s. Watercolour and bodycolour, associated with John White? Inscribed: 'Tulipae diversimodae. Et variores colorum'. (P&D SL,5270,39r)

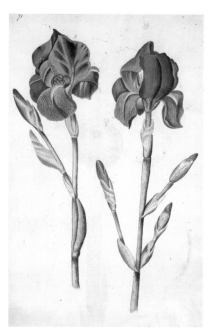

146. *Two studies of German iris (Iris germanica)*, c.1580s or 1590s. Watercolour and bodycolour, associated with John White? This is a bearded iris, also commonly known as a flag iris. British Museum (P&D SL,5270,55r)

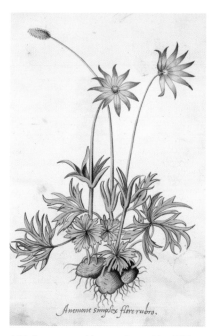

147. *Star anemone (Anemone hortensis)*, c.1580s or 1590s. Watercolour and bodycolour, associated with John White? Inscribed: 'Anemone simplex flore rubro'. British Museum (P&D SL,5270,73r)

in the early eighteenth century. Sloane inscribed the end flyleaf with a list of seventeen of Catesby's plates that related to drawings in the volume (PH fig. 106). Catesby apparently did not see the volume itself, which Sloane eventually managed to acquire from White's descendants some time around 1717, the date it was first entered in his library catalogue (SL MS 3972c, vol. V, p. 1556, no. 56 [previously no. 79, struck through]).

The volume bears an inscription in Sloane's own hand: *The originall draughts of ye habits towns customs &c of the West Indians, and of the plants birds fishes &c found in Groenland, Virginia, Guiana &c. by M. John White who was a Painter & accompanied Sr. Walter Ralegh in his voyag. See the preface to the first part of America of Theodore de Bry or the description of Virginia where some of these draughts are curiously cutt by that Graver.*

Above Sloane's inscription was another one by an earlier owner: *There is in this Book a hondred and 12 Leaues with flowers and Pickters and of fish and of fowles beside wast Paper this Lent to my soon whit 11 Aprell 1673* This has always been interpreted to mean that this was inscribed by a widow previously married to a man named White, who would refer to her son as 'my son White'.

The watercolours in the Sloane volume fall into several different groups. Some have been discussed and reproduced already in the foregoing catalogue: five watercolours relating to the images of the North Carolina Algonquians (figs 64, 70, 76, 83, 85), four relating to the images of the Inuit (pp. 164–9), three costume studies (p. 146) and a series relating to the flora and fauna (see nos 37–76). They are none of them direct copies of the White watercolours; there are very obvious and noticeable differences in several details that cannot be the invention of a copier. These differences probably point to the existence of yet another set of watercolours, which is quite likely, and suggest that either this artist or White was responsible for the variations or elaborations in their set. The watercolours Sloane had made from the album are rightly and correctly described as copies but in regard to the Sloane volume watercolours and the White watercolours, it is impossible to state categorically

which artist was copying what and it is therefore much better to refer to these as versions rather than copies.

The remainder of the watercolours in the Sloane volume are discussed on the following pages: five images of the Tupinambá Indians of Brazil, fifty-seven flowers, twenty-seven birds of North Carolina inscribed with their Algonquian names, and seventeen fish and reptiles similarly inscribed. There are also two pencil and wash figure drawings, possibly copied from sixteenth- or seventeenth-century sources, and one print of Cromwell stuck into the album. They are on the versos of non-related pages and do not merit discussion here.

It is very difficult to assign these various groups to certain hands: at a guess, from the use of different medium and styles, one might say that the three costume studies form one group, the copies of the North Carolina Indians another, the Tupinambá and Inuit are possibly by one hand, and the fish and birds by another. Even all the flowers are not definitely by one artist. The paper used is consistently from the last few decades of the sixteenth century and the flowers were very new but all present in Europe and England by 1600. Edward Topsell had access to versions of the bird drawings in 1608 (see p. 231). There is no reason therefore to assume that the drawings must all date from after 1600 as has generally been considered to be the case in the past. Nor is there any reason to assume that they are all copies after John White, as the watercolours we have by him are *not* the source of the versions here.

Instead of trying to sort out copies and originals – a very twentieth-century approach – it might be useful instead to look at this volume in a different and contemporary light and consider it as a form of *vade mecum* displaying the same encyclopaedic interest in the *theatrum mundi* and natural history as the artist of our main group of watercolours. Whether John White was a professional artist or a gentleman, it is most likely that he would have had an apprentice, assistant or servant. Harriot employed Christopher Kellett, whom he mentioned in his will as a 'Lymning paynter' (see p. 231). White's assistant may have helped to carry his

equipment and keep it in order, to prepare pigments for use, to take notes, to assist with surveying, etc. It is not impossible that he too may have known how to draw. Other gentlemen travelling with the party may also have known how to draw. The watercolours in this album are most likely a mixture of works by White himself, an assistant, a member of his family, an artist hired on return to make copies, other artists at court, and possibly even Le Moyne de Morgues. White may have drawn the costume drawings, Tupinambá and Inuit himself at an early date in the 1570s (one is dated 1575), using a pen and ink outline technique with watercolours and lead pigments and gold. His technique may have changed to the one used in the watercolours that are the subject of the main catalogue here at a later date after exposure to the work of another artist with a different technique. He later accumulated other groups of drawings as he made or acquired them. These would form a *vade mecum* of images for future reference of the type often found in the studios of artists or libraries of gentlemen. Whether he inserted them all together into an album as he acquired them or whether they were inserted later is difficult to tell. A series of numbers inscribed on them indicates that their order changed several times – the current binding is not the original but dates from the nineteenth century.

There are no straightforward explanations for the versions in the Sloane volume, but it is certain that it must no longer be relegated to the status of mere copies and dismissed as such. It holds the clues to White's work and that of his contemporaries, if only we could read them. Finally, it also raises the rather frightening possibility that the watercolours found in the Earl of Charlemont's album and catalogued here, as always, as originals by John White (although none of them is signed and the inscribed title does not mention his name) might be versions executed by an unknown professional court artist and that the versions in the Sloane album are John White's originals.

Lit.: LB 3; ECM 78; PH&DBQ 50, 66; PH 21–3, figs 34–106; for Sloane see MacGregor and Sloan 2003; for Catesby's copies see McBurney

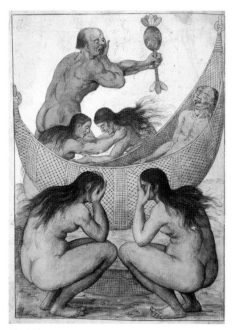

Fig 148

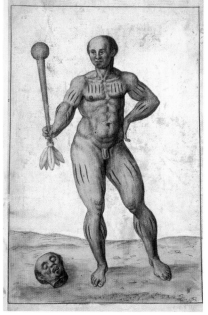

Fig 149

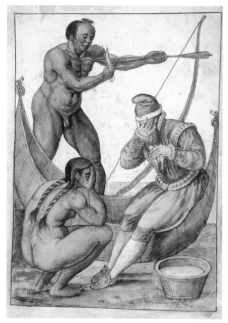

Fig 150

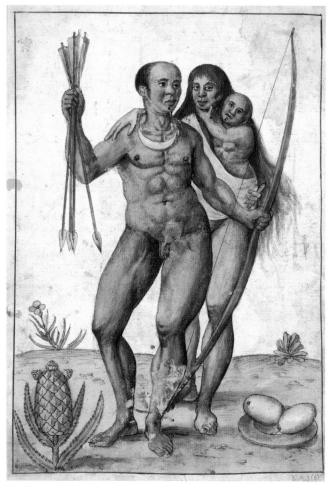

Fig 151

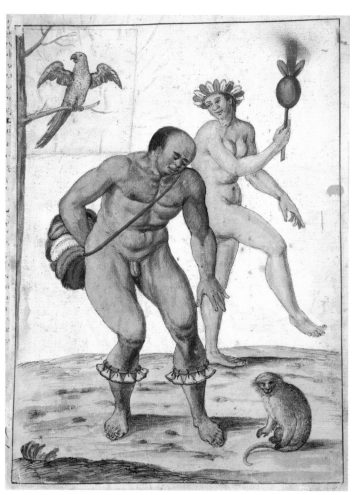

Fig 152

WATERCOLOURS OF TUPINAMBÁ INDIANS OF BRAZIL

In addition to versions of the Inuit, Indian and costume studies, the Sloane volume contains these five images of the Tupinambá from the Amazon in Brazil. They are not direct copies but certainly related to five woodcuts which appeared in Jean de Léry's *Histoire d'vn Voyage fait en la terre dv Bresil avtrement dite Amerique* (La Rochelle) in 1578 (fig. 153; all reproduced in PH&DBQ, pl. 148).

As Christian Feest has noted in Chapter 5, Hans Staden, working for the Portuguese who had controlled Brazil from 1500, was captured by a group of Tupinambá in 1553. He published an illustrated account of his year with them in 1557, which was in turn the basis for de Bry's *America* part III in 1592. Also in 1557, André Thevet published his *Les Singularitez de la France Antarctique avtrement nommee Amerique … (Paris).* Thevet was a Catholic, a cosmographer of the King of France and lived in the colony the French attempted to establish on the site of Rio di Janeiro. His account was also illustrated, although the images owed much to the invention of their Flemish engravers. Both Staden's and Thevet's accounts, with their images of cannibalism and naked people with distinctive feather ornaments on their heads and buttocks, had an immediate impact on the European imagination. These became the identifying attributes of allegorical images representing all indigenous Americans, North and South, long after John White's and Le Moyne's images appeared in Parts I and II of de Bry's *America* in the 1590s.

This collective idea of the inhabitants of the New World was reinforced by Thevet's re-use of his images and variations of them in his *Cosmographie Universelle … illustree de diverses figures* (Paris) in 1575 and his *Les Vrais Pourtraits et vies des hommes illustres* (Paris) in 1584.

Jean de Léry, however, a Calvinist member of the same French colony as Thevet, actually fled *to* the Tupinambá because of the increasing hostility of the colony's Catholic leader. He published his own 1578 account with its five woodcuts to which these watercolours relate, as a reply to Thevet and an attack on French Catholicism. De Léry wrote that he had lived amongst the Tupinambá for a year 'so as I might conceive in my mind a certain idea or proportion of them, yet I say, by reason of their diverse gestures and behaviours, utterly different from ours, it is a very difficult matter to express their true proportion, either in writing or in painting: but if any one covet to enjoy the full pleasure of them, I could wish him to go into America himself' (p. 129, cited in PH&DBQ 33). Just as Hakluyt, Harriot and de Bry were to do, Thevet emphasized the more civilized societal, familial and religious aspects of the lives of the Indians of America and employed his account as a tool of Protestant propaganda. He indicated that Catholic powers ruled through suppression with violence and slavery and were met by violence in return while the Protestant argument was that understanding the Indians, living amongst and working with them and teaching them the values of Christianity by example was the best way of achieving successful colonization in America.

De Léry adapted some of the features of Thevet's illustrations for his own five woodcuts but isolated the figures, removing them from the landscape backgrounds that the engravers had provided and making them individual portraits and illustrating ceremonies just as John White's and Le Moyne's original watercolours were to do (see chp. 5, pp. 67–8).

Some of the images have been mounted on the backs of others; all are pen and brown ink with watercolour, heightened with lead pigments.

Lit.: LB 3 (2–5), ECM 78 (7–10), PH&DBQ 119–23 and PH 44–8. Sloane copies BL Add MS 5253, nos 23, 24, 25, 28, 29. I am indebted to Christian Feest for information about Thevet and Léry's accounts.

Fig. 148 Tupinambá Indians mourning.
SL.5270.7r

A dead man is suspended in a hammock, mourned by four women. Both men wear a plug or labret in their chin.

Fig. 149 A Tupinambá warrior.
SL.5270.7v

In the woodcut a man drawing a bow stands behind him and the head is to the right.

Fig. 150 Tupinambá Indians welcoming a Frenchman.
SL.5270.9r

The European, his long white beard discoloured to grey, sits in a hammock and he and the woman hide their faces as part of the welcoming ceremony. A Tupinambá man behind them straightens an arrow shaft with a knife.

Fig. 151 A Tupinambá man, woman and child.
SL.5270.9v

A pineapple and two fruits are by their feet; a hammock is behind them in the woodcut.

Fig. 152 Tupinambá dancing.
SL.5270.10r

A woman holding a rattle in the background is a man in the woodcut. The man has bell-shaped rattles, possibly pods, on his calves and an ornament of ostrich feathers.

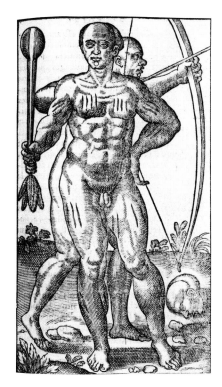

153. *Two Tupinambá warriors with a club and bow,* 1578. Woodcut from Jean de Léry, *Histoire d'vn Voyage fait en la terre dv Bresil avtrement dite Amerique,* La Rochelle. By permission of The British Library, London (G.7101)

Hyacinthus orientalis.

Fig 154

Anemone flore coeruleo.

Fig 155

Anemone

Hyacinthus Botryodes.

Fig 156

Pulsatilla.

Fig 157

Consolida regalis.

Armerius flos.

Fig 158

Narcissus juncifolius.

Fig 159

Lilia Persicum.

Fig 160

Calceolus Mariæ.

Fig 161

Fritillaria.

Fig 162

Fig 163

Anemone flore rubro multiplex.

Fig 164

WATERCOLOURS OF FLOWERS

There are fifty-seven watercolours of flowers in the Sloane volume on forty-five folios. Although they are in this volume acquired by Sir Hans Sloane from the descendants of John White, they were thought by Edward Croft Murray, David Quinn and Paul Hulton to be copies, probably from a Dutch florilegium of c.1600, of European or Western Asiatic plants 'which cannot have been in existence before 1600' and which had 'no known connection with White' (DBQ &PH 66). Perhaps because they were not New World plants, Sloane did not commission watercolour copies of them before he was able to acquire the volume, as he had done for the other watercolours of costumes, Indians, birds and fish and the Virginia and West Indian plants. The flowers were catalogued as part of the Sloane volume by Laurence Binyon and Croft Murray, but they were not included or reproduced in any of the later books on White by Hulton or Quinn. However, given the amount of recent research on the introduction of new plants to England and Europe and on botanical artists such as Jacques Le Moyne, it seems opportune to include them here and re-introduce them to the consideration of John White and his artistic and cultural milieu.

The publication of herbals had undergone a revolution in the sixteenth century with increasingly sophisticated woodcuts. Leonard Fuchs's *De historia stirpium* (Basel 1542), had beautifully delicate, detailed woodcuts which included roots and the flower at various stages as seen here. Publishers of herbals, including John Gerard whose milkweed was based on White's drawing of it, constantly borrowed and re-used images from each others works. Le Moyne copied and slightly reworked some of the plates from Fuchs's and other herbals for his watercolour florilegia. In herbals which focussed on identifying plants for their medicinal purposes, the text was more important than the images, but florilegia (literally 'flower books') only sometimes had captions and little or no text and were generally painted for wealthy patrons as a record of plants, many of them new to

Europe, grown for their beauty rather than practical use.

The drawings and inscriptions here fall into roughly three groups, presumably three different hands or drawn from three sources. The inscriptions are the Latin polynomials for these plants which were in use at least by 1616 when the final edition of *Stirpium historiae pemptades sex sive libri XXX* by the Flemish physician and botanist Rembert Dodoens (1517–85) was published posthumously. The original Latin edition had been published in 1583. One of the inscriptions on the flowers in the Sloane volume refers its nomenclature to Dodoens's herbal (SL, 5270.50r) and several of the images of narcissi and the lily are very close to the woodcuts in the 1616 and 1644 editions and are no doubt based on a common source that pre-dates them. The first 1554 Flemish edition had 714 woodcuts, most of them including the roots or bulbs as seen here, but it has not been possible to compare these watercolours with all the earlier editions or other sixteenth-century illustrated herbals, many of which were hand-coloured.

Only some of the flowers here might be copied from such sources. Others seem to be copied from another watercolour rather than from a print, while others appear to be drawn from the original flowers themselves, notably the irises, some of the narcissi, hyacinths and the larkspur and pink. Some of these are cut on the stem in a manner very reminiscent of Le Moyne's flower drawings and indeed bear a remarkable resemblance in style, technique and medium to his originals in the British Museum and elsewhere (figs 109, 112, 113). It is this re-connection of these flower paintings with the work of Le Moyne that brings them back into John White's artistic milieu and argues for a closer examination in the hope that it will reveal more about the connection between these two artists. This cannot be done here but publishing them in the present context is intended to remind readers of their existence and encourage their examination by experts in this field.

Lit.: LB 3 (32–91); ECM 78 (27–74); recent studies of botanical illustration are Desmond 1986; and Saunders 1995; Dodoens is available at http://plantaardigheden. nl/dodoens/english.htm; I am grateful to Robert

Huxley and Roy Vickery of the Botany Department of the Natural History Museum for checking the identification of the flowers. Kathleen Stuart of the Morgan Library in New York kindly shared her thoughts on their possible relationship with the work of Le Moyne.

Fig. 154 Hyacinth (*Hyacinthus orientalis*)
Inscribed: 'Hyacinthus orientalis'
SL,5270.27r

Fig. 155 Apenine anemone (*Anemone apennina*)
Inscribed: 'Anemone flore coeruleo'
SL,5270.27v

Fig. 156 Anemone (*Anemone coronaria*) and two studies of a grape hyacinth (*Muscari*),
Inscribed: 'Anemone' and 'Hyacinthus Botroydes'
SL,5270.29r

Fig. 157 Pasque flower (*Pulsatilla vulgaris*)
Inscribed: 'Pulsatsilla.'
SL,5270.30r

Fig. 158 Larkspur (*Consolida*) and grass pink (*Dianthus*)
Inscribed: 'Consolida regalis' and 'A[r]merius flos.'
SL,5270.30v

Fig. 159 Jonquil (*Narcissus jonquilla*)
Inscribed: 'Narcissus juncifolius'
SL,5270.32r
This watercolour is related to engravings in the 1616 (p. 242) and 1644 (p. 354) editions of Dodoens's herbal.

Fig. 160 Persian fritillary (*Fritillaria persica*)
Inscribed: 'Liliu persicum'
SL,5270.33r
This watercolour is very close to engravings in two editions of Dodoens.

Fig. 161 Lady's slipper orchid (*Cypripedium calceolus*)
Inscribed: 'Calceolus Mariae'
SL,5270.44r

Fig. 162 Two studies of snake's head fritillary (*Fritillaria meleagris*)
Inscribed: 'Fritillaria'
SL,5270.45r

Fig. 163 Siberian Iris (*Iris sibirica*)
SL,5270.58r

Fig. 164 Double peacock anemone (*Anemone pavonina*)
Inscribed: 'Anemone flore rubro multiplex'
SL,5270.70r

Náhyapuw. The Gripe. almost as bigg as an Eagle.

Fig 165

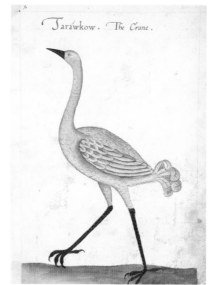
Taráwkow. The Crane.

Fig 166

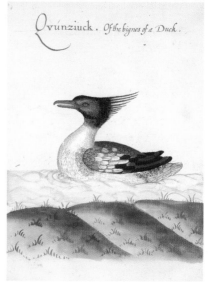
Qvúnziuck. Of the bignes of a Duck.

Fig 167

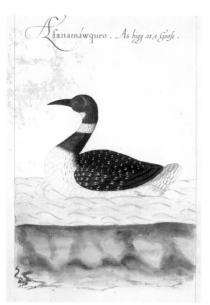
Alanamáwqueo. As bigg as a Goose.

Fig 168

A wuddpicker. Maraleequo. Of this bignes.

Fig 169

Fig 170

Fig 171

Meelquouns. Almost as bigg as a Parratt.

Fig 172

Artamóckes. The linguist. A birde that imitateth and vseth the founde and tunes almost of all the birds in the centrie. As bigg as a Pigeon.

Fig 173

WATERCOLOURS OF NORTH CAROLINA BIRDS

There are twenty sheets with twenty-seven watercolours of birds, most inscribed with their North Carolina Algonquian names. Although they have always been described as 'copies after John White', in fact their association with him is difficult to assess. As mentioned earlier, there are about five different hands in this volume, and these birds seem to be by the same hand as the similarly inscribed fish. There are no 'originals' by John White of any of these, which may indicate he never drew these birds at all. Indeed, if he left North Carolina in the late summer or September of 1585 as has been argued in Chapter 3, then he would not have seen some of these birds, which are winter migrants to the area (e.g. the merganser). In his *Briefe and true report*, Harriot noted that he had taken the Indian names for fourscore and six fowl; and they had taken the pictures of eight water and seventeen land fowl, 'although wee haue seene and eaten of may more, which for want of leasure there for the purpose coulde not bee pictured; and after wee are better furnished and stored vpon further discouery, with their strange beastes, fishe, trees, plants, and hearbes, thy shalbe also published' (cited Quinn, pp. 358–9). There are eight water birds and nineteen land birds in the volume. In his will, Harriot mentioned his long-time servant Christopher Kellett, a 'Lymning paynter', and it is just feasible that these may be his work, though his name is not recorded in the list of Lane colonists for 1585–6. It would be natural for a set of these to end up in White's volume if they did eventually intend to publish them.

What is certain, however, is that Hakluyt had access to these or versions of them between 1608 to 1614 when he made them available to Edward Topsell, who was collecting bird illustrations for his manuscript 'The Fowles of Heauen' (Huntington Library, Ellesmere MS 1142). His watercolour of another towhee (PH 83) was inscribed: 'This is also a virginia bird whose picture I receiued from that worthye, industrious, & learned compiler of nauigations … *Master Hackluyt*.' It is difficult to tell whether Topsell copied the Sloane volume drawings reproduced here or other versions but it probably indicates there were several sets circulating, just as there were of the other watercolours.

These records of birds are generally very stylized and sometimes it is quite difficult to be certain of the race or even species. The branches, water, ground etc. are an attempt to show the birds in their natural habitat but many of the birds in the album have not been drawn in a pose natural for them (e.g. the woodpecker). The artist generally observes the toes and their placement on the ground or branch accurately – the woodpecker's are correctly two front and two back. The descriptions in the inscriptions may seem strange to us but we must remember that the only birds they could compare them with were ones they knew from Europe or had seen in the West Indies. The drawings are all in pen and ink with watercolour and some lead pigment, and the sheets generally measure 390 × 260 mm. Only a selection is reproduced here.

Lit.: Discussed and reproduced in full in black and white in PH&DBQ 58–84 and PH figs 67–88; I am extremely grateful to Joanne Cooper and Mark Adams of the Natural History Museum Bird Group at Tring for checking earlier identifications for their accuracy.

Fig. 165 Bald eagle (*Halieaetus leucocephalus* Linn.)
Inscribed: 'Nahyápuw. The Grype. almost as bigg / as an Eagle.'
SL,5270.75 (Sloane copy BL Add MS 5263, no.9)
If drawn in North Carolina, then it probably depicts the southern race of the bald eagle.

Fig. 166 Sandhill crane (*Grus canadensis* Linn.)
Inscribed: 'Taráwkow. The Crane.'
SL,5270.76 (Sloane copy BL Add MS 5265, no. 87; Topsell copy fol. 206v)
These cranes can no longer be seen in North Carolina. The wings have extended feathers at the tips which droop over its rear and look like a tail. The artist here has turned them into a true tail, a common mistake.

Fig. 167 Red-breasted merganser (*Mergus serrator* Linn.)
Inscribed: 'Qvúnziuck. Of the bignes of a Duck'
SL,5270.79 (Sloane copy BL Add MS 5625, no. 20)
The typical red breast is not shown clearly here. These birds visit the North Carolina coast in the winter.

Fig. 168 Common loon (*Gavia immer* Brünnich)
Inscribed: 'Asanamáwqueo. As bigg as a Goose'
SL,5270.81 (Sloane copy BL Add MS 5265, no. 62)
The common English name for this bird is the great northern diver. It is shown here in its breeding summer plumage.

Fig. 169 Red-headed woodpecker (*Melanerpes erythrocephalus* Linn.)
Inscribed: 'Maraseequo. A woddpicker. / Of this bignes'
SL,5270.84 (Sloane copy BL Add MS 5263, no. 121)
The pose is quite wrong for the bird. It should be clinging vertically to a tree.

Fig. 170 Bluebird and Rufous-sided towhee (*Sialia* Linn. and *Pipilo erythrophthalmus* Linn.)
Inscribed: 'Iacháwanjes. Of this beggnes.'
SL,5270.87 (Sloane copies BL Add MS 5264, no. 130 and 104; Topsell copies fol. 31v)
The bluebird is difficult to identify: one would expect the eastern bluebird in North Carolina but they do not have blue extending below their beak as the western bluebird does and as seen here. This may be the artist's error. The towhee eating maize is a female. This type of maize with multicoloured kernels was common throughout eastern North America.

Fig. 171 Brown thrasher? and Baltimore? oriole (*Toxostoma rufum* Linn. and *Icterus galbula* Linn.)
SL,5270.89 (Sloane copies BL Add MS 5264, no. 105, and 5263, no. 87; Topsell copy of Oriole fol. 86r)
These are two examples where the plumage has been so stylized that the birds are not properly identifiable and a guess has to be made from the colouring and the extent of known birds. The depiction of the honeysuckle is interesting, as none of the other images of birds includes similar detail of their habitat.

Fig. 172 Northern cardinal (*Cardinalis cardinalis* Linn.)
Inscribed: 'Meesquouns. Almost as bigg as a Parratt.'
SL,5270.92 (Sloane copy BL Add MS 5264, no. 77)
Rather than an eastern cardinal, this bird has now been identified as a northern cardinal.

Fig. 173 Blue jay (*Cyanocitta cristata*)
Inscribed: 'Artamóckes. The linguist. A birde that imitateth and useth the sounde and tunes almost of all the birdes in the contrie. As bigg as a Pigeon.'
SL,5270.94 (Sloane copy BL Add MS 5263, no. 70; Topsell copy fol. 32r)
The artist seems to have confused this bird with the mockingbird which is the imitator; the confusion may have arisen from the Indian name.

Chaham /
Wunduñaham } The hearing. 2. foote in length.

Fig 174

Mesickek. Some 5. or 6. foote in lengthe.

Fig 175

Kowabetteo. Some 5. or. 6. foote in length.

Fig 176

Memeskson. A foote in length.

Fig 177

Keetrauk. Some 2. foote and a halfe in length.

Fig 178

Masunnehockeo. The olde wyfe.
2. foote in length.

Fig 179

Telicqueo. A kinde of Snake which the Saluages (being
rest or sodden) doe eate. Some an ell long.

Fig 180

Coppauseo. The Sturgeen. Some 10. 11. 12. or 13 foote in length.

Fig 181

WATERCOLOURS OF NORTH CAROLINA FISH AND REPTILES

Previous writers have been very dismissive of these watercolours inscribed with Algonquian names which have always been described as copies after lost John White originals. They are not by the accomplished copiest already discussed in connection with catalogue numbers 44–60. They appear to be by the same hand who drew the birds with their Algonquian names and which have also been dismissed as flat, stylized, badly drawn and inaccurate. However, these watercolours of fish are accomplished for their time and compare very well with contemporary woodcuts. The features are clearly delineated and easily recognizable. In fact Mark Catesby used Sloane's watercolour copies of two of them, the catfish and the gar (fig. 182), as the source for his own illustrations of these fish in his *Natural History of Carolina*; they in turn were used by Linnaeus as the type specimens for his binomials for these fish.

White's watercolours were mainly of fish found in the West Indies inscribed with their Spanish names, whereas these are probably what Harriot was referring to in his *Briefe and true report* when he stated there were 'very many other sortes of excellent good fish, which we haue taken & eaten, whose names I know not but in the countrey language; wee haue of twelue sorts more the pictures as they were drawn in the countrey with their names.' There are seventeen images in this group: excluding the reptiles, herring or sturgeon, there are twelve. Their use as a guide to the fish available as a source of food in the fresh and sea waters around 'Virginia' was perfectly adequate and the Algonquian inscriptions meant they would also be useful for future negotiations with the Indians when the English plantation began in earnest.

The sheets on which they, like the birds, are drawn are badly stained. They are all drawn in watercolour with some use of lead pigments which have discoloured.

Lit.: Only a selection is reproduced here but they have all been catalogued in LB 3 (114–26), ECM 78 (97v–113), PH&DBQ 85–107, and are reproduced in full in black and white in PH figs 88–105; for a basic guide see Henry B. Bigelow and William C. Schroeder, *Fishes of the Gulf of Maine*, Washington, 1953, revised 2002, available at http://www.gma.org/fogm; I am grateful to Oliver Crimmen and to Colin McCarthy of the Zoology Department of the Natural History Museum for their assistance.

Fig. 174 Alewife or shad (*Pomolubus pseudoharengus* Wilson)
Inscribed: 'Chaham / Wundúnãham / The hearing. 2. foote in length'
SL,5270.100 (Sloane copy BL Add MS 5267, no. 110)
Like salmon and shad, alewife grow in the sea but enter freshwater streams to spawn in ponds. They are eaten fresh or salted.

Fig. 175 Striped bass (*Roccus saxatilis* Walbaum)
Inscribed: 'Mesíckek. Some 5 or 6 foote in lengthe'
SL,5270.101 (Sloane copy BL Add MS 5267, no. 120)
These bass feed on smaller fish, including alewife, and can grow to the size indicated here. They live in schools off sandy beaches seldom more that a few miles offshore. They spawn up the Roanoke River in late spring.

Fig. 176 Gar pike (*Lepisosteus osseus* Linn.)
Inscribed: 'Kowabetteo. Some 5. or 6. foote in length'
SL,5270.106 (Sloane copy BL Add MS 5267, no. 96)
The gar is a freshwater fish that can tolerate quite brackish water with low oxygen levels. They have a heavy armour of interlocking scales and few predators. They are not good eating fish but are host to a freshwater mussel. Catesby included this fish in his *Natural History* (II, 30), basing his illustration on the watercolour copy Sloane had made from it (see fig. 182).

Fig. 177 Skink (genus *Eumeces*)
Inscribed: 'Meméskson. A foote in length.'
SL,5270.109 (Sloane copy BL Add MS 5272, no. 45)
This genus is sometimes called the New World skink and is a lizard with smooth shiny scales. Its tail will break off and distract a predator when it is grabbed; a new one grows later, sometimes shorter than the original. There are various kinds of skinks in North Carolina but it is not possible to identify which this might be.

Fig. 178 Catfish (probably *Ameriurus catus* Linn.)
Inscribed: 'Keetrauk. Some 2. foote and a halfe in length.'
SL,5270.107 (Sloane copy BL Add MS 5267, no. 33)
The white catfish is a good eating fish and likes mud-bottomed pools, river backwaters and lakes and is common on the east coast from Florida to New York. Catesby used this image for his plate of a catfish in his *Natural History of Carolina* (II, 23)

Fig. 179 Sheepshead bream (*Archosargus probatocephalus* Walbaum)
Inscribed: 'Masunnehockeo. The olde wyfe, / 2. foote in length.'
SL,5270.108 (Sloane copy BL Add MS 5267, no. 117)
This fish used to be common along the east coast and can grow to a length of 30 inches and can weigh about 20 pounds.

Fig. 180 Red and yellow snake
Inscribed: 'Tesicqueo. A kinde of Snake which the Saluages (being / rost or sodden) doe eate. Some an ell long.'
SL,5270.110 (Sloane copy BL Add MS 5272, no. 52)
The specimen is perhaps one of the non-poisonous kingsnakes (genus *Lampropeltis*), possibly either the scarlet kingsnake (*L. triangulum elapsoides*) or the milksnake (*L. Lampropeltis triangulum triangulum*). The scarlet kingsnake has black red and yellow rings rather than the pattern shown here and the milksnake is greyish. They eat lizards and are not poisonous.

Fig. 181 Sharp-nosed sturgeon (*Acipenser oxyrhynchus* Mitchill)
Inscribed: 'Coppáuseo. The Sturgeon some 10. 11. 12. or 13 foote in length'
SL,5270.111 (Sloane copy BL Add MS 5267, no. 95)
Rather than scales, sturgeon have five rows of bony plates. Atlantic sturgeon grow to be 6 to 8 feet in length and around 300 pounds, though they have been reported much larger. They were once abundant off the east coast of America but are now considered endangered. They spend the first few years in brackish water before moving into the ocean and live to a great age, commonly fifty years. Harriot noted there were plenty of sturgeons and herrings, for the most part larger than those in England. This drawing is very similar in appearance to the sharp-nosed sturgeon but the latter is much smaller and occurs in rivers and estuaries along the coast. It too is now endangered.

182. *Acus maxima, squammosa, viridis, the green gar-fish and Frutex aqauticus …*, 1743. Hand-coloured etching by Mark Catesby from *The Natural History of Carolina, …*, vol. II, p. 30. The British Library, London (44.k.8)

JOHN WHITE'S WATERCOLOUR TECHNIQUES AND PIGMENTS

Most histories of English watercolour painting begin with John White. But having mentioned him as the first English artist to paint in watercolour, they quickly dismiss him as a recorder of people, flora and fauna of the New World, before the authors go on to mention Le Moyne as a flower painter in watercolour and Hilliard as a painter of miniatures in watercolour. But these have traditionally been considered minor, decorative genres and are described only briefly before getting on to the business of painting landscapes in watercolour, considered to be the major contribution the English have made to the art of painting in watercolour.

This is not an attempt to reclaim John White as the father of English watercolour painting: instead it is a careful examination of the techniques he used to create his images in order to place him in the context of artistic practice of his time in Europe rather than just in England or just in the context of English watercolour painting. Artists of all types moved about with amazing frequency from court to court during this period and artistic practices evolved with comparable speed. As explained in Chapter 2, manuscripts were still being illuminated at this time, court maps and personal albums were decorated with emblems, coats of arms and costumes, woodcuts were being replaced by copperplates and hand-colouring was used to increase the value and visual impact of engravings. Exquisite watercolours recording natural history and people of the world were produced and copied in order to share the beautiful and exotic images or turned into prints in order to circulate and share knowledge of them. It is into these traditions that John White's work must be placed rather than on the path to Sandby and Turner's landscapes.

TECHNIQUES

John White may have made sketches or even detailed coloured drawings of some sort in the New World but it is impossible to know what form they might have taken. He may have begun to make the watercolours that are the main subject of this book while he was still in North Carolina and continued working on them on board ship or once he reached home. It is impossible to say for certain, as the pigments he used were portable in powdered form, easy to mix with water and binders to prepare for use and did not require much equipment other than brushes and shells. He did however require a dry, clean, undisturbed space in which to work where dirt and other matter would not enter the pigment mixtures or surface of the paper.

He began each watercolour with a light sketch in what the Elizabethans called 'black lead', the term we have used consistently in the catalogue here, but which is actually a graphite. Some of this has transferred to the offsets and is clearly visible around the edges of most of the figures. Some artists prepared watercolours in this manner but then followed them with outlines in pen and ink, as found in the Sloane volume drawings. White did not use outlines and, unlike miniaturists or manuscript illuminators, he did not first lay a ground of grey or pink, but laid his coloured pigments suspended in water and gum directly on the paper. The basic background colour was laid first with a wider brush; then, with increasingly deeper tones and finer brushes, he built up the image with small strokes of the brush, which are clearly visible in fig. 183 in the flesh of the legs and arms. He also drew with the brush, seen here in the tail, fringe and body paint. He would then add bodycolours, pigments containing lead which added opacity and richness of colour to more deeply coloured areas and to pick out certain details such as tattoos or jewellery. Finally, in selected places he would use white lead as a highlight and occasionally he added gold leaf or silver which had been ground to a powder: the resulting 'shell gold' was applied with a brush (see fig. 20). The gold is still visible in many of the images, although in others it has been transferred to the offset (see figs 185 and 186). The white lead has usually, although not always, altered to black or grey, as have many of the other colours with which lead was mixed for depth of colour, and the silver has uniformly also altered to black or grey.

We have not attempted to reverse this colour change on any of the watercolours, but in figs 183 and 184 it has been reversed using digital technology. The offsets, the result of the album being saturated in the nineteenth century, are explained on p. 94. The rather grainy areas in many parts of the drawings (in the hair and feathers here for instance) are also the result of this water damage. In this digital reconstruction, the colours have been enhanced to attempt to recreate the original appearance of White's watercolours. They included many opaque pigments which have blackened or lost much of their pigment and depth to the offsets and they originally must have appeared much deeper and bolder and much less like what we normally think of as watercolour drawings.

In this depth of colour, White's painting was close to many of these artistic traditions: part illumination in the use of lead whites and deep colours, part portrait limning in the techniques used to indicate details of jewellery, and part natural history painting, as witnessed by the flower paintings of Jacques Le Moyne de Morgues (figs 109, 112, 113). White knew his work well and copied Le Moyne's Florida Indians and it is to the work of this Huguenot artist, much of which is now lost, that White probably owed the greatest debt. White was not a portrait limner like Hilliard (see fig. 22) nor is his work like the two works on vellum in the illuminator's tradition that have been attributed to Le Moyne (figs 77, 94). White used the skills he had developed from all these sources, and probably many others now lost, to create a rich and courtly visual imitation of what he found in the New World. The fact that nothing comparable by other artists survives is a tribute to his ability but also an indication of works by him and other artists that have now probably been lost. It is also a reminder that the culture of the Elizabethan court required a visual record, while in the following century such expeditions reported to commercial patrons who relied on the actual goods or

specimens brought back or written accounts rather than these beautiful, richly illustrated souvenirs. It was not until the requirements of science came to the fore in the eighteenth century that visual records again became important and artists once more accompanied voyages such as Captain Cook's to other New Worlds.

PIGMENTS

Watercolours are made of pigments that have been ground to a powder and mixed with water; gum, also ground, is added as a binder to help the pigments adhere to the paper. Lead white or other lead pigments are thicker, more opaque; they can blacken or change colour over time as they are exposed to chemicals in the air or in the pigments near to them. A selection of White's watercolours has been examined under the microscope and with X-ray florescence (XRF), which lists the elements present on the surface, and also with Raman spectroscopy, which identifies specific compounds. Further examination will be made and detailed results will be presented elsewhere later; the following is a brief initial summary.

Some of the images, such as the fishing scene (no. 7), look very colourful but in fact only a few pigments were used and the varying shades are due to the skill of the artist in employing them. Indigo provided the blue tones, and yellow and other ochres most of the rest of the earthy tones, in various mixtures to produce different shades, along with vermilion in the bright red flowers, carbon for the dark details and gold for the fire in the canoe.

In the image of the woman with the girl with the doll (no. 14), again ochres are the main pigments but various lead pigments have also been used, including possibly massicot or lithage (yellow or red/yellow). Vermilion and gold are also in evidence and the minutely detailed application of these pigments is clear in the magnified offsets (figs 185, 186). The mother's beads contain lead which was probably originally white and probably meant to represent pearls or shell beads.

Silver and gold simulated iridescence in the fish where the usual lead and ochre pigments and vermilion are also present; but there is also evidence in the flying fish (fig. 184) of smalt, a blue glassy pigment.

The Inuit skirmish in the Sloane volume (fig. 102) contains a wider palette, with copper-based blues such as azurite combined with yellow ochre in greener areas; the azurite was probably combined with lead white to produce the deep blue in the centre. Red lead may have been mixed with the vermilion, and organic pigments elsewhere may have faded. Gold and silver are present on other images in the Sloane volume and the colours are uniformly deeper; in this way they are perhaps much closer to the original appearance of the damaged White watercolours. Questions of attribution of the two volumes or where the drawings were made could not be answered by this analysis.

PAPER

The paper of the offsets and of the John White watercolours are contemporary and can be dated from their watermarks to the 1580s. The paper of the Sloane volume, including the flower drawings, bears watermarks which were in use from around the 1570s to c. 1590 but cannot be dated any more specifically.

The basic histories of English watercolour are by Laurence Binyon, Martin Hardie and Iolo Williams; the information on pigments and technique is distilled from discussions with Katie Coombs and Alan Derbyshire of the Victoria and Albert Museum and with Jenny Bescoby of the Western Pictorial Art Conservation Department of the British Museum. Scientific examination was carried out by Janet Ambers and Duncan Hook of the British Museum Department of Scientific Research and Conservation. Antony Simpson of the same department produced the images for figs 183–186 (below).

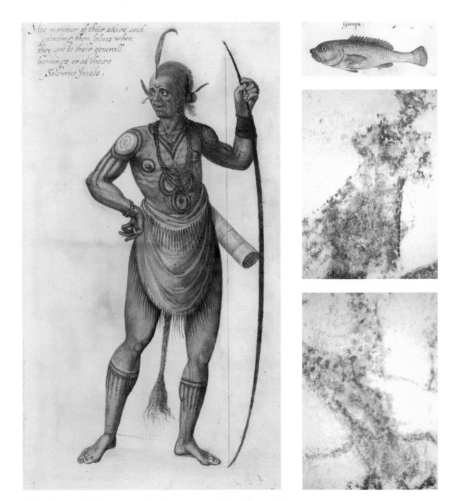

183. Above. 184. Top right. 185. Centre right. 186. Below right.

ABBREVIATIONS

Notes for Chapters 1–6 give full references the first time a work is referred to and then author's name and date or short title where necessary for subsequent references. Some Hakluyt and Harriot publications are included in the Select Bibliography but other important seventeenth-century titles are listed in the Chronology (pp. 249–51).

In the 'Lit.' sections of the catalogue most references are to the main catalogues listed in Abbreviations below. For other works, if only cited once, full reference is given, for other references, author's name and date refer to the Select Bibliography.

BL British Library

BM British Museum

DTHS *The Durham Thomas Harriot Seminar*, published by the Department of Education, University of Durham

ECM Edward Croft Murray and Paul Hulton, *Catalogue of British Drawings of the 16th and 17th Centuries in the Department of Prints and Drawings in the British Museum*, London, 1960

exh. exhibition catalogue

Harriot *Brief and true report*
A briefe and true report of the new found land of Virginia, by Thomas Harriot, published as a pamphlet in London 1588; published by Theodor de Bry in Frankfurt 1590 with 28 engravings after John White's drawings, plus title page, dedication to Raleigh and image of Adam and Eve; also known as de Bry's *Virginia* and de Bry's *America* part I; text cited in full in Quinn, pp. 317–87 and reproduced in Dover ed. New York, 1971

LB Laurence Binyon, *Catalogue of Drawings by British Artists and Artists of Foreign Origin working in Britain preserved in the Department of Prints and Drawings in the British Museum*, vol. IV, London, 1907

P&D Department of Prints and Drawings, British Museum

PH Paul Hulton, *America 1585: The Complete Drawings of John White*, Chapel Hill and London, 1985

PH&DBQ Paul Hulton and David Beers Quinn, eds, *The American Drawings of John White*, 2 vols. I *A Catalogue Raisonné and a Study of the Artist*, II *Reproductions of the Originals in Colour Facsimile and of Deriv-*

atives in Monochrome, Chapel Hill and London, 1964

Quinn David Beers, ed., *The Roanoke Voyages 1584–1590: Documents to Illustrate the English Voyages to North America under the Patent Granted to Walter Raleigh in 1584*, 2 vols, New York, 1991 (unabridged edition of work published by the Hakluyt Society, second series, no. CIV, London, 1955)

R&R Helen Wallis, *Raleigh & Roanoke: The First English Colony In America, 1584–1590*, exh. British Library, London and North Carolina Museum of History, Raleigh, NC, 1985

Sloane volume The volume of drawings associated with John White acquired by Sir Hans Sloane from the descendants of John White c.1715 and now SL 5270 in BM P&D

Sloane copy, BL Add MS 5253, etc. Watercolour copies commissioned by Sir Hans Sloane from an unknown artist c.1705–7 of the Sloane volume when it was still with John White's descendants before Sloane purchased it c.1715. All now distributed through several albums in the BL Department of Manuscripts, arranged by subject

NOTES

CHAPTER 1: KIM SLOAN: SETTING THE STAGE FOR JOHN WHITE, A GENTLEMAN IN VIRGINIA

1 The full accounts of all White's voyages are transcribed in David Beers Quinn, ed., *The Roanoke Voyages 1584–1590*, 2 vols, New York, 1991; the account of the drowning of Captain Spicer on the fifth voyage (originally published by Hakluyt) is on p. 612. The 1991 edition is a modern reprint of the original work published by the Hakluyt Society, London in 1955 (Second Series, No. CIV) and will be referred to hereafter as Quinn. The English believed the Indians called their land 'Assama-comock' but, when the name was printed by Hakluyt, the typesetter used long 's' which has been misread as two 'f's . See Quinn, pp. 117, 508, 590, for the various names for the country. Christian Feest considers it unlikely that the North Carolina Algonquians would have had a name for a large area or land comparable to the English conception of it and this is

more likely to be the name of a place or even a house.

2 There are three main accounts of the album and the watercolours, listed following with page references to the history of the album (see also pp. 93-5 here): Edward Croft Murray and Paul Hulton, *Catalogue of British Drawings of the 16th and 17th Centuries in the Department of Prints and Drawings in the British Museum*, London, 1960, pp. 30–31 (hereafter ECM) ; Paul Hulton and David Beers Quinn, eds, *The American drawings of John White*, 2 vols: I *A Catalogue Raisonné and a Study of the Artist*, II *Reproductions of the Originals in Colour Facsimile and of Derivatives in Monochrome*, Chapel Hill and London, 1964, pp. 24-8 (hereafter PH&DBQ); and Paul Hulton, *America 1585: The Complete Drawings of John White*, Chapel Hill and London, 1985, pp. 22–3 (hereafter PH). ECM illustrates some of the watercolours and PH&DBQ and PH reproduce them in full, in colour. Quinn also lists and describes the watercolours but with no reproductions.

3 ECM, pp. 59–61; PH&DBQ, p. 27; PH p. 22 and see here pp. 224-5.

4 PH&DBQ, published in two folio volumes (600 copies only), with contributions by W. C. Sturtevant, C. E. Raven, R. A Skelton and Louis B. Wright. It should be noted however that the method they had to employ for the facsimiles, coloured collotypes with *pochoir* stencilling, resulted in many inaccuracies and rather blurred images by modern standards. William Sturtevant issued an article with corrections to the ethnographic details in *Ethnohistory*, 12 (1), Winter, 1965, pp. 54–63, and for reliable reproductions it is best to refer to the present volume or PH – the latter (now out of print) provided a less expensive summary publication of the contents of the 1964 volume and included colour reproductions of all of the watercolours and black and white images of all the engravings by de Bry and all the drawings in the Sloane album. For a history of the earlier publication of the drawings see PH&DBQ pp. ix-xiii and PH, pp. 24–5.

5 For the best general introductions to European ways of seeing and naming the New World, and accounts of the earliest voyages, see Samuel Eliot Morison, *The European Discovery of America: The Northern Voyages, AD 500–1600*, Oxford and New York, 1971, John R. Hale, *Age of Exploration*, New York, 1966, and Hugh Honour, *The European Vision of America*, exh. Cleveland Museum of Art, Ohio, 1975, and *The New Golden Land: European Images of America from the Discoveries to the Present Time*, New York, 1975. More recently see Kenneth R. Andrews, *Trade, Plunder, and Settlement: Maritime Enterprise and the Genesis of the British Empire, 1480–1630*, Cambridge, 1984 and J. H. Elliott, *Empires of the Atlantic World: Britain and Spain in America, 1492–1830*, New Haven and London, 2006.

6 For detailed accounts of all these voyages see Morison, *European Discovery of America*, passim, and for the Indian names see pp. 395, 411–13, 488.

7 The line was 1,770 km west of the Cape Verde Islands. For more detailed accounts see Helen Wallis, *Raleigh & Roanoke: The First English Colony in America, 1584–1590* (hereafter R&R), exh. British Library, London, and North Carolina Museum of History, Raleigh, NC, 1985, pp. 21–7, Hale, pp. 95–104, and Honour, *New Golden Land*, pp. 8ff.

8 Quoted by V. Stefansson and E. McCaskill, *The Three Voyages of Martin Frobisher*, II, London, 1938, p. 231, and cited in James McDermott, *Martin Frobisher: Elizabethan Privateer*, New Haven and London 2001, p. 287.

9 Morison, *European Discovery of America*, pp. 483–4.

10 See R&R, pp. 29–41. For Dee and the idea of the British Empire see William H. Sherman, *John Dee: The Politics of Reading and Writing in the English Renaissance*, Amherst, MA, 1995, ch. 7, '"This British Discovery and Recovery Enterprise": Dee and England's Maritime Empire'. For Hakluyt see David Armitage, 'The New World and British Historical Thought: From Richard Hakluyt to William Robertson', in Karen Ordahl Kupperman, ed., *America in European Consciousness, 1493–1750*, Chapel Hill, 1995, pp. 52–75.

11 Morison, *European Discovery of America*, pp. 496–7. For Gilbert's voyages and publications see D. B. Quinn, ed., *The Voyages and Colonising Enterprises of Sir Humphrey Gilbert*, Hakluyt Society, 2nd ser., 83–4, 1940.

12 Raleigh Trevelyan, *Sir Walter Raleigh*, London 2002, pp. 19–21.

13 Morison, *European Discovery of America*, p.

523; for a detailed account of Frobisher's capture of Inuit on two voyages and White's possible presence on the voyage see William C. Sturtevant and David Beers Quinn, 'This New Prey: Eskimos in Europe in 1567, 1576, and 1577', in Christian F. Feest, ed., *Indians and Europe: An Interdisciplinary Collection of Essays*, Forum 11, Aachen, 1987, pp. 61–140 and pp. 164–9 here.

14 McDermott, *Frobisher*, pp. 180, 456, n.47. There is no mention of him in George Best and Dionyse Settle's published account of the voyage in 1577 and the engraving used to illustrate the account bore no relationship at all to White's drawings (see fig. 103).

15 Morison, *European Discovery of America*, p. 503.

16 James McDermott, 'Humphrey Cole and the Frobisher Voyages', in Silke Ackermann, ed., *Humphrey Cole: Mint, Measurement and Maps in Elizabethan England*, British Museum Occasional Paper no. 126, 1998, pp. 15–19.

17 Cited in Henry Ellis, 'Copy of a Plan proposed to Queen Elizabeth by Sir Humphry Gilbert, for instituting a London Academy …', *Archaeologia*, 21, Society of Antiquaries of London, 1827, pp. 505–6.

18 Oliver Lawson Dick, ed., *Aubrey's Brief Lives*, Harmondsworth, 1972, p. 416.

19 Walter Oakeshott, 'Sir Walter Ralegh's Library', *The Library*, 5th ser., XXIII (4), December 1968, pp. 285–327; the list of over five hundred books is from a commonplace book connected with his work on *The History of the World*.

20 Kim Sloan, *A Noble Art: Amateur Artists and Drawing Masters c.1600–1800*, exh. British Museum, London, 2000, p. 11, and Ann Bermingham, *Learning to Draw: Studies in the Cultural History of a Polite and Useful Art*, New Haven and London, 2000, ch. 1.

21 See ibid., and also see Walter Houghton, 'The English Virtuoso in the Seventeenth Century', *Journal of the History of Ideas*, III (I), 1942, pp. 51–73.

22 The original is in the Lansdowne MS in BL, MS Lansd. XCVIII, fol. 1; transcribed in full in modernized (nineteenth-century) English by Henry Ellis of the British Museum, (see n. 17 above), pp. 506–21, and by F. J. Furnivall with original spellings in *the Publication of Early English Text Society*, Extra Series, VIII, London, 1869, pp. 1–12; see also John W. Shirley, *Sir Walter Ralegh and the New World*, Raleigh, 1985, pp. 78–9.

23 Ellis, 'Copy of a Plan', p. 512.

24 Ibid., pp. 511–14.

25 Ibid., p. 515.

26 'in fee simple or otherwise according to the order of the lawes of England', Morison,

European Discovery of America, p. 566.

27 Ibid., p. 568.

28 Trevelyan, *Raleigh*, pp. 61–2.

29 Ibid., p. 62.

30 Quinn, p. 90; see Morison, pp. 569–70; for more details see Quinn, ed., *Voyages … of Sir Humphrey Gilbert*.

31 Edward Hayes, Captain of the *Golden Hinde*, cited in Morison, *European Discovery of America*, p. 573.

32 Ibid, p. 577. Recently David Armitage has argued that it is more likely that Gilbert, a humanist, was drawing comfort directly from Cicero's stoicism rather than mediated through More's *Utopia*: see 'Literature and Empire', in Nicholas Canny, ed., *The Oxford History of the British Empire,* I: *The Origins of Empire*, Oxford, 1998, pp. 107–8.

33 Full text in Quinn, pp. 82–9.

CHAPTER 2: KIM SLOAN: KNOWING JOHN WHITE: THE COURTIER'S 'CURIOUS AND GENTLE ART OF LIMNING'

1 ECM, p. 27.

2 Quinn, pp. 395, 506–10.

3 William Powell, 'The Search for Ananias Dare', in E. Thomson Shields and Charles E. Ewen, eds, *Searching for the Roanoke Colonies: An Interdisciplinary Collection*, Raleigh, 2003, pp. 62–5.

4 The petition was first made in 1594 by Robert Satchfield, listed as his next of kin and later transferred to John Nokes, a 'blood kinsman', and finally granted in 1597; see Powell, 'The Search'. The records concerning John White's marriage and the birth of Elinor were published in part by William Powell, 'Who Were the Roanoke Colonists?', in H. Jones, ed. *Raleigh and Quinn: The Explorer and His Boswell*, Chapel Hill, 1987, pp. 65–6, and Robert Baldwin, 'Cartography in Thomas Harriot's Circle', *The Durham Thomas Harriot Seminar: Occasional Paper, No. 22*, University of Durham, n.d.[1996], p. 52, n. 76. Further details given here were received through personal communication (June 2005) with lebame houston, to whom I am extremely grateful for so generously sharing the results of her work and a very insightful discussion. She has also found that Elinor gave birth to two other children, Thomasine and Ananias (who presumably died young), before leaving for Virginia pregnant with another, who was born there and named after the country.

5 Quinn, pp. 40–46, grant transcribed fully, pp. 506–20; PH&DBQ, pp. 12–13; PH, pp. 7–8.

6 John Brooke-Little, Norroy and Ulster King of Arms, College of Arms, foreword to

The Two Draft Grants of Arms to the City of Raleigh 1586 (Manteo, NC, 1984).

7 I am extremely grateful to Clive Cheesman for going over the 1573-4 and 1620 Visitations and correcting errors made in the 1964 publication which have been the basis for remarks on White's coat of arms ever since. The Visitation was 1573-4 (College of Arms record ms E15, f. 43v and 44) (not 1586 as stated in PH&DBQ p. 12); the pedigree is for the Cole family who were also descended from Robert White and Alice Wymark.

8 The 1620 Visitation of Cornwall and Devon is College of Arms record ms C1, f 471. John White the Haberdasher's will is PRO Canterbury Probate 11/68, proved 15 June 1585; he left money to his brother Richard White of St Germans and to his two nephews John and Robert. Robert's will is PRO Canterbury Probate 11/129 (written 1616, proved 1617). He left money to his nephew John White (b. 1595) 'son of my brother John Whitt of Plymouth deceased'. Their connection with the earlier Whites is not clear, although as mentioned, they shared the same White quartering.

9 The other family names were Wymark, Wyat, Kyllyowe (Killiow), Saker, Buddyer (Bodyar) and Butler, see Quinn, pp. 509–10, PH&DBQ, p. 12. The first four names he shared with the pedigree in the 1573-4 Visitation.

10 The portrait is still at Hatfield House. Roy Strong, *The Cult of Elizabeth: Elizabethan Portraiture and Pageantry*, London, 1999, pp. 147–9; see also Susan Doran, 'Virginity, Divinity and Power: the Portraits of Elizabeth I', ch. 7 in Susan Doran and Thomas S. Freeman, eds, *The Myth of Elizabeth*, Basingstoke and New York, 2003, p. 188.

11 De Bry's address 'To the gentle Reader', in *Briefe and true report*, n.p.

12 They included William Dethick, who granted arms to Shakespeare's glovemaker father; see John Neitz, 'Origins and Development of Armory and the Office of Herald' at http://renaissance.dm.net/heraldry/heralds.html.

13 Quinn, p. 508. Three of the assistants also shared White's ermine field (William Fullwood, John Sampson and Roger Pratt).

14 Quinn, p. 615, for his description of armour found left behind and p. 714 for his 1593 letter stating that he was not allowed to take even a boy with him and see p.48 here.

15 Quinn, p. 190.

16 See White's 1593 letter, Quinn pp. 712-13.

17 'To the gentle Reader', n.p. The double translation and the use of German typesetters resulted in some very strange interpretations of English words. De Bry

used the word 'grauinge' for 'engraving' later in the preface; therefore the word 'craeued' used twice must be taken to mean 'craved' (begged for) or 'acquired'.

18 ECM, p. 27.

19 See Christopher Brown, 'British Painting and the Low Countries 1530–1630', in Karen Hearn *Dynasties: Painting in Tudor and Jacobean England 1530–1630*, London, exh. Tate Britain, 1995, p. 30; others included Hans Eworth and Marcus Gheeraerts the Elder.

20 Alan Borg, *The History of the Worshipful Company of Painters Otherwise Painter-Stainers*, London, 2005, pp. 28–9. Court artists and London painters were coalesced by the time the Painter Stainers Company was formed in 1502 when they already perceived a threat from foreign painters. Stainers were concerned with staining or painting of cloth; painters were of any kind, including painting emblems and images and scenes on walls, wood, altarpieces etc. for churches. See Borg, pp. 23–7.

21 Erna Auerbach and Roy Strong have written a number of books on these artists, but more recently see especially studies by Karen Hearn, Tarnya Cooper, Susan Foister and Susan Doran.

22 Borg, *History*, pp. 30–1.

23 Ibid., pp. 195–6; this has been noted earlier by PH&DBQ, p. 12.

24 Hearn, *Dynasties*, p. 107.

25 Ibid.; he carried out mainly decorative work for her and held the rights as purveyor of art materials, but, in spite of his being given the monopoly of all painted and engraved portraits of the Queen, none appears to survive.

26 Katherine Coombs, *The Portrait Miniature in England*, London, 1998, p. 8.

27 Cited in Coombs, ibid., the best general guide, but see also Kim Sloan, *A Noble Art: Amateur Artists and Drawing Masters c.1600–1800*, exh. British Museum, London, 2000, pp. 40–1.

28 Hearn, *Dynasties*, p. 125; from 1574 he spent time in France where limning portraits in miniature was common at court. For Hilliard see also Karen Hearn, *Nicholas Hilliard*, London, 2005; Erna Auerbach, *Nicholas Hilliard*, London, 1961, and Mary Edmond, *Hilliard and Oliver*, London, 1983.

29 Hearn, *Dynasties*, p. 125.

30 Coombs, *Portrait Miniature*, p. 8.

31 Cited in Sloan, *A Noble Art*, pp. 40–1; see also Coombs, *Portrait Miniature*, pp. 54–6.

32 John Murdoch, Jim Murrell, Patrick J. Noon and Roy Strong, *The English Miniature*, V&A exh. at Yale Center for British Art, New Haven, and Art Gallery of Ontario, Toronto, 1981, p. 25.

33 'Miniatura, or the Art of Limning', written 1627–8, revised 1648, Jeffrey M. Muller and Jim Murrell, *Edward Norgate: Miniatura or the Art of Limning*, New Haven and London, 1997, p. 12. Several amateurs are known from the reign of James I, Sir Nathaniel Bacon and Sir Balthazar Gerbier, to name only two; see Sloan, pp. 41–2, and Karen Hearn, *Nathaniel Bacon: Artist, Gentleman and Gardener*, London, exh. Tate Britain, 2005.

34 Muller and Murrell, *Edward Norgate*, p. 2, citing biographer of 1662.

35 Ibid., p. 96.

36 Ibid.

37 Muller and Murrell, *Edward Norgate*, p. 1.

38 Albert Feuillerat, ed., *Documents Relating to the Office of the Revels in the Time of Queen Elizabeth*, Louvain, Leipzig and London, 1908, p. 204; the payment of 22 shillings each was made to White and to '—— Boswell' for the two suits of armour; I am very grateful to lebame houston for pointing out the existence of this payment.

39 Ibid., p. 287. The knights were probably William Tresham and Robert Knowles, who took part in the Accession Day tilts in 1581 and 1583; see Strong, *Cult of Elizabeth*, app. I, p. 206.

40 Feuillerat, *Documents*, p. 287.

41 Ibid., p. 288.

42 I am grateful to David Beasley, Librarian of the Goldsmiths Company, for searching their records, which are however missing the volume of minutes for 1579–92. The payment for the carriage of the armour is also recorded, from Greenwich where it was made in the Royal Armoury to the workshops of the Office of the Revels at the old priory of St John's Clerkenwell, where it was gilded and from there to the Lord Chamberlain at Richmond Palace who was responsible for the Revels; see Feuillerat, *Documents*, p. 299.

43 Ibid., *Documents*, p. 204.

44 Raleigh Trevelyan, *Sir Walter Raleigh*, London, 2002, p. 27.

45 John Shirley, *Thomas Harriot: A Biography*, Oxford, 1983, pp. 54–60; Hakluyt received his Master from Oxford in 1577 and Harriot in 1580: see Anthony Payne, 'Hakluyt, Richard (1552?–1616)', *Oxford Dictionary of National Biography*, Oxford, 2004 (http://www.oxforddnb.com/view/article/11892, accessed 17 March 2006) and J. J. Roche, 'Harriot, Thomas (c.1560–1621)', ibid. (http://www.oxforddnb.com/view/article/12379, accessed 17 March 2006).

46 Trevelyan, p. 16.

47 See J. Bruce Williamson, *The History of the Temple, London*, London, 1925, although he

mistakenly describes Drake as a Middle Templar. When lawyers are 'called to the Bar' there, they sign the roll on an oak table, once the hatch cover from his ship the *Golden Hinde*, presented to the Inn by Drake. I am grateful to the archivist, Lesley Whitelaw, for her kind assistance.

48 Quinn, pp. 576–8, and Anita McConnell, 'Sanderson, William (1547/8–1638)', *Oxford Dictionary of National Biography*, Oxford, 2004 (http://www.oxforddnb.com/view/article/52001, accessed 17 March 2006).

49 For the 1589 additional Virginia venture tripartite agreement between Raleigh, Sanderson and a group of merchant associates and White and his 'Cittie of Raleigh' assistants; see Quinn, pp. 557, 569–76.

50 See Shannon Miller, *Invested with Meaning: The Raleigh Circle in the New World*, Philadelphia, 1998.

51 Wallace T. MacCaffrey, 'Hatton, Sir Christopher (c.1540–1591)', *Oxford Dictionary of National Biography*, Oxford, 2004 (http://www.oxforddnb.com/view/article/12605, accessed 15 May 2006).

52 David Loades, 'Grenville, Sir Richard (1542–1591)', *Oxford Dictionary of National Biography*, Oxford, 2004 (http://www.oxforddnb.com/view/article/11493, accessed 1 March 2005).

53 Inner Temple Admissions Database, http://innertemple.org.uk/archive. He was admitted on the pledges of Philip and Basingborne Gawdy, of Norfolk.

54 'Parishes: South Warnborough', *A History of the County of Hampshire: Vol. 3* (1908), pp. 378–82 (*Victoria History of the Counties of England*) (http://www.british-history.ac.uk/report.asp?compid=42005, accessed 8 May 2006). Other members of this family were admitted to the Inner Temple between 1549 to 1566. The father, Thomas White (1532/34–1558), was an MP for Downton 1555–8 and was living in the Middle Temple where he had been elected Master of Revels when he died. Before 1551 he had married Anne, daughter of Stephen Kirton a wealthy merchant of London. See S. T. Bindoff, *History of Parliament, House of Commons 1509-1553*, III, London, 1982, p. 608. Their son John was admitted to the Inner Temple as the son of Thomas White of Warnborough (the old family home rather than Downton) and he was MP for Clitheroe in 1589 (see P. W. Hasler, *History of Parliament, House of Commons 1558-1603*, III, London, 1981, pp. 610–11).

55 His will was made 23 July 1597 and proved 22 October: Public Record Office, PROB11/90, image ref. 323.

56 He left specific amounts to his godson Edward Twyne, his godson John Deffery and his servant Thomas Dutton, to the 'poor prisoners' of London and Winchester and to his godson John Dutton, and he left his 'best gelding and £10' to his brother William Dutton, who was his executor. He and other Duttons and John Davenporte witnessed it. Standish Manor in Gloucester was conveyed to William Dutton in 1611 – there is a record of admission to the Inner Temple for John Dutton (1594–1657), son and heir of William Dutton, armiger, of Sherborne, Gloucestershire, pledged by John Dutton in 1614 who had been proceeded at the Inner Temple by his younger brother William the previous year. They were a prominent family, royalists in the Civil War and among the commissioners who drew up the articles of Oxford (see Jan Broadway, 'Dutton Family (*per.* 1522–1743)', *Oxford Dictionary of National Biography*, Oxford, 2004 (http://www.oxforddnb.com/view/article/72340, accessed 27 May 2006).

57 Quinn, p. 542; John White claimed that 150 colonists travelled with him but named only 110 on his own list of the colonists published by Hakluyt which includes his own name and that of Simon Fernadez, who we know returned; we know that the colonists sent John White back for help, but nowhere does it say that he did not take any of them with him. He would, at the very least, have taken a personal servant when he returned to London for assistance for the colony.

58 Cited in Ann Bermingham, *Learning to Draw: Studies in the Cultural History of a Polite and Useful Art*, New Haven and London, 2000, p. 16; I have relied on her excellent first chapter extensively here.

59 Ibid.

60 Ibid., p. 19.

61 'as I hold it the parte of every studious minde to offer up the picture of his private muse in carefulliest written bookes, to this shrine [Bodley's Temple to all the Muses, his *Pambiblion*] … I conceived not a little hope, that this shaddow of my Shaddowing Muse shall find some place there' (Dedication, n.p.).

62 His purpose was to teach princes to judge better when commissioning their portraits and to improve the work of artists themselves, and he listed three of the best whose example should be emulated.

63 For example, those by Henry Peacham, Balthazar Gerbier, and Norgate; for Peacham and Gerbier see Sloan, *Noble Art* and Bermingham, for Norgate see Muller and Murrell (n. 33 above).

64 See for example Christopher White, 'The Theory and Practice of Drawing in Early Stuart England', in Lindsay Stainton and Christopher White, *Hilliard to Hogarth*, exh. British Museum, London, 1987, apart from ECM, the only extensive publication to date on drawing in England during this period: few today would make his statement that 'As is generally recognized, the Elizabethan age was not a glorious episode in the history of the patronage of the arts in England and, with the exception of miniature painting (limning) and some highly individual architecture, no branch of art either flourished or – no less significantly – kept in touch with what was happening on the Continent', p. 13.

65 For these new approaches see Hearn, *Dynasties*, Paula Henderson, *The Tudor House and Garden*, New Haven and London, 2005, and an excellent series, *Studies in British Art* published since 1994 by Yale University Press for the Paul Mellon Centre for Studies in British Art, London.

66 For late illuminated manuscripts and Simon Bening's work see Thomas Kren and Scot McKenrick, *Illuminating the Renaissance: The Triumph of Flemish Manuscript Painting in Europe*, exh. J. Paul Getty Museum, Los Angeles, 2003, pp. 411–13, 447–9 and 483–6. See also Janet Backhouse, 'Illuminated Manuscripts and the Early Development of the Portrait Miniature', in Daniel Williams, ed., *Early Tudor England: Proceedings of the 1987 Harlaxton Symposium*, Woodbridge, 1989, pp. 1–17.

67 See M. A. E. Nickson, *Early Autograph Albums in the British Museum* [now British Library], London, 1970; I am very grateful to Antony Griffiths for bringing this publication to my attention; for an English example see Lord Henry Howard's 'Regina Fortunata' and Elizabeth's own pen and ink drawing in a French Psalter, in Susan Doran, ed., *Elizabeth*, exh. curated by David Starkey, National Maritime Museum, Greenwich, 2003, pp. 200–1.

68 See David Landau and Peter Parshall, *The Renaissance Print 1470–1550*, London and New Haven, 1994.

69 Nickson, *Autograph Albums*, p. 12.

70 See the example by Ellen Power in Sloan, *Noble Art*, p. 60 (once bound with a copy of Le Moyne's *Clef de Champs*, a book of woodcuts of flowers, birds etc.), and for Lavina Teernlick see Hearn, *Dynasties*, p. 121, and Coombs, *Miniatures*, pp. 24–8. Although it was not a pattern book, the ink and watercolour drawings of sculptures and furniture and heraldic devices that record the Lumley Inventory of 1590 fall into this album category; see Hearn, *Dynasties*, p. 158.

71 Peter Cunningham, *Extracts from the Accounts of the Revels at Court in the Reigns of Queen*

Elizabeth and James I, from the Original Office Books of the Masters and Yeomen, London, 1842, p. 32; see also Edmund Kerchever Chambers, *Notes on the History of the Revels Office under the Tudors*, London, 1907, p. 41: 'order given to a connynge paynter to enter into a fayer large ligeard booke in the manner of limnynge the maskes and showes sett fourthe in that last service, to thende varyetye may be used from tyme to tyme'. Cuningham, p. 37, records the note that 'the Chiefe busynes of the office resteth speciallye in three poyntes, In making of garmentses, In making of hedpeces, and in payntinge'.

72 See Hearn, *Dynasties*, p. 155.

73 See ibid., pp. 160–64, Thomas Da Costa Kaufmann, *The Mastery of Nature: Aspects of Art, Science and Humanism in the Renaissance*, Princeton, 1993, and Jacopo Ligozzi's and others' studies in the Uffizi in Anna Omodeo, *Mostra di stampe populare Venete del '500*, Florence, 1965 and Anna Maria Petrioli, *Mostra di Disegni Vasariani*, Florence 1966.

74 Shirley, *Harriot*, p. 465.

75 For Holbein's use of drawings see Susan Foister, *Holbein and England*, New Haven and London, 2004, pp. 60–65; for Hilliard, see Murdoch, Murrell *et al. English Miniature*, pp. 5-6, 56-7 and Coombs, *Portrait Miniature*, p. 41, for Hilliard's use of a brush for drawing in the first stages of painting a miniature.

76 Hearn, *Dynasties*, p. 154. Isaac Oliver (c.1560/5–1617), the son of a Huguenot goldsmith of Rouen, was in London by 1568, and his earliest works, miniatures in the style of Hilliard, but also larger Mannerist classical compositions, date from the 1580s and may have exerted some influence on John White – there are two very strange drawings in this manner in the Sloane volume which have always been dated to the middle of the seventeenth century, but might be isolated attempts to copy work such as Oliver's; see Stainton and White, *Hilliard to Hogarth*, pp. 48–51, and Hearn, *Dynasties*, pp. 156–7.

77 See Verlyn Klinkenborg and Patrick O'Brian, *The Drake Manuscript in the Pierpont Morgan Library: Histoire Naturelle des Indes,* London, 1996.

CHAPTER 3: KIM SLOAN: AN ELIZABETHAN 'GOVERNOUR' IN VIRGINIA

1 Cited in John W. Shirley, *Thomas Harriot: A Biography*, Oxford, 1983, p. 80.

2 Raleigh Trevelayan, *Sir Walter Raleigh*, London, 2003, pp. 57–60.

3 Shirley, *Harriot*, pp. 86–104.

4 Ibid., pp. 86ff for detailed accounts of his navigational and mathematical preparations.

5 David Beers Quinn, *The Roanoke Voyages 1584–1590*, 2 vols, London, Hakluyt Society, 1955; reprint Dover, NY, 1991 (hereafter Quinn), pp. 90–91; and for the possibility of Harriot and White accompanying this early voyage see pp. 38-40.

6 Many accounts of the Raleigh voyages to 'Virginia' have been written but the best, including preparations and an assessment of the reports, are by D. B. Quinn; the most essential, on which I rely heavily in this chapter, are his 1955 collection of original documents relating to the voyage, with commentary, *The Roanoke Voyages 1584–1590* and *Set Fair for Roanoke: Voyages and Colonies, 1584–1606* (Chapel Hill, 1985). Several other assessments were part of the four hundredth anniversary celebrations around 1985, including Karen Ordahl Kupperman, *Roanoke: The Abandoned Colony*, Lanham, MD, 1984 (new ed. forthcoming), and the 1985 British Library exhibition organized by Helen Wallis, *Raleigh to Roanoke*; others are listed in the Select Bibliography here along with two more recent popular accounts by Lee Miller and Giles Milton. For an analysis of the written accounts see also Paul A. S. Harvey, 'Barlowe, Lane and Harriot's Accounts of the New World', *Durham Thomas Harriot Seminar* (hereafter *DTHS*), no. 20, 1995.

7 Quinn, pp. 91–116.

8 For Manteo and Wanchese and Harriot's efforts to learn and transcribe Algonquian phonetically, see Quinn, pp. 877–8, 884–900; Shirley, *Harriot*, pp. 106–12; Karen Ordahl Kupperman, *Indians & English: Facing Off in North America*, Ithaca and London, 2000, pp. 79–82; Vivian Salmon, 'Thomas Harriot and the English Origins of Algonkian Linguistics', *DTHS*, no. 8 (1993); and Michael Booth, 'Thomas Harriot's Algonquian Linguistics', *DTHS*, no. 32, 2004. Harriot's script was vitally important as it allowed the pronunciation of any language to be preserved and he used it to record the Roanoke-area language.

9 Quinn on preparations, pp. 49–57, 130–39, and *Set Fair*, pp. 45–51, 102–4; see also John L. Humber, *Backgrounds and Preparations for the Roanoke Voyages, 1584–1590*, Raleigh, 1986.

10 The document is transcribed in full in David Beers Quinn, ed., *New American World: A Documentary History of North America to 1612* (5 vols), vol. 3: *English Plans for North America. The Roanoke Voyages. New England Ventures*, London and Basingstoke 1979, pp. 64-9; see also Humber, *Preparations*, p. 18.

11 Quinn, pp. 135–6. Joachim Ganz, a Jew from Prague living in the Blackfriars, had been advising the Company of Mines Royal in Cornwall and Keswick on smelting and accompanied this voyage.

12 BL Add MS 38,823, fols 1–8. These instructions have been summarized several times in the past, but they are missing their first page and are very difficult to read. The entire document was transcribed in Quinn, ed., *New American World*, vol. 3: *English Plans for North America*, pp. 239-45 and pl. 111a for the map symbols. Before that, errors crept in every time they were cited, particularly to the list of instruments. They have been discussed in Humber, *Preparations*, pp. 63–6; Quinn, pp. 51–4; PH&DBQ, pp. 52–7, and E. G. R. Taylor, 'Instructions to a Colonial Surveyor in 1582', *The Mariner's Mirror*, XXXVII (1951), pp. 48–62. The instructions included a very early attempt to calculate longitude with the use of a clock.

13 BL Add MS 38,832, fols 1–2.

14 Quinn, pp. 52–3 and Quinn, ed., *New American World*, vol. 3, pp. 242-4.

15 Quinn, p. 54 and Quinn, ed., *New American World*, vol. 3, p. 244.

16 Richard Hakluyt, *Principal Navigations*, 1589, p. 735.

17 Quinn, pp. 194–7.

18 Quinn, p. 41.

19 In its full title Harriot's original 1588 *A briefe and true report* covers the 'colony' that was seated there by Grenville and remained there under Lane for twelve months (Quinn, pp. 317–18). We also know that those who did stay, including Harriot, had all of their papers thrown overboard during their hasty departure with Drake (Quinn, p. 254) and White clearly had some first-hand material on which to base his portrait images. Quinn felt that the fact that migrating birds were depicted in the fishing scene (no. 7) meant that White was recording something he had witnessed in the autumn; however, if he left on the flyboat that departed after the 8th of September (Quinn p. 210-11), then he may well have seen some. In any case, the image of migrating birds need not be taken so literally; the hermit crabs shown in the foreground were seen in the West Indies.

20 See Quinn, p. 244.

21 Ibid., pp. 37–40.

22 Ibid., p. 498. For the circulation of manuscripts at court see Harold Love and Arthur F. Marotti, 'Manuscript Transmission and Circulation' in David Loewenstein and Janet Mueller, eds, *The Cambridge History of Early Modern English Literature*, Cambridge, 2002, pp. 55–80.

23 Hakluyt's letter of 30 December 1586 to Raleigh is in Quinn, pp. 493–4; he had a few weeks earlier sent to Raleigh his dedication of his edition of the *Decades of Peter Martyr*, in which he praised him for his achievements in colonizing Virginia and exhorted him to persist (see Wallis, *Raleigh to Roanoke*, p. 45). See also Quinn, *Set Fair*, pp. 270–80.

24 Quinn, pp. 532–6, and Quinn, *Set Fair*, pp. 289–92.

25 In Hakluyt's *Principal Navigations* of 1589; see Quinn, pp. 515–43.

26 Quinn, pp. 555–6, based on John White's account published in Hakluyt in 1589.

27 Quinn, pp. 569–76. The double long 's' in Assamacomock has sometimes mistakenly been read as a double 'f' (cf. chp 1 n. 1).

28 Quinn, *Elizabethans*, p. 106; more recently see especially Nicholas Canny, *Making Ireland British 1580-1650*, Oxford, 2001.

29 For this attitude see Shannon Miller, *Invested with Meaning: The Raleigh Circle in the New World*, Philadelphia, 1998, pp. 51ff. For the English in Ireland see the articles cited in the introduction to the catalogue entries on the Picts (pp. 153–63); but for Raleigh see especially Nicholas Canny, 'Raleigh's Ireland', in H. G. Jones, ed., *Raleigh and Quinn, the Explorer and His Boswell*, Chapel Hill, 1987, pp. 87–101.

30 W. A. Wallace, 'John White, Thomas Harriot and Walter Raleigh in Ireland', *DTHS*, no. 2, [1980], pp. 7–8.

31 Shirley, *Harriot*, pp. 159–67.

32 Harriot's phonetic inscription on the Blackwater/Lismore map was translated by Wallace, p. 11: 'Copid uwt of descriptshon of Artr Robins by Tomas Haryots of Yohal, 1589 August 28ᵗʰ'. The main inscription on the map indicated it contained a lot of bad ground and the surveyors (one of whom must have been Arthur Robins) had not yet resolved how it was to be divided or assigned. The Inchquin map in the same collection at Greenwich (Dartmouth collection, P/49(38)) is of the area to the west of Youghal and is very similar but doesn't bear the phonetic inscription. The map in Dublin, however, is substantially different and much later; see for its attribution see J. H. Andrews, *Irish Maps*, Dublin, 1978, pp. 184–5 and see also Shirley, *Harriot*, pp. 159–62.

33 From his 1593 letter to Hakluyt, published 1599, Quinn, p. 714.

34 Ibid., pp. 615–16.

35 Hakluyt, *Principal Navigations*, 2, p. 305, cited in Miller, *Raleigh Circle*, p. 40.

36 Philip Sidney's father was Elizabeth's governor of Ireland and the poet Edmund Spenser followed him into government service there and was writing *The Fairie Queene* when he came to know Raleigh in exile from Elizabeth's court in 1589. Spenser's poem, littered with references to the New World, was eventually dedicated to Elizabeth with a long preface to Raleigh, and Raleigh in turn was then composing his poem *The Book of the Ocean to Cynthia*, of which only a fragment remains. See Trevelyan, *Raleigh*, pp. 147–51.

37 (Book 2, Canto 6, 23, 2–8) cited in Miller, *Raleigh Circle*, pp. 39–40.

38 Quinn, pp. 715–16.

CHAPTER 4 JOYCE E. CHAPLIN: ROANOKE 'COUNTERFEITED ACCORDING TO THE TRUTH'

1 Lynda G. Christian, *Theatrum mundi: The History of an Idea*, New York, 1987; Ann Blair, *The Theater of Nature: Jean Bodin and Renaissance Science*, Princeton, 1997, pp. 153–79. The word 'Roanoke' is used here to describe the town, the Indians who lived there and the location of the English colony.

2 David Beers Quinn, ed., *The Roanoke Voyages, 1584–1590*, 2 vols, London, 1955, 1, pp. 5–6 (hereafter Quinn); Kenneth R. Andrews, *Trade, Plunder, and Settlement: Maritime Enterprise and the Genesis of the British Empire, 1480–1630*, Cambridge, 1984, pp. 167–222.

3 Thomas H. B. Symons, ed., *Meta Incognita: A Discourse of Discovery. Martin Frobisher's Arctic Expeditions, 1575–1578*, Hull and Quebec, 1999. For the map with Frobisher's 'Straightes' on which Lok's map (fig. 10) was partly based see George Best, *A True Discourse of the Late Voyages of Discoverie*, London, 1578.

4 Joyce E. Chaplin, *Subject Matter: Technology, the Body, and Science on the Anglo-American Frontier, 1500–1676*, Cambridge, MA and London, 2001, pp. 46–7.

5 'The fift voyage of Master Iohn White', *Roanoke Voyages*, Quinn, 2, p. 598; Chaplin, *Subject Matter*, p. 51.

6 Chaplin, *Subject Matter*, pp. 51–5.

7 Ibid., pp. 47–50.

8 Ibid., pp. 56–7.

9 Andrews, *Trade, Plunder, and Settlement*, pp. 1–40.

10 Richard Hakluyt the younger, *Discourse of Western Planting*, ed. David B. Quinn and Alison M. Quinn, London, 1993, pp. xv–xxxi, 4, 7, 115.

11 Karen Ordahl Kupperman, *Indians and English: Facing Off in Early America*, Ithaca, 2000, pp. 49–59.

12 Karen Ordahl Kupperman, 'Presentment of Civility: English Reading of American Self-Presentation in the Early Years of Colonization', *William and Mary Quarterly*, 3rd ser. 54, 1997, pp. 210–17.

13 Paul Hulton and David Beers Quinn, eds, *The American Drawings of John White, 1577–1590*, 2 vols, London and Chapel Hill, 1964, 1, pp. 37–43 (hereafter PH&DBQ).

14 Chaplin, *Subject Matter*, pp. 97–9.

15 Ibid., pp. 85–97.

16 Thomas Harriot, *A briefe and true report of the new found land of Virginia* (1588), in Quinn, 1, pp. 322, 371.

17 Harriot, *Briefe and true report*, in Quinn, p. 343.

18 Ibid., pp. 343n, 377; David W. Stahle *et al.*, 'The Lost Colony and Jamestown Droughts', *Science*, 280 n.s. (1998), pp. 564–67.

19 Harriot, *Briefe and true report*, in Quinn, p. 372.

20 Henry Lowood, 'The New World and the European Catalog of Nature', in Karen Ordahl Kupperman, ed., *America in European Consciousness 1493–1750*, Chapel Hill, 1995, pp. 295–323; Richard Drayton, 'Knowledge and Empire', in P. J. Marshall, ed., *The Oxford History of the British Empire*, 2, *The Eighteenth Century*, Oxford, 1998, pp. 231–52; PH&DBQ, pp. 47–52.

21 Quinn, 1, p. 47.

22 Harriot, *Briefe and true report*, in Quinn, p. 369.

23 Quinn, 1, pp. 11, 248–9.

24 Paul Hulton, ed., *The Work of Jacques le Moyne de Morgues…*, 2 vols, London, 1977, 2, pl. 34a; Verlyn Klinkenborg and Patrick O'Brian, eds, *The Drake Manuscript in the Pierpont Morgan Library: Histoire Naturelle des Indes*, London, 1996, fols 103, 111.

25 Harriot, *Briefe and true report*, in Quinn, pp. 378, 380.

26 Andrew Hadfield and John McVeagh, eds, *Strangers to That Land: British Perceptions of Ireland from the Reformation to the Famine*, Gerrards Cross, 1994, pls 1–3; John Derricke, *The Image of Irelande, with a discouerie of woodkerne*, London, 1581; John Speed, *Theatre of the Empire of Great Britain*, London, 1612; Quinn, 1, pp. 45–6; Nicholas Canny, 'The Ideology of English Colonization: From Ireland to America', *William and Mary Quarterly*, 3rd ser. 30, 1973, pp. 575–98.

27 J. H. Elliott, *Empires of the Atlantic World: Britain and Spain in America, 1492–1830*, New Haven, 2006.

CHAPTER 5: CHRISTIAN F. FEEST: JOHN WHITE'S NEW WORLD

1 Paul Hulton and David B. Quinn, eds, *The American Drawings of John White 1577–1590*, London and Chapel Hill, 1964 (hereafter

PH&DBQ): Paul Hulton, *America 1585: The Complete Drawings of John White*, Chapel Hill and London, 1985 (hereafter PH).

2 Thomas Harriot, *A briefe and true report of the new found land of Virginia*, Frankfurt 1590: Theodor de Bry. See W. John Faupel, *A Briefe and True Report of the New Found Land of Virginia – a Study of the De Bry Engravings*, [East Grinstead], 1989.

3 See, e.g., Henry Lowood, 'The New World and the European Catalogue of Nature', in Karen O. Kupperman, ed., *America in European Consciousness, 1493–1750*, Chapel Hill, 1995, pp. 295–323; see David Landau and Peter Parshall, *The Renaissance Print 1470–1550*, New Haven and London, 1994, pp. 245–59.

4 On some of the effects of reproductive prints see Landau and Parshall, *The Renaissance Print*, pp. 162–8.

5 John Howland Rowe, 'The Renaissance Foundations of Anthropology', *American Anthropologist*, 67 (1), 1965, pp. 1-20; Anthony Pagden, *The Fall of Natural Man. The American Indian and the Origins of Comparative Ethnology*, Cambridge, 1982.

6 See, e.g., Theodor Zwinger, *Methodus apodemica in eorum gratiam, qui cum fructu in quocunque tandem vitae genere peregrinari cupiunt*, Basel, 1577: Episcopius; for the origin and development of apodemics see especially Justin Stagl, *A History of Curiosity: The Theory of Travel 1550–1800*, Chur, 1995.

7 David Beers Quinn, *The Roanoke Voyages 1584–1590*, Works issued by the Hakluyt Society, second series CIII–CIV, 2 vols, London 1955) (hereafter Quinn), 1, pp. 255–94.

8 See Quinn, *Roanoke Voyages*, 1, pp. 317–87, for a collation of versions, including Harriot, *Brief report* (1590).

9 Susi Colin, *Das Bild des Indianers im 16. Jahrhundert*, Beiträge zur Kunstgeschichte 102, Idstein, 1988, pp. 198–376, remains the best checklist of sixteenth-century representations of the inhabitants of the New World by European artists. In terms of their ethnographic relevance, this list should be read together with William C. Sturtevant, 'First Visual Images of Native America', in Fredi Chiapelli, ed., *First Images of America*, 2 vols, Berkeley, 1976, 1, pp. 417–54. See also Hugh Honour, *The New Golden Land: European Images of America*, New York, 1975, and Karl-Heinz Kohl, ed., *Mythen der Neuen Welt*, Berlin, 1982.

10 Susi Colin, 'The Wild Man and the Indian in Early 16th Century Book Illustration', in Christian F. Feest, ed., *Indians and Europe: An Interdisciplinary Collection of Essays*, Forum 11, Aachen, 1987), pp. 5–36; see Roger Barta, *Wild Man in the Looking Glass: The Mythic Origin of European Otherness*, Ann Arbor, 1994.

11 William C. Sturtevant, 'Le Tupinambisation des Indiens de l'Amérique du Nord', in Gilles Thérien, ed., *Les Figures de l'Indien*, Les Cahiers du Département d'Études Littéraires 9, Montréal, 1988, pp. 293–303, suggests that this process of 'Tupinambisation' continued to be of importance in later centuries and especially affected the popular image of North American Indians.

12 Sturtevant, 'First Visual Images', p. 423, fig. 4; see also Christian F. Feest, 'Dürer et les premières évaluations européennes de l'art mexicain', in Joëlle Rostkowski and Sylvie Devers, eds, *Destins croisés: Cinq siècles de rencontres avec les Amérindiens*, Paris, 1992, pp. 107–19.

13 John Rowlands, *The Age of Dürer and Holbein: German Drawings 1400–1550*, London, 1988, pp. 187–8, pl. XXIII.

14 *The Triumph of Maximilian I*. With a translation of descriptive text, introduction and notes by Stanley Applebaum, New York, 1964, pp. 129–31; see Sturtevant, 'First Visual Images', pp. 420–2, fig. 3

15 Gonzalo Fernández de Oviedo y Valdés, *De la natural hystoria de las Indias*, Toledo, 1526; see Sturtevant, 'First Visual Images', pp. 424–6, figs 6, 7.

16 Alfred Métraux, 'The Tupinambá', in Julian H. Steward, ed., *Handbook of North American Indians*, Bulletin of the Bureau of American Ethnology 143, 7 vols, Washington, DC, 1948, 3, pp. 95–133.

17 Hans Staden, *Warhaftige beschreibung einer Landschafft der wilden nacketen grimmigen menschenfresser leuthen in der newen welt America gelegen*, Marburg, 1557.

18 André Thevet, *Les Singularitez de la France Antarctiqve avtrement nommée Amérique …*, Paris: Maurice de la Porte Erben, 1557.

19 Jean de Léry, *Histoire d'vn Voyage fait en la terre dv Bresil avtrement dite Amerique*, La Rochelle, 1578: André Chupin; PH&DBQ, 1, p. 145; PH, p. 194.

20 Jacques Le Moyne, *Brevis narratio eorum quae in Florida Americae provincia Gallis acciderunt … quae est secundo pars Americae*, Frankfurt, 1591: Theodor de Bry.

21 On Le Moyne see especially Paul Hulton's monumental work *The Work of Jacques Le Moyne de Morgues*, 2 vols, London, 1977, and the comments by Christian F. Feest, 'Jacques Le Moyne Minus Four', *European Review of Native American Studies*, 2 (1), 1988, pp. 35–40.

22 Girolamo Benzoni, *La Historia del mondo Nvovo*, Venice, 1565: Francesco Rampazetto.

23 See Daniel Defert, 'Un genre ethnographique profane au XVIe: Les livres d'habits (Essai d'ethnographie)', in Britta Rupp-Eisenreich, ed., *Histoires d'anthropologie: XVI–XIX siècles*, Paris, 1984, pp. 25–41.

24 François Deserps, *Recueil de la diversité des habits, qui sont de present en usage, tant es pays d'Europe, Asie, Affrique & Isles sauuages*, Paris, 1562; Johannes Sluperius, *Omnium fere gentium nostraeque aetatis nationum, habitus et effigies, et in eosdem epigrammata*, Antwerp, 1572; Hans Weigel, *Habitvs praecipvorvm popvlorvm … Trachtenbuch: darin fast allerley und der fürnembsten Nationen, die heutigs tags bekandt sind, Kleidungen* (Nuremberg, 1577; Abraham de Bruyn, *Omnium pene Evropae, Asiae, Aphricae atque Americae Gentium Habitus*, Antwerp, 1582; Jost Amann, *Im Frauwenzimmer wirt vermeldt von allerley schönen Kleidungen unnd Trachten der Weiber*, Frankfurt, 1586: Feyerabend; Cesare Vecellio, *De Gli Habiti Antichi, Et Moderni di Diverse Parti del Mondo*, Venice, 1590: Zenaro); see Colin, *Bild des Indianers*, pp. 219–20, 227, 230–31, 238, fig. 40; Rachel Doggett, ed., *New World of Wonders*, Washington, DC, 1992, pp. 30, 50, 88–90.

25 André Thevet, *Les vrais Pourtraits et vies des hommes illustres, Grecz, Latins at Payens*, 2 vols, Paris, 1584: Veuve J. Kerver et G. Chaudière.

26 Frank Lestringant, 'The Myth of the Indian Monarchy: An Aspect of the Controversy between Thevet and Léry (1575–1585)', in Feest, ed., *Indians and Europe*, pp. 37–60.

27 Quinn, p. 108.

28 That these were probably added by de Bry in the engravings is suggested by the non-native burden basket in pl. XIIII, by the equally suspect fan and the 'conjuror's' animal skin apron worn by the woman in pl. XV.

29 De Bry's engraving (perhaps based on a different version produced by White) is enriched by the addition of further appropriate items of material culture (Harriot, *Briefe and true report*, pl. XVI).

30 The map of the Aztec capital of Tenochtitlán, published together with a text by Hernán Cortés in 1524, became the basis for a series of merely imaginative views with European style houses. See Kohl, *Mythen der Neuen Welt*, pp. 173–82, 271.

31 William C. Sturtevant and David Beers Quinn, 'This New Prey: Eskimos in Europe in 1567, 1576, and 1577', in Feest, ed., *Indians and Europe*, pp. 61–140, especially 80, 82 (fig. 5), 137.

32 Feest, 'Jacques Le Moyne', pp. 33–5.

33 Christian F. Feest, 'Virginia Indian in

Pictures, 1612–1624', *The Smithsonian Journal of History*, 2 (1), 1967, pp. 1–30 (17–27).

34 Sturtevant, 'First Visual Images', p. 444.

35 Quinn, p. 438, note 4.

36 Quinn, p. 424.

37 PH, p. 35.

38 PH&DBQ, 1, p. 40.

39 See, e.g., J. N. B. Hewitt, ed., *Journal of Rudolph Friedrich* Kurz, Bureau of American Ethnology, Bulletin 115, Washington, 1937, p. 214. For Manteo's role and 'invisible bullets' see Joyce Chaplin, *Subject Matter: Technology, the Body, and Science on the Anglo-American Frontier, 1500-1676*, Cambridge, MA, 2001, pp. 32–4. With respect to the outbreak of epidemics in coastal North Carolina, however, Harriot merely states 'that they would impute to vs the cause or meanes thereof for offending or not pleasing vs' (Quinn, p. 378).

40 William B. Kemp, 'Baffinland Eskimo', in David Damas, ed., *Arctic Northeast*, W. C. Sturtevant, gen. ed., *Handbook of North American Indians* 5; Washington, DC, 1984, pp. 463–75.

41 Sturtevant and Quinn, 'This New Prey', pp. 68–76, figs 1, 2. While Coenen claimed that his copy represented the 1576 captive, the subject looks much more like the man shown as the 1577 male captive in other illustrations.

42 Sturtevant and Quinn, 'This New Prey', pp. 76–98, figs 3–10; PH&DBQ, 1, p.13, ; PH, pp. 8, 29.

43 Kemp, 'Baffinland Eskimo', p. 475.

44 Sturtevant and Quinn, 'This New Prey', pp. 61–9, fig. 1a–c.

45 For a more extensive historical and ethnographic summary see Christian F. Feest, 'North Carolina Algonquians', in Bruce G. Trigger, *Northeast*, W. C. Sturtevant, gen. ed., *Handbook of North American Indians* 15, Washington, DC, 1978, pp. 271–81.

46 On the Iroquoian neighbours see Douglas W. Boyce, 'Iroquoian Tribes of the Virginia-North Carolina Coastal Plain', in Trigger, *Northeast*, pp. 282–9; the Siouan groups of the North Carolina Piedmont are discussed in Raymond J. De Mallie, 'Tutelo and Neighboring Groups', and Blair A. Rudes, Thomas J. Blumer and J. Alan May, 'Catawba and Neighboring Groups`, both in Raymond D. Fogelson, ed., *Southeast*, W. C. Sturtevant, gen. ed., *Handbook of North American Indians* 14, Washington, DC,. 2004, pp. 286–300, 301–18.

47 On Virginia Algonquians see Christian F. Feest, 'Virginia Algonquians', in Trigger, *Northeast*, pp. 253–70, and *The Powhatan Tribes*, New York and Philadelphia, 1990.

The most extensive treatment of the ethnographic and historical record is found in Helen C. Rountree, *The Powhatan Indians of Virginia: Their Traditional Culture*, Norman, 1989, and *Pocahontas's People: The Powhatan Indians of Virginia Through Four* Centuries, Norman, 1989.

48 E.g., Lee Miller, *Roanoke: Solving the Mystery of England's Lost Colony*, London, 2001.

49 François-Marc Gagnon and Nicole Cloutier, *Premiers reintres de la Nouvelle-France*, 2 vols, Québec, 1976; Gagnon, 'L'éxperience ethnographique de Louis Nicolas', *Recherches Amérindiennes au Québec*, 8 (4), 1979, pp. 281–95.

50 See, e.g., *Von Reck's Voyage: Drawings and Journal of Philip Georg Friedrich von Reck*, ed. Kristian Hvidt, Savannah, GA, 1980. The general paucity of British visual material in south-eastern North America is shown by the survey produced by Emma Lila Fundaburk, *Southeastern Indians – Life Portraits: A Catalogue of Pictures*, Luverne, AL, 1957.

51 Feest, 'Virginia Indian in Pictures'.

52 PH, p. 191; PH&DBQ, 1, p. 93.

53 Vicenzo Cartari, *Seconda Novissima Editione delle Imagini de gli dei delli Antichi*, Padua, 1626: Pietro Paolo Tozzi, pp. 561–4.

54 Christian F. Feest, 'Zemes Idolum Diabolicum', *Archiv für Völkerkunde*, 44, 1986, pp. 181–98 (190–91, figs 9, 10).

55 PH&DBQ, 1, p. 93, and notes 2–3.

56 See Clifford M. Lewis and Albert J. Loomie, *The Spanish Jesuit Mission in Virginia, 1570–1572*, Chapel Hill, 1953.

57 Christian F. Feest, 'Southeastern Algonquian Burial Customs: Ethnohistoric Evidence', *Proceedings of the 4th Middle Atlantic Archaeological Conference*, Milford, 1975, pp. 1–16; Feest, 'Ethnohistory and Archaeology: A View from Coastal Virginia and Maryland', in Karl R. Wernhart, ed., *Ethnohistory in Vienna*, Aachen, 1987, pp. 87–100.

58 Fernández de Oviedo, *De la hystoria natural*, depicts only the drill; his manuscript shows the drill being operated by detached hands (Sturtevant, 'First Visual Images', p. 425, fig. 6), while the 1534 edition of his book instead adds a male figure holding the drill (Colin, *Bild des Indianers*, fig. 35). See also Thevet, *Singularitez*, p. 101; Staden, *Warhaftige beschreibung*, p. 3 verso; Benzoni, *Historia*, p. 103.

59 John R. Swanton, *The Indians of the Southeastern Unites States*, Bureau of American Ethnology, Bulletin 137, Washington, DC, 1946, pp. 422–3.

60 Other types of shirts and aprons are shown in use by the 'conjuror' and 'priest'. In one case a man is seen wearing the garment

over the right shoulder, and a women in the dance around the carved posts wears a dress passing over both shoulders.

61 Quinn, pp. 368–9, 419. With the exception just noted, Harriot's captions to de Bry's plates hardly go beyond his summary statement.

62 See Swanton, *Indians of the Southeastern United States*, pp. 457–66.

63 Piero Bertelli, *Diversarum nationum habitus*, Padua, 1592: Alicatus Alcia and Pietro Bertelli, pp. 21, 22; reprinted in 1594 on pages 27, 28. See Doggett, *New World of Wonders*, p. 60, fig. 21.

64 Alexandro di Fabri, *Diversar[um] nationum habitus*, Paua, 1593: Alexandro de Fabri, pp. 21, 22.

65 Harriot, *Brief and true report*, pls III, V, VII, X; Cesare Vecellio, *Habiti antichi et moderni di tutto il mondo di nuovo accresciuti di molte figure*, Venice, 1598: Sessa, pp. 503–6; see Colin, *Das Bild des Indianers*, p. 425, fig. 41.

66 E.g., Joseph François Lafitau, *Mœurs des sauvages ameriquains, comparées aux mœurs des premiers temps*, 2 vols, Paris, 1724: Saugrain l'aíné, p. 1: pl. 33.

67 *Systematische Bilder-Gallerie zur allgemeinen deutschen Real-Encyclopädie*, Carlsruhe and Freiburg, 1827, part II.B, pl. 15; *Welt-Gemälde-Gallerie oder Geschichte und Beschreibung aller Länder und Völker, 2: Amerika*, Stuttgart, 1828, unnumbered plate.

68 See Monika Kopplin, '"Was frembd und seltsam ist": Exotica in Kunst- und Wunderkammern', in Tilman Osterwold and Hermann Pollig, eds, *Exotische Welten, Europäische Phantasien*, Stuttgart, 1987, pp. 296–317, especially 207–8.

69 Gustav Parthey, *Wenzel Hollar: Beschreibendes Verzeichnis seiner Kupferstiche*, Berlin, 1853, p. 417, no. 1907 (Mulier ex Virginia / a Virginian Woman from Hollar's Theatrum Mulieram, c.1644).

70 Matthaeus Dresser, *Historien und Bericht, von dem newlicher Zeit erfundenen Königr[eich]. China … Item von dem auch new erfundenen Lande Virginia*, Leipzig, 1598: F. Schnelboltz.

71 Feest, 'Virginian Indian in Pictures'.

72 Robert Beverley, *The History and Present State of Virginia*, London, 1705; a second edition appeared in 1722, a French translations with poor engravings in 1707.

73 The title pages of both books by Helen Rountree, *The Powhatan Indians* and *Pocahontas's People*, feature drawings by John White. One of the Jamestown 350th Anniversary Historical Booklets Historical Booklets, Ben C. McCary's *Indians in Seventeenth-Century Virginia*, Charlottesville, 1957, was almost exclusively illustrated with John White's work.

CHAPTER 6: UTE KUHLEMANN: BETWEEN REPRODUCTION, INVENTION AND PROPAGANDA: THEODOR DE BRY'S ENGRAVINGS AFTER JOHN WHITE'S WATERCOLOURS

1 Their exact orders have not survived, but they can be deduced from instructions given to Thomas Bavin, an artist who attended an English expedition in 1582. See pp. 41–2 and Paul Hulton, *America 1585: The Complete Drawings of John White*, Chapel Hill and London, 1984 (hereafter PH), p. 9.

2 This number does not include the drawings not made on the Virginia voyage or those in the Sloane album. Paul Hulton and David Quinn, eds, *The American Drawings of John White 1577-1590*, 2 vols, London, 1964 (hereafter PH&DBQ).

3 For the scientific aspect of John White's drawings see pp. 170–71; PH&DBQ, pp. 47–52; Mary Baine Campbell, *Wonder & Science – Imagining Worlds in Early Modern Europe*, Ithaca and London, 1999; and Julie Robin Solomon, '"To Know, To Fly, To Conjure"; Situating Baconian Science at the Juncture of Early Modern Modes of Reading', *Renaissance Quarterly*, 44 (3), Autumn 1991, pp. 513–58.

4 Only a few of the surviving drawings by John White do place some of the detail studies in their proper context: for example the views of the Indian village of Secotan (no. 8) show the exterior of the tomb (no. 10), the festive dance (no. 11) and their eating habits (no. 24).

5 See, for example, Anna Dünnebier and Gert von Pacensky, *Kulturgeschichte des Essens und Trinkens*, Munich, 1999, the cover of which shows de Bry's engraving of two Indians eating (see no. 24), cited in Anna Greve, *Die Konstruktion Amerikas: Bilderpolitik in den Grands Voyages aus der Werkstatt de Bry*, Cologne, Weimar and Berlin, 2004, pp. 8, 9 (note 30).

6 For biographical information see ibid., pp. 15–51.; Arthur M. Hind, *Engraving in England in the Sixteenth and Seventeenth Centuries, Part I*, Cambridge, 1952, pp. 124ff; and U. Hansche, 'Theodor de Bry', in *Sauer Allgemeines Künstler-Lexicon*, vol. 14, Munich and Leipzig, 1996, p. 62; Jane Campbell Hutchison, 'Theodor de Bry', *Great Art on Line*, Oxford University Press, http://www.greatart.com, accessed 17 March 2006.

7 It is known that de Bry was interested in making engravings already in the 1570s. Michiel van Groesen, 'De Bry and Antwerp, 1577–1585: A Formative Period', in Susanna Burghartz, ed., *Inszenierte Welten – Staging New Worlds; Die west- und ostindischen Reisen der Verleger de Bry, 1590-1630 – De Bry's Illustrated Travel Reports, 1590–1630*, Basel, 2004, pp. 21–2, 25ff. At that time it was quite common for goldsmiths to do their own engravings, and they sometimes changed their profession entirely. Probably the most famous example is the German artist and engraver Albrecht Dürer, who was a trained goldsmith.

8 Groesen speculates whether de Bry may have worked for Philips Galle, leading book engraver for the Officiana Plantiniana. Ibid., p. 35.

9 De Bry applied on 29 October 1588 for citizenship in Frankfurt, which was granted on 9 February 1591. Institute für Stadtgeschichte Frankfurt am Main, Bürgermeisterbuch, No. 159 and Bürgerbuch, No. 7, p. 80v, cited in Greve, *Die Konstruktion Amerikas*, pp. 23–4.

10 Other popular destinations were the northern Netherlands, Hamburg and London. Groesen, 'De Bry and Antwerp', p. 25.

11 Greve, *Die Konstruktion Amerikas*, p. 23.

12 For more information on Merian see Lucas Heinrich Wüthrich, *Das Druckgraphische Werk von Matthaeus Merian d.Ä.*, 3 vols, Hamburg, 1966–93. Merian's granddaughter was Maria Sybilla Merian (1647–1717) who was also an early traveller to America, to Surinam at the end of the seventeenth century, where she painted flora and fauna. See Natalie Zeman Davis, *Women on the Margins: Three Sixteenth-century Lives*, Cambridge, MA, and London, 1995, and the forthcoming exhibition at the Rembrandthuis, The Hague.

13 The production details of the print read: 'graven in Copper by Derick Theodor de Bry in the Citty of London 1587'. The first two plates are dated 1587, and plate 30 1588. For this print and other prints by de Bry produced in London, see Hind, *Engraving in England*, pp. 127ff. For more information on the funeral see Elizabeth Golding, 'The Funeral of Sir Philip Sidney and the Politics of Elizabethan Festival', in Golding and J. R. Mulryne, *Court Festivals of the European Renaissance: Art, Politics and Performance*, Aldershot, 2002, pp. 199–224.

14 For more information on Netherlandish exile networks in Frankfurt and London see Groesen, 'De Bry and Antwerp', pp. 36–40; Tine Meganck, *Erudite Eyes: Artists and Antiquarians in the circle of Abraham Ortelius*, An Arbor, c.2003; Heinz Schilling, *Niederländische Exulanten im 16. Jahrhundert*, Gütersloh, 1972; Alexander Dietz, *Frankfurter Handelsgeschichte*, 3 vols, Frankfurt am Main, 1921.; and Robert A. Gerard, 'Woutneel, de Passe and the Anglo-Netherlandish Print Trade', *Print Quarterly*, XIII (4), 1996, pp. 363–76.

15 The title of the English version is *Journal of the Huguenot expedition to Florida*. Hind, *Engraving in England*, p.124. The publication was initiated by Hakluyt. Greve, *Die Konstruktion Amerikas*, 2004, p. 115.

16 Hakluyt was living mainly in Paris in 1584–8, working there as chaplain of the British Embassy. For more information on Hakluyt see Eva G. Taylor, ed., *The Original Writings and Correspondence of the Two Richard Hakluyts*, 2 vols, Nendeln, 1967.

17 Hind, *Engraving in England*, p. 124.

18 For biographical details on Le Moyne de Morgues see Paul Hulton, *The Work of Jacques Le Moyne de Morgues: A Huguenot Artist in France, Florida and England*, 2 vols, London, 1977. For his connection to the Sidney family see ibid., p. 15. For his service for Raleigh see Hind, *Engraving in England*, p. 124. For general information on Le Moyne and de Brys' Florida volume see Greve, *Die Konstruktion Amerikas*, pp. 110–34.

19 Hulton, *Jacques Le Moyne de Morgues*, p. 11. For the English translation of de Bry's foreword to the second volume, *Brevis narratio, eorvm qvae in Florida Americae Provincia …* (German title: *Der ander Theyl, der Newlich erfundenen Landtschafft Americae …*), Frankfurt, 1591 (from here referred to as *Florida*) see ibid., p. 117.

20 See de Bry's foreword to the plates, entitled 'To the gentle Reader', Thomas Harriot, *A briefe and true report of the new found land of Virginia*, Frankfurt, 1590, n.p.

21 Hind, *Engraving in England*, p. 128. Today this publication is extremely rare: apparently only six to eight copies are known.

22 Richard Hakluyt, *Principal Navigations …*, London, 1589 (1598–1600).

23 Foreword to plates entitled 'To the gentle reader', Harriot, *Briefe and true report*: 'I … offer vnto you the … Pictures … which by the helfe of Maister Richard Hakluyt…, who first Incouraged me to publishe the Worke, I creaved out of the verye original of Maister Ihon White an Englisch paynter who was sent in to the contrye by the queenes Maiestye, onlye to draw the description of the place, lynelye to describe the shapes of the Inhabitants their apparell, manners of Livinge, and fashions … I creaved … them [the originals] at London, an brought, Them hither to Franckfurt, wher I and my sonnes haven taken ernest paynes in [en]gravinge the pictures ther of in Copper, seeing yt is a matter of noe small importance'.

24 Sondheim mentions the English medical doctor Robert Fludd, who reported that he

had sent his works to be published in Germany because the English printer demanded £500 for the printing of one book with illustrations, while de Bry's publishing house published his work without any charges, instead supplying him with sixteen free copies and with a reward of £40 in gold. Moriz Sondheim, 'Die de Bry, Matthäus Merian und Wilhelm Fitzer', *Philobiblon*, 1933, p. 10.

25 The German edition of the *Great Voyages* was published in fourteen volumes (1590–1630), the Latin edition in thirteen volumes (1590–1634). The German edition of the *Small Voyages* comprises thirteen volumes (1597–1628), and the Latin edition twelve volumes (1598–1628). Additionally there are compilations, and various re-editions. For a detailed description of the series and its various editions see Armand G. Camus, *Mémoire sur la collection des Grands et Petits Voyages, et sur la collection des Voyages de Melchisedeck Thevenot*, Paris, 1802; Jacques Charles Brunet, *Manuel du libraire et de l'amateurs de livres*, Paris, 1860 (reprinted Berlin, 1922); George Watson Cole, *A Catalogue of Books Relating to the Discovery and Early History of North and South America, Forming a Part of the Library of Elihu Dwingh Church*, vol. 1, New York, 1907 (reprinted New York, 1951); Geron Sievernich, ed., *America de Bry 1590–1634*, Berlin, New York and Casablanca, 1990.

26 For the translators involved, see note 30. The relatively high costs of such a publication explain why most of the title pages of the various language editions feature the same engraved frame with the title in the respective language printed on an affixed piece of paper.

27· For edition details see note 25.

28 For example, the Grenville Library (now in the British Library, London) is described, amongst other things, by pointing out the presence of the Latin and German edition of the de Bry series 'with several volumes in unique or extremely rare editions and states'. Together with the volumes of the British Library, both collections offer 'unexampled completeness'. Graham Jefcoate *et al.*, eds, *Handbuch Deutscher Historischer Buchbestände in Europa: Vol. 10*, Hildesheim, Zürich and New York, 2000, p. 83. The Grenville Library includes, for example, all four 1590 editions of the *Virginia* volume, two of which are very rare.

29 The various editions of the *Virginia* volume are: Thomas Hariot [*sic*], *A briefe and true report of the new found land of Virginia …*, Frankfurt am Main: Theodor de Bry, 1590 (reprint of this edition: New York, 1972); Latin edition 1590, same details but with

the title *Admiranda narratio fida tamen, de commodis et incolarvm ritibvs virginiae …* (2nd ed. c.1608 by the sons de Bry; 3rd ed. 1634 by Merian with new title page); German edition 1590, same details but with the title *Wunderbarliche doch Warhafftige Erklärung Von der Gelegenheit vnd Sitten der Wilden in Virginia …* (2nd ed. 1600 by the widow and sons de Bry; 3rd ed. 1620 by Johann Theodor de Bry); French edition 1590, same details but with the title *Merveilleux et estrange Rapport, tovtesfois fidele, des Commoditez qvi se trovvent en Virginia …* The abridged versions are included in Philipp Ziegler, *America, das ist, Erfindung und Offenbahrung der Newen Welt*, Oppenheim: Johann Theodor de Bry, 1617, and Johann Ludwig Gottfried, *Historia Antipodum oder Newe Welt*, Frankfurt am Main: Matthaeus Merian the Elder, 1631 (2nd ed. 1655). For bibliographical references see note 25.

30 Harriot's and White's names are mentioned on the title pages of all 1590 editions; Winghe is credited as designer in the Adam and Eve engraving; the translators' names are mentioned on the title pages of the relevant language edition. See note 29 for the respective 1590 de Bry editions. L'Escluse, also known as L'Ecluse or Carolus Clusius of Arras, was credited with initials CCA. The German translator 'Christ. P' is described in Georg Willer's contemporary sales catalogue as 'Christoff P'. Bernhard Fabian, *Die Messkataloge Georg Willers 1564-1600*, 5 vols, Hildesheim and New York, 1972–2001, vol. no. IV, p. 287.

31 'I craeued both of them at London, an brought, Them hither to Franckfurt, wher I an my sonnes hauen taken ernest paynes in grauinge the pictures ther of in Copper.' De Bry's foreword to the plates, addressed 'To the gentle Reader' in Harriot, *Briefe and true report*, n.p. The plates V, VI, XI and XV are signed 'G.Veen'.

32 The printer Johann Wechel is mentioned credited on the title pages of all 1590 editions of vol. I, as well as on the title pages of the first Latin editions of vols II and III. The name of the bookseller and publisher Sigmund Feyerabend appears on the title pages of the first three volumes of the *Great Voyages* (1590–93); however Feyerabend died in 1590. Greve, *Die Konstruktion Amerikas*, pp. 62–4.

33 In 1589 Theodor de Bry and Sigmund Feyerabend both pleaded that the copperplate printer Jakob Kempener should stay in Frankfurt until he had finished the works they had commissioned from him. Sondheim suggested that the mentioned works are identical with the plates for the Virginia volume. Moriz Sondheim, 'Die de

Bryschen Grands Voyages', *Het Boek*, 24, 1936, p. 334, cited in ibid., p. 24.

34 Johann Wechel, the printer who worked for Theodor de Bry, printed works which were dedicated to Philip Sidney. Sidney visited André Wechel in 1573 in Frankfurt; André Wechel was acquainted with the French botanist Charles de l'Escluse, who translated the Latin editions of de Bry's vols I and II, and for vol. III two French letters into Latin. Ibid., pp. 57 and 64. For more information on the printer family Wechel see Robert J. W. Evans, *The Wechel Presses: Humanism and Calvinism in Central Europe 1572–1627*, Oxford, 1975, and Ian Maclean, 'André Wechel at Frankfurt, 1572–1627', *Gutenberg Jahrbuch*, 1988, pp. 146–55.

35 Philip Gaskell, *A New Introduction to Bibliography*, Oxford, 1972, p. 161, cited in Greve, *Die Konstruktion Amerikas*, p. 68.

36 Ibid., p. 70.

37 The price of the 1631 summary by Gottfried (see note 29) was seven guilders, and in 1680 the heirs of Merian offered the complete Latin and German editions for 22 guilders each. Ibid., p. 69.

38 David Paisey, 'Prints at the Frankfurt Book Fairs, 1588–1600', *Print Quarterly*, XXIII (1), 2006, pp. 54–5. I'm very grateful to David Paisey for his constant support and interest, and for having drawn my attention to Johann Willer's catalogues.

39 Fabian, *Die Messkataloge Georg Willers*, vol. IV, pp. 256 and 287. For listings of de Bry's volumes II–VIII and Additamentum see ibid., vol. IV, pp. 370, 462; 577–8, vol.V, pp. 136, 260–61, 330; 492, 507, 546–7. The foreword of Virginia is dated 1 April 1590. Harriot, *Briefe and true report*, p. 4.

40 The English edition of the *Virginia* volume is dedicated to the courtier Sir Walter Raleigh, while the other language editions are dedicated to princes (the Latin edition to Prince Maximilian, King of Poland; the German edition to Christian I, Elector (Duke) of Saxony; the French edition to Wilhelm, Pfalzgraf bei Rhein). Appendix 4.1 in Greve, *Die Konstruktion Amerikas*, pp. 233–53. Artists who were interested in the subject and could afford the expenses would certainly have bought de Bry's (and other) engravings for their personal enlightenment, but also for artistic inspiration. A good, though later, example is Rubens, who bought nine volumes of de Bry's *America* series in 1613 and adapted details from the engravings for different art works. Henry Keazor, 'Theodore De Bry's Image for America', *Print Quarterly*, XV (2), 1998, pp. 134–5.

41 In appendix 4.2 Greve gives physical

descriptions of copies of the first six volumes in various German libraries, mentioning features such as painted coats of arms, metal clasps, (gold) embossed leather bindings, and colouring of the plates. Greve, *Die Konstruktion Amerikas*, pp. 253ff. As far as I know, no detailed research has been undertaken into the issue of whether de Bry also offered ready-coloured images (executed by local *Briefmaler* or illuminators), or whether the colouring, like the binding of the sheets, was an entirely individual matter and commissioned independently by the owner. For a brief list of coloured copies in German collections, see ibid., p. 74, note 309. For information on the complex, yet important aspect of coloured prints see Susan Dackerman, *Painted Prints: The Revelation of Color*, exh. Baltimore, The Baltimore Museum of Art, 2003. While this publication was in the final stages of writing, I learned of a census of the 1590 editions of de Bry – focusing particularly on coloured versions – being conducted by the American historian Larry E. Tise at the newly named Harriot College of Arts and Sciences at East Carolina University. Preliminary findings in Tise's study suggest that de Bry's book has been bound and rebound in many creative ways. Those seen to date in libraries in the USA, France and Britain are highly varied in colours, colour schemes and applications used for different language versions. He believes that the colouring also tended to reflect distinct cultural perceptions or interpretations of American Indians.

42 Greve, *Die Konstruktion Amerikas*, pp. 74–5, and note 313.

43 William Strachey, *Historie of travaile into Virginia Britannia* (British Library, London, Sloane MS 1622). The manuscript with the coloured de Bry engravings dates from 1610–12, and it was presented to Francis Bacon. It was published only in the nineteenth century. Paul Hulton, *The Persistence of White–De Bry Image of the North American Indian*, Seville, 1990, pp. 6–7.

44 It was common practice to display the title pages of books for advertisement purposes. For this and an analysis of de Bry's title pages see Maike Christadler, 'Die Samm-lung zur Schau gestellt: Die Titelblätter der America-Serie', in Burghartz, *Inszenierte Welten*.

45 Harriot, *Briefe and true report*, title page for the Picts (n.p.). In this title page de Bry also states that he had received the drawings from 'the painter of whom I have had the first of the Inhabitans of Virginia', i.e. John White. On the basis of the drawing 'A Daughter of the Picts', which has been attributed to Le Moyne (fig. 94), Hulton wonders whether White's drawings of the Picts are all copies from Le Moyne (see Paul Hulton's foreword to the 1972 edition of Thomas Harriot's *A briefe and true report*, pp. xi–xii). I am inclined to agree with Christian F. Feest, who suggests that this drawing is in fact a copy after de Bry's engraving, and that there is no reason to doubt de Bry's statement. Christian F. Feest, 'Jacques Le Moyne Minus Four', *Native American Studies*, 1, 1988, pp. 33–8.

46 Greve, *Die Konstruktion Amerikas*, p. 37.

47 See, for example, Bernadette Bucher, *Icon and Conquest*, Chicago and London, 1981, or more recently, Keazor, 'Theodore De Bry's Image for America' and Shannon Miller, *Invested with Meaning: The Raleigh Circle in the New World*, Philadelphia, 1998, chapter 4.

48 Three of de Bry's engravings in the *Virginia* volume seem not to be based on designs by John White, or at least the watercolours have not survived. Harriot, *Briefe and true report*, plates XII, XXI, XXIII (see Figures 61, 66, 47).

49 Hulton, introduction to Harriot, *Briefe and true report*, 1972 reprint, pp. xi–xii.

50 Greve, *Die Konstruktion Amerikas*, p. 96, note 370. The same loincloth is worn by the Indian men depicted in de Bry's plate XII (fig. 61), which suggests that this plate may also be an invention by de Bry rather than based on an observation by White.

51 Ziegler, *America*.

52 Ibid., p. 230. The same engraving was used in vol. 13 of the *Great Voyages, Fortsetzung der Historien von der Newen Welt*, printed by Capar Roetel, published by Matthäus Merian, Frankfurt, 1628, p. 401, and in the summary of the first fourteen de Bry volumes, Gottfried, *Historia Antipodum*, p. 168. According to Wüthrich, this plate is not by Merian the Elder. Wüthrich, *Das Druckgraphische Werk*, 3, p. 293.

53 The impact of Theodor de Bry's training and workshop practice on his *America* engravings remains largely unstudied. For further references, see Kaezor, 'Theodore De Bry's Image'.

54 De Bry's foreword to plate section, in Harriot, *Briefe and true report*, n.p.

55 Other aspects of the legacy of John White relate to his impact on natural history studies and cartography, which are briefly discussed in PH, pp. 30–34.

56 I would like to thank Diana Dethloff for drawing attention to this image and to Hans Newman of The Old Print Shop, New York, and William Reese of New Haven, for helping to locate it and for information about the artist and provenance.

57 For more information on this concept see Hugh Honour, *The New Golden Land: European Images of America from the Discoveries to the Present Time*, New York, 1975, pp. 118ff, and see Stephanie Pratt, *British Art and the American Indian 1700–1840*, Norman, 2005.

58 For discussion of the image see Hulton, *The Persistence*, fig. 17, and Joyce E. Chaplin, *Subject Matter: Technology, the Body, and Science on the Anglo-American Frontier, 1500–1676*, Cambridge, MA, and London, 2001, p. 37.

59 This plate is discussed in Hulton, *The Persistence*, pp. 8–9, as well as in Rachel Doggett, ed., *New World of Wonders: European Images of the Americas 1492–1700*, Washington, exh. Folger Shakespeare Library, 1992, p. 61.

60 Pietro Bertelli, *Diversarum nationum habitus*, 3 parts, Padua, 1591–6. The image was copied by Alexandro di Fabri, *Diversarum nationum ornatus*, Padua, 1593, plate 22.

61 The last section of Vecellio's book contains twelve images of 'Virginian' Indians after de Bry. Cesare Vecellio, *Habiti Antichi, Et Moderni di tutto il Mondo*, Venice, 1598, fols 495v–506v (fol. 500v shows the woman with a gourd within a woodcut border).

62 See, for example, the 'Habit of a Lady of Virginia' in *A Collection of Dresses of Different Nations*, London, 1772, vol. IV, plate 215.

63 Richard Pennington, *A Descriptive Catalogue of the Etched Work of Wenceslaus Hollar*, Cambridge, 1982, no. 1907. I'm very grateful to Simon Turner for drawing my attention to this image.

64 John Speed, *A Prospect of the Most Famous Parts of the World*, London, 1662, between pages 9–10 the map 'America', engraved by Abraham Goos, Amsterdam. Another, earlier example is William Hole's engraved map of 'Virginia' (fig.33), which features decorative and symbolic elements which are based on de Bry's map and engravings after John White, such as figures of Indians, cooking pot etc. The map was included in John Smith's *Map of Virginia with a description of the country*, Oxford, 1612. PH&DBQ, p. 137.

65 For the early symbolic or emblematic significance of feathers and gold see Hugh Honour, *The European Vision of America*, exh. Cleveland Museum of Art, Ohio, 1975, chapters 6–8; Doggett, *New World of Wonders*; Susi Colin, *Das Bild des Indianers im 16. Jahrhundert*, Idstein, 1988.

Andrews, Kenneth R., *Trade, Plunder, and Settlement: Maritime Enterprise and the Genesis of the British Empire, 1480–1630*, Cambridge, 1984

Appelbaum, Robert, and Sweet, John Wood, eds, *Envisioning an English Empire: Jamestown and the Making of the North Atlantic World* , Philadelphia, 2004

Armitage, David, *The Ideological Origins of the British Empire*, Cambridge, 2000

Armitage, David, *Greater Britain, 1516–1776: Essays in Atlantic History*, Aldershot and Burlington, VT, 2004

Baldwin, Robert, 'Cartography in Thomas Harriot's Circle', *DTHA*, 22, 1996

Barber, Peter, 'England I: Pagentry, Defence and Government: Maps at Court to 1550', in David Buisseret, ed., *Monarchs, Ministers and Maps*, Chicago, 1992

Barta, Roger, *Wild Man in the Looking Glass: The Mythic Origin of European Otherness*, Ann Arbor, 1994

Bedini, Silvio A., ed., *Christopher Columbus and the Age of Exploration: An Encyclopedia*, New York, 1998

Bermingham, Ann, *Learning to Draw: Studies in the Cultural History of a Polite and Useful Art*, New Haven and London, 2000

Binyon, Laurence, see Abbreviations

Blair, Ann, *The Theater of Nature: Jean Bodin and Renaissance Science*, Princeton, 1997

Bucher, Bernadette, *Icon and Conquest*, Chicago and London, 1981

Burghartz, Susanna, ed., *Inszenierte Welten: die west- und ostindischen Reisen der Verleger de Bry, 1590–1630/Staging New Worlds: de Brys' Illustrated Travel Reports, 1590–1630*, Basel, 2004

Campbell, Mary Baine, *Wonder and Science: Imagining Worlds in Early Modern Europe*, Ithaca and London, 1999

Canny, Nicholas, 'The Ideology of English Colonization: From Ireland to America', *William and Mary Quarterly*, 3rd ser. 30, 1973, pp. 575–98

Catesby, Mark, *The Natural History of Carolina, Florida and the Bahama Islands*, 2 vols, London 1731–43

Chaplin, Joyce E., *Subject Matter: Technology, the Body, and Science on the Anglo-American Frontier, 1500–1676*, Cambridge, MA, and London, 2001

Christadler, Maike, 'Die Sammlung zur Schau gestellt: Die Titelblätter der *America*-Serie', in Susanna Burghartz, ed., *Inszenierte Welten/ Staging New Worlds*, Basel, 2004, pp. 47–93

Christian, Lynda G., *Theatrum mundi: The History of an Idea*, New York, 1987

Colin, Susi, *Das Bild des Indianers im 16. Jahrhundert,* Beiträge zur Kunstgeschichte 102, Idstein, 1988

Coombs, Katherine, *The Portrait Miniature in England*, London, 1998

Croft Murray, Edward, see Abbreviations

Cumming, William P. *Mapping the North Carolina Coast: Sixteenth-Century Cartography and the Roanoke Voyages*, Raleigh, 1988

Dackerman, Susan, *Painted Prints – The Revelation of Color*, Baltimore, exh., Museum of Art, 2003

Desmond, Ray, *Wonders of Creation: Natural History Drawings in the British Library*, London, 1986

Desmond, Ray, *Great Natural History Books and their Creators*, London and Delaware, 2003

Doggett, Rachel, ed., *New World of Wonders: European Images of the Americas, 1492–1700*, Washington, exh. The Folger Shakespeare Library, 1992

Doran, Susan, ed., *Elizabeth*, Greenwich, exh. National Maritime Museum, 2003

Drayton, Richard, 'Knowledge and Empire', in *The Oxford History of the British Empire*, vol. II, *The Eighteenth Century*, ed. P. J. Marshall, Oxford, 1998

Elliott, J. H., *Empires of the Atlantic World: Britain and Spain in America, 1492–1830*, New Haven, 2006

Feest, Christian F., 'Virginia Indian in Pictures, 1612–1624', *The Smithsonian Journal of History*, 2 (1), 1967, pp. 1–30

Feest, Christian, 'Virginia Algonquians' and 'North Carolina Algonquians' in Bruce G. Trigger, ed., *Handbook of North American Indians*, vol. 15 *The Northeast*, Washington, 1978, pp. 253–70 and 271–81

Feest, Christian F., ed., *Indians and Europe: An Interdisciplinary Collection of Essays*, Forum 11, Aachen and Alanao, 1987

Feest, Christian F., 'Jacques Le Moyne Minus Four', *European Review of Native American Studies*, 2 (1), 1988, pp. 35–40

Feest, Christian F., *The Powhatan Tribes*, New York and Philadelphia, 1990

Feuillerat, Albert, ed., *Documents Relating to the Office of the Revels in the Time of Queen Elizabeth*, Louvain, Leipzig and London, 1908

Furst, Peter T., 'Tobacco', in Silvio A. Bedini, ed., *Christopher Columbus and the Age of Exploration: An Encyclopedia*, New York, 1998, pp. 279–81

Gerard, Robert A., 'Woutneel, de Passe and the Anglo-Netherlandish Print Trade', *Print Quarterly*, XIII (4), 1996, pp. 363–76

Greve, Anna, *Die Konstruktion Amerikas – Bilderpolitik in den Grands Voyages aus der Werkstatt de Bry*, Cologne, Weimar and Berlin, 2004

Groesen, Michiel van, 'De Bry and Antwerp,

1577–1585: A Formative Period', in Susanna Burghartz, ed., *Inszenierte Welten / Staging New Worlds*, Basel, 2004, pp. 19–45

Hadfield, Andrew, and McVeagh, John, eds, *Strangers to That Land: British Perceptions of Ireland from the Reformation to the Famine*, Gerrards Cross, 1994

Harriot, Thomas, see Abbreviations

Hakluyt, Richard the younger, *Discourse of Western Planting*, 1584, ed. David B. Quinn and Alison M. Quinn, London, Hakluyt Society, 1993

Hakluyt, Richard, *The Principal Navigations, Voyages, Traffiques and Discoveries of the English Nation*, London, 1st ed. 1589–90, 2nd ed. 3 vols 1598–1600

Hale, John R., *Age of Exploration*, New York, 1966

Hearn, Karen, ed., *Dynasties: Painting in Tudor and Jacobean England 1530–1630*, London, exh. Tate, 1995

Hind, Arthur M., *Engraving in England in the Sixteenth and Seventeenth Centuries: Part I, The Tudor Period*, Cambridge, 1952

Hodgen, Margaret T., *Early Anthropology in the 16th and 17th Centuries*, Philadelphia, 1974

Hoeniger, David F., 'How Plants and Animals Were Studied in the Mid-Sixteenth Century', in John W. Shirley and F. David Hoeniger, *Science and the Arts in the Renaissance*, Washington, London and Toronto, 1985, pp. 130–48

Honour, Hugh, *The European Vision of America*, Cleveland, exh. Museum of Art, 1975

Honour, Hugh, *The New Golden Land: European Images of America from the Discoveries to the Present Time*, New York, 1975

Hulton, Paul, see Abbreviations

Hulton, Paul, 'Introduction' to the Dover edition of Thomas Harriot, *A Briefe and True Report of the New Found Land of Virginia*, New York, 1972, pp. vii–xv

Hulton, Paul, ed., *The Work of Jacques Le Moyne de Morgues: A Huguenot Artist in France, Florida and England*, 2 vols, London, 1977

Hulton, Paul, 'Jacques Le Moyne de Morgues and John White', in Keith Andrews, Nicholas Canny and P. Hair, eds, *The Westward Enterprise*, Liverpool, 1978, pp. 195–214

Humber, John L. *Backgrounds and Preparations for the Roanoke Voyages, 1584–1590*, Raleigh, 1986

Hume, Ivor Noël, *The Virginia Adventure. Roanoke to James Towne: An Archaeological and Historical Odyssey*, Charlottesville and London, 1994

Jones, H. G., ed., *Raleigh and Quinn: The Explorer and His Boswell*, Chapel Hill, NC, 1987

Keazor, Henry, 'Theodore De Bry's Image for

America', *Print Quarterly*, XV (2), 1998, pp. 131–49

Kemp, William B., 'Baffinland Eskimo', in David Damas, ed., *Arctic* in W. C. Sturtevant, gen. ed., *Handbook of North American Indians* vol. 5, Washington, 1984, pp. 463–75

King, J. C. H., *First Peoples, First Contacts: Native Peoples of North America*, London, 1999

Klinkenborg, Verlyn, and O'Brian, Patrick, eds, *The Drake Manuscript in the Pierpont Morgan Library: Histoire Naturelle des Indes*, London, 1996

Kupperman, Karen Ordahl, *Settling with the Indians: The Meeting of English and Indian Cultures in America, 1580–1640*, London, 1980

Kupperman, Karen Ordahl, *Roanoke: The Abandoned Colony*, Lanham, 1984 (new edition forthcoming 2007)

Kupperman, Karen Ordahl, ed., *Major Problems in American Colonial History: Documents and Essays*, Lexington and Toronto, 1993

Kupperman, Karen Ordahl, ed., *America in European Consciousness*, Chapel Hill and London, 1995

Kupperman, Karen Ordahl, 'Presentment of Civility: English Reading of American Self-Presentation in the Early Years of Colonization', *William and Mary Quarterly*, 3d ser. 54, 1997, pp. 193–228

Kupperman, Karen Ordahl, *Indians and English: Facing Off in Early America*, Ithaca and London, 2000

Lacey, Robert, *Sir Walter Ralegh*, London, 2000

Lowood, Henry, 'The New World and the European Catalog of Nature', in Karen Ordahl Kupperman, ed., *America in European Consciousness*, Chapel Hill and London, 1995, pp. 295–323

McBurney, Henrietta, *Mark Catesby's 'Natural History of America': The Watercolours from the Royal Library Windsor Castle*, exh. Houston and London, 1997

McDermott, James, *Martin Frobisher: Elizabethan Privateer*, New Haven and London, 2001

MacGregor, Arthur, ed., *Sir Hans Sloane: Collector, Scientist, Antiquary*, London, 1994

Meganck, Tine, *Erudite Eyes: Artists and Antiquarians in the Circle of Abraham Ortelius*, Ann Arbor, 2003

Métraux, Alfred, 'The Tupinambá', in Julian H. Steward, ed., *Handbook of North American Indians* (Bulletin of the Bureau of American Ethnology 143; 7 vols), vol. 3, Washington, 1948, pp. 95–133

Miller, Helen, *Passage to America: Ralegh's Colonists Take Ship for Roanoke*, Raleigh, 1983

Miller, Lee, *Roanoke: Solving the Mystery of England's Lost Colony*, London, 2001

Miller, Shannon, *Invested with Meaning: The Raleigh Circle in the New World*, Philadelphia, 1998

Milton, Giles, *Big Chief Elizabeth: The Adventures and Fate of the First English Colonists in America*, New York, 2000

Morison, Samuel Eliot, *The European Discovery of America: The Northern Voyages, AD 500–1600*, Oxford and New York, 1971

O'Connor, Cynthia, *The Pleasing Hours: James Caulfeild, First Earl of Charlemont 1728–99, Traveller, Connoisseur and Patron of the Arts in Ireland*, Cork, 1999

Pagden, Anthony, *The Fall of Natural Man: The American Indian and the Origins of Comparative Ethnology*, Cambridge, 1982

Paisey, David, 'Prints at the Frankfurt Book Fairs, 1588–1600', *Print Quarterly*, 2006, pp. 54–61

Perdue, Theda, *Native Carolinians: The Indians of North Carolina*, Raleigh, 1985

Piggott, Stuart, *Ancient Britons and the Antiquarian Imagination*, London, 1989

Quinn, David Beers, *Roanoke Voyages*, see Abbreviations

Quinn, David B., *North American Discovery Circa 1000–1612*, New York and London, 1971

Quinn, David Beers, ed., *New American World: A Documentary History of North America to 1612*, 5 vols; *English Plans for North America; The Roanoke Voyages; New England Ventures*, vol. 3, New York 1979

Quinn, David B., and Quinn, Alison, eds, *The First Colonists: Documents of the First English Settlements in North America 1584–1590*, Raleigh, 1982

Quinn, David Beers, *The Lost Colonists: Their Fortune and Probable Fate*, Raleigh, 1984

Quinn, David Beers, *Set Fair for Roanoke: Voyages and Colonies, 1584–1606*, Chapel Hill, 1985

Quinn, David Beers, *Explorers and Colonies: America, 1500–1625*, London and Roncevereto, WV, 1990

Rountree, Helen C., *The Powhatan Indians of Virginia: Their Traditional Culture*, Norman, 1989

Rountree, Helen C., and Turner, E. Randolph III, *Before and After Jamestown: Virginia's Powhatans and Their Predecessors*, Gainesville, 2002

Saunders, Gill, *Picturing Plants: An Analytical History of Botanical Illustration*, Berkeley, Los Angeles and London, 1995

Schilling, Heinz, *Niederländische Exulanten im 16. Jahrhundert*, Gütersloh, 1972

Shields, E. Thomson, and Ewen, Charles E., eds, *Searching for the Roanoke Colonies: An Interdisciplinary Collection*, Raleigh, 2003

Shirley, John W., *Thomas Harriot: A Biography*, Oxford, 1983

Shirley, John W., *Sir Walter Ralegh and the New World*, Raleigh, 1985

Sievernich, Geron, ed., *America de Bry 1590–1634*, Berlin, New York and Casablanca, 1990

Sloan, Kim, *A Noble Art: Amateur Artists and Drawing Masters c.1600–1800*, London, exh. British Museum, 2000

Sloan, Kim, ed., *Enlightenment: Discovering the World in the Eighteenth Century*, London, 2003

Smith, Pamela H., and Findlen, Paula, eds, *Merchants & Marvels: Commerce, Science, and Art in Early Modern Europe*, New York and London, 2002

Solomon, Julie Robin, '"To Know, To Fly, To Conjure": Situating Baconian Science at the Juncture of Early Modern Modes of Reading', *Renaissance Quarterly*, 44 (3), Autumn 1991, pp. 513–58

Sondheim, Moriz, 'Die de Bry, Matthäus Merian und Wilhelm Fitzer', *Philobiblon*, 1933, pp. 9–34

Sondheim, Moriz, 'Die de Bryschen Grands Voyages', *Het Boek*, 24, 1936, The Hague, pp. 331–64

Stagl, Justin, *A History of Curiosity: The Theory of Travel 1550–1800*, Chur, 1995

Stainton, Lindsay, and White, Christopher, *Hilliard to Hogarth*, London, exh. British Museum, 1987

Strong, Roy, *The Cult of Elizabeth: Elizabethan Portraiture and Pageantry*, London, 1999

Stuart, Kathleen, 'A Sketchbook in the Pierpont Morgan Library by Jacques le Moyne de Morgues and His Workshop', unpublished MA dissertation, CUNY, 2001

Sturtevant, William C., and Quinn, David Beers, 'This New Prey: Eskimos in Europe in 1567, 1576, and 1577', in Christian F. Feest, ed., *Indians and Europe. An Interdisciplinary Collection of Essays*, Forum 11, Aachen and Alanao, 1987, pp. 61–140

Sturtevant, William C., 'First Visual Images of Native America', in Chiappelli, Fredi, ed., *First Image of America: The Impact of the New World on the Old*, 2 vols, Berkley, 1976, vol. I, pp. 417–54

Sturtevant, William C., 'The Sources for European Imagery of Native Americans', in Doggett, ed., 1992, pp. 25–33

Sturtevant, William C., 'Le Tupinambisation des Indiens de l'Amérique du Nord', in Gilles Thérien, ed., *Les Figures de l'Indien*, Les Cahiers du Département d'Études Littéraires 9, Montréal, 1988, pp. 293–303

Symons, Thomas H. B., ed., *Meta Incognita: A Discourse of Discovery. Martin Frobisher's Arctic Expeditions, 1575–1578*, Hull, exh. Canadian Museum of Civilization, 1999

Trevelyan, Raleigh, *Sir Walter Raleigh*, London, 2002

Trigger, Bruce G., *Northeast*, in Sturtevant, William C., gen. ed., *Handbook of North American Indians*, vol. 15, Washington, 1978

Wallis, Helen, see R&R in Abbreviations

Wüthrich, Lucas Heinrich, *Das Druckgraphische Werk von Matthaeus Merian d. Ä.*, 3 vols, Hamburg, 1966–93

1492 Christopher Columbus of Genoa sails to the **Bahamas**, Cuba and Hispaniola and claims them for **Spain**

1493 Pope Alexander VI's Bull of 4 May gives Spain the right to all lands not already held by a Christian prince lying west of a line drawn 100 leagues beyond the Azores or Cape Verde Islands; Portugal entitled to those to the east of the line

1493–4 Columbus sails to the Lesser Antilles and Puerto Rico and founds a colony at Isabella, Hispaniola, bringing back gold, slaves and spices

1494 Treaty of Tordesillas between Spain and Portugal moves the line to 370 leagues west of the Azores thus entitling Portugal to most of Brazil and parts of Newfoundland and Labrador and Spain to most of the rest of North and South America. Protestant powers increasingly dispute the authority of the papal bull and treaty through the 1560s and 1570s.

1496 Henry VII gives letters patent to **John Cabot** and his sons to 'seeke out discover and finde' lands unknown to Christians, wherever they may be

1497 John Cabot voyages to **Newfoundland** and claims it for England

1498 Vasco da Gama reaches **India**, opening all-sea route for Portugal

1500 Cabral claims **Brazil** for **Portugal**

1504 French begin fishing cod on the **Grand Banks** off Newfoundland

1508 Michelangelo begins to paint the **Sistine Chapel**

1516 Thomas More publishes *Utopia*

1519–22 Ferdinand Magellan, a Portuguese sailor in the service of Spain, circumnavigates the globe while searching for a route to Cathay; **Suleyman I** becomes Sultan of Ottoman Empire (to 1566); **Luther** excommunicated; death of **Raphael**

1524 Verrazano for France reaches the **Outer Banks**, which he believes is an isthmus with the Pacific Ocean beyond; sails north as far as New York and Maine

1526 Gonzalo Fernández de Oviedo y Valdés, *De la natural hystoria de las Indias*, Toledo

1528 Castiglione publishes *The Courtier*

1530 Charles I of Spain crowned Holy Roman Emperor **Charles V**

1531 Thomas Elyot, *The Boke Named The Governour*

1534 Jacques Cartier for France to **Labrador** and the Gaspe; England Act of Supremacy; **Holbein** made court painter to Henry VIII

1535–42 Cartier explores the **St Lawrence** and as far as Hochelaga (Montreal) and 'Norumbega'

1540 Foundation of Society of Jesus (**Jesuits**)

1546 Death of **Martin Luther**

1547 Death of Henry VIII and accession of **Edward VI**

1553 Death of Edward VI and accession of **Mary**; Royal Charter to 'The Merchants Adventurers of England for the Discovery of Lands, Territories, Isles, Dominions and Seignories Unknown' (from 1555 the **Muscovy Company**), with Sebastian Cabot as governor; search for the **Northeast Passage** to Asia, under the advice of John Dee, various attempts 1553–6

1554 Marriage of **Mary and Philip** of Spain

1555 R. Eden's translation of **Peter Martyr's** *Decades of the newe worlde*

1556 Philip II becomes **King of Spain** (to 1598)

1557 André Thevet, *Les Singularitez de la France Antarctiqve avtrement nommée Amérique …*, Paris (trans. into English as *The New Found Worlde* 1568); **Hans Staden**, *Warhaftige beschreibung einer Landschafft der wilden nacketen grimmigen menschenfresser leuthen in der newen welt America gelegen*, Marburg.

1558 Elizabeth I's accession to English throne; loses Calais to French; Netherlands revolt against Spanish rule

1559 Elizabeth's coronation; **Mary Stuart** married to Francis II becomes Queen of France; treaty with France and Spain

1560 Death of **Francis II** of France; Elizabeth I re-coinage of debased coinage; 1560s and 1570s English, French, Spanish and Portuguese fishing in **Grand Banks**

1561 Thomas Hoby translates Castiglione's *Il Cortigiano*

1562 François Deserps, *Recueil de la diversité des habits, qui sont de present en usage, tant es pays d'Europe, Asie, Affrique & Isles sauuages*. Paris; 1562–5 **French in Florida**

1564 Death of **Michelangelo**

1564–5 Le Moyne in **Florida**; **Girolamo Benzoni**, *La Historia del mondo Nvovo*, Venice

1566–74 Spanish in **Florida**

1566 John White marries Thomasine Cooper, St Martin Ludgate, London

1566 Humphry Gilbert, letter accompanying manuscript 'Discourse of a discoverie for a new passage to Cataia' (published in 1576): 'Sir, you might justly have charged mee with an unsetled head if I had at any time taken in hand, to discover Utopia, or any countrey fained by imagination: but Cataia is none such, it is a countrey, well known to be described and set foorth by all moderne Geographers … and the *passage thereunto, by the Northwest* from us, through a sea which

lieth on the Northside of Labrador, … I (amongst others) have been moved, to hope of that passage, who can justly blame me' (Quinn, *Gilbert*, I, 1940, p. 134)

1567–9 Hawkins and Drake sail to West Indies and Mexico and end the Tudor alliance with Habsburgs, beginning state of quasi-war in New World

1568 Elinor White christened 9 May, St Martin Ludgate, London

1569–70 Humphry Gilbert savagely crushes Munster rebellion in Ireland and is knighted; **Mercator's map** of the world; **Papal bull of excommunication; Ortelius**, *Orbis terrarum mundi*

1571 William Cecil becomes **Lord Burghley**

1572 St Bartholomew's Day massacre of Protestants in France; **Johannes Sluperius**, *Omnium fere gentium nostraeque aetatis nationum, habitus et effigies, et in eosdem epigrammata*, Antwerp

1573 Sir Francis Walsingham appointed principal secretary

1574 Henry III King of France (to 1589)

1575 Christopher Saxton, *County Atlas of England and Wales*

1576 Humphry Gilbert *A Discourse of a Discoverie for a New Passage to Cataia*; **Martin Frobisher's first voyage** to search for the Northwest Passage, with merchant-shipowner Michael Lok, believes Frobisher Bay is the passage to Cathay and returns with a captive Inuit man and a lump of iron pyrites which is assayed as gold; the Inuit man is drawn by Lucas de Heere and painted by Cornelis Ketel

1577–8 Martin Frobisher sails back to mine gold (on Kodlunarn Island) and follow the passage to Cathay – they returned with 'gold' and **three Inuit captives**, drawn by John White and painted by Cornelis Ketel

1577 Francis Drake sets out on **circumnavigation**; John Dee's *General and rare memorials pertayning to the Perfect Arte of navigation*; **Hans Weigel**, *Habitus praecipvorvm popvlorvm … Trachtenbuch: darin fast allerley und der fürnembsten Nationen, die heutigs tags bekandt sind, Kleidungen*, Nuremberg

1578 Frobisher's third voyage, large fleet; Walsingham, Sydney, Lok all invest and purpose is solely mining – returned with 1350 tons of ore but 'when neither Gold, Silver, nor any other metall could be drawne … we saw them throwne away to repayre the high-wayes' (Camden's *Annals*); Thomas Churchyard, *A prayse, and reporte of Maister Martyne Forboishers voyage to Meta Incognita*; **Jean de Léry**, *Histoire d'vn Voyage fait en la terre dv Bresil avtrement dite Amerique*, La

Rochelle; **George Best**, *A True Discourse of the late voyages of discoueries, for the finding of a passage to Cathaya, by the Northuuest* ; **John Dee** produces map of North America with summary of Elizabeth's claims to title to land; **Sir Humphry Gilbert** given letters **patent** to 'discover, searche, finde out and viewe such remote heathen and barbarous landes countires and territories not actually possessed of any Christian prince or people' and may settle and take possession – but voyage set out too late and turned back

1579 Twelfth Night Court Masque of Amazons and Knights followed by a tournament

1580 Sir Humphry Gilbert promises land to Dee and Philip Sidney and to English Catholics, Walsingham and Raleigh invested; **Simon Fernandez** in Gilbert's ship, *The Squirrel*, sails to **New England** and back and produces a chart of the Atlantic and North America which is copied for John Dee; **Philip II of Spain** accedes to the throne of **Portugal**; Drake returns from circumnavigation; Montaigne, essay 'Des Cannibales' (trans. into English 1603)

1581 About this time **Jacques Le Moyne** arrived in London with his wife as a religious refugee; **Abraham de Bruyn**, *Omnium pene Evropae, Asiae, Aphricae atque Americae Gentium Habitus*, Antwerp

1582 Richard Hakluyt the younger, *Divers voyages touching the discouerie of America* illustrated with Michael Lok's map of North America and describing the voyages of the Cabots and Verrazzano, adding notes on the value to England of colonizing northern regions and commodities to be expected there, goods to shipped there, etc., written to promote Gilbert's drive for investors for his North American ventures, dedicated to **Philip Sidney**, who remarked to Stafford that he 'was haulf perswaded to enter into the journey of Sir Humphry Gilbert very eagerli; whereunto your Mr Hackluit hath served for a very good trumpet'. Richard Hakluyt the younger (1552–1616) was at Oxford until 1577, was ordained in 1580; from 1583 to 1588 he was Chaplain to Edward Stafford, English ambassador in Paris, gathered intelligence for Sir Francis Walsingham; in his dedication to Walsingham of the first edition of his *Principal Navigations*, 1589, he wrote: 'I do remember that being a youth it was my hap to visit the chamber of Mr Richard Hakluyt my cousin, a gentleman of the Middle Temple, well known unto you, at a time when I found lying open upon his board certain books of Cosmography, with an universal Map: he, seeing me somewhat curious … began to instruct my ignorance … he pointed with his wand to all the known Seas, Gulfs, Bays, Straights, Capes, Rivers, Empires, Kingdoms, Dukedoms and territories of each part, with declaration also of their special commodities, and particular wants, which by the benefit of traffike, and entercourse of merchants, are plentifully supplied … tooke in me so deepe an impression, that I constantly resolved, if ever I were preferred to the University … I would by Gods assistance prosecute that knowledge and kinde of literature'

1583 Sir Humphry Gilbert sails with the Hungarian chronicler **Stephen Parmenius** and takes possession of **Newfoundland** at St John's for England; drowns on the return voyage; **Elinor White** marries Ananias Dare 24 June, St Clement Danes, London

1584 Hakluyt the younger wrote 'at the request and direction of the righte worshipfull Mr Walter Raghley, nowe Knight' 'A Particular discourse concerninge the greate and manifolde comodyties that are like to growe to this Realme of Englande by the Westerne discoveries lately attempted, Written in the yere 1584' (**'Discourse of Western Planting'**) presented to the Queen, intended only to circulate in manuscript as a plea for royal support for the English settlement in America for various purposes and benefits to the nation – the establishment of a colony that was to be the beginning of an empire

1584 24 March: **Raleigh** obtains Gilbert's **patent for a colony in North America**; 27 April **Philip Amadas and Arthur Barlowe** with Simon Fernandez as pilot (and **possibly John White and Thomas Harriot**) on reconnaisance voyage; early July reach Outer Banks and Port Ferdinando inlet to **Roanoke Island** where established good relations with Wingina from **Roanoke**; mid-September return to England with **Manteo** and **Wanchese**

1584–5 Hakluyt the elder wrote two versions of his manuscript 'Inducements to the lykinge of the voyadge intended to that parte of America which lyeth betwene 34. and 36. degree of Septentrionall Latytude' and 'Inducements to the Liking of the Voyage intended towards Virginia in 40. and 42. degrees'

1585 Raleigh knighted and permitted to call the new land **Virginia** and prepared colonizing expedition; 9 April expedition sails under **Sir Richard Grenville** with Fernandez as pilot and **Harriot and White** to write and illustrate an account – partly funded by William Sanderson (five ships and around five to six hundred men, of whom half were seamen, over a hundred colonists, rest soldiers or specialists not expected to stay) – specialists included Joachim Ganz, a Jewish mineral expert from Prague who had been advising on more efficient smelting processes for copper mines in Cumberland in 1581; 15–29 May temporary camp at Guayanilla Bay, Puerto Rico; 26 June anchor at **Wococon**; 3 July send word of arrival to Wingina at Roanoke; 11 July Grenville, Lane, Harriot, White and Amadas and others travelled from Wococon to mainland with food for eight days; 12 July to **Pomeiooc**, 13 to **Aquascogoc**, 15 to **Secotan** and 'were well intertayned there of the Sauages'; 16 returned from there and one boat sent to Aquascogoc to demand a silver cup believed to be stolen and set fire to town; 18 returned to fleet at Wococon; 21 weighed anchor for Hatoraske and anchored there and 27 rested; 29 Granganimo, brother of Wingina, boarded Grenville's ship with Manteo; 2 August Grenville to Weapemeoc; 5 Arundell returns to England; 25 Grenville (possibly with John White) returns to England and takes prize en route; August fort on Roanoke completed and Ralph Lane commands colonists including Thomas Harriot over winter; 6 October *Tyger* anchors at Falmouth; 18 Grenville on prize arrives Plymouth; Lane's colonists survey and explore as far as Chesapeake over winter

1585–6 Drake's expedition against **Spanish West Indies**, with Frobisher as vice-admiral (sails September, attacks Santiago in Cape Verde Islands, Santo Domingo (1 January **1586**), Cartagena, St Augustine in Florida (May); evacuates Roanoke (June); Treaty of Nonsuch, Elizabeth promises military help to Dutch

1585–7 John Davis, master mariner, makes further searches for the **North-west passage** under Royal patent with funding from William Sanderson, and sails into Cumberland Sound (named after George Clifford, the Earl, fig. 22) and Davis Strait

1586 Hakluyt the younger in Paris met **Andre Thevet** who lent him **Rene de Laudonniere**'s ms *L'Histoire notable de la Floride* which Hakluyt had printed in 1586 and English translation by H in 1587 as *A notable Historie containting foure voyages … unto Florida*; **Raleigh** made **captain of the guard**

1586 April or May **Grenville** leaves with seven or eight ships for **'Virginia'**; June Lane kills **Wingina** and then Drake arrives and evacuates colonists; July–August Grenville arrives and leaves fifteen men at deserted fort; death of **Philip Sidney**; **William Camden's** *Britannia*

1587 Hakluyt the younger published his new edition in Latin of *De orbe novo … decdes octo* by **Peter Martyr** (later used by Michael Lok for the first English translation *De Novo Orbe,*

or the Historie of the West Indies, 1612), dedicated to Raleigh and in his preface he projected his *Principal Navigations* along same lines, to bring scattered records together and 'to the end that posterity … may at last be inspired to seize the opportunity offered to them of playing a worth part'; as a vast improvement upon 'those wearie volumes bearing the titles of univerall cosmographie … most untruly and unprofitablie amassed and hurled together', parallel with Camden's efforts for English history at home; execution of **Mary Queen of Scots**; Drake attacks Spanish fleet at Cadiz

1587 7 January **Cittie of Raleigh in Virginia** incorporated with **John White as Governor** with twelve assistants to establish a settlement on Chesapeake Bay; 8 May three ships leave Plymouth; July reach Port Ferdinando and colonists installed on Roanoke; 18 August birth of Virginia Dare, granddaughter of John White; 27 August White leaves for home for supplies; November reaches England

1587–8 Theodor de Bry engraves 30 plates after Thomas Lant of 'The Procession at the Obsequies of Sir Philip Sidney'

1588 ?February publication of **Harriot**'s *A brief and true report of the new found land of Virginia*; March–April new colonizing expedition under Grenville abandoned; April–May **White** makes abortive attempt to return to Virginia; July, defeat of **Spanish Armada** – Frobisher, Drake and others are captains

1589 Richard Hakluyt the younger, *Principall Navigations, Voiages and Discoveries of the English Nation*, dedicated to Walsingham; **Henry IV** of France ends religious wars; **Walter Bigges**, *A Summarie and True Discourse of Sir Francis Drakes West Indian Voyage* published with Baptista Boazio's map of

'The famous West Indian voyadge made by the English fleete' and maps of Drake's naval conquests

1590 Death of Francis Walsingham; **White returns to Roanoke** Island where finds settlement deserted but sign that colonists had left for Croatoan; **Theodor de Bry,** *America part I* consisting of Harriot's *A Briefe and True Report of the New Found Land of Virginia* and engravings after John White's watercolours published, Frankfurt, in English, German, Latin and French

1590 Cesare Vecellio, *De Gli Habiti Antichi, Et Moderni di Diverse Parti del Mondo*, Venice:

Edmund Spenser, *Fairie Queene*, **Sir Philip Sidney's** *Arcadia* published posthumously (and 1593)

1591 Theodor de Bry, *America part II* consisting of **Jacques Le Moyne,** *Brevis narratio eorum quae in Florida Americae provincia Gallis acciderunt … quae est secundo pars Americae* and engravings after Le Moyne, Frankfurt

1592 Pietro Bertelli, *Diversarvm nationvm habitvs iconibus in aere incisis expressi,* 2nd ed., Patavia; **Emery Molyneux's** great terrestrial **globe** with information from Raleigh is engraved by Jodocus Hondius

1593 John White writes an account of the Lost Colony for Hakluyt from Newtowne, Munster 3 February; **Alexandro di Fabri,** *Diversar[um]. nationum habitus*, Padua

1595 Raleigh's voyage to Guiana to find **El Dorado**

1596 Robert Cecil is appointed principal secretary; death of **Drake**

1597 John Gerard *The Herball or generall Historie of Plantes*; William Camden, *Annales rerum Angliae et Hiberniae regnante Elizabetha*

1598 Death of **Lord Burghley**

1598–1600 Richard Hakluyt's three-volume *The Principall Navigations, Voiages and*

Discoveries of the English Nation; John Stowe, *Survey of London*; Elizabeth grants charter of new **East India Company**

1602 Bodleian Library opens; **Dutch East India Company** chartered

1603 Death of Elizabeth I and accession of **James I**; arrest of **Raleigh**

1605 Gunpowder plot; George Chapman, *Eastward Ho!*

1608 John Smith *A True Relation of such occurrences and accidents of noate as hath hapned in Virginia*; **Samuel Champlain** founds a French colony at **Québec**

1611 Shakespeare's *Tempest* first performed

1612 William Hole engraving of **John Smith's** map of Virginia in Smith's pamphlet *A Map of Virginia*

1610 Henry Hudson explores Hudson Bay

1610–12 William Strachey's manuscript 'The first Boke of the historie of Trauaile into Virginia Britannia'

1615 Dutch settle **Manhattan** Island as fur-trading post

1616 Raleigh released from Tower to lead expedition to **Giuana** for gold; death of **Shakespeare**

1616–17 John Rolfe's manuscript 'A true relation of the state of Virginia'; **Pocahontas** received at court and dies shortly before return to Jamestown

1617–18 Raleigh in Guiana

1618 Execution of Raleigh on return to England

1620 English pilgrims land at **Plymouth Bay**; *Heroologia Anglica* by Henry Holland and de Passe family

1621 Death of **Thomas Harriot** from cancer caused by tobacco

1624 John Smith, *The Generall Historie of Virginia, New-England, and the Summer Isles*, with map

1625 Death of **James I**

PHOTOGRAPHIC ACKNOWLEDGEMENTS

Photographs © The Trustees of the British Museum, excluding the following figures (in order of city):

National Library of Ireland, Dublin: 28
Edinburgh University Library: 40
Paula Henderson (photo), courtesy of Lord Verulam, Gorhambury: 108
National Maritime Museum, Greenwich: 12, 22, 56, 57, 78, 79, 80, 120
By permission of The British Library, London: 2, 3, 6, 10, 33, 34, 36, 37, 39, 42, 44, 46,

46–8, 50, 58–63, 65–9, 71–5, 81, 82, 84, 86, 95–8, 100, 101, 103, 117–19, 122, 128, 132, 136, 137, 140, 144, 153, 182
House of Commons Library, London, on loan to the Enlightenment Gallery, British Museum: 123
National Portrait Gallery, London: 1, 17, 27
Victoria and Albert Museum (©V&A Images), London: 19, 20, 21
Yale Center for British Art, New Haven / Bridgeman Art Library: 94
Humanities and Social Sciences Library / Print

Collection, Miriam and Ira D. Wallach Division of Art, Prints and Photographs, New York Public Library, New York: 77
The Pierpont Morgan Library, New York: 41
Ashmolean Museum, Oxford: 9
The Bodleian Library, University of Oxford: 4, 38
The Provost, Fellow and Scholars of The Queen's College, Oxford: 16
Allgemeinen Geschäftsbedingungen der Klassik Stiftung Weimar-Fotothek, Weimar: 43
Private Collection: 49

CONCORDANCE OF TITLES, FIGURES AND CATALOGUE NUMBERS FOR DE BRY ENGRAVINGS AND JOHN WHITE DRAWINGS OF INDIANS AND PICTS

SHORT TITLE	DE BRY	CAT. NO	FIG.	PH PL/FIG.
Title page		**2**		1/
Map of Virginia		**6**	*3, 58*	60/5
Arrival in Virginia	II	p. 107	*59*	/6
'Werowance' or great Lord of Virginia	III	**13**	*69*	48/7
Wife of a chief of Secotan	IIII/IV	**22**	*82*	37/8
A priest/religious man of Secotan	V	**15**	*72*	42/9
Young woman of Secotan/a wife of Wingina	VI	**18**	*75*	47/10
A chief lord of Roanoke	VII	**21**	*81*	46/11
A chief lady of Pomeiooc with her daughter	VIII	**14**	*71*	33/12
An aged man in his winter garment	VIIII/IX	**23**	*84*	34/13
Their manner of carrying their children	X	**16**	*73*	35/14
The flyer/conjurer	XI	**17**	*74*	49/15
Their manner of making their canoes	XII	**7**	*61*	/16
Their manner of fishing	XIII	**7**	*60*	43/17
The broiling of fish	XIIII/XIV	**43**	*118*	45/18
The boiling of meat in earthen pots	XV	**42**	*117*	44/19
Their sitting at meat	XVI	**24**	*86*	41/20
Their manner of praying around a fire	XVII	**12**	*68*	40/21
Their dances at high feasts	XVIII	**11**	*67*	39/22
The town of Pomeiooc	XVIII/XIX	**9**	*63*	32/23
The town of Secotan	XX	**8**	*62*	36/24
Their idol Kiwasa	XXI	**10**	*66*	/25
The tomb of their 'werowances' or chief lords	XXII	**10**	*65*	38/26
The marks of sundry of the chief men of Virginia	XXII	pp. 85, 116	*47*	/27
Adam and Eve		p. 84	*46*	

Some Pictures of the Picts which in old time inhabited part of Great Britain

A Pict	I	30	*96*	65/29
A woman Pict	II	33	*100*	67/30
A young daughter of the Picts	III	32 and p. 153	*94, 98*	/31
A neighbour of the Picts	IV	34	*101*	68/32
A woman neighbour of the Picts	V	31	*97*	69/33

Index